The Bible
and its Painters

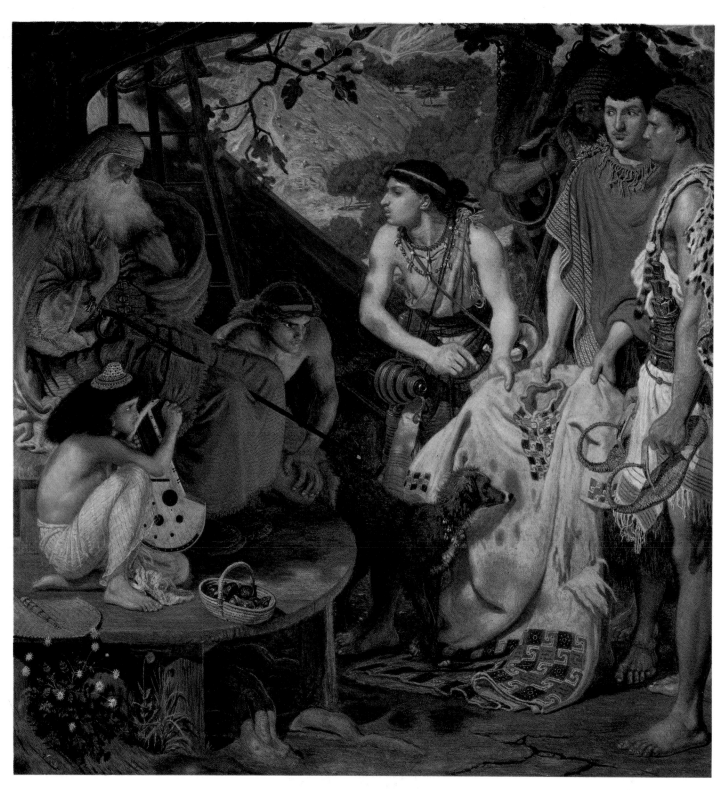

Ford Madox Brown
(1821–1893)
'The Coat of Many Colours'
(see note for page 61)

The Bible
and its Painters

Bruce Bernard

With an Introduction by Lawrence Gowing

Macmillan Publishing Company
New York

This book is dedicated to my godson Leo

Picture Acknowledgments

The author and publishers are grateful to the museums, galleries and collections credited with each illustration for permission to reproduce the paintings in this book. The paintings on pages 62t, 120/1, 241 are reproduced by Gracious Permission of Her Majesty The Queen and the painting on page 36 is reproduced by Gracious Permission of Her Majesty The Queen Mother. Photographs were supplied by these collections except in the following cases: APEA Photographers, Toronto 116/17; Artothek, Munich 115, 149, 153, 171, 173, 212, 223, 226, 233, 237b, 246; Arxiu Mas, Barcelona 18, 57, 128, 222, 224, 237t; Bavaria Verlag Bildagentur, Munich 62b, 72/3, 122; Bildarchiv Preussischer Kulturbesitz, Berlin 78, 156/7; J. E. Bulloz, Paris 81, 83; Charmcraft, Yorkshire 53, 192, 232; Trustees of the Chatsworth Settlement, Derbyshire 59; A. C. Cooper, London 66/7, 84/5; Corvina Archives, Budapest 208; Photo Ellebé, Rouen 187; Photo Etienne, Bayonne 86; Colorphoto Hans Hinz, Basle 87; Archivio IGDA, Milan 72, 79, 125, 142, 144, 145, 147, 176, 183, 203, 228; Institut Royal du Patrimoine Artistique, Brussels 143, 177, 227, 229, 258, 266/7; Ralph Kleinhempel, Hamburg 179; Lauros-Giraudon, Paris 34, 35, 41, 48, 64, 75, 100, 110, 113, 197, 243, 245, 252; Studio Lourmel 77/Photo Routhier, Paris 32/3; Magnum/Eric Lessing/ John Hillelson Agency, London 92, 221, 238; Photo Meyer, Vienna 42, 68, 129, 130/1, 160, 174, 236; Monumenti Musei e Gallerie Pontificie, Vatican City 20/1, 23, 65; Novosti, London 53, 232; Pedicini, Naples 182; Réunion des Musées Nationaux, Paris 16, 37, 136; Scala, Florence 10, 24/5, 29, 97, 138/9, 170, 184/5, 190/1, 200, 204/5, 206, 210, 214, 218, 230/1, 239, 248, 255, 257, 270, 273; Tom Scott, Edinburgh 40, 101, 189; Whitfield Fine Art, London 109. The painting reproduced on page 194 is © SPADEM, Paris 1983.

Macmillan Publishing Company
866 Third Avenue, New York, N.Y. 10022
Collier Macmillan Canada, Inc.

First American Edition 1984

Library of Congress Cataloging in Publication Data
Bernard, Bruce.
 The Bible and its painters.

 Bibliography: p.
 1. Bible—Illustrations. 2. Painting. I. Title.
ND1430.B44 1984 755'.4 84–9742
ISBN 0-02-510130-7

Macmillan books are available at special discounts for bulk purchases for sales promotions, premiums, fund-raising, or educational use. Special editions or book excerpts can also be created to specification. For details, contact:

 Special Sales Director
 Macmillan Publishing Company
 866 Third Avenue
 New York, New York 10022

10 9 8 7 6 5 4 3 2 1

Printed in Italy by SAGDOS, Milan

Contents

5

Contents

Contents

Foreword

This book is about the way all kinds of painters of pictures illustrated the Bible between the fourteenth and twentieth centuries. It deliberately avoids every form other than portable pictures designed to hang on walls or those painted in oil or fresco directly onto walls and ceilings, and I am conscious that by making it so I have deprived the reader of the pleasures both of medieval manuscript illumination and of all kinds of prints and drawings (except for William Blake's mixed media). The supreme imagery of the devotional painting has also been excluded – The Madonna and Child, alone or with saints, and Her Immaculate Conception, Assumption and Coronation, together with the *Pietà* and the kind of representation of the Crucifixion that betrays no narrative intention.

It will be seen from my notes that I have included a few pictures that I do not admire and some that I like but do not rate highly in the canon of art. I have done so both to demonstrate the variety of picture the Bible has provoked and to underline what I feel to be the supreme images. Although I have tried not to impose any coherent moral or aesthetic censorship, the selection is unashamedly personal. But I have been anxious to include what I believe to be the very greatest images that the Bible narrative has inspired, and my personal taste and judgment are to blame if anyone feels that a particular masterpiece has been *unforgivably* excluded.

Lawrence Gowing observes in his introductory essay, that Rembrandt is the hero of this book and I cannot deny it, though the great painter and human being himself is responsible. He poses so many alternatives that I could easily have called on more than three times the quantity of his pictures without lowering the quality of his contribution.

All great, good and bad painters have in varying degrees felt and indulged the urge to make their own contributions to the Bible stories they have illustrated and this book is in part about both the compulsive inventiveness and the unruliness of artists. Surely no other religion than the Christian one has tolerated the licence that painters in Europe have so often demanded and been granted in their sometimes capricious deviations from both the sense and feeling of sacred texts. It seems to me both surprising and gratifying that none was ever burned at the stake. This makes the Christian art of the West an extraordinarily rich record of human personality with all the failings that Christianity has been with us in part to admonish, as well as of faith. It also provides a record of the varying character of belief as it has changed down the centuries and across the denominations.

Artists even when directly employed by the Church seem to a remarkable degree to have enjoyed the liberties we now take so for granted, long before they were allowed to any other kinds of human and social commentator, to scientists, or indeed the ordinary mass of humanity. This suggests that those who have generally commissioned religious art, whether cardinals, aristocrats or tradesmen, obtained a vicarious and not quite openly admitted sense of imaginative liberty through it, and also that art is an essential nourishment for more parts of our being than we may imagine – however much we think we value it.

I very much hope that the book will be enjoyed on several levels: among many possible ones by those whose primary interest is from reasons of faith; as a happy reminder for those who take pleasure in paintings of the rich variety of story that the Bible contains even if they have never opened it since childhood (or never opened it at all); and also as an impression of European painting at grips with the only theme that has both called on, and been granted, every single aspect of its potential.

I owe the deepest personal thanks, firstly to Lawrence Gowing, whose extraordinary restraint in not telling me which paintings he feels are sadly missing from the book has been such an inspiring kind of discretion. He also kindly gave up much of his time to reading my notes and advised me to remove a great deal of nonsense from them, while being too considerate to point it out in every single instance, and the presence of his inimitable essay is a reassurance beyond value to me. But perhaps I should have begun by thanking Martin Heller who first conceived the idea and then asked me to get the book together and has been the soul of patience and generosity throughout the whole year it has taken to assemble it.

Others to whom I owe thanks for both help and encouragement in varying degrees but with equal warmth are Graham Bingham, Rosanna Bortoli, Christopher Brown, Judy Carlomagno, Jean Coxsey, Ann Davies, Marsh Dunbar, the late Peter Dunbar, William Feaver, Robert Gordon, Charlie Hunt, Leonard Lambourne, Catherine Lampert, M-J. Lancaster, Jeremy Maas, Graham Mason, Andrew McIntosh Patrick, Anthony Roscoe, Kate Shave, Andrée Thorpe, Malcolm Warner, Ben Weinreb, and to Ian Chilvers for his knowledgeable assistance in research, the staff of the Fine Art Library at Westminster Central Reference Libraries, for providing facilities beyond the call of duty and The Warburg Institute, London. I would finally like gratefully to acknowledge the spirit of Walter Shaw Sparrow, who at the beginning of the century produced three anthologies of Biblical paintings which are the venerable ancestors of this collection.

Bruce Bernard

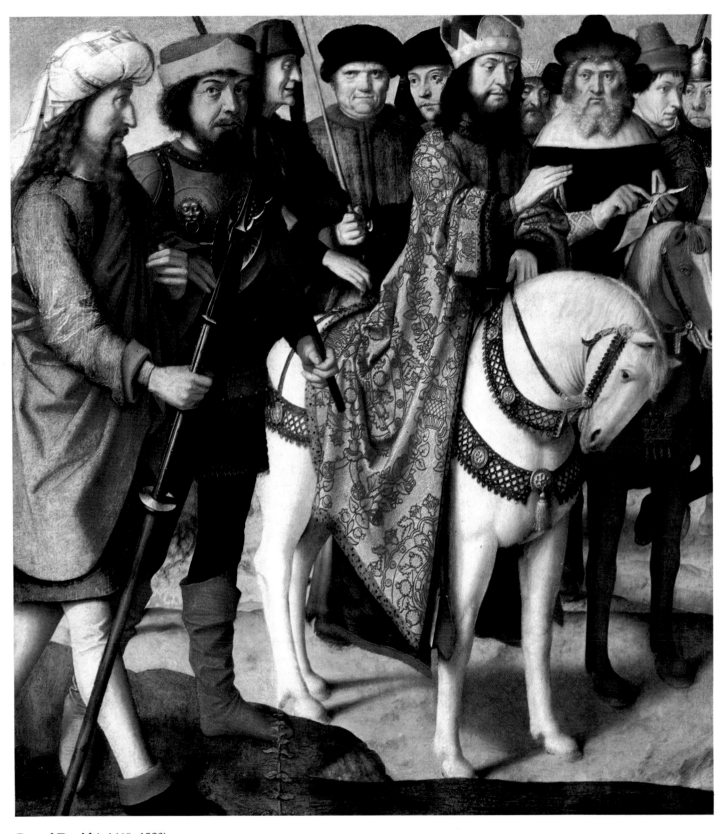

Gerard David (*c.*1460–1523)
'Jewish Judges and Roman
Soldiers'

Introduction

This book is prompted, more than anything else, by a sense of wonder. We find the material fabulous – in several senses. The richness seems to us beyond belief – again, in more than one sense. However far each of us is from the faith (or the scepticism) of his fathers, we are overwhelmed by the abundance that lies before us when we begin to look at the Western painting that illustrates the Bible. The sheer abundance is astonishing. Not only the number of pictures, but the extent of the subject matter – the quantity and variety of the stories from the Judaeo–Christian epic that were found to require illustration.

This was not only a devotional need; indeed the primarily devotional subjects stand rather apart. They do not illustrate the narrative and they are not included here. After 1300, when painted illustration swelled into a flood, it was no longer needed chiefly for the instruction of the illiterate, as Gregory the Great had laid down six hundred years before. Even the majority who could not read must have been made endlessly familiar with the narrative tradition by oral repetition. The need seems to have been rather for an imaginative nourishment, for which the present view of art does not fully account. Visual illustration, which became possible, indeed urgent, as Western painting developed, indulges an appetite as a dream does.

The national literature that is the Old Testament possessed in its origin no faculty of visualization and no pictorial gloss. Originally it was oral. Images were categorically forbidden. Even to write the narrative would have added a material impurity to the working of the Spirit. The scripture of Judaism was realized only in the verbal picturing and in the music, in which it was and is sung, Sabbath by Sabbath through the year.

The Christian world married the purity of Hebrew scripture to the sensuous awareness of the Greco–Roman world. In this new form, not only imagined but open to tangible portrayal, the Christian West fell on it with an insatiable appetite. It added a new dimension to religious observance. The twist that the West gave to the aesthetic self-denial of Judaism revealed an unrealized hunger. Painting must have become in itself an immense and unique imaginative indulgence.

There is nothing like this flood of narrative picturing, nothing so imagined yet specific, pictured exactly and in detail, then re-imagined, over and over down the centuries. There is nothing resembling it among all the cultures of man. It is one strand in the unique fabric that our painting has woven, which we become aware of at last when it is slipping away, a precious sign of the unparalleled dual value that Western society and its painters have given both to the outward, perceptible, world and at the same time, in the same picturing, to what is inward and invisible, either ideal or compulsive.

In this unique weave, Bible painting has been the most lasting and indispensable thread in the continuing imaginative weft. Why, we must wonder? What is it *about*? Though preacher and painter try to tell us, we may still hardly know. Can it be that these repeated illustrations were themselves part of the ritual that sustained the myth? Mythology has to be realized continually in the medium that means most to the imagining of a people – it is sustained by being visibly performed over and over as long as the culture has life, as the Greek narratives were dramatized and performed in the theatre, and the Hebrew narrative, myth and chronicle together, is sung at worship.

Can it be that for us the stories that so mysteriously yet durably enshrined a way of life were maintained precisely by being so often painted? The repetitions are suggestive in themselves. Myth naturally repeats itself. The first man is succeeded by another primal parent and it seems that Hieronymus Bosch was in doubt whether to preface his great triptych of transgression, indulgence and their punishment with the world as first created or as rediscovered under the rainbow of the Covenant. Greco–Roman imagery presented personages that were evidently human. In our epoch the impulse stirs within us restlessly to re-imagine the action and interaction of the sacred. The stillness in our art, revived in the mood that we think of as classical, is achieved by the will.

Watching the York or Wakefield mysteries roll by, you realize how the appetite for illustrative imagining would have been stimulated by plays that were already separable and mobile entities, like pictorial objects. Looking at the earliest-painted pictures in this collection, the Entry into Jerusalem by Duccio from the back of

the Maestà 'altarpiece' in Siena Cathedral (where it indulged the clergy, and was never seen by anyone who could not read) and Giotto's Betrayal of Christ, we are not far from the mobile and vivid effect of episodes in a Mystery cycle. Yet the two pictures illustrate their subjects quite differently, with a difference that already shows the options that were opening to Western painters (see pages 200 and 210).

The Entry into Jerusalem, for which Duccio provided one of the tallest panels in his series, is a progression through a graphic space, and a confrontation, across one of the first dramatic spark-gaps in painting, between committed sanctity and the crowd in the street. It is a true entrance to the climax of the Christian story, the Passion which was to be suffered in Jerusalem.

In Giotto's picture the fateful kiss, which rivets the attention of everyone around, is imagined with intense emotion. Yet the arrangement of the pictures at Padua informs us that nothing in the whole story is private or incidental. In the Arena Chapel each subject is linked, not only in the narrative order with those on either side in a horizontal band, but by the analogy with those vertically above or below it, in relations that hint at the higher purpose. So the kiss of Judas is not only the treachery that the narrative recounts. It also relates to the presentation in the Temple, which appears above it; it has the character of a ritual dedication.

The void in another of Giotto's frescos at Padua (the space into which Joachim was expelled from the Temple) must have been conceived a year or two before Duccio's vivid spatial punctuation of the scene outside the city gates on the first Palm Sunday. The story of Joachim and Anna is part of the legend of their child, the Virgin Mary, and is thus, with all else but the biblical record, outside our subject here. We are concerned with the realization of the narratives in painting – they had been carved during the previous century and illustrated graphically with varying credibility for longer still. But for the painting that makes things real in somewhat the terms they might be seen in, the realization of Bible stories was inaugurated in these two great series in the first ten years of the fourteenth century. Giotto's scenes, painted broadly in fresco on plaster, are six feet square. Duccio's largest panels, like the Entry into Jerusalem, no more than forty inches high, were precisely painted in tempera. But otherwise the two achievements were complementary in style and in influence. When the two schemes were complete, Bible painting was in orbit. Something of its subsequent course through more than five hundred years is seen in this book.

Read, as it is, in the context of worship, the Old Testament can hardly be heard as Bible painting is seen – as a specifically and compellingly emotional experience. It does not indulge a dream, as painting of its nature may, or offer a sensuous realization. The human story as the painters see it is replete with love and violence. There are tales of truth and deceit, obedience and defiance, intemperance, benevolence and malice and prudence. The qualities collide in their most spectacular form.

Sometimes the morality is apparent only by virtue of standards that are inverted by the necessities of a sacred destiny. In this light it is right that Jacob's deceit should succeed while Esau's obedience does not, and the robust characterization that makes him sympathetic shows Flinck at his best (page 55). But when it is a question of assessing the appropriateness to the scheming woman of the story of the humane characterization of the Rembrandt model who served Flinck for Rebecca, we are at a loss. We can only accept the various, perhaps incongruous pleasures that painting provides, and feel grateful that the Old Testament offers so many. Refracted in great painting, the Hebrew saga affords far richer satisfactions than most of us have gathered through any other means.

Only painting surely, perhaps only Rubens, has identified and portrayed the delight in the fratricidal aggressiveness of Cain (page 30). We must enjoy the agony of Abel if we are to feel Cain's vice and recognize its mark on ourselves. The achievement of Goya was of the same kind; he could recognize the sensual savagery which links the virtue of Judith with the lust of Salome (page 129). With Artemisia Gentileschi and her full-blooded response to the story we become aware that, read into Israelite patriotism, passion can be liberated and also avenged (page 126). It was left to Cranach the Elder with his meretricious adornments to render quite coolly Judith who prostituted herself to her mission (page 128).

Painting shows in the murderous vice of Cain the inhumanity that is an inseparable quality of mankind. It also shows the consequences, and how long they lasted. In about 1809 William Blake imagined Cain as pursued by an accusing fireball (page 31). A native sincerity and naturalness brought within Blake's range much that no one else could paint. After Michelangelo, only Blake painted Godhead without embarrassment. Only he could paint Adam in his morning innocence. At the Creation of Adam, under the brooding feathered Elohim, Blake had the insight to paint man's enslavement in the material world and the worm of mortality that curls around him (page 21). In 1880 the intelligent (rather than visionary) Fernand Cormon, made an unforgettable image of the abject primitivism to which Cain and his family reverted – painted him driven out on that day from the face of the earth and hidden from the grace of God, condemned to be a vagabond and a fugitive in the earth, with every hand raised against him (page 33).

The human value of the Judaeo–Christian saga is self-evident in the great painting that it inspired. So it comes about that this book is a tribute to the most profoundly human of painters, whom we never have

sufficient occasion to honour – a tribute to Rembrandt.

The magnificent savagery of Rubens, painting Cain and Abel, has its counterpart in the even more splendid compassion of Rembrandt painting the Sacrifice of Abraham (page 53). Rubens gives Abel an expression of horror, as Cain takes him by the throat, which remains with us. Yet the unforgettable impression is the mercy that relieved Abraham and Isaac of the fearful command, and relieves us of the horror, which is Rubens's pride – and must have been the despair of Salvator Rosa, who liked horror as much as anyone, yet, when he imitated the Rubens in his picture in the Doria Gallery in Rome, had to contrive a Venetian shadow, to avoid portraying Abel's face. We are relieved of all this in the Rembrandt, yet we are not spared the situation, as Abraham was not spared it. On the contrary, we see how he felt it, and feel it with him, because his recourse was savagely to plant his great hand over his son's face to hide it. The expedient tells more than horror – it tells of grief.

The virtue of the genetic destiny in the line of Abraham echoes through the Book of Genesis almost to the exclusion of other values. The predicament of Hagar, maid to Abraham's wife Sarah, cast out with her son Ishmael in the wilderness, was painted in the seventeenth century and in the nineteenth, and usually with a lyrical beauty that is at first sight mysterious. The story is fearful. When the water ran out Hagar threw the child under a shrub and sat down a bow-shot away so she would not see him die. But the angel was sent to comfort her because the boy was the seed of Abraham and water for his survival, as well as a future for his descendants, was guaranteed by the genetic destiny. God was with Abraham in all that he did, as Abimelech prudently observed. This was the assurance that was inherited by Christian culture and the pictures painted in its name.

Something in these stories communicated itself to the pictorial imagination of the West. In part, it was a genius in the telling, so specific, so perceptive of character, so alert to peril and salvation. There was compelling drama in story after story of the fate that waited in some place of terror – the parched desert with only a bush for shadow where the child Ishmael was to die, or the brook at evening by the ford called Jabbok (which means excrement and dissipation), where Jacob was left alone to wrestle with an angel till the break of day. And so on. Now that they have been painted so well we can see that they were pictorially irresistible – more compelling to painters than anything in the history of their own lands.

But looking at the art that resulted, we find ourselves far from clear what it meant to the painters and their communities in the Christian West to adopt the Hebrew sense of genetic destiny as their own. It predicated a different kind of art from any that is imaginable in the classical context. We cannot now envisage a Europe that is not accustomed to see itself in terms of Judaeo–Christian tradition. Our image of ourselves is conditioned by its literature, its myth and its legend. So the fantastic abundance of the imagery illustrating the Bible story in our culture makes real not only the human drama, the fateful happenings back to the beginning of time, with the vividness of dreams. Much more, it makes real the structure of these stories, with the patterns of reminiscence and presentiment and the repetitive correspondences which are built into them, as the dialogue with God is built into Judaeo–Christian history. Giotto, at the very start of this torrent of illustrative realization introduces us not only to the chain of events, but to the analogies and correspondences knitting scripture to legend, which give the New Testament a structure that is read as divine purpose.

The New Testament is anticipated and foretold, and it is linked to what went before in common patterns. The correspondences link the illustrations in the first half of this book to the second. The angel whom Luke describes coming to Christ in the agony of his struggle with his destiny at Gethsemane is seen by El Greco as carrying the metaphoric cup that Christ prays may pass from him (page 208). We are reminded of Jacob's struggle until the breaking of the day at the ford called Jabbok. The healing of the Shunammite Woman's son anticipated the Raising of Lazarus. The Cross was raised as the staff of Moses had been raised; Moses lifted his arms in the wilderness as Jesus was to be lifted in Crucifixion. For the painters it is one, almost continuous story.

The authorities of Jerusalem and Rome are each as guilty of the Crucifixion as the other. There is a moving subject here by Gerard David and one that only painting could deal with (as painting alone dealt with two creations or three gospels at once) – Imperial soldiery and Jewish judges are seen herded together in one equally responsible human crowd, a crowd as much of the painter's time as any other – seen in fact as they had to be seen if the common Judaeo–Christian heritage, of equal guilt and the same redemption was to be a reality (page 10).

In the adoption of the Jewish heritage and the spiritual achievement of Israel, the painters' record was no more above approach, than anyone else's. At the Last Supper, which is seen by Justus of Ghent as a mystic Eucharist for the Italian court of Urbino, one could wish that the ambassador from the Shah of Persia, called Isaac, who had lately been converted, was treated with a shade less condescension (page 206).

Bible painting, like the Bible itself, is a whole lexicon of natural reactions and surprisingly few of them are quite as innocent as you might expect. This book offers a whole spectrum of moral dimensions; each painter

sees his part of the story refracted in the preferences of his time and his temperament. In the seventeenth century, when human skin, catching the light, and the physical bulk of people were accessible to painters as never before, Isaac took on for Ribera a more fleshly weight as he lay down in the open to sleep than any patriarch had been given by another painter. His slumber was grosser, his dream more evanescent. It is one of the most affectingly human of Bible pictures (page 57). Turner, on the other hand, cast the opposite light on the story. For him Jacob's dream was a fairyland that could only have been dreamt or painted at the height of the Romantic movement (page 56). He came to it in much the mood that he brought to reading Shelley and to painting Queen Mab's Grotto. Ribera's contemporary, Orazio Gentileschi, father of the ferociously feminist Artemisia, was equally influenced by the sombre materialism of Caravaggio, and gave the Holy Family's Rest on the Flight into Egypt similarly human weight and volume. It was the refinement of painterly poetry to bring to a story that we imagined with more sentiment than substance so physical a sense of how solid and tired the family on its journey really was, and to contrast humanity with the dumb patience of the donkey and the flatness of the sheltering wall (page 151).

Narrative material as rich as this gives opportunities that realism finds nowhere else. Jan Massys never observed anything more truthfully than the travellers turned away from the inn at a Flemish Bethlehem (page 143). The uncomfortable salutary truths are always the social ones.

In this book two series of quite different kinds are superimposed. From the Hebrew myth of the first terrestial day to the Christian vision of the end of time the span of the Bible narrative is immense. We see it through a graduated range of changing and developing capacities to imagine it, and the evolving resources to represent or realize episodes from it – through the talents, in fact, of more than a hundred painters spread over more than five hundred years.

Turning over the illustrations in Bible-order we are jumping to and fro in the art-historical sequence. For many subjects we are confronted with versions, quite far apart in time and style, of a story that is basically constant, being derived from the established text, yet imagined in different social contexts as well as realized in a different artistic one. Some stories become imaginable in one period rather than another. Although the candid eye of a Northern Renaissance master based a masterpiece of lust and embarrassment on Joseph breaking away from Potiphar's wife, the story became the special property of the seventeenth century. Only then, when style cast its telling shadows round the dark side of sexual behaviour, were there resources for illustration as subtly perceptive as the account of the great novelist who contributed the thirty-ninth chapter to the Book of Genesis. Orazio Gentileschi painted the urgency of the sexual imperative as well as anyone has, but the profound pictures of the story revealed something beyond that. In Rembrandt's versions the avidness apparent in the woman's allegation became not malignant but pathetic, and Joseph's predicament was more comprehensible than ever (page 62).

Caravaggio, who uncovered the disturbing emotional potentiality thrown up by painting figures from life, was the great master of bodily proximity and Rembrandt's achievement would have been impossible without the depth that he added to the art. But Rubens, who admired Caravaggio no less, and sought his masterpieces for his patrons, also owed to Caravaggio more than we might guess from the rhythm and the coherence of his style. Only in this emotional climate was it possible to re-imagine the intimacy of Samson with Delilah in its Herculean, yet vulnerable consummation, and to paint the touch of skin in sexual congress – to portray, for example this chilling hand resting on the gigantic back in seduction and imminent betrayal (page 88).

The Hebrew dialogue with God, the continuing thread in the Old Testament story, is a real argument: that is its greatness. It was more readily within the reach of the national literature than of narrative art in a distant culture and another millennium. Yet European painting does sometimes realize the tension in the dialogue – and realize it more frankly than Biblical commentaries in other media. Orthodox commentaries find a certain difficulty to this day in explaining the role of a benevolent Deity in the story of Babel. It was just that ironic contradiction that was to the taste of Pieter Bruegel, who painted it more often than any other subject. His enormous, sliding, toppling tower, like a fantasy of the Roman Colosseum turned inside out, celebrated beyond a doubt the doomed ideal of understanding among men. Bruegel's faith was very likely heterodox. For him it would have reflected no credit on the Deity of the established order that He should have rewarded the sympathetic aspirations of the inhabitants of Babel (aspirations as evidently progressive as those of the Erasmian Netherlands) by going down to confound their language and scatter them abroad. Not that the inhabitants concerned emerge with honour; the foreground, illustrating the folly of abasing yourself before kings was Bruegel's characteristic addition to the story (page 42).

Many, perhaps most of the painters allowed common, human experience to shed light on the Bible story; it was thus that the Franciscans interpreted the gospels, and provided lasting themes for the familiar humanity of painting. Bruegel thought of the Christmas story as happening as if in his own time in a Netherlandish village with the predictable Northern weather. But conceivably he was among those who believed that Christ was no longer to be looked on as an historical personage so much as a 'condition' common to those who live in union

with God. For him a theme like the Nativity (or the carrying of the Cross) has an oddly insubstantial look among the vivid life around it. It appears pallid, almost transparent, existing more in imagination than in the flesh. In Bruegel's Nativity a Holy Family so withdrawn, so veiled and inward-looking that it scarcely seems to be present in the flesh, is adored by monarchs who appear almost grotesque. But if we look closely at Jasper's cloak, embroidered with emblems of the elements, we find that it is the whole material world – earth, air, fire and water – that is paying tribute to the child (page 146). Heretical or not, Bruegel had in him more than most painters of an essential Judaeo–Christian ideal.

At the beginning and the end of the story, with the Deluge and the Last Judgment, narrative painting as such necessarily falls silent. The unimaginable themes and the major thunderclaps in the Judaeo–Christian story, the sun commanded to stand still over Gibeon or the explosive openings in the Apocalypse, could be met only by the cosmic fantasy of the British painting which so saddened Constable when he saw Francis Danby's Sixth Seal in 1829 that he observed despairingly, 'The art is now full of Phantasmagoria' (page 264). If he had lived to see John Martin's Plains of Heaven he would surely have recognized what he used to call 'the vacant fields of idealism' (page 274).

Martin and Danby fantasized infinitude like a tempestuous descant on Turner's theme of natural immensity, with its overtones of industrial revolution. The enfolding immensity of nature and power turned into a nightmare of boundless biblical catastrophe, a nightmare out of evangelical preaching. The outcome of it was great illustration, pictorial drama that swept all before it. British romanticism engendered a unique and monstrous mutation in the imagining of first and last things, and its serious sensationalism takes its rightful place in this book.

Nothing makes us more aware than painting of the unity of the Bible narrative. Painters from Duccio to Poynter each maintained a constant standpoint to a tradition of which they were the latest heirs. The community surrounds Joseph, as he tells his dreams in Rembrandt's humane imagining, with just the impatient attention that the Doctors accord to Jesus in the temple (page 60). Memling imagines Bathsheba – in one of the masterpieces that show to particular advantage in a collection like this – as a lady, with characteristic Northern modesty and grace, attended at her bath and receiving the attention with just the delicate yet generous recognition that she gives it in Rembrandt's open-hearted vision of her (pages 99 and 100). Spiritually, the two masters have much in common. Europe has fostered a comprehension of the flesh, which was never learnt better than in those chapters of the Old Testament that were written with such sympathy for desire and nakedness and shame, and for the tactical falsehoods that even the patriarchs were sometimes forced to tell to protect their loves.

Rembrandt is the hero of this book because he is the most responsive of all painters to what is age-old, immemorial and unchanging in the Judaeo–Christian standpoint. It is he, more than any other artist, who best identifies it for us. As the Christian story reaches its climax, Rembrandt paints best the tragedy that has been foretold – indeed in the Legend of the Cross predicated almost from the beginning – and he is unrivalled in painting the exaltation that is its outcome, in the series of Passion pictures painted for Prince Frederick Henry of Orange in the 1630s – the pictures which gave him so much trouble to finish that at last he was constrained to explain, as he never did before or later, that they had been executed with a quality that he specified in words, which may mean either 'the most natural movement' or 'the most innate emotion' – or else mean both, as we would choose for this summit of Bible painting – the peak of the ability in our tradition to make real in painting the destination of the Judaeo–Christian story (page 233).

Two of Rembrandt's moods are seen, as it happens, in neighbouring illustrations towards the end of this book (pages 215 and 216). Constantijn Huygens, the secretary to Prince Frederick Henry, exaggerated the animation of Judas returning the thirty pieces of silver. Movement is suspended; the expression is in the stillness and the incandescent colour. Light coruscates with an acid brilliance on the carpet-covered table and the glittering coins. The sense of vileness is concentrated in the gesture with which the high priest averts his eyes. Thirty-one years later Rembrandt painted St Peter's three-fold denial before the cock crew. Light from a shielded candle catches Peter's face in the bitter moment of awareness that the foresight has been confirmed. The watchers and everything else are veiled in penumbra with glinting reflections; as Turner noticed, the shades of doubt are a beauty in themselves. With Rembrandt the beauty extends to Peter's self-doubt in the grey light of dawn.

Rembrandt had painted more than once another such unforgettable moment when Christ revealed himself over supper at Emmaus (page 245). It was Goethe who noticed that the sudden recognition, this time silhouetted in profile against the candle-light, was borrowed from Adam Elsheimer's picture of Jupiter and Mercury, recognized – equally overwhelmingly – at dinner with their rustic hosts, Philemon and Baucis. The classical memory adds its meaning to the Bible story, as it does more than once in this book; Degas imagined David like a young Spartan (page 96). Goethe thought the stroke which Rembrandt borrowed from Elsheimer worth more than an arsenal of antique chamber-pots.

The Bible narrative is full of such lightning flashes of awareness and they are never lost on great painters. At the climax of Jacob's struggle through the night, the angel, who could not shake him, renamed him Israel, because he had power with God and with men and had prevailed. Jacob, as the sun rose on him, named the place Peniel or Vision of God, 'For I have seen God face to face and my life is preserved'.

Almost as many of the subjects that appealed to painters were homely insights into everyday situations. Dieric Bouts saw the gathering of Manna as the routine of desert housekeeping (page 75). Georges de La Tour painted the annunciation to Joseph as a dream of a most charmingly natural angel-child (page 136). Gerard David and Patenier thought of the Rest on the Flight into Egypt as an incident of common country life; St Joseph has time to beat down nuts from the trees (page 152). The balance of duties in the household of Martha and Mary is a subject of perennial domestic interest and when Vermeer painted them it led him to a reverie on womanly stature that continued all his life (page 189). The scriptures were a key to life, just as life offered a gloss on the scriptures.

It is at first sight surprising that comparatively little of the Bible narrative is construed as visionary or doctrinal. When the doctrine and the vision are reached they take precedence over everything else. Around Christ the judge on the altar wall of the papal chapel, Michelangelo painted a ferocious cyclone of damnation and salvation. It revolves clockwise, tumbling to hell on the right, floating up through resurrection to salvation on the left (page 273). The same antithesis is balanced round a similar gesture in El Greco's Cleansing of the Temple; the attentive disciples gather on the right; the money-changers are expelled in the rotary current imparted to the profane crowd on the left (page 202).

El Greco's transcendental vision of the Opening of the Fifth Seal in the Revelation of St John and the impatient souls of them that were slain for the word of God, who cry out for vengeance in the sixth chapter of the book (until they are pacified somewhat by white robes given unto every one of them) is so memorable in its agitation that we hardly accept any less convulsive image for the Apocalypse (page 262). Turner's sketch of a white horse ridden by Death is quite apocalyptic enough to be the apparition that was given power over the fourth part of the earth in consequence of the opening of the fourth seal (page 260). Perhaps his panel was a rejoinder to the derivative romanticism of the huge version which Benjamin West took to the Salon in Paris during the peace of Amiens in 1802. West had been a pioneer, in turn, of stoic classicism and of the revived taste for Salvator Rosa. In the latter style, his picture of King Saul's consultation with the kind of witch that he had been persecuting, in pursuit of Samuel's support against the Philistines, had a genuine biblical awe (page 98).

It is quite difficult for us to recognize any of the transcendental and thunderous omens that accompanied the apocalyptic worship of the Lamb in the well-ordered Paradise of the great vision that forms part of the founding masterpiece of Northern art, painted by one or both Van Eycks in Ghent (page 267). Nevertheless the idyllic landscape, and the jewelled colour through which we look into another world present the mystic destination of the New Testament as the prospering materialism of the early-fifteenth century conceived it. Looking at Bible painting we do indeed join 'a great multitude, which no man could number, of all nations and kindreds, and peoples, and tongues . . .' The Van Eycks showed them as they 'stood before the throne, and before the Lamb, clothed with white robes, and palms in their hands; and cried with a loud voice, saying, Salvation to our God which sitteth upon the throne, and unto the Lamb.'

If we cannot recognize ourselves or the standpoint that means most to us among the obedient groupings in the flowery meadow at Ghent, we can search in the very different assembly that Masaccio was painting in Florence no more than five years earlier – the apostles gathered as if outside a town in the Val d'Arno to discuss with their Master the rights and wrongs of taxation and cogitate as best they could his sardonic instruction. There we can hardly fail to recognize a situation like our own. Masaccio's view of the disciples as a group of steadfast and solidly reasonable individuals was almost the first image of how modern men incline to imagine themselves. Masaccio knew his limitations as we ought to; he left the figure of Christ in the Tribute Money to be painted by his older collaborator Masolino in a simple and delicate Gothic style, which was untouched by rationalism or self consciousness (page 185).

Or, if we prefer, we can look elsewhere and seek again. On nearly every page of this book we can find some imaginative realization that has contributed to our own frame of mind.

Lawrence Gowing

The Old Testament

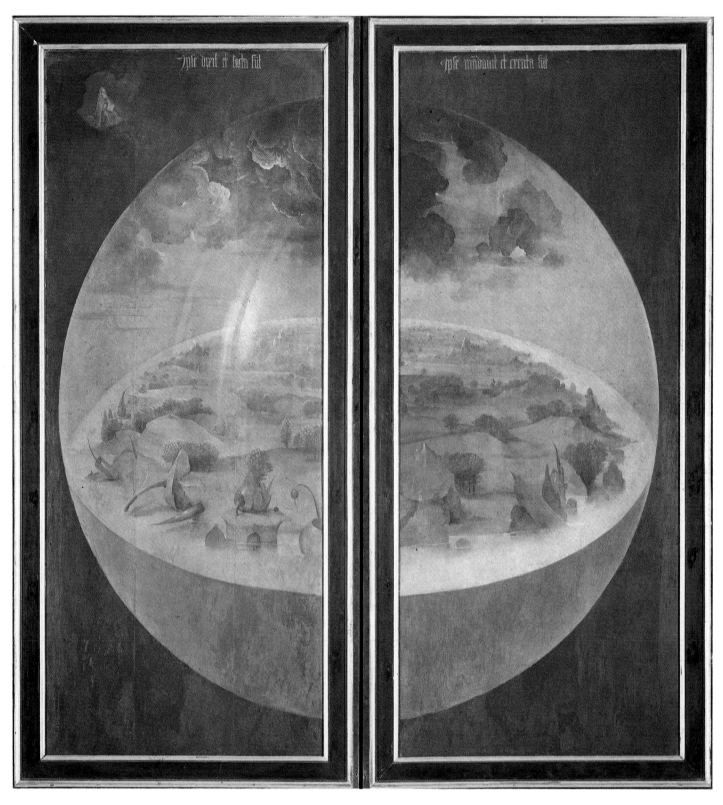

Hieronymus Bosch
(*c.*1450–1516)
'The Creation', side panels of
'The Garden of Earthly
Delights'

In the beginning God created the heavens and the earth. The earth was without form and void, and darkness was upon the face of the deep; and the Spirit of God was moving over the face of the waters.

And God said, "Let there be light"; and there was light. And God saw that the light was good; and God separated the light from the darkness. God called the light Day, and the darkness he called Night. And there was evening and there was morning, one day.

And God said, "Let there be a firmament in the midst of the waters, and let it separate the waters from the waters." And God made the firmament and separated the waters which were under the firmament from the waters which were above the firmament. And it was so. And God called the firmament Heaven. And there was evening and there was morning, a second day.

And God said, "Let the waters under the heavens be gathered together into one place, and let the dry land appear." And it was so. God called the dry land Earth, and the waters that were gathered together he called Seas. And God saw that it was good.

And God said, "Let the earth put forth vegetation, plants yielding seed, and fruit trees bearing fruit in which is their seed, each according to its kind, upon the earth." And it was so. The earth brought forth vegetation, plants yielding seed according to their own kinds, and trees bearing fruit in which is their seed, each according to its kind. And God saw that it was good. And there was evening and there was morning, a third day.

GENESIS
Chapter 1, Verses 1–13

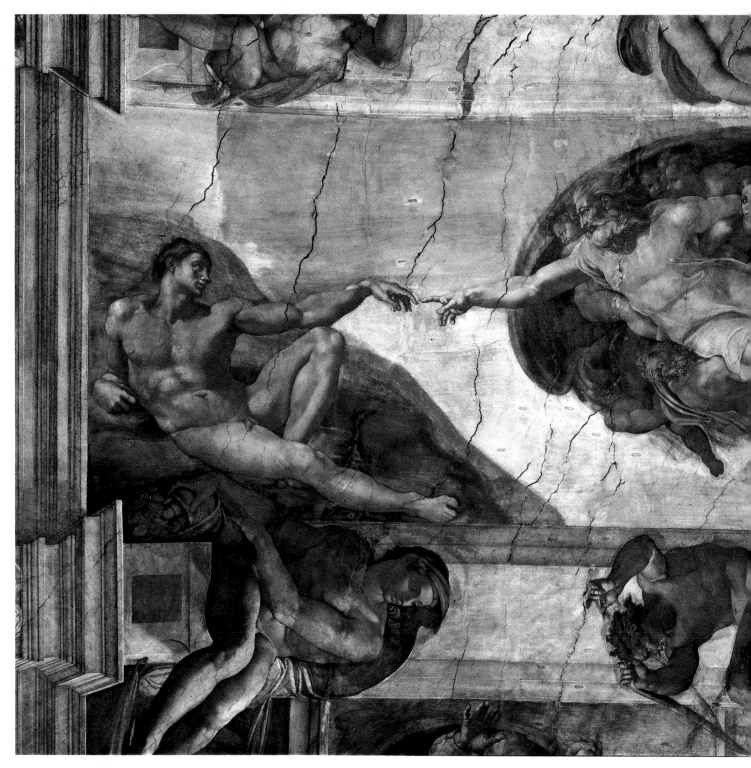

Michelangelo Buonarroti
(1475–1564)
'The Creation of Adam'

These are the generations of the heavens and the earth when they were created.

In the day that the LORD God made the earth and the heavens, when no plant of the field was yet in the earth and no herb of the field had yet sprung up—for the LORD God had not caused it to rain upon the earth, and there was no man to till the ground; but a mist went up from the earth and watered the whole face of the ground—then the LORD God formed man of dust from the ground, and breathed into his nostrils the breath of life; and man became a living being.

William Blake (1757–1827)
'Elohim Creating Adam'

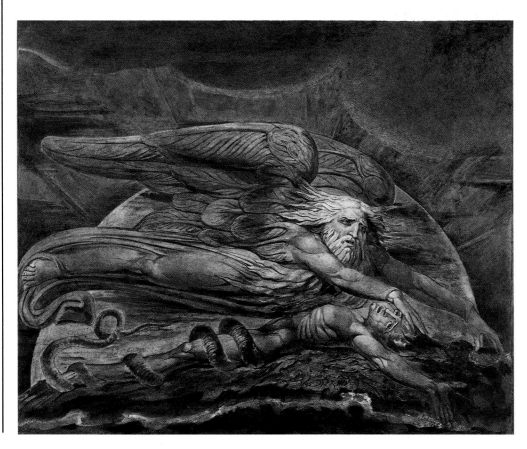

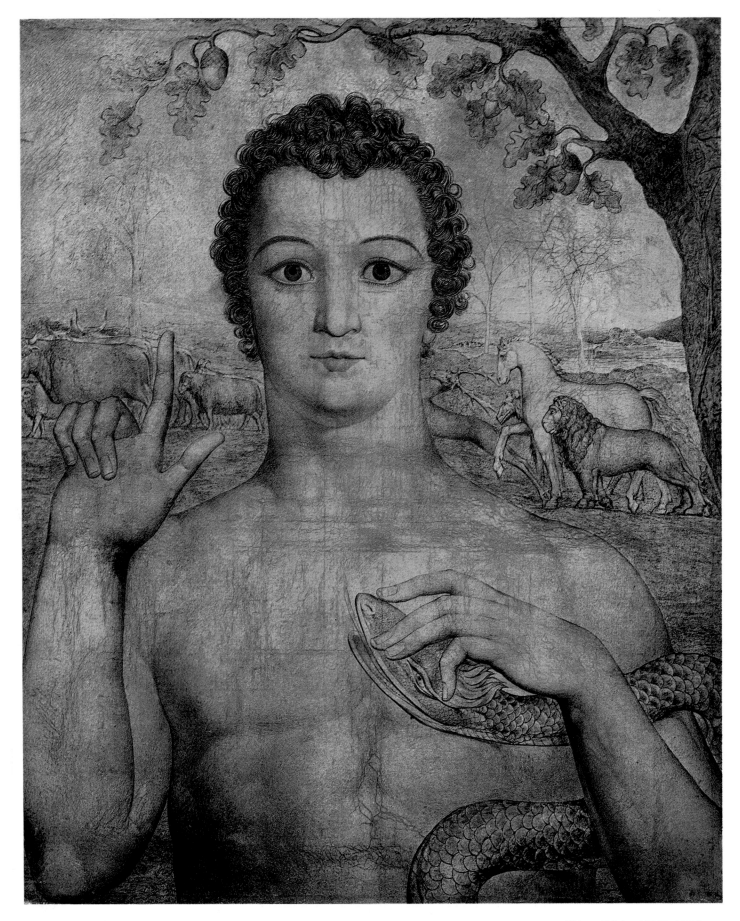

William Blake (1757–1827)
'Adam Naming the Beasts'

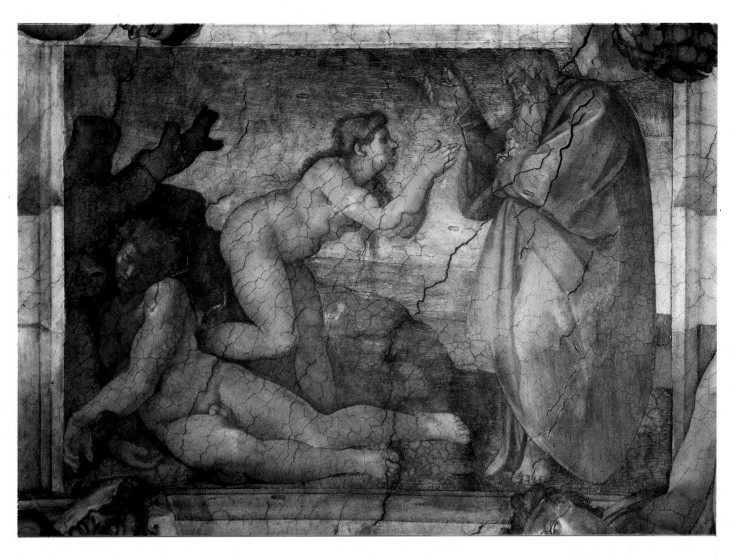

Michelangelo (1475–1564)
'The Creation of Eve'

GENESIS
Chapter 2, Verses 18–25

Then the LORD God said, "It is not good that the man should be alone; I will make him a helper fit for him." So out of the ground the LORD God formed every beast of the field and every bird of the air, and brought them to the man to see what he would call them; and whatever the man called every living creature, that was its name. The man gave names to all cattle, and to the birds of the air, and to every beast of the field; but for the man there was not found a helper fit for him.

So the LORD God caused a deep sleep to fall upon the man, and while he slept took one of his ribs and closed up its place with flesh; and the rib which the LORD God had taken from the man he made into a woman and brought her to the man. Then the man said,

"This at last is bone of my bones and flesh of my flesh;

she shall be called Woman, because she was taken out of Man."

Therefore a man leaves his father and his mother and cleaves to his wife, and they become one flesh. And the man and his wife were both naked, and were not ashamed.

Jacopo (da Ponte) Bassano
(1517/18–1592)
'The Earthly Paradise'

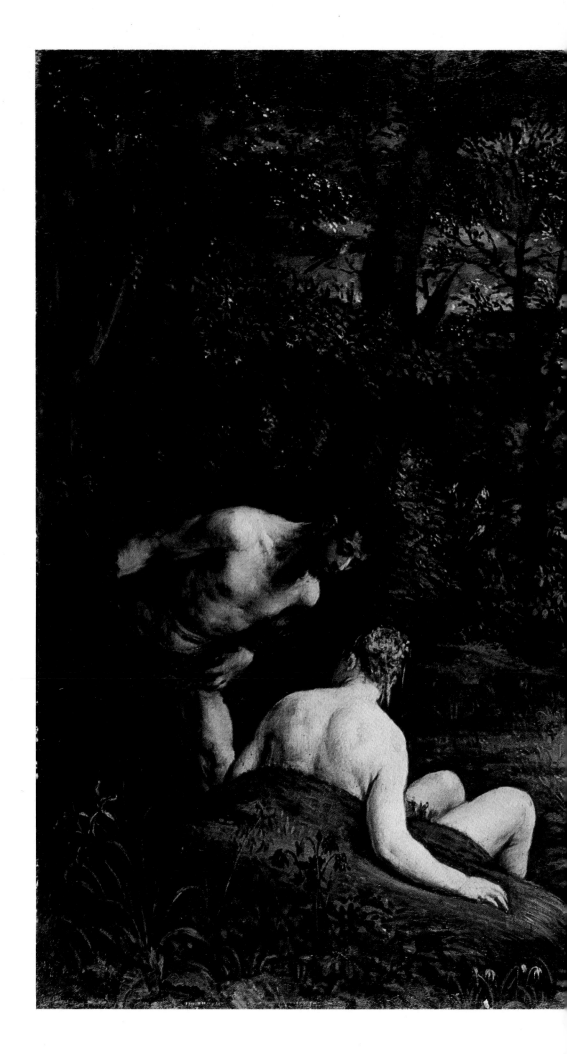

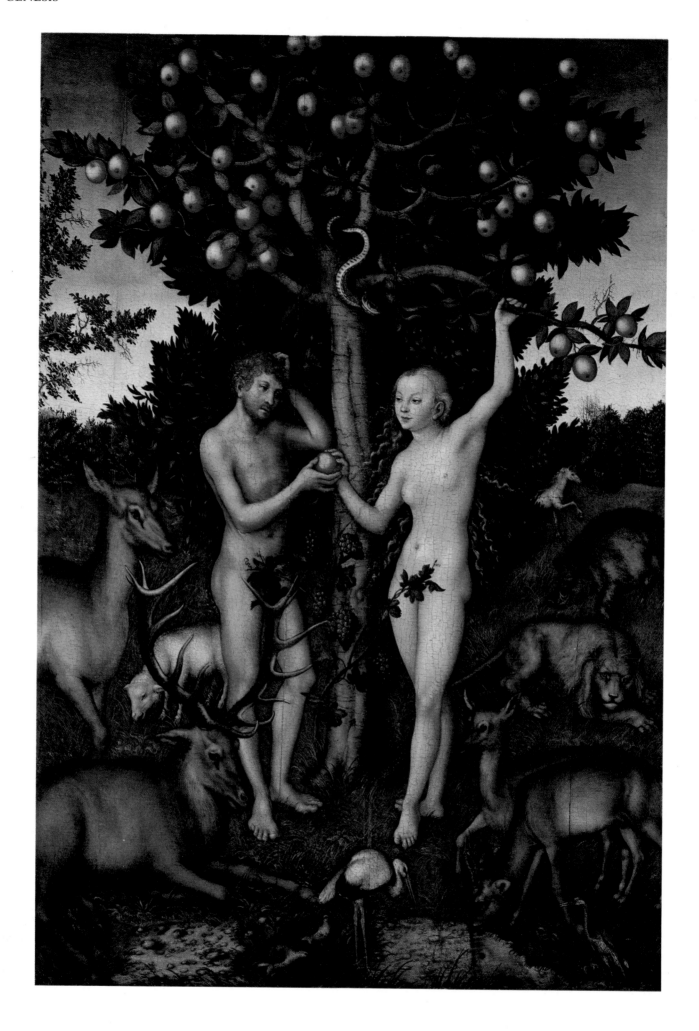

GENESIS
Chapter 3, Verses 1–13

Now the serpent was more subtle than any other wild creature that the LORD God had made. He said to the woman, "Did God say, 'You shall not eat of any tree of the garden'?" And the woman said to the serpent, "We may eat of the fruit of the trees of the garden; but God said, 'You shall not eat of the fruit of the tree which is in the midst of the garden, neither shall you touch it, lest you die.'" But the serpent said to the woman, "You will not die. For God knows that when you eat of it your eyes will be opened, and you will be like God, knowing good and evil." So when the woman saw that the tree was good for food, and that it was a delight to the eyes, and that the tree was to be desired to make one wise, she took of its fruit and ate; and she also gave some to her husband, and he ate. Then the eyes of both were opened, and they knew that they were naked; and they sewed fig leaves together and made themselves aprons.

And they heard the sound of the LORD God walking in the garden in the cool of the day, and the man and his wife hid themselves from the presence of the LORD God among the trees of the garden. But the LORD God called to the man, and said to him, "Where are you?" And he said, "I heard the sound of thee in the garden, and I was afraid, because I was naked; and I hid myself." He said, "Who told you that you were naked? Have you eaten of the tree of which I commanded you not to eat?" The man said, "The woman whom thou gavest to be with me, she gave me fruit of the tree, and I ate." Then the LORD God said to the woman, "What is this that you have done?" The woman said, "The serpent beguiled me, and I ate."

Lucas Cranach the Elder
(1472–1553)
'Adam and Eve'

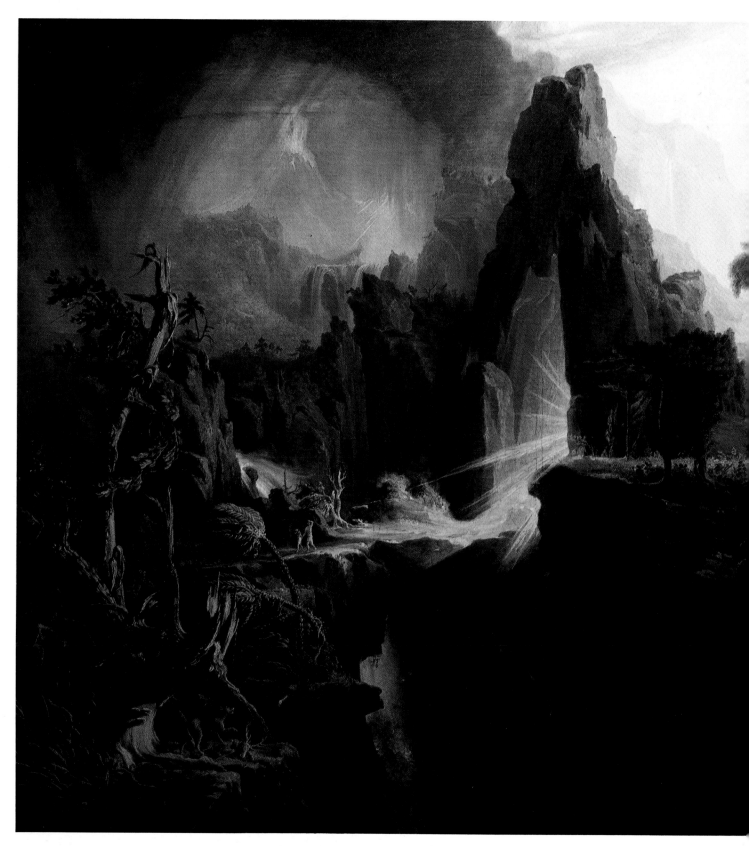

Then the LORD God said, "Behold, the man has become like one of us, knowing good and evil; and now, lest he put forth his hand and take also of the tree of life, and eat, and live for ever"— therefore the LORD God sent him forth from the garden of Eden, to till the ground from which he was taken. He drove out the man; and at the east of the garden of Eden he placed the cherubim, and a flaming sword which turned every way, to guard the way to the tree of life.

GENESIS
Chapter 3, Verses 22–24

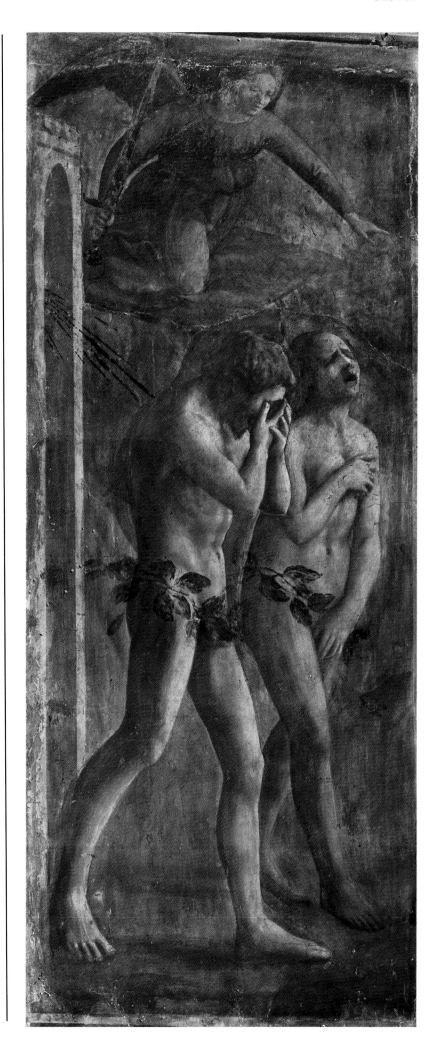

Thomas Cole (1801–1848)
Above 'The Expulsion from the
Garden of Eden'

**Masaccio (Tommaso di
Giovanni),** (1401–1428)
Right 'The Expulsion from
Eden'

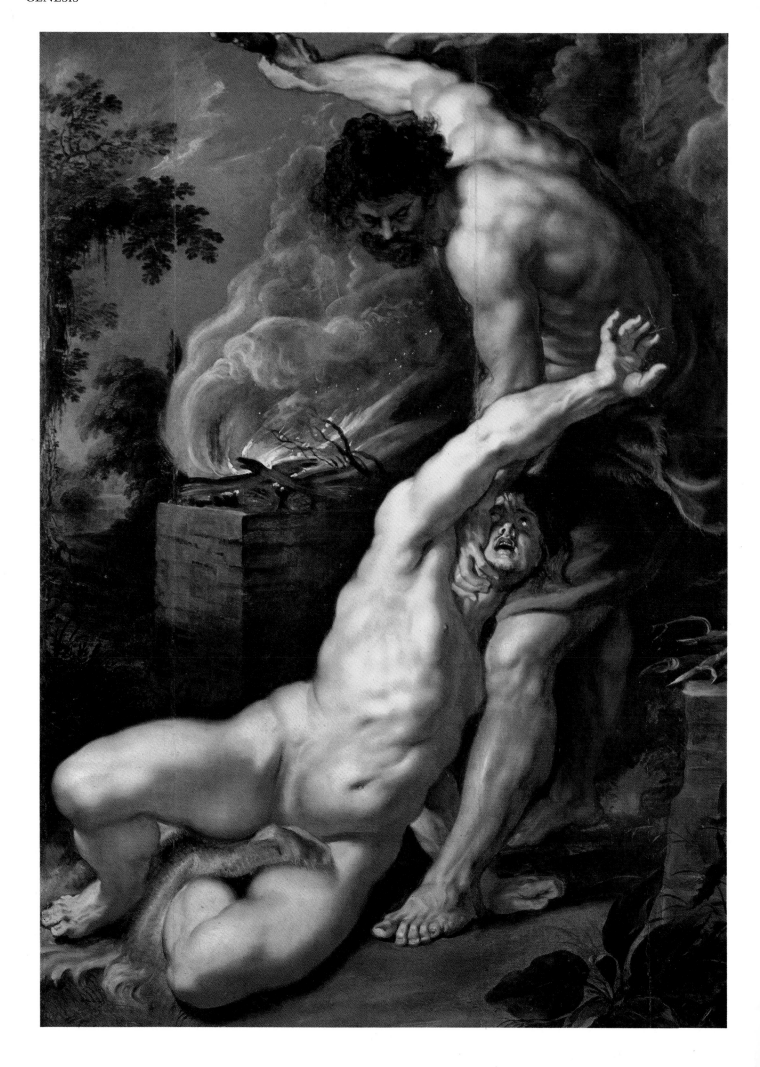

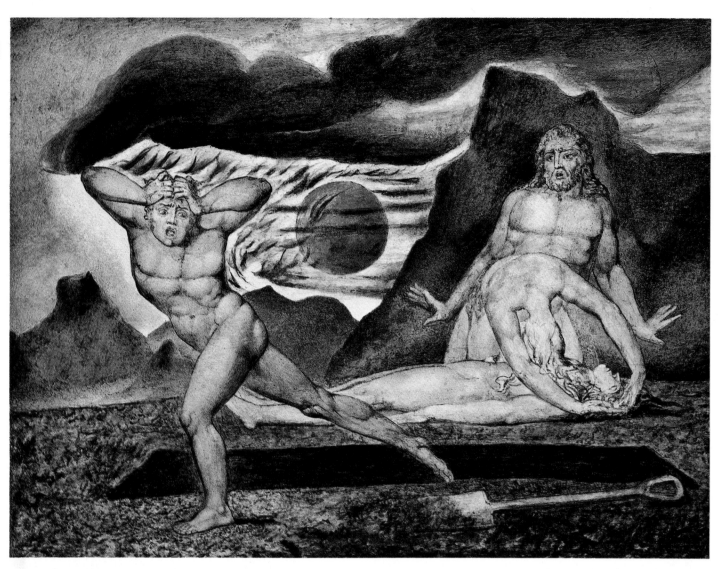

Peter Paul Rubens
(1577–1640)
Left 'Cain Slaying Abel'

William Blake (1757–1827)
Above 'The Body of Abel
Discovered by Adam and Eve'

GENESIS
Chapter 4, Verses 1–8

Now Adam knew Eve his wife, and she conceived and bore Cain, saying, "I have gotten a man with the help of the LORD." And again, she bore his brother Abel. Now Abel was a keeper of sheep, and Cain a tiller of the ground. In the course of time Cain brought to the LORD an offering of the fruit of the ground, and Abel brought of the firstlings of his flock and of their fat portions. And the LORD had regard for Abel and his offering, but for Cain and his offering he had no regard. So Cain was very angry, and his countenance fell. The LORD said to Cain, "Why are you angry, and why has your countenance fallen? If you do well, will you not be accepted? And if you do not do well, sin is couching at the door; its desire is for you, but you must master it."

Cain said to Abel his brother, "Let us go out to the field." And when they were in the field, Cain rose up against his brother Abel, and killed him.

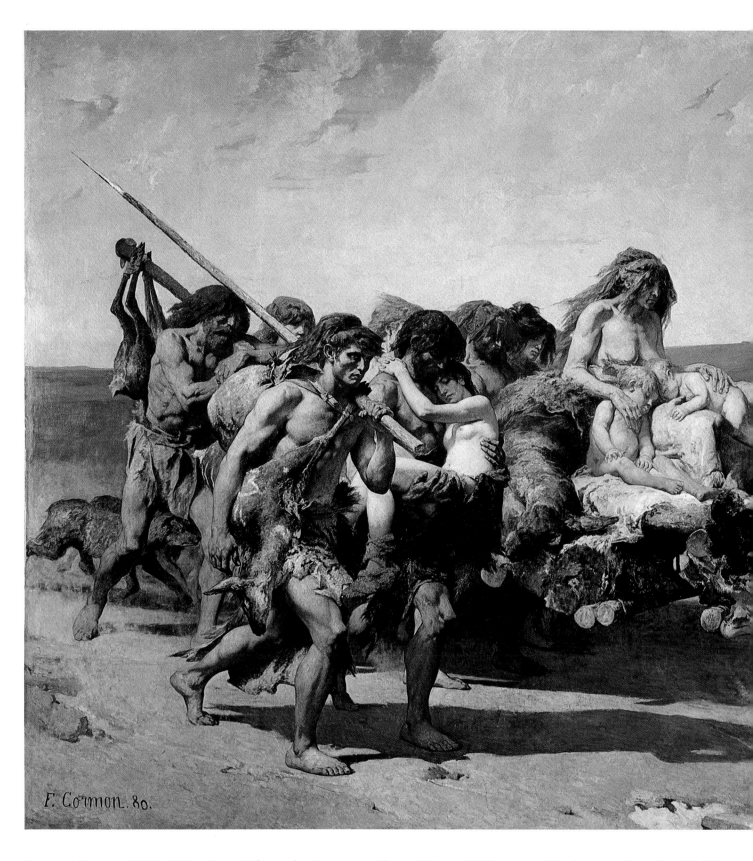

Fernand Cormon (1845–1924)
'The Flight of Cain'

GENESIS
Chapter 4, Verses 9–16

Then the LORD said to Cain, "Where is Abel your brother?" He said, "I do not know; am I my brother's keeper?" And the LORD said, "What have you done? The voice of your brother's blood is crying to me from the ground. And now you are cursed from the ground, which has opened its mouth to receive your brother's blood from your hand. When you till the ground, it shall no longer yield to you its strength; you shall be a fugitive and a wanderer on the earth." Cain said to the LORD, "My punishment is greater than I

can bear. Behold, thou hast driven me this day away from the ground; and from thy face I shall be hidden; and I shall be a fugitive and a wanderer on the earth, and whoever finds me will slay me." Then the LORD said to him, "Not so! If any one slays Cain, vengeance shall be taken on him sevenfold." And the LORD put a mark on Cain, lest any who came upon him should kill him. Then Cain went away from the presence of the LORD, and dwelt in the land of Nod, east of Eden.

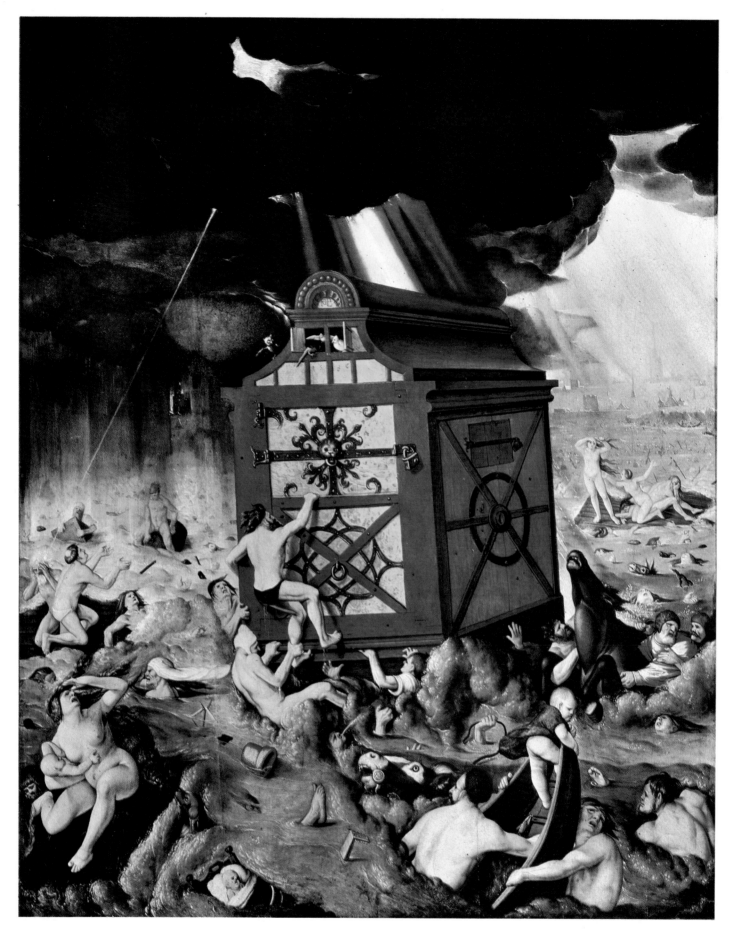

Hans Baldung (Grien)
(1484/5–1545)
'The Deluge'

Jacopo Bassano (1517/18–1592)
'The Building of the Ark'

GENESIS
Chapter 6, Verses 5–8

GENESIS
Chapter 6, Verses 13–17

The LORD saw that the wickedness of man was great in the earth, and that every imagination of the thoughts of his heart was only evil continually. And the LORD was sorry that he had made man on the earth, and it grieved him to his heart. So the LORD said, "I will blot out man whom I have created from the face of the ground, man and beast and creeping things and birds of the air, for I am sorry that I have made them." But Noah found favour in the eyes of the LORD.

And God said to Noah, "I have determined to make an end of all flesh; for the earth is filled with violence through them; behold, I will destroy them with the earth. Make yourself an ark of gopher wood; make rooms in the ark, and cover it inside and out with pitch. This is how you are to make it: the length of the ark three hundred cubits, its breadth fifty cubits, and its height thirty cubits. Make a roof for the ark, and finish it to a cubit above; and set the door of the ark in its side; make it with lower, second, and third decks. For behold, I will bring a flood of waters upon the earth, to

GENESIS
Chapter 6, Verses 17–22

destroy all flesh in which is the breath of life from under heaven; everything that is on the earth shall die. But I will establish my covenant with you; and you shall come into the ark, you, your sons, your wife, and your sons' wives with you. And of every living thing of all flesh, you shall bring two of every sort into the ark, to keep them alive with you; they shall be male and female. Of the birds according to their kinds, and of the animals according to their kinds, of every creeping thing of the ground according to its kind, two of every sort shall come in to you, to keep them alive. Also take with you every sort of food that is eaten, and store it up; and it shall serve as food for you and for them." Noah did this; he did all that God commanded him.

In the six hundredth year of Noah's life, in the second month, on the seventeenth day of the month, on that day all the fountains of the great deep burst forth, and the windows of the heavens were opened. And rain fell upon the earth forty days and forty nights. On the very same day Noah and his sons, Shem and Ham and Japheth, and Noah's wife and the three wives of his sons with them entered the ark, they and every beast according to its kind, and all the cattle according to their kinds, and every creeping thing that creeps on the earth according to its kind, and every bird according to its kind, every bird of every sort. They went into the ark with Noah, two and two of all flesh in which there was the breath of life. And they that entered, male and female of all flesh, went in as God had commanded him; and the LORD shut him in.

Jacopo Bassano
(1517/18–1592)
Above 'The Animals Entering the Ark'

Anne-Louis Girodet Trioson (or Girodet de Roucy)
(1767–1824)
Right 'The Deluge'

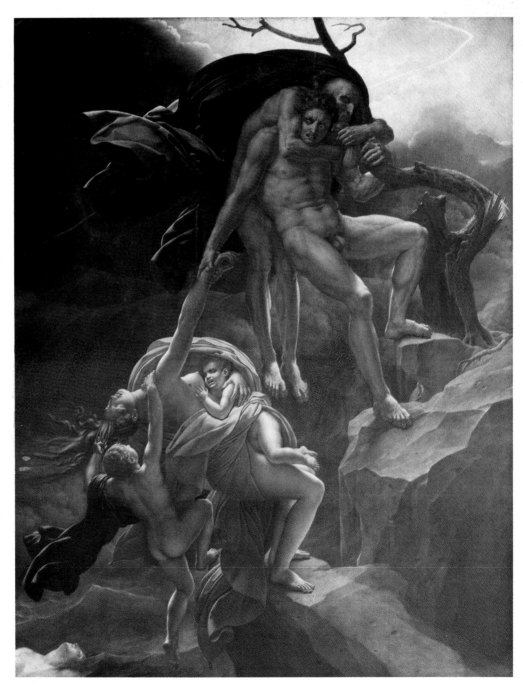

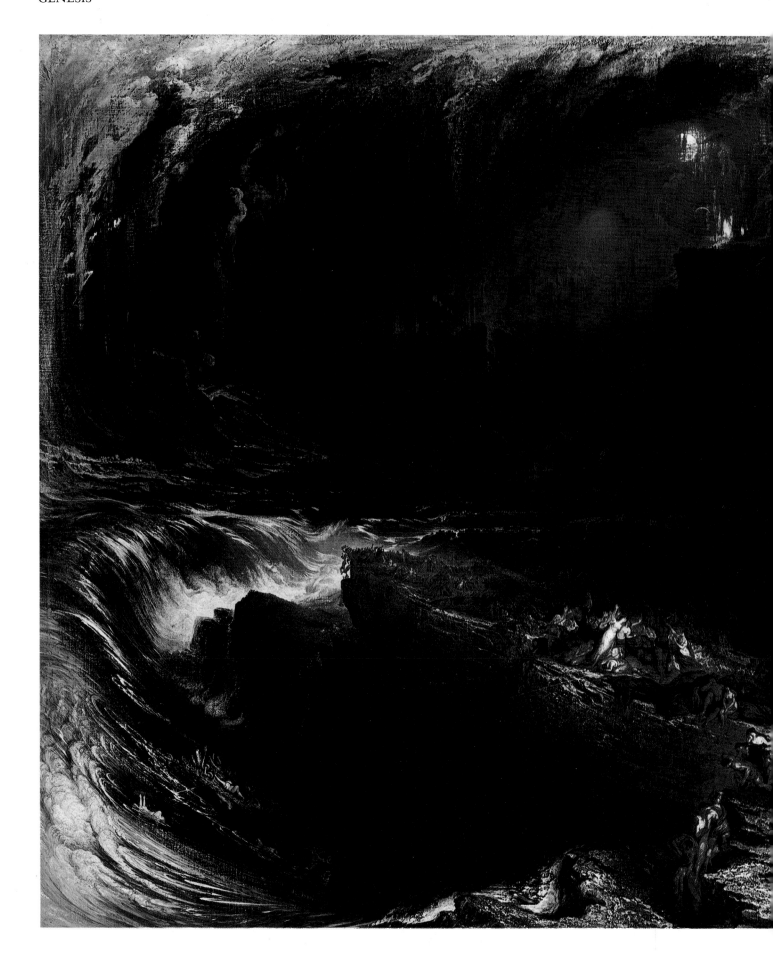

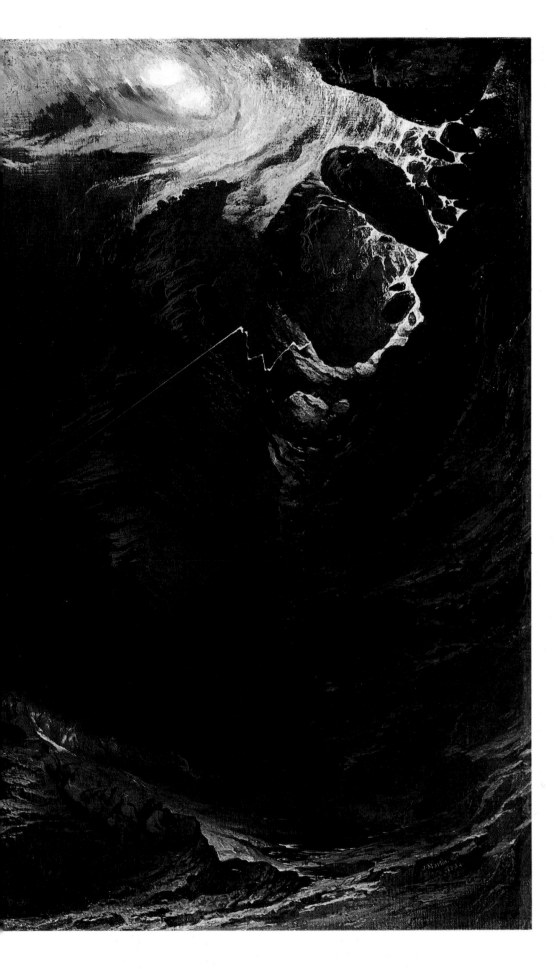

John Martin (1789–1854)
'The Deluge'

GENESIS
Chapter 8, Verses 1–8

But God remembered Noah and all the beasts and all the cattle that were with him in the ark. And God made a wind blow over the earth, and the waters subsided; the fountains of the deep and the windows of the heavens were closed, the rain from the heavens was restrained, and the waters receded from the earth continually. At the end of a hundred and fifty days the waters had abated; and in the seventh month, on the seventeenth day of the month, the ark came to rest upon the mountains of Ararat. And the waters continued to abate until the tenth month; in the tenth month, on the first day of the month, the tops of the mountains were seen.

At the end of forty days Noah opened the window of the ark which he had made, and sent forth a raven; and it went to and fro until the waters were dried up from the earth. Then he sent forth a dove from him, to see if the waters had subsided from the face of

John Martin (1789–1854)
'The Assuaging of the Waters'

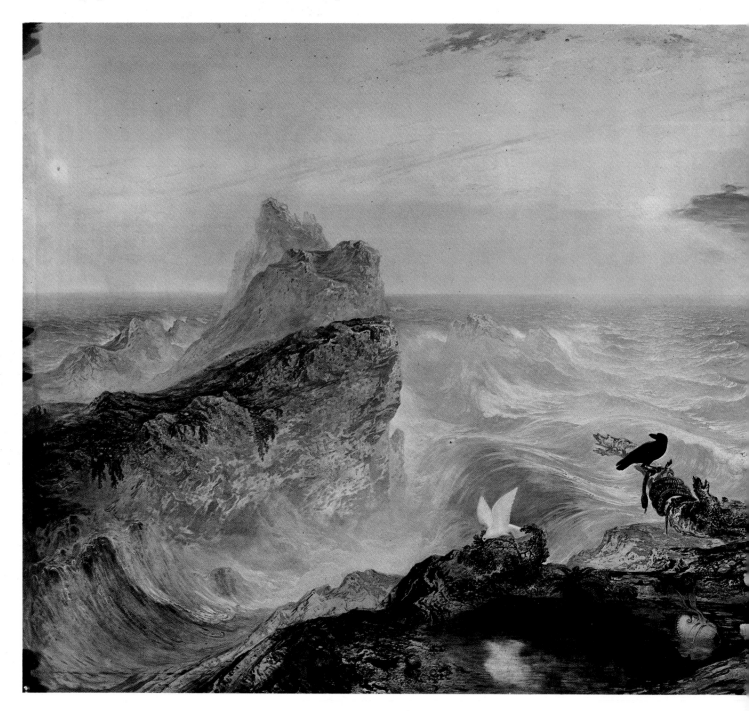

GENESIS
Chapter 8, Verses 8–12

the ground; but the dove found no place to set her foot, and she returned to him to the ark, for the waters were still on the face of the whole earth. So he put forth his hand and took her and brought her into the ark with him. He waited another seven days, and again he sent forth the dove out of the ark; and the dove came back to him in the evening, and lo, in her mouth a freshly plucked olive leaf; so Noah knew that the waters had subsided from the earth. Then he waited another seven days, and sent forth the dove; and she did not return to him any more.

Giovanni Bellini
(*c.*1430–1516)
'The Drunkenness of Noah'

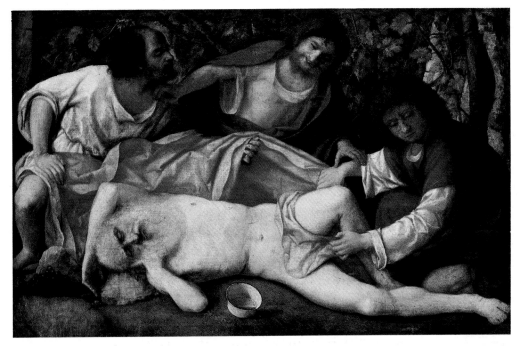

GENESIS Chapter 9, Verses 20–27

Noah was the first tiller of the soil. He planted a vineyard; and he drank of the wine, and became drunk, and lay uncovered in his tent. And Ham, the father of Canaan, saw the nakedness of his father, and told his two brothers outside. Then Shem and Japheth took a garment, laid it upon both their shoulders, and walked backward and covered the nakedness of their father; their faces were turned away, and they did not see their father's nakedness. When Noah awoke from his wine and knew what his youngest son had done to him, he said,
 "Cursed be Canaan; a slave of slaves shall he be to his brothers."
 He also said,
 "Blessed by the LORD my God be Shem; and let Canaan be his
 slave.
 God enlarge Japheth, and let him dwell in the tents of Shem; and
 let Canaan be his slave."

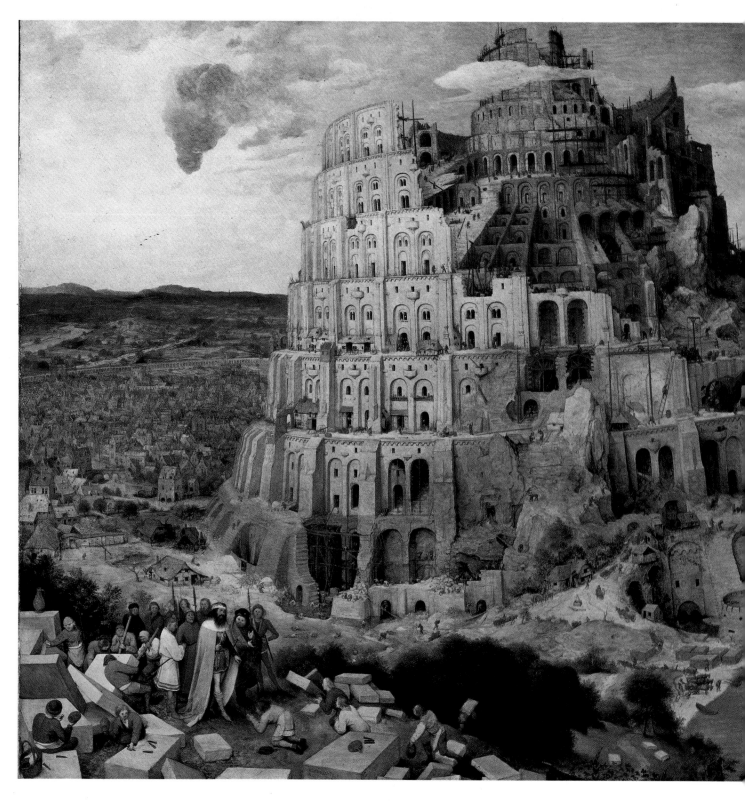

Pieter Bruegel the Elder
(*c*.1525–1569)
'The Tower of Babel'

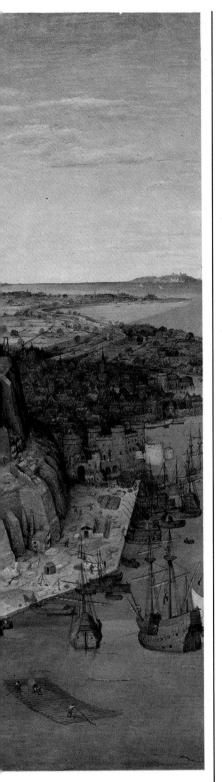

GENESIS Chapter 11, Verses 1–9

Now the whole earth had one language and few words. And as men migrated from the east, they found a plain in the land of Shinar and settled there. And they said to one another, "Come, let us make bricks, and burn them thoroughly." And they had brick for stone, and bitumen for mortar. Then they said, "Come, let us build ourselves a city, and a tower with its top in the heavens, and let us make a name for ourselves, lest we be scattered abroad upon the face of the whole earth." And the LORD came down to see the city and the tower, which the sons of men had built. And the LORD said, "Behold, they are one people, and they have all one language; and this is only the beginning of what they will do; and nothing that they propose to do will now be impossible for them. Come, let us go down, and there confuse their language, that they may not understand one another's speech." So the LORD scattered them abroad from there over the face of all the earth, and they left off building the city. Therefore its name was called Babel, because there the LORD confused the language of all the earth; and from there the LORD scattered them abroad over the face of all the earth.

When morning dawned, the angels urged Lot, saying, "Arise, take your wife and your two daughters who are here, lest you be consumed in the punishment of the city." But he lingered; so the men seized him and his wife and his two daughters by the hand, the LORD being merciful to him, and they brought him forth and set him outside the city. And when they had brought them forth, they said, "Flee for your life; do not look back or stop anywhere in the valley; flee to the hills, lest you be consumed." And Lot said to them, "Oh, no, my lords; behold, your servant has found favour in your sight, and you have shown me great kindness in saving my life; but I cannot flee to the hills, lest the disaster overtake me, and I die. Behold, yonder city is near enough to flee to, and it is a little one. Let me escape there—is it not a little one?—and my life will be saved!" He said to him, "Behold, I grant you this favour also, that I will not overthrow the city of which you have spoken. Make haste, escape there; for I can do nothing till you arrive there." Therefore the name of the city was called Zoar. The sun had risen on the earth when Lot came to Zoar.

Then the LORD rained on Sodom and Gomorrah brimstone and fire from the LORD out of heaven; and he overthrew those cities, and all the valley, and all the inhabitants of the cities, and what grew on the ground. But Lot's wife behind him looked back, and she became a pillar of salt.

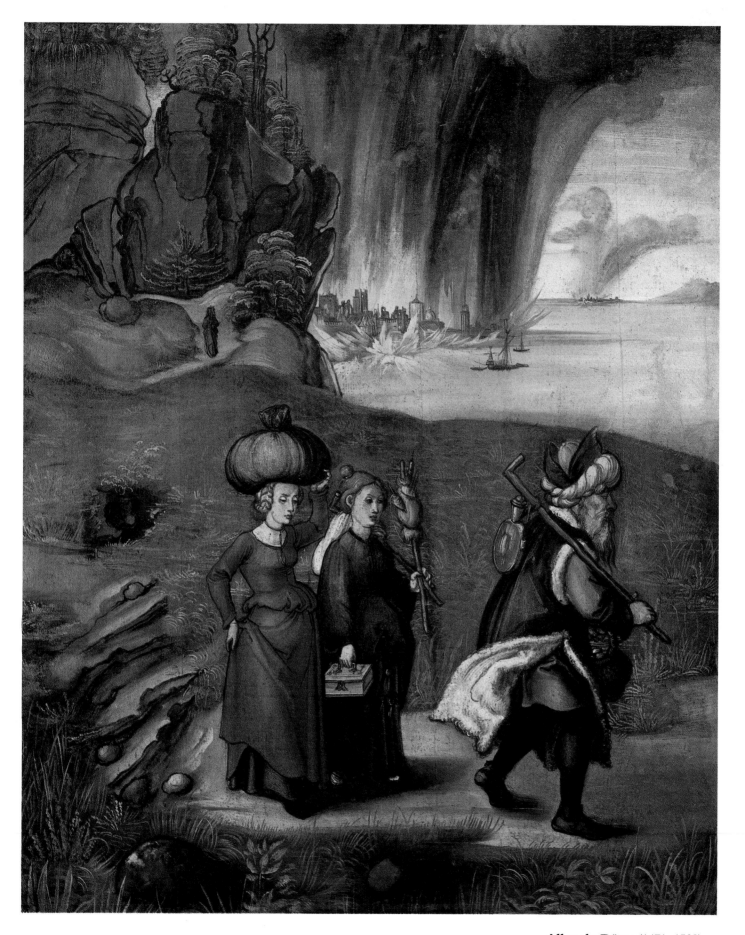

Albrecht Dürer (1471–1528)
'Lot and his Daughters'

**Joseph Mallord William
Turner** (1775–1851)
'The Destruction of Sodom'

Now Lot went up out of Zoar, and dwelt in the hills with his two daughters, for he was afraid to dwell in Zoar; so he dwelt in a cave with his two daughters. And the first-born said to the younger, "Our father is old, and there is not a man on earth to come in to us after the manner of all the earth. Come, let us make our father drink wine, and we will lie with him, that we may preserve offspring through our father." So they made their father drink wine that night; and the first-born went in, and lay with her father; he did not know when she lay down or when she arose. And on the next day, the first-born said to the younger, "Behold, I lay last night with my father; let us make him drink wine tonight also; then you go in and lie with him, that we may preserve offspring through our father." So they made their father drink wine that night also; and the younger arose, and lay with him; and he did not know when she lay down or when she arose. Thus both the daughters of Lot were with child by their father. The first-born bore a son, and called his name Moab; he is the father of the Moabites to this day. The younger also bore a son, and called his name Ben-ammi; he is the father of the Ammonites to this day.

GENESIS
Chapter 19, Verses 30–38

Jan Massys (or Metsys),
(1509–1575)
'Lot and his Daughters'

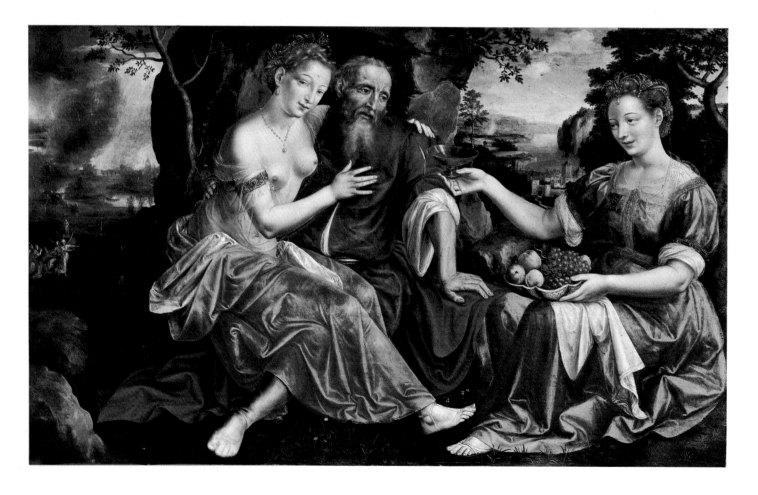

But Sarah saw the son of Hagar the Egyptian, whom she had borne to Abraham, playing with her son Isaac. So she said to Abraham, "Cast out this slave woman with her son; for the son of this slave woman shall not be heir with my son Isaac." And the thing was very displeasing to Abraham on account of his son. But

GENESIS
Chapter 21, Verses 9–11

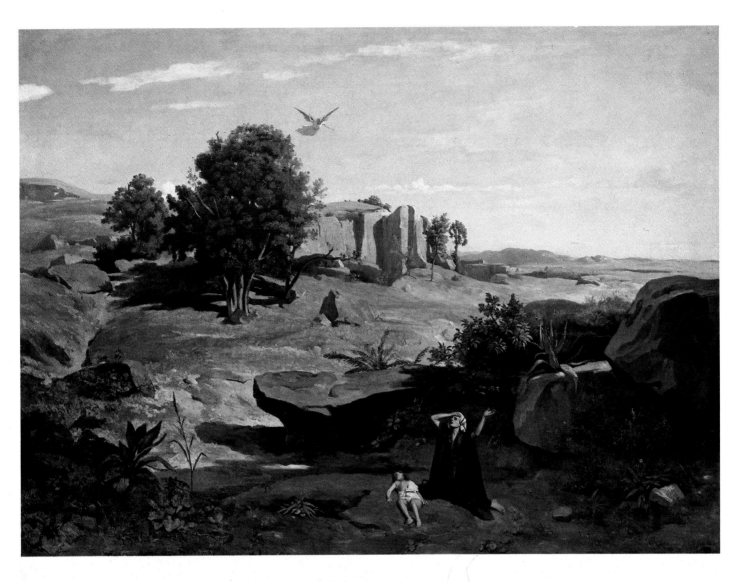

God said to Abraham, "Be not displeased because of the lad and because of your slave woman; whatever Sarah says to you, do as she tells you, for through Isaac shall your descendants be named. And I will make a nation of the son of the slave woman also, because he is your offspring." So Abraham rose early in the morning, and took bread and a skin of water, and gave it to Hagar, putting it on her shoulder, along with the child, and sent her away. And she departed, and wandered in the wilderness of Beersheba.

When the water in the skin was gone, she cast the child under one of the bushes. Then she went, and sat down over against him a good way off, about the distance of a bowshot; for she said, "Let me not look upon the death of the child." And as she sat over against him, the child lifted up his voice and wept. And God heard the voice of the lad; and the angel of God called to Hagar from heaven, and said to her, "What troubles you, Hagar? Fear not; for God has heard the voice of the lad where he is. Arise, lift up the lad, and hold him fast with your hand; for I will make him a great nation." Then God opened her eyes, and she saw a well of water; and she went, and filled the skin with water, and gave the lad a drink.

Jean–Baptiste Camille Corot
(1796–1875)
'Hagar in the Wilderness'

GENESIS
Chapter 21, Verses 12–19

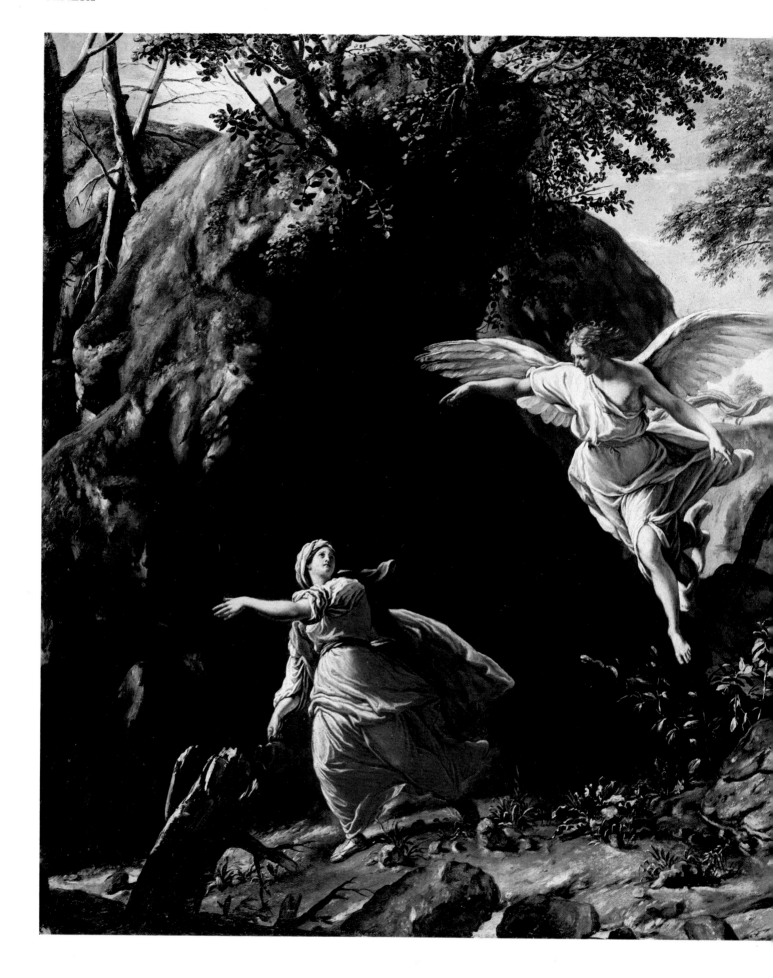

Francesco Cozza (1605–1682)
'Hagar in the Wilderness'

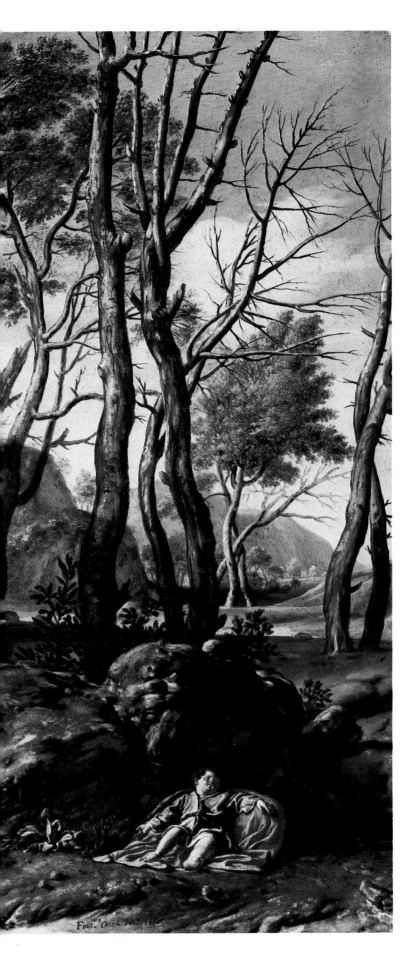

GENESIS
Chapter 22, Verses 1–19

After these things God tested Abraham, and said to him, "Abraham!" And he said, "Here am I." He said, "Take your son, your only son Isaac, whom you love, and go to the land of Moriah, and offer him there as a burnt offering upon one of the mountains of which I shall tell you." So Abraham rose early in the morning, saddled his ass, and took two of his young men with him, and his son Isaac; and he cut the wood for the burnt offering, and arose and went to the place of which God had told him. On the third day Abraham lifted up his eyes and saw the place afar off. Then Abraham said to his young men, "Stay here with the ass; I and the lad will go yonder and worship, and come again to you." And Abraham took the wood of the burnt offering, and laid it on Isaac his son; and he took in his hand the fire and the knife. So they went both of them together. And Isaac said to his father Abraham, "My father!" And he said, "Here am I, my son." He said, "Behold, the fire and the wood; but where is the lamb for a burnt offering?" Abraham said, "God will provide himself the lamb for a burnt offering, my son." So they went both of them together.

When they came to the place of which God had told him, Abraham built an altar there, and laid the wood in order, and bound Isaac his son, and laid him on the altar, upon the wood. Then Abraham put forth his hand, and took the knife to slay his son. But the angel of the LORD called to him from heaven, and said, "Abraham, Abraham!" And he said, "Here am I." He said, "Do not lay your hand on the lad or do anything to him; for now I know that you fear God, seeing you have not withheld your son, your only son, from me." And Abraham lifted up his eyes and looked, and behold, behind him was a ram, caught in a thicket by his horns; and Abraham went and took the ram, and offered it up as a burnt offering instead of his son. So Abraham called the name of that place The LORD will provide; as it is said to this day, "On the mount of the LORD it shall be provided."

And the angel of the LORD called to Abraham a second time from heaven, and said, "By myself I have sworn, says the LORD, because you have done this, and have not withheld your son, your only son, I will indeed bless you, and I will multiply your descendants as the stars of heaven and as the sand which is on the seashore. And your descendants shall possess the gate of their enemies, and by your descendants shall all the nations of the earth bless themselves, because you have obeyed my voice." So Abraham returned to his young men, and they arose and went together to Beersheba; and Abraham dwelt at Beersheba.

Rembrandt van Rijn
(1606–1669)
'Abraham and Isaac'

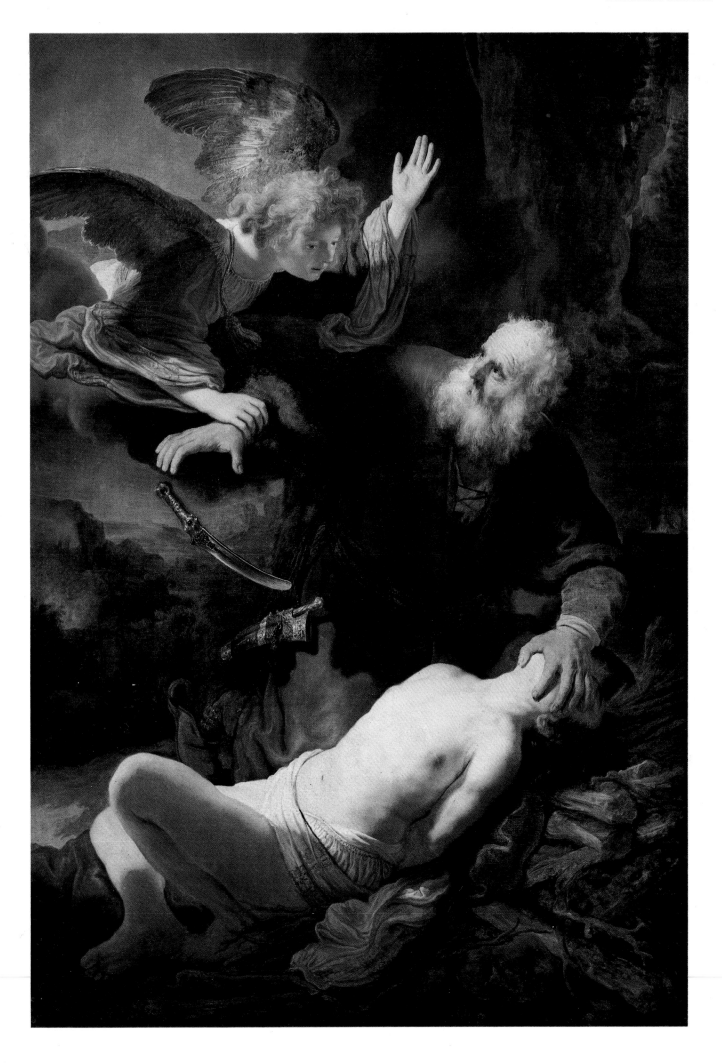

When Isaac was old and his eyes were dim so that he could not see, he called Esau his older son, and said to him, "My son"; and he answered, "Here I am." He said, "Behold, I am old; I do not know the day of my death. Now then, take your weapons, your quiver and your bow, and go out to the field, and hunt game for me, and prepare for me savoury food, such as I love, and bring it to me that I may eat; that I may bless you before I die."

Now Rebekah was listening when Isaac spoke to his son Esau. So when Esau went to the field to hunt for game and bring it, Rebekah said to her son Jacob, "I heard your father speak to your brother Esau, 'Bring me game, and prepare for me savoury food, that I may eat it, and bless you before the LORD before I die.' Now therefore, my son, obey my word as I command you. Go to the flock, and fetch me two good kids, that I may prepare from them savoury food for your father, such as he loves; and you shall bring it to your father to eat, so that he may bless you before he dies." But Jacob said to Rebekah his mother, "Behold, my brother Esau is a hairy man, and I am a smooth man. Perhaps my father will feel me, and I shall seem to be mocking him, and bring a curse upon myself and not a blessing." His mother said to him, "Upon me be your curse, my son; only obey my word, and go, fetch them to me." So he went and took them and brought them to his mother; and his mother prepared savoury food, such as his father loved. Then Rebekah took the best garments of Esau her older son, which were with her in the house, and put them on Jacob her younger son; and the skins of the kids she put upon his hands and upon the smooth part of his neck; and she gave the savoury food and the bread, which she had prepared, into the hand of her son Jacob.

So he went in to his father, and said, "My father"; and he said, "Here I am; who are you, my son?" Jacob said to his father, "I am Esau your first-born. I have done as you told me; now sit up and eat of my game, that you may bless me." But Isaac said to his son, "How is it that you have found it so quickly, my son?" He answered, "Because the LORD your God granted me success." Then Isaac said to Jacob, "Come near, that I may feel you, my son, to know whether you are really my son Esau or not." So Jacob went near to Isaac his father, who felt him and said, "The voice is Jacob's voice, but the hands are the hands of Esau." And he did not recognize him, because his hands were hairy like his brother Esau's hands; so he blessed him.

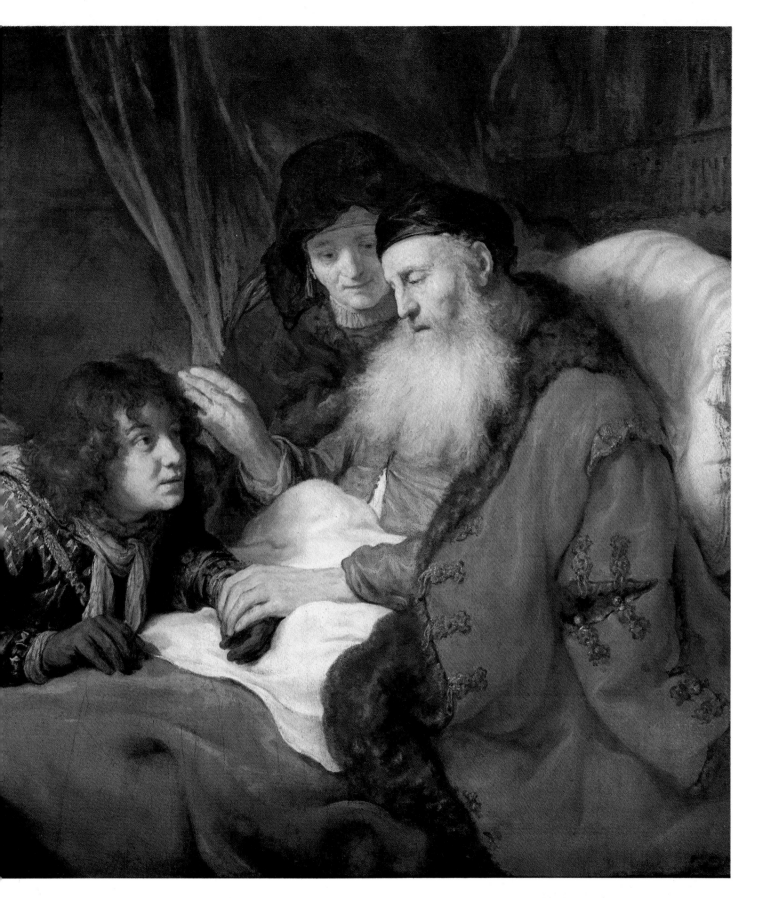

Govaert Flinck (1615–1660)
'Isaac Blessing Jacob'

J.M.W. Turner (1775–1851)
'Jacob's Dream'

GENESIS
Chapter 28, Verses 10–17

Jacob left Beersheba, and went toward Haran. And he came to a certain place, and stayed there that night, because the sun had set. Taking one of the stones of the place, he put it under his head and lay down in that place to sleep. And he dreamed that there was a ladder set up on the earth, and the top of it reached to heaven; and behold, the angels of God were ascending and descending on it! And behold, the LORD stood above it and said, "I am the LORD, the God of Abraham your father and the God of Isaac; the land on which you lie I will give to you and to your descendants; and your descendants shall be like the dust of the earth, and you shall spread abroad to the west and to the east and to the north and to the south; and by you and your descendants shall all the families of the earth bless themselves. Behold, I am with you and will keep you wherever you go, and will bring you back to this land; for I will not

José de Ribera (1591–1652)
'Jacob's Dream'

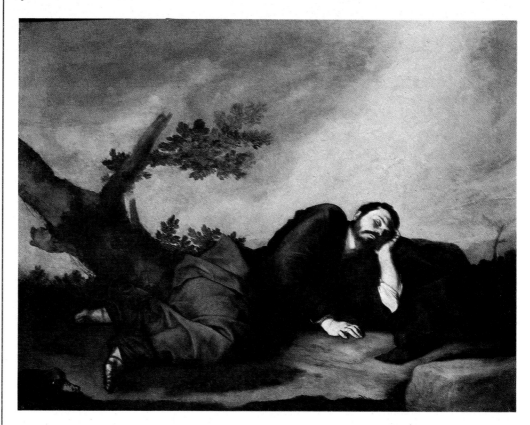

leave you until I have done that of which I have spoken to you."
Then Jacob awoke from his sleep and said, "Surely the LORD is in
this place; and I did not know it." And he was afraid, and said,
"How awesome is this place! This is none other than the house of
God, and this is the gate of heaven."

GENESIS Chapter 29, Verses 15–20

Then Laban said to Jacob, "Because you are my kinsman, should
you therefore serve me for nothing? Tell me, what shall your wages
be?" Now Laban had two daughters; the name of the older was
Leah, and the name of the younger was Rachel. Leah's eyes were
weak, but Rachel was beautiful and lovely. Jacob loved Rachel; and
he said, "I will serve you seven years for your younger daughter
Rachel." Laban said, "It is better that I give her to you than that I
should give her to any other man; stay with me." So Jacob served
seven years for Rachel, and they seemed to him but a few days
because of the love he had for her.

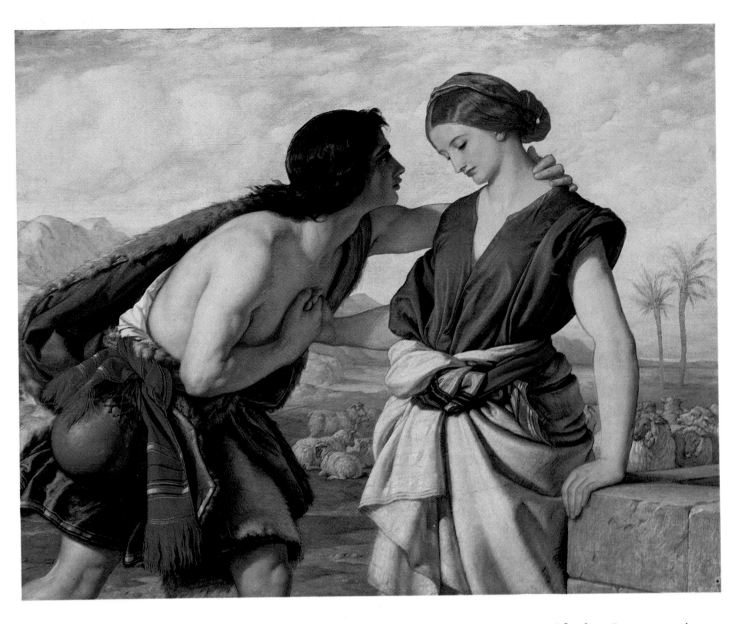

William Dyce (1806–1864)
'Jacob and Rachel'

GENESIS
Chapter 29, Verses 21–30

Then Jacob said to Laban, "Give me my wife that I may go in to her, for my time is completed." So Laban gathered together all the men of the place, and made a feast. But in the evening he took his daughter Leah and brought her to Jacob; and he went in to her. (Laban gave his maid Zilpah to his daughter Leah to be her maid.) And in the morning, behold, it was Leah; and Jacob said to Laban, "What is this you have done to me? Did I not serve with you for Rachel? Why then have you deceived me?" Laban said, "It is not so done in our country, to give the younger before the first-born. Complete the week of this one, and we will give you the other also in return for serving me another seven years." Jacob did so, and completed her week; then Laban gave him his daughter Rachel to wife. (Laban gave his maid Bilhah to his daughter Rachel to be her maid.) So Jacob went in to Rachel also, and he loved Rachel more than Leah, and served Laban for another seven years.

GENESIS
Chapter 32, Verses 22–32

The same night he arose and took his two wives, his two maids, and his eleven children, and crossed the ford of the Jabbok. He took them and sent them across the stream, and likewise everything that he had. And Jacob was left alone; and a man wrestled with him until the breaking of the day. When the man saw that he did not prevail against Jacob, he touched the hollow of his thigh; and Jacob's thigh was put out of joint as he wrestled with him. Then he said, "Let me

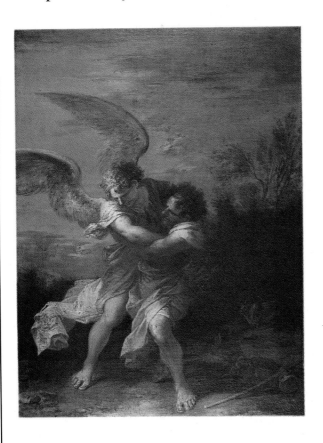

Salvator Rosa (1615–1673)
'Jacob and the Angel'

go, for the day is breaking." But Jacob said, "I will not let you go, unless you bless me." And he said to him, "What is your name?" And he said, "Jacob." Then he said, "Your name shall no more be called Jacob, but Israel, for you have striven with God and with men, and have prevailed." Then Jacob asked him, "Tell me, I pray, your name." But he said, "Why is it that you ask my name?" And there he blessed him. So Jacob called the name of the place Peniel, saying, "For I have seen God face to face, and yet my life is preserved." The sun rose upon him as he passed Penuel, limping because of his thigh. Therefore to this day the Israelites do not eat the sinew of the hip which is upon the hollow of the thigh, because he touched the hollow of Jacob's thigh on the sinew of the hip.

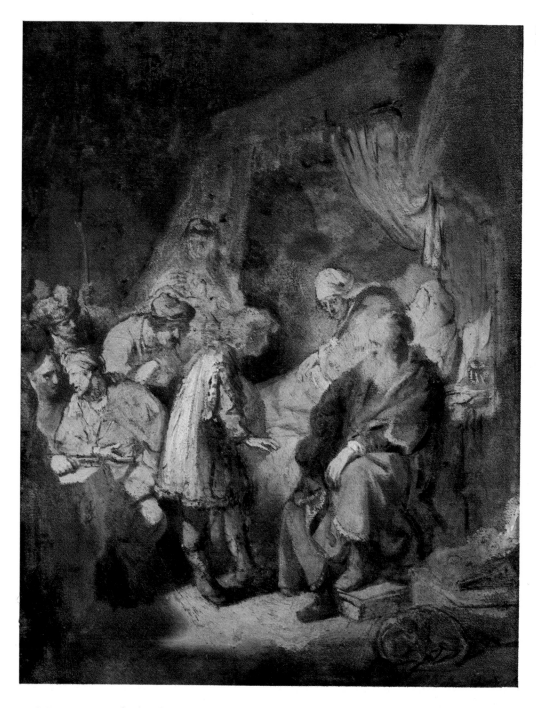

Rembrandt (1606–1669)
'Joseph Telling his Dream'

Now Joseph had a dream, and when he told it to his brothers they only hated him the more. He said to them, "Hear this dream which I have dreamed: behold, we were binding sheaves in the field, and lo, my sheaf arose and stood upright; and behold, your sheaves gathered round it, and bowed down to my sheaf." His brothers said to him, "Are you indeed to reign over us? Or are you indeed to have dominion over us?" So they hated him yet more for his dreams and for his words. Then he dreamed another dream, and told it to his brothers, and said, "Behold, I have dreamed another dream; and behold, the sun, the moon, and eleven stars were bowing down to me." But when he told it to his father and to his brothers, his father rebuked him, and said to him, "What is this dream that you have dreamed? Shall I and your mother and your brothers indeed come to bow ourselves to the ground before you?" And his brothers were jealous of him, but his father kept the saying in mind.

GENESIS
Chapter 37, Verses 5–11

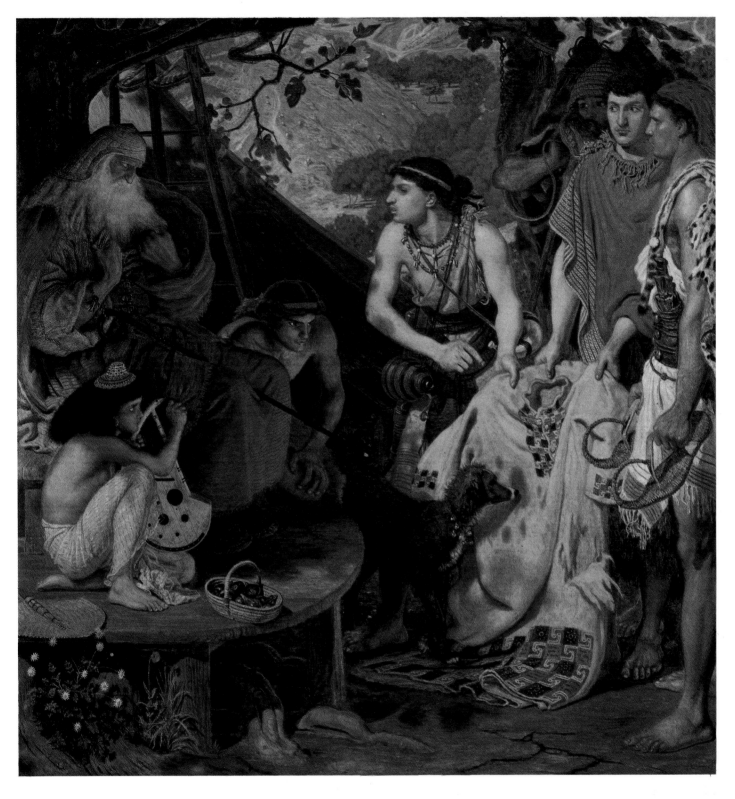

Then they took Joseph's robe, and killed a goat, and dipped the robe in the blood; and they sent the long robe with sleeves and brought it to their father, and said, "This we have found; see now whether it is your son's robe or not." And he recognized it, and said, "It is my son's robe; a wild beast has devoured him; Joseph is without doubt torn to pieces." Then Jacob rent his garments, and put sackcloth upon his loins, and mourned for his son many days. All his sons and all his daughters rose up to comfort him; but he refused to be comforted, and said, "No, I shall go down to Sheol to my son, mourning." Thus his father wept for him.

Ford Madox Brown
(1821–1893)
'The Coat of Many Colours'

GENESIS
Chapter 37, Verses 31–35

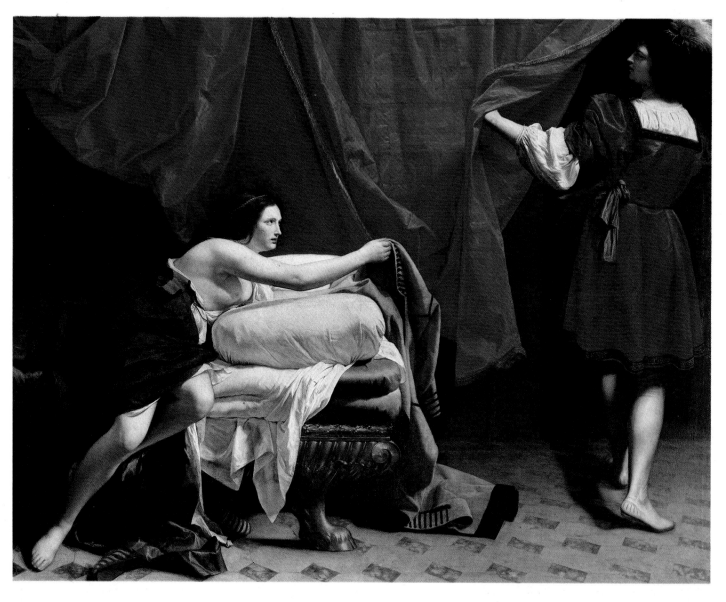

Orazio Gentileschi
(1563–1639)
'Joseph and Potiphar's Wife'

GENESIS
Chapter 39, Verses 6–16

The Master of the Joseph Legend (active Brussels, 1500)
'Joseph and Potiphar's Wife'

Now Joseph was handsome and good-looking. And after a time his master's wife cast her eyes upon Joseph, and said, "Lie with me." But he refused and said to his master's wife, "Lo, having me my master has no concern about anything in the house, and he has put everything that he has in my hand; he is not greater in this house than I am; nor has he kept back anything from me except yourself, because you are his wife; how then can I do this great wickedness, and sin against God?" And although she spoke to Joseph day after day, he would not listen to her, to lie with her or to be with her. But one day, when he went into the house to do his work and none of the men of the house was there in the house, she caught him by his garment, saying, "Lie with me." But he left his garment in her hand, and fled and got out of the house. And when she saw that he had left his garment in her hand, and had fled out of the house, she called to the men of her household and said to them, "See, he has brought among us a Hebrew to insult us; he came in to me to lie with me, and I cried out with a loud voice; and when he heard that I lifted up my voice and cried, he left his garment with me, and fled and got out of the house." Then she laid up his

garment by her until his master came home, and she told him the same story, saying, "The Hebrew servant, whom you have brought among us, came in to me to insult me; but as soon as I lifted up my voice and cried, he left his garment with me, and fled out of the house."

When his master heard the words which his wife spoke to him, "This is the way your servant treated me," his anger was kindled. And Joseph's master took him and put him into the prison, the place where the king's prisoners were confined, and he was there in prison.

GENESIS
Chapter 39, Verses 16–20

Rembrandt (1606–1669)
'Joseph Accused by Potiphar's Wife'

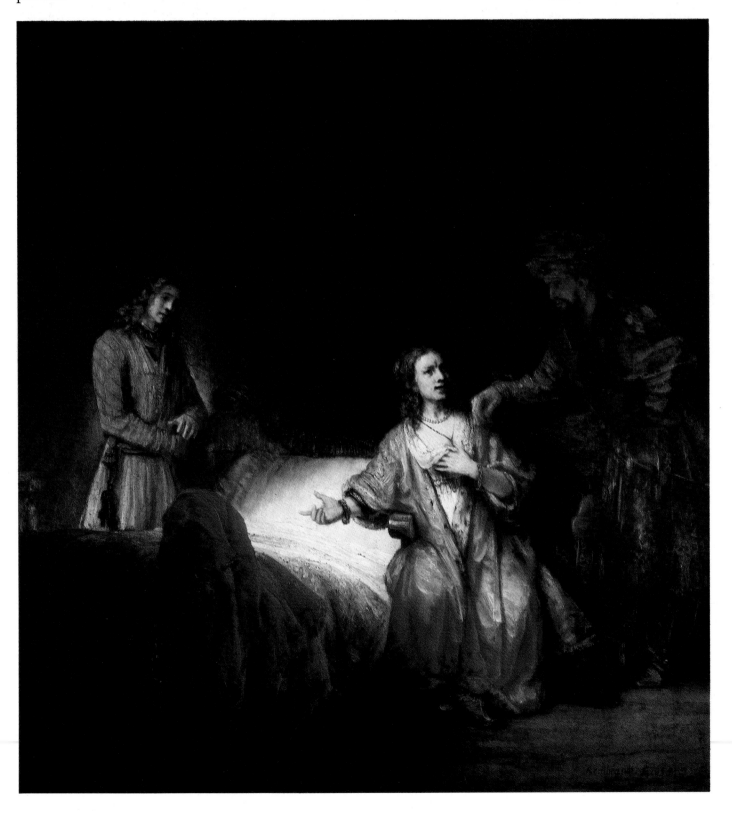

As soon as the morning was light, the men were sent away with their asses. When they had gone but a short distance from the city, Joseph said to his steward, "Up, follow after the men; and when you overtake them, say to them, 'Why have you returned evil for good? Why have you stolen my silver cup? Is it not from this that my lord drinks, and by this that he divines? You have done wrong in so doing.'"

When he overtook them, he spoke to them these words. They said to him, "Why does my lord speak such words as these? Far be it from your servants that they should do such a thing! Behold, the money which we found in the mouth of our sacks, we brought back to you from the land of Canaan; how then should we steal silver or gold from your lord's house?"

GENESIS
Chapter 44, Verses 3–8

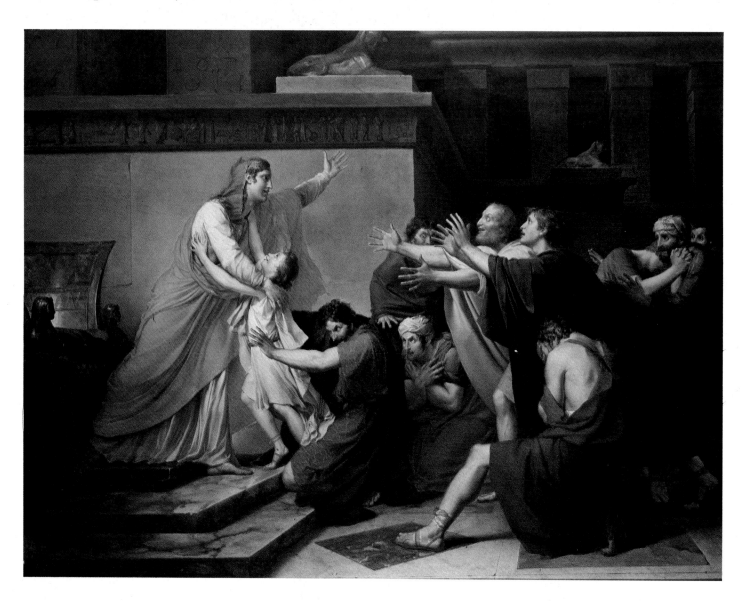

And Joseph said to his brothers, "I am Joseph; is my father still alive?" But his brothers could not answer him, for they were dismayed at his presence.

So Joseph said to his brothers, "Come near to me, I pray you." And they came near. And he said, "I am your brother, Joseph, whom you sold into Egypt. And now do not be distressed, or

Baron François-Pascal Gérard (1770–1837) 'Joseph Recognized by his Brethren'

GENESIS
Chapter 45, Verses 3–5

GENESIS
Chapter 45, Verses 5–8

angry with yourselves, because you sold me here; for God sent me before you to preserve life. For the famine has been in the land these two years; and there are yet five years in which there will be neither ploughing nor harvest. And God sent me before you to preserve for you a remnant on earth, and to keep alive for you many survivors.''

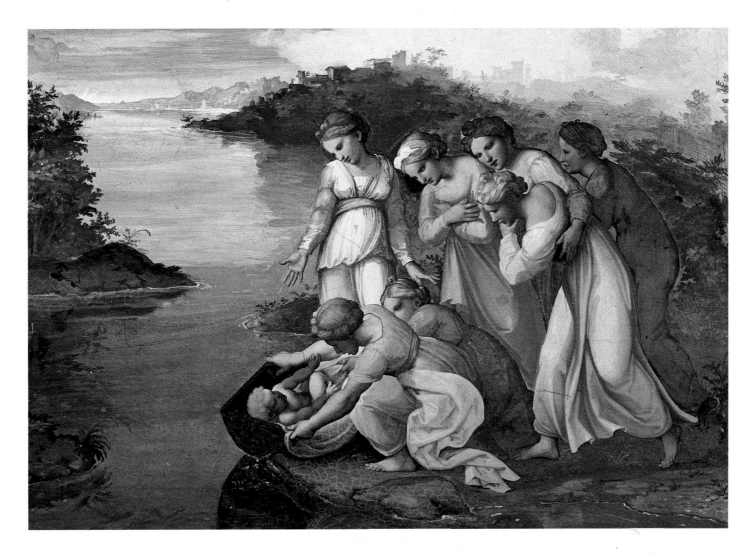

Raphael (Raffaello Sanzio)
(1483–1520)
'The Finding of Moses'

EXODUS
Chapter 2, Verses 1–7

Now a man from the house of Levi went and took to wife a daughter of Levi. The woman conceived and bore a son; and when she saw that he was a goodly child, she hid him three months. And when she could hide him no longer she took for him a basket made of bulrushes, and daubed it with bitumen and pitch; and she put the child in it and placed it among the reeds at the river's brink. And his sister stood at a distance, to know what would be done to him. Now the daughter of Pharaoh came down to bathe at the river, and her maidens walked beside the river; she saw the basket among the reeds and sent her maid to fetch it. When she opened it she saw the child; and lo, the babe was crying. She took pity on him and said, ''This is one of the Hebrews' children.'' Then his sister said to Pharaoh's daughter, ''Shall I go and call you a nurse from the

Frederick Dillon (1823–1909)
'The Finding of Moses'

EXODUS
Chapter 2, Verses 7–10

Hebrew women to nurse the child for you?'' And Pharaoh's daughter said to her, "Go." So the girl went and called the child's mother. And Pharaoh's daughter said to her, "Take this child away, and nurse him for me, and I will give you your wages." So

the woman took the child and nursed him. And the child grew, and
she brought him to Pharaoh's daughter, and he became her son; and
she named him Moses, for she said, "Because I drew him out of the
water."

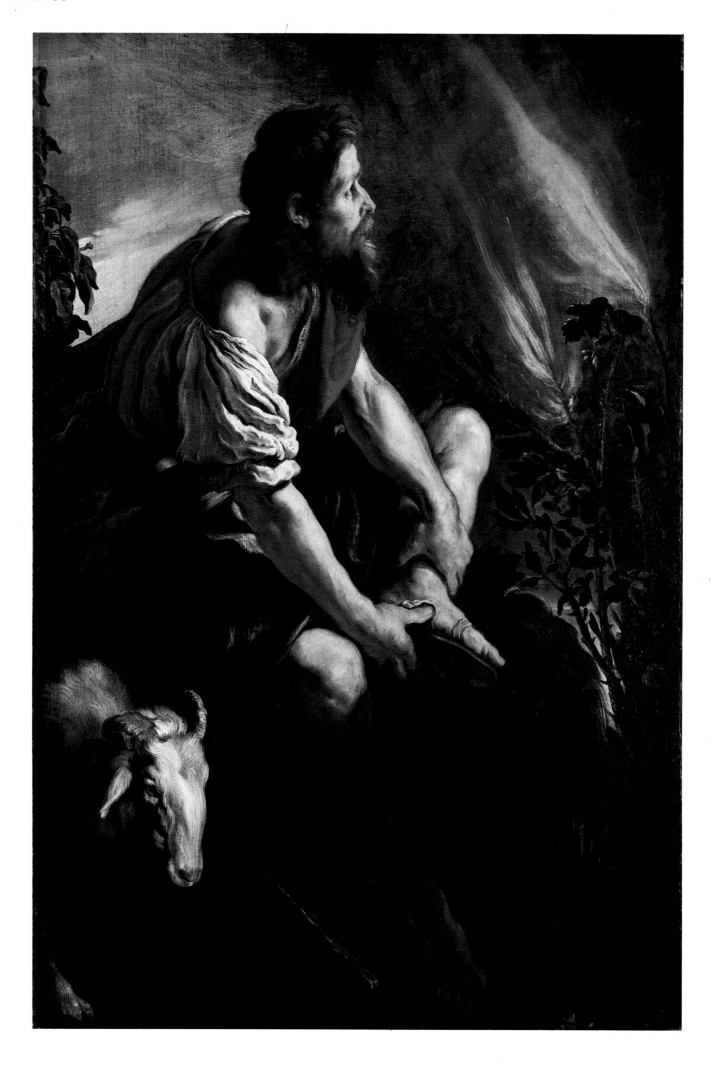

EXODUS
Chapter 3, Verses 1–12

Now Moses was keeping the flock of his father-in-law, Jethro, the priest of Midian; and he led his flock to the west side of the wilderness, and came to Horeb, the mountain of God. And the angel of the LORD appeared to him in a flame of fire out of the midst of a bush; and he looked, and lo, the bush was burning, yet it was not consumed. And Moses said, "I will turn aside and see this great sight, why the bush is not burnt." When the LORD saw that he turned aside to see, God called to him out of the bush, "Moses, Moses!" And he said, "Here am I." Then he said, "Do not come near; put off your shoes from your feet, for the place on which you are standing is holy ground." And he said, "I am the God of your father, the God of Abraham, the God of Isaac, and the God of Jacob." And Moses hid his face, for he was afraid to look at God.

Then the LORD said, "I have seen the affliction of my people who are in Egypt, and have heard their cry because of their taskmasters; I know their sufferings, and I have come down to deliver them out of the hand of the Egyptians, and to bring them up out of that land to a good and broad land, a land flowing with milk and honey, to the place of the Canaanites, the Hittites, the Amorites, the Perizzites, the Hivites, and the Jebusites. And now, behold, the cry of the people of Israel has come to me, and I have seen the oppression with which the Egyptians oppress them. Come, I will send you to Pharaoh that you may bring forth my people, the sons of Israel, out of Egypt." But Moses said to God, "Who am I that I should go to Pharaoh, and bring the sons of Israel out of Egypt?" He said, "But I will be with you; and this shall be the sign for you, that I have sent you: when you have brought forth the people out of Egypt, you shall serve God upon this mountain."

EXODUS
Chapter 12, Verses 50–51

Thus did all the people of Israel; as the LORD commanded Moses and Aaron, so they did. And on that very day the LORD brought the people of Israel out of the land of Egypt by their hosts.

Domenico Fetti (*c.*1589–1623)
'Moses and the Burning Bush'

David Roberts (1796–1864)
'The Departure of the Israelites'

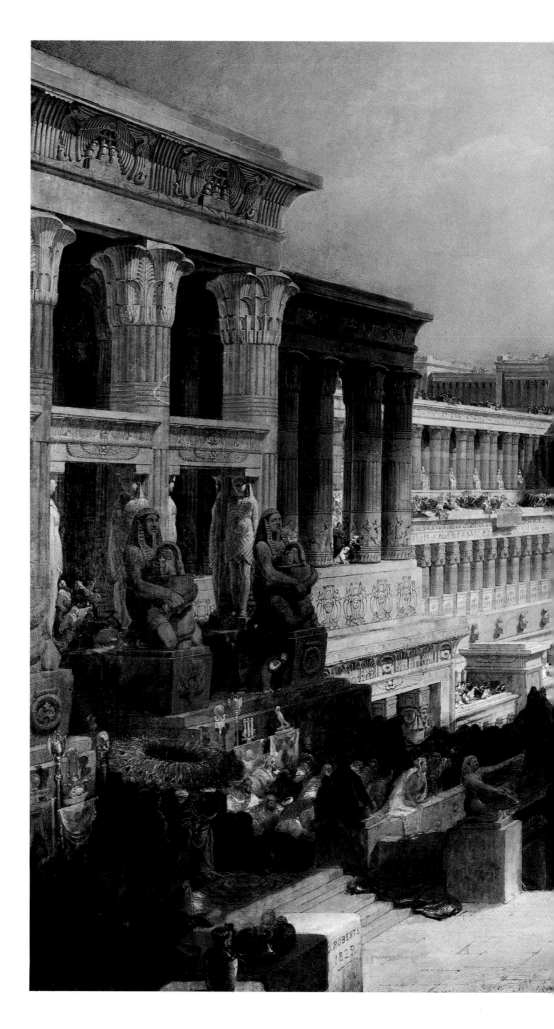

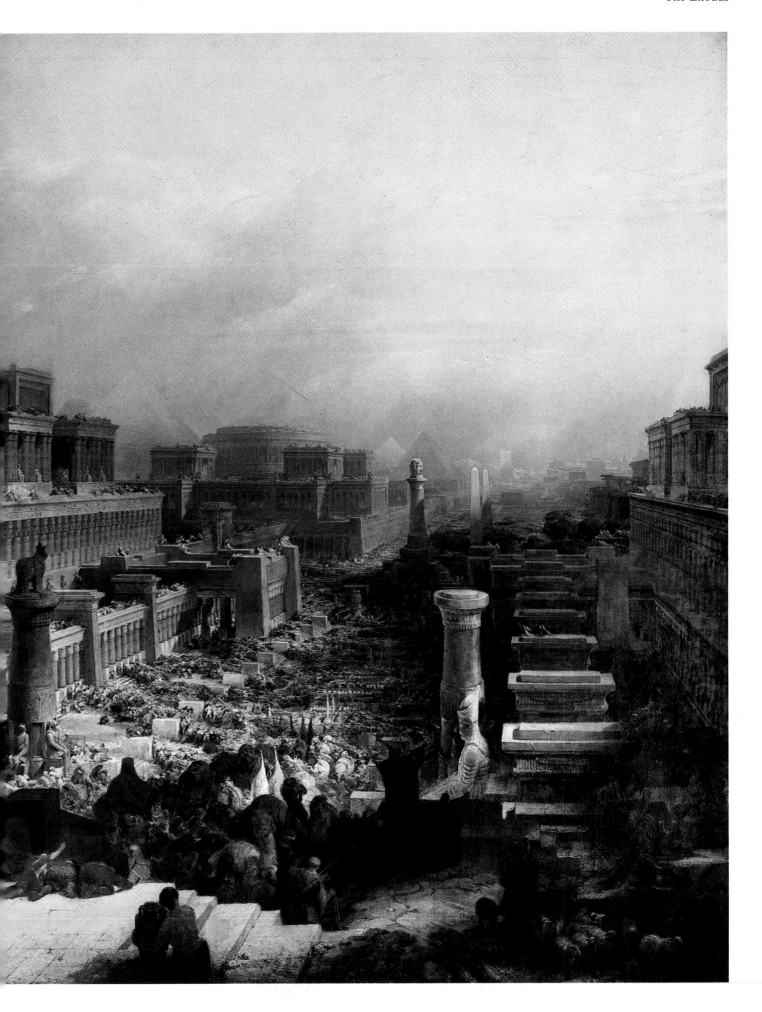

EXODUS Chapter 13, Verses 21–22

And the LORD went before them by day in a pillar of cloud to lead them along the way, and by night in a pillar of fire to give them light, that they might travel by day and by night; the pillar of cloud by day and the pillar of fire by night did not depart from before the people.

Lucas Cranach the Elder
(1472–1553)
'The Submersion of Pharaoh's Army'

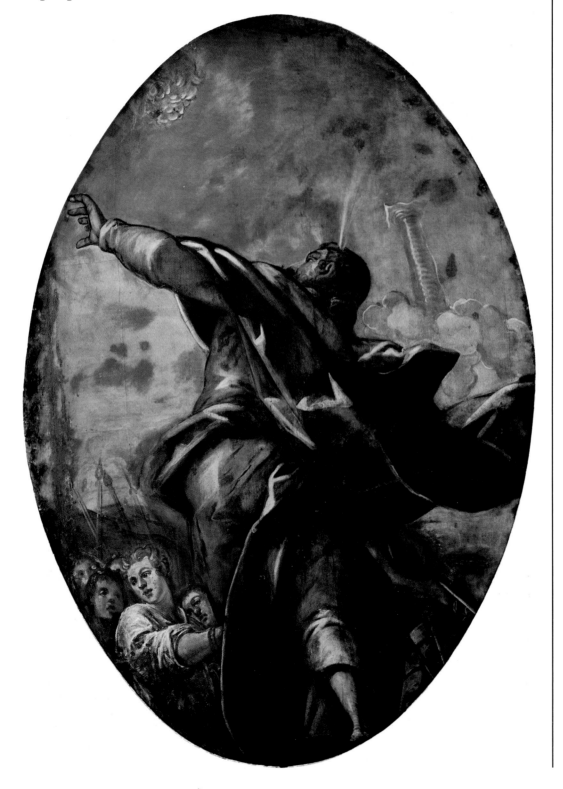

Tintoretto (Jacopo Robusti)
(1518–1594)
'Moses with the Pillar of Fire'

EXODUS
Chapter 14, Verses 22–27

And the people of Israel went into the midst of the sea on dry ground, the waters being a wall to them on their right hand and on their left. The Egyptians pursued, and went in after them into the midst of the sea, all Pharaoh's horses, his chariots, and his horsemen. And in the morning watch the LORD in the pillar of fire and of cloud looked down upon the host of the Egyptians, and discomfited the host of the Egyptians, clogging their chariot wheels so that they drove heavily; and the Egyptians said, "Let us flee from before Israel; for the LORD fights for them against the Egyptians."

Then the LORD said to Moses, "Stretch out your hand over the sea, that the water may come back upon the Egyptians, upon their chariots, and upon their horsemen." So Moses stretched forth his

hand over the sea, and the sea returned to its wonted flow when the morning appeared; and the Egyptians fled into it, and the LORD routed the Egyptians in the midst of the sea. The waters returned and covered the chariots and the horsemen and all the host of Pharaoh that had followed them into the sea; not so much as one of them remained.

EXODUS
Chapter 14, Verses 27–28

Samuel Colman
(active 1816–1840)
'The Delivery of Israel out of
Egypt'

Dieric Bouts (*c.*1415–1475)
'The Gathering of the Manna'

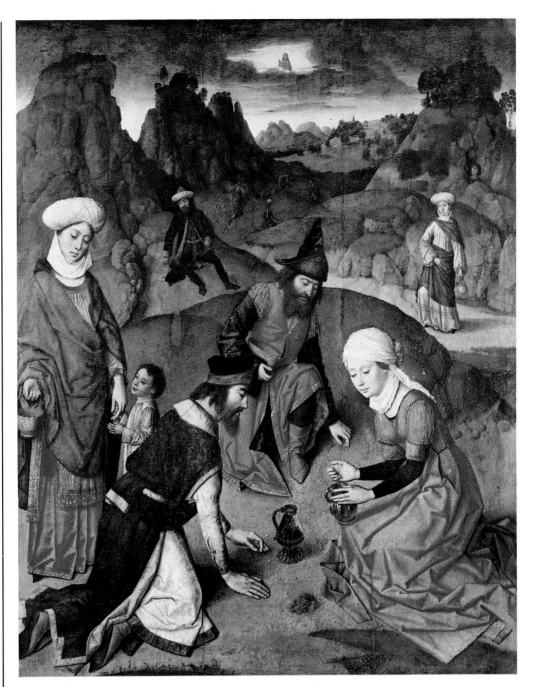

EXODUS Chapter 16, Verses 14–18

And when the dew had gone up, there was on the face of the wilderness a fine, flake-like thing, fine as hoarfrost on the ground. When the people of Israel saw it, they said to one another, "What is it?" For they did not know what it was. And Moses said to them, "It is the bread which the LORD has given you to eat. This is what the LORD has commanded: 'Gather of it, every man of you, as much as he can eat; you shall take an omer apiece, according to the number of the persons whom each of you has in his tent.'" And the people of Israel did so; they gathered, some more, some less. But when they measured it with an omer, he that gathered much had nothing over, and he that gathered little had no lack; each gathered according to what he could eat.

EXODUS Chapter 32, Verses 1–6

When the people saw that Moses delayed to come down from the mountain, the people gathered themselves together to Aaron, and said to him, "Up, make us gods, who shall go before us; as for this Moses, the man who brought us up out of the land of Egypt, we do not know what has become of him." And Aaron said to them, "Take off the rings of gold which are in the ears of your wives, your sons, and your daughters, and bring them to me." So all the people took off the rings of gold which were in their ears, and brought them to Aaron. And he received the gold at their hand, and fashioned it with a graving tool, and made a molten calf; and they said, "These are your gods, O Israel, who brought you up out of the land of Egypt!" When Aaron saw this, he built an altar before it; and Aaron made proclamation and said, "Tomorrow shall be a feast to the LORD." And they rose up early on the morrow, and offered burnt offerings and brought peace offerings; and the people sat down to eat and drink, and rose up to play.

EXODUS Chapter 32, Verses 15–19

And Moses turned, and went down from the mountain with the two tables of the testimony in his hands, tables that were written on both sides; on the one side and on the other were they written. And the tables were the work of God, and the writing was the writing of God, graven upon the tables. When Joshua heard the noise of the people as they shouted, he said to Moses, "There is a noise of war in the camp." But he said, "It is not the sound of shouting for victory, or the sound of the cry of defeat, but the sound of singing that I hear." And as soon as he came near the camp and saw the calf and the dancing, Moses' anger burned hot, and he threw the tables out of his hands and broke them at the foot of the mountain.

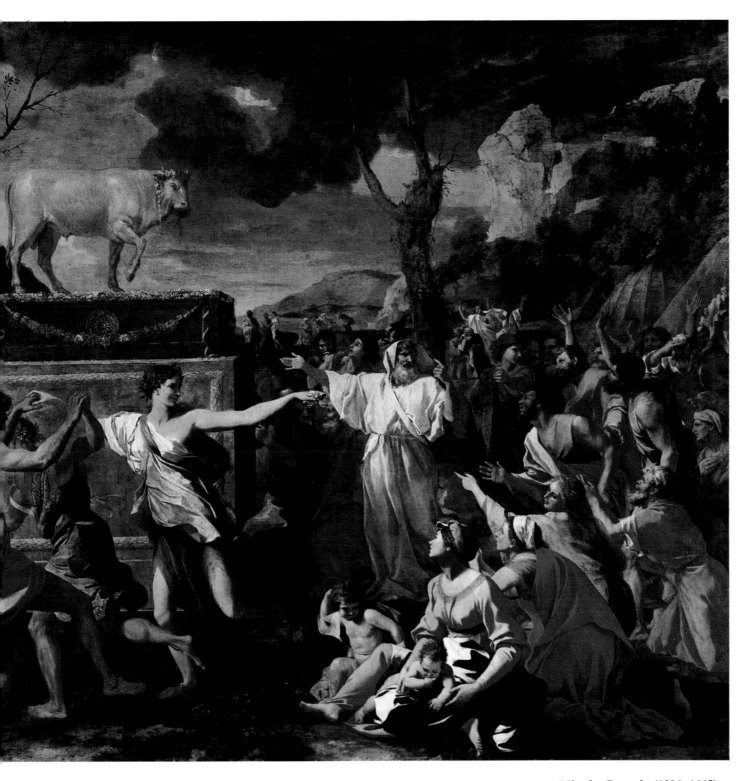

Nicolas Poussin (1594–1665)
'The Worship of the Golden
Calf'

Rembrandt (1606–1669)
'Moses Breaking the Tables of
the Law'

NUMBERS
Chapter 20, Verses 6–11

Then Moses and Aaron went from the presence of the assembly to the door of the tent of meeting, and fell on their faces. And the glory of the LORD appeared to them, and the LORD said to Moses, "Take the rod, and assemble the congregation, you and Aaron your brother, and tell the rock before their eyes to yield its water; so you shall bring water out of the rock for them; so you shall give drink to the congregation and their cattle." And Moses took the rod from before the LORD, as he commanded him.

And Moses and Aaron gathered the assembly together before the rock, and he said to them, "Hear now, you rebels; shall we bring forth water for you out of this rock?" And Moses lifted up his hand and struck the rock with his rod twice; and water came forth abundantly, and the congregation drank, and their cattle.

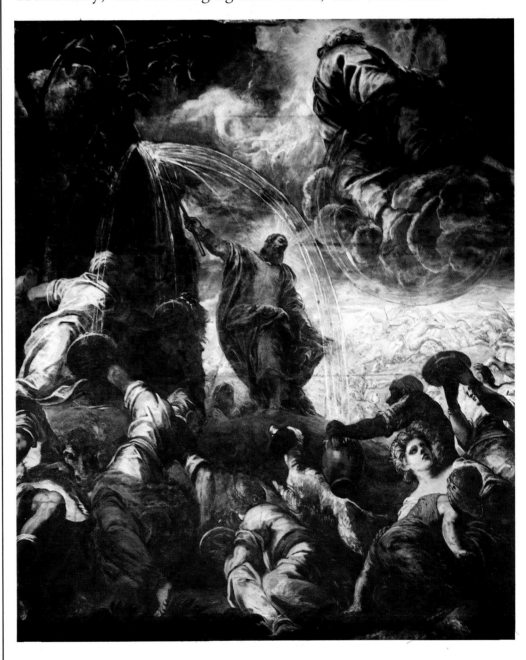

Tintoretto (1518–1594)
'Moses Striking the Rock'

From Mount Hor they set out by the way to the Red Sea, to go around the land of Edom; and the people became impatient on the way. And the people spoke against God and against Moses, "Why have you brought us up out of Egypt to die in the wilderness? For there is no food and no water, and we loathe this worthless food." Then the LORD sent fiery serpents among the people, and they bit the people, so that many people of Israel died. And the people came to Moses, and said, "We have sinned, for we have spoken against the LORD and against you; pray to the LORD, that he take away the serpents from us." So Moses prayed for the people. And the LORD said to Moses, "Make a fiery serpent, and set it on a pole; and every one who is bitten, when he sees it, shall live." So Moses made a bronze serpent, and set it on a pole; and if a serpent bit any man, he would look at the bronze serpent and live.

NUMBERS
Chapter 21, Verses 4–9

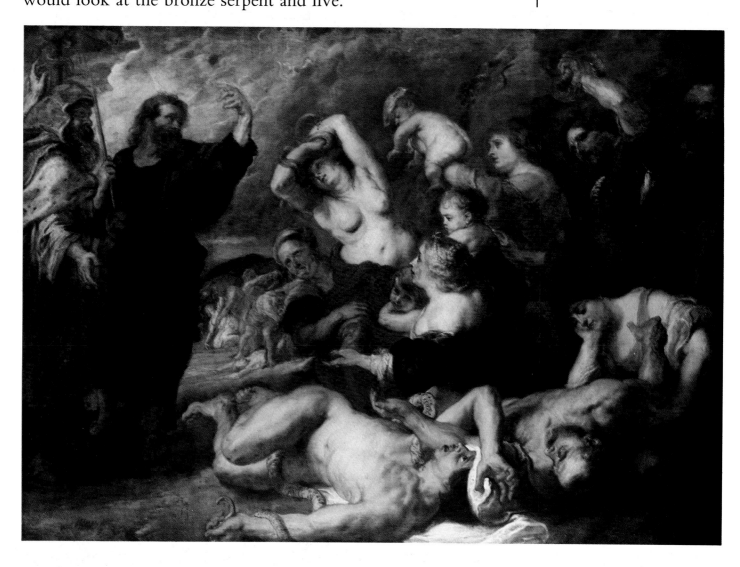

So Balaam rose in the morning, and saddled his ass, and went with the princes of Moab. But God's anger was kindled because he went; and the angel of the LORD took his stand in the way as his adversary. Now he was riding on the ass, and his two servants were with him. And the ass saw the angel of the LORD standing in the road, with a drawn sword in his hand; and the ass turned aside out of the road, and went into the field; and Balaam struck the ass, to

Rubens (1577–1640)
'The Brazen Serpent'

NUMBERS
Chapter 22, Verses 21–23

Rembrandt (1606–1669)
'Balaam and his Ass'

turn her into the road. Then the angel of the LORD stood in a narrow path between the vineyards, with a wall on either side. And when the ass saw the angel of the LORD, she pushed against the wall, and pressed Balaam's foot against the wall; so he struck her again. Then the angel of the LORD went ahead, and stood in a narrow place, where there was no way to turn either to the right or to the left. When the ass saw the angel of the LORD, she lay down under Balaam; and Balaam's anger was kindled, and he struck the ass with his staff. Then the LORD opened the mouth of the ass, and she said to Balaam, "What have I done to you, that you have struck me these three times?" And Balaam said to the ass, "Because you have made sport of me. I wish I had a sword in my hand, for then I would kill you." And the ass said to Balaam, "Am I not your ass, upon which you have ridden all your life long to this day? Was I ever accustomed to do so to you?" And he said, "No."

Then the LORD opened the eyes of Balaam, and he saw the angel of the LORD standing in the way, with his drawn sword in his hand; and he bowed his head, and fell on his face. And the angel of the LORD said to him, "Why have you struck your ass these three times? Behold, I have come forth to withstand you, because your way is perverse before me; and the ass saw me, and turned aside before me these three times. If she had not turned aside from me, surely just now I would have slain you and let her live."

Then Balaam said to the angel of the LORD, "I have sinned, for I did not know that thou didst stand in the road against me. Now therefore, if it is evil in thy sight, I will go back again."

NUMBERS
Chapter 22, Verses 23–34

And Moses went up from the plains of Moab to Mount Nebo, to the top of Pisgah, which is opposite Jericho. And the LORD showed him all the land, Gilead as far as Dan, all Naphtali, the land of Ephraim and Manasseh, all the land of Judah as far as the Western Sea, the Negeb, and the Plain, that is, the valley of Jericho the city of palm trees, as far as Zoar. And the LORD said to him, "This is the land of which I swore to Abraham, to Isaac, and to Jacob, 'I will give it to your descendants.' I have let you see it with your eyes, but you shall not go over there."

DEUTERONOMY
Chapter 34, Verses 1–4

Gustave Moreau (1826–1898)
'Moses Sheds his Sandals in Sight of the Holy Land'

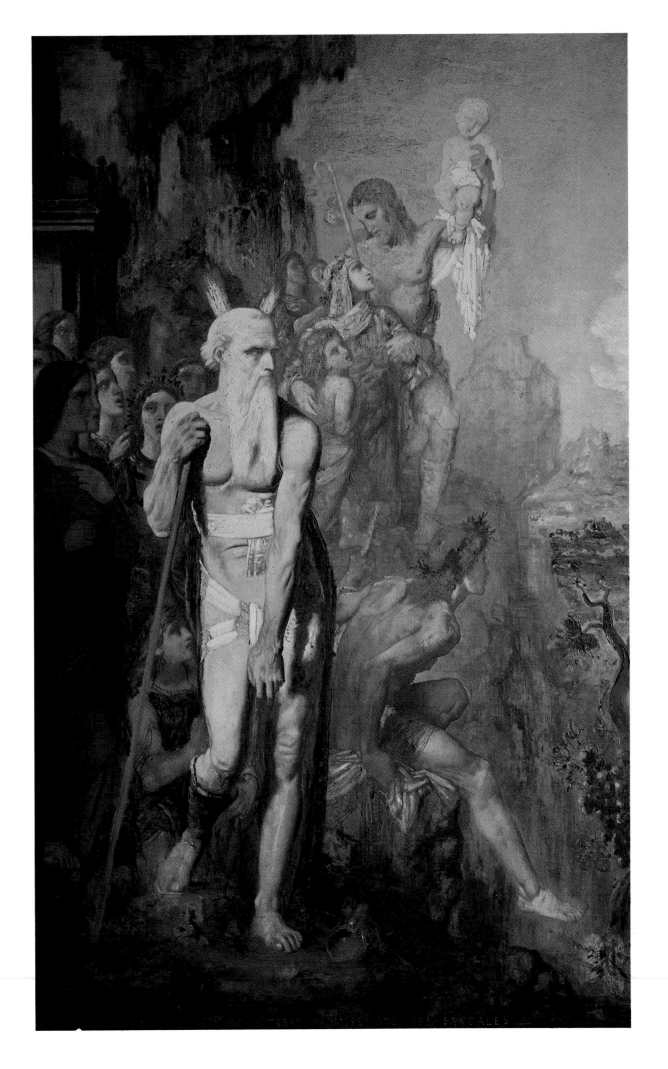

Then spoke Joshua to the LORD in the day when the LORD gave the Amorites over to the men of Israel; and he said in the sight of Israel,

"Sun, stand thou still at Gibeon,
and thou Moon in the valley of Aijalon."
And the sun stood still, and the moon stayed,
until the nation took vengeance on their enemies.

Is this not written in the Book of Jashar? The sun stayed in the midst of heaven, and did not hasten to go down for about a whole day. There has been no day like it before or since, when the LORD hearkened to the voice of a man; for the LORD fought for Israel.

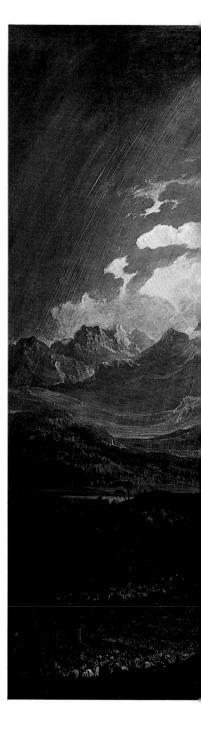

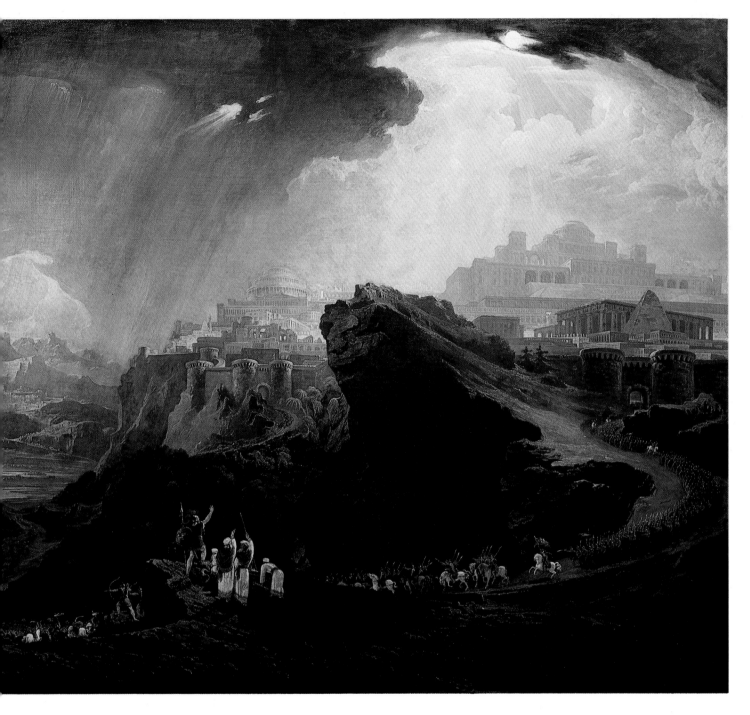

John Martin (1789–1854)
'Joshua Commanding the Sun
to Stand Still over Gibeon'

Then Samson went down with his father and mother to Timnah, and he came to the vineyards of Timnah. And behold, a young lion roared against him; and the Spirit of the LORD came mightily upon him, and he tore the lion asunder as one tears a kid; and he had nothing in his hand. But he did not tell his father or his mother what he had done.

JUDGES
Chapter 14, Verses 5–6

Léon Bonnat (1833–1922)
'Samson Killing the Lion'

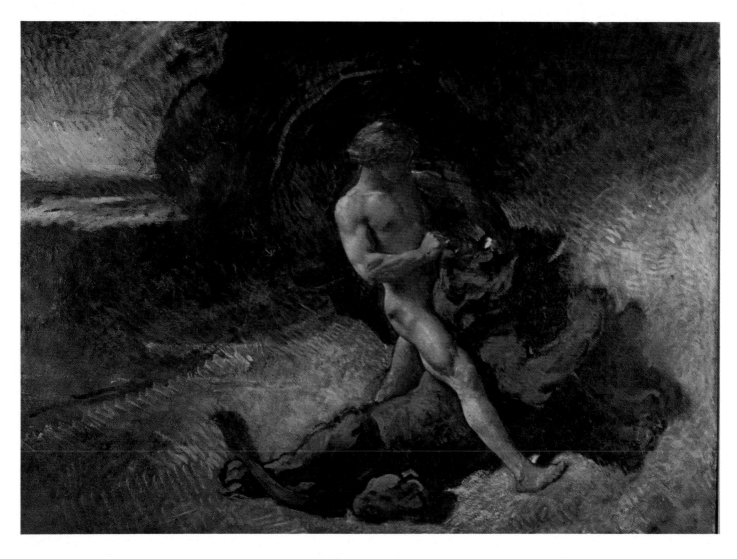

JUDGES
Chapter 15, Verses 14–16

When he came to Lehi, the Philistines came shouting to meet him; and the Spirit of the LORD came mightily upon him, and the ropes which were on his arms became as flax that has caught fire, and his bonds melted off his hands. And he found a fresh jawbone of an ass, and put out his hand and seized it, and with it he slew a thousand men. And Samson said,
"With the jawbone of an ass, heaps upon heaps,
with the jawbone of an ass have I slain a thousand men."

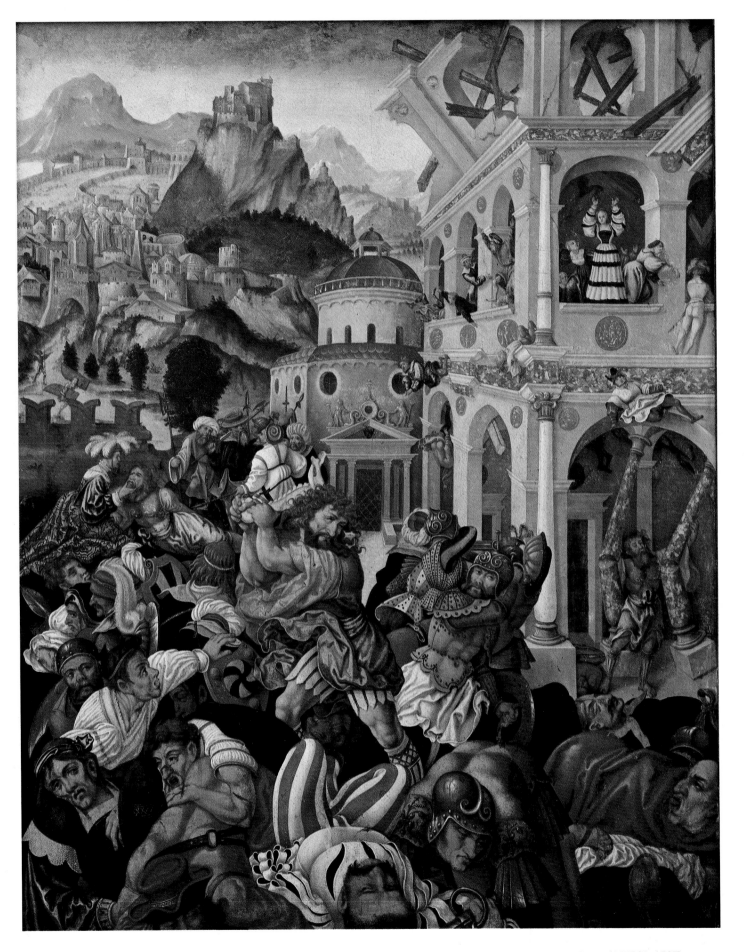

Jorg Breu (1475/6–1537)
'The Story of Samson'

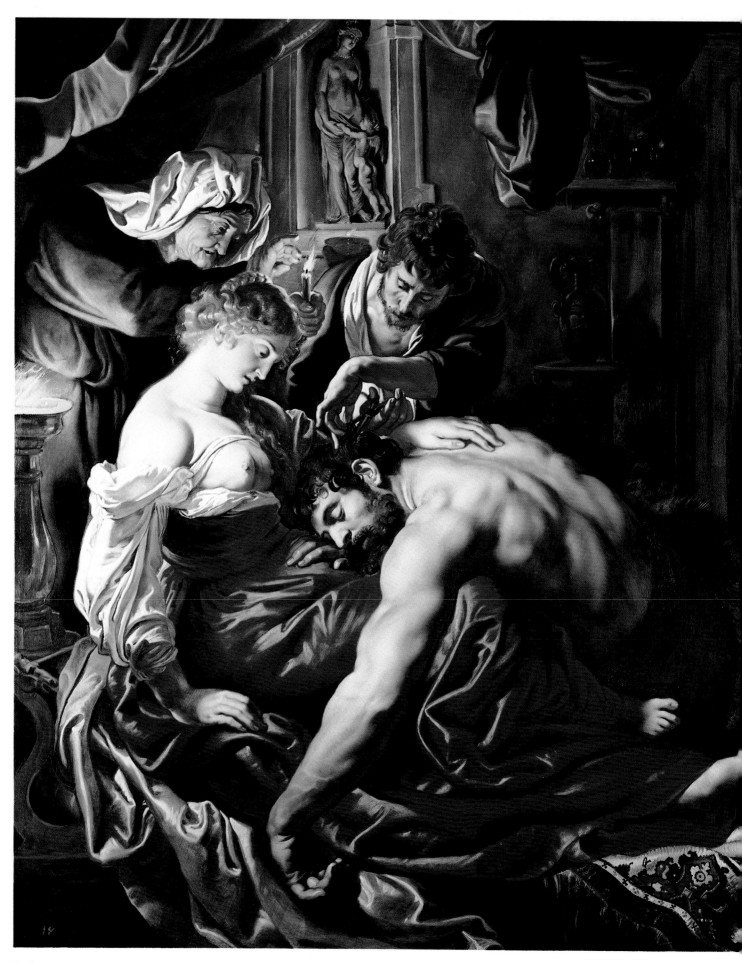

Rubens (1577–1640)
'Samson and Delilah'

JUDGES Chapter 16, Verses 17–18

And he told her all his mind, and said to her, "A razor has never come upon my head; for I have been a Nazirite to God from my mother's womb. If I be shaved, then my strength will leave me, and I shall become weak, and be like any other man."

When Delilah saw that he had told her all his mind, she sent and called the lords of the Philistines, saying, "Come up this once, for he has told me all his mind." Then the lords of the Philistines came

Solomon J. Solomon
(1860–1927)
'Samson and Delilah'

JUDGES
Chapter 16, Verses 18–21

up to her, and brought the money in their hands. She made him sleep upon her knees; and she called a man, and had him shave off the seven locks of his head. Then she began to torment him, and his strength left him. And she said, "The Philistines are upon you, Samson!" And he awoke from his sleep, and said, "I will go out as

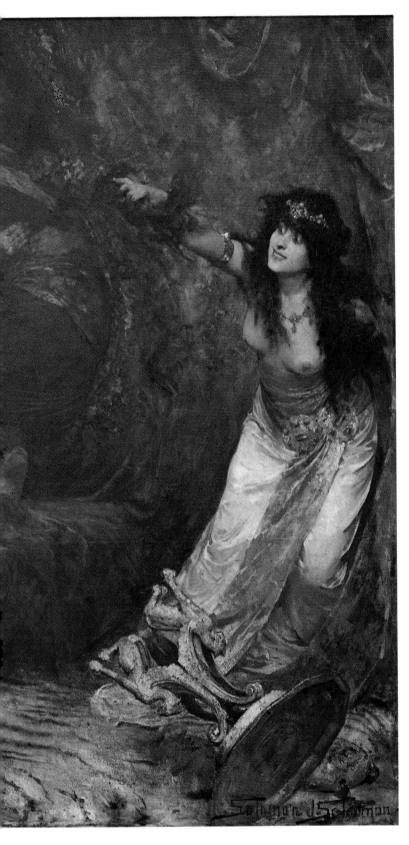

at other times, and shake myself free.'' And he did not know that the LORD had left him. And the Philistines seized him and gouged out his eyes, and brought him down to Gaza, and bound him with bronze fetters; and he ground at the mill in the prison.

Then Boaz said to the elders and all the people, "You are witnesses this day that I have bought from the hand of Naomi all that belonged to Elimelech and all that belonged to Chilion and to Mahlon. Also Ruth the Moabitess, the widow of Mahlon, I have bought to be my wife, to perpetuate the name of the dead in his inheritance, that the name of the dead may not be cut off from among his brethren and from the gate of his native place; you are witnesses this day." Then all the people who were at the gate, and the elders, said, "We are witnesses. May the LORD make the woman, who is coming into your house, like Rachel and Leah, who together built up the house of Israel. May you prosper in Ephrathah and be renowned in Bethlehem; and may your house be like the house of Perez, whom Tamar bore to Judah, because of the children that the LORD will give you by this young woman."

So Boaz took Ruth and she became his wife; and he went in to her, and the LORD gave her conception, and she bore a son.

RUTH
Chapter 4, Verses 9–13

Gerrit Dou (1613–1675)
'Eli Instructing Samuel'

Aert (Arent) de Gelder
(1645–1727)
'Ruth and Boaz'

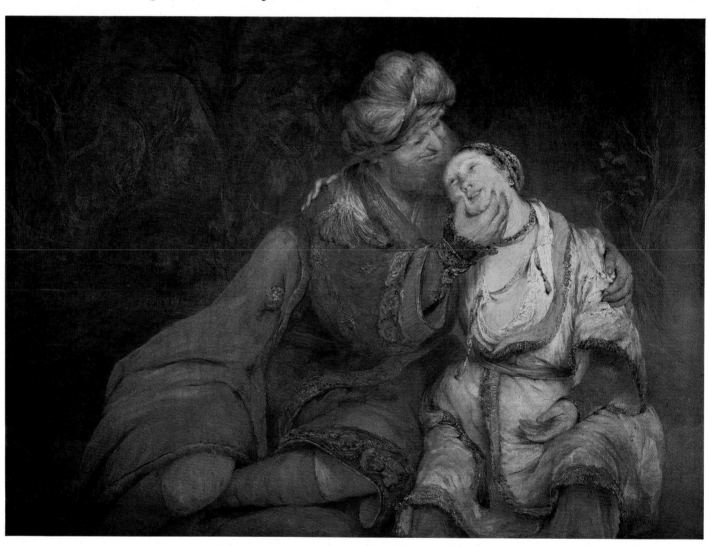

I SAMUEL
Chapter 1, Verses 24–28

And when she had weaned him, she took him up with her, along with a three-year-old bull, an ephah of flour, and a skin of wine; and she brought him to the house of the LORD at Shiloh; and the child was young. Then they slew the bull, and they brought the child to Eli. And she said, "Oh, my lord! As you live, my lord, I

am the woman who was standing here in your presence, praying to the LORD. For this child I prayed; and the LORD has granted me my petition which I made to him. Therefore I have lent him to the LORD; as long as he lives, he is lent to the LORD."

Then Elkanah went home to Ramah. And the boy ministered to the LORD, in the presence of Eli the priest.

I SAMUEL
Chapter 2, Verse 11

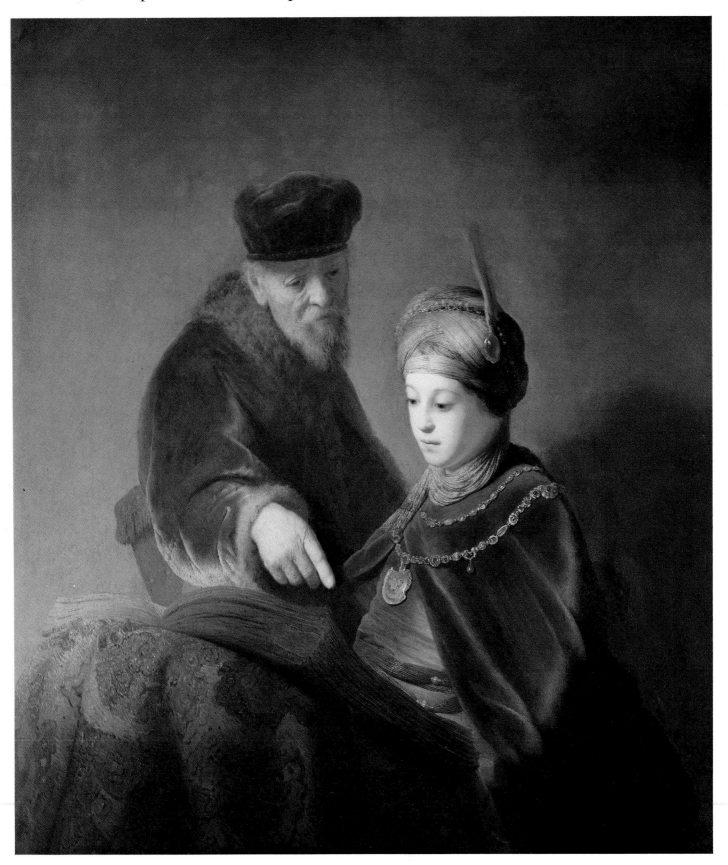

93

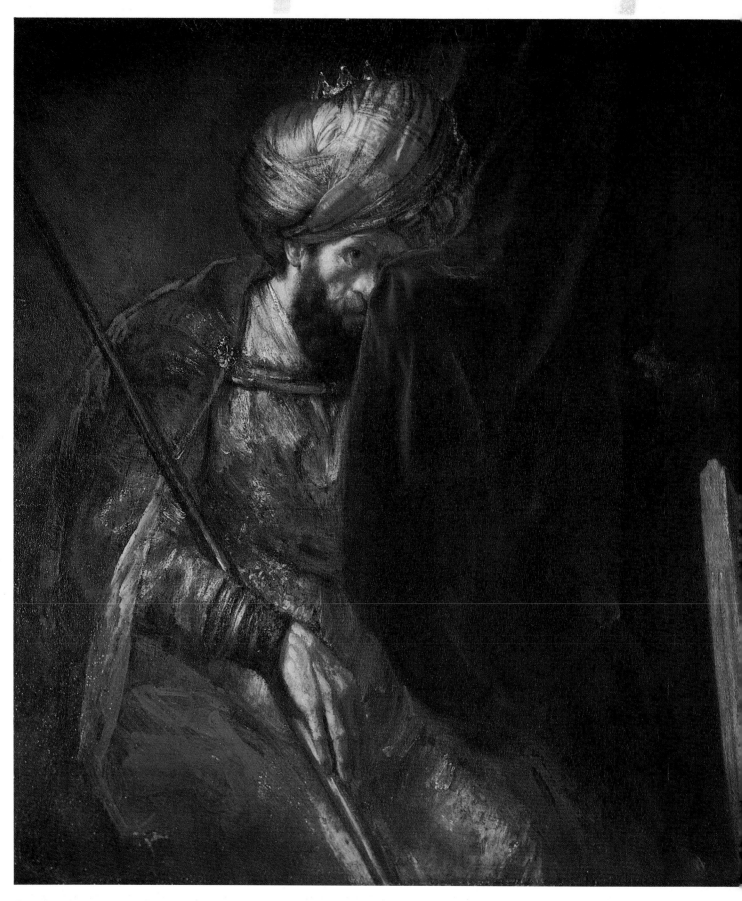

Rembrandt (1606–1669)
'Saul and David'

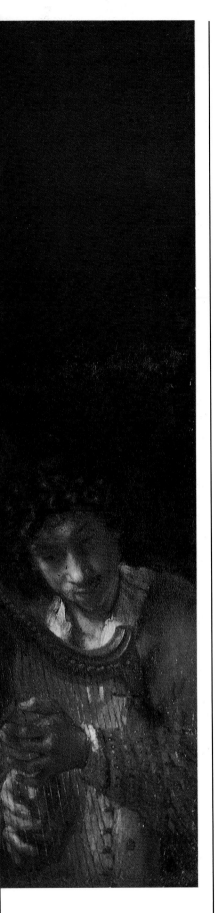

Now the Spirit of the LORD departed from Saul, and an evil spirit from the LORD tormented him. And Saul's servants said to him, "Behold now, an evil spirit from God is tormenting you. Let our lord now command your servants, who are before you, to seek out a man who is skilful in playing the lyre; and when the evil spirit from God is upon you, he will play it, and you will be well." So Saul said to his servants, "Provide for me a man who can play well, and bring him to me." One of the young men answered, "Behold, I have seen a son of Jesse the Bethlehemite, who is skilful in playing, a man of valour, a man of war, prudent in speech, and a man of good presence; and the LORD is with him." Therefore Saul sent messengers to Jesse, and said, "Send me David your son, who is with the sheep." And Jesse took an ass laden with bread, and a skin of wine and a kid, and sent them by David his son to Saul. And David came to Saul, and entered his service. And Saul loved him greatly, and he became his armour-bearer. And Saul sent to Jesse, saying, "Let David remain in my service, for he has found favour in my sight." And whenever the evil spirit from God was upon Saul, David took the lyre and played it with his hand; so Saul was refreshed, and was well, and the evil spirit departed from him.

I SAMUEL Chapter 17, Verses 42–50

And when the Philistine looked, and saw David, he disdained him; for he was but a youth, ruddy and comely in appearance. And the Philistine said to David, "Am I a dog, that you come to me with sticks?" And the Philistine cursed David by his gods. The Philistine said to David, "Come to me, and I will give your flesh to the birds of the air and to the beasts of the field." Then David said to the Philistine, "You come to me with a sword and with a spear and with a javelin; but I come to you in the name of the LORD of hosts, the God of the armies of Israel, whom you have defied. This day the LORD will deliver you into my hand, and I will strike you down, and cut off your head; and I will give the dead bodies of the host of the Philistines this day to the birds of the air and to the wild beasts of the earth; that all the earth may know that there is a God in Israel, and that all this assembly may know that the LORD saves not with sword and spear; for the battle is the LORD's and he will give you into our hand."

When the Philistine arose and came and drew near to meet David, David ran quickly toward the battle line to meet the Philistine. And David put his hand in his bag and took out a stone, and slung it, and struck the Philistine on his forehead; the stone sank into his forehead, and he fell on his face to the ground.

So David prevailed over the Philistine with a sling and with a

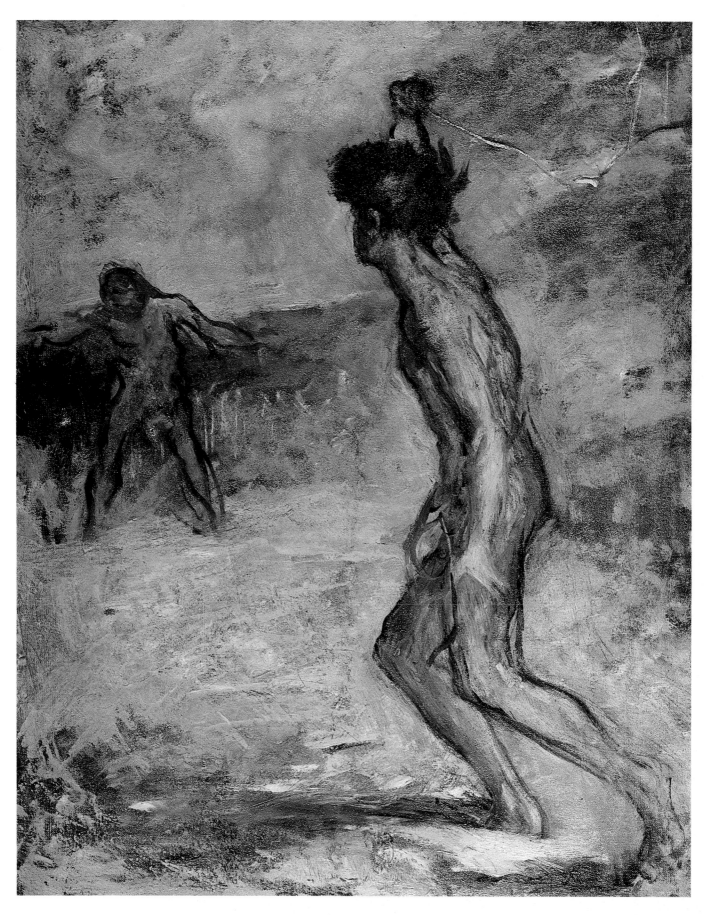

stone, and struck the Philistine, and killed him; there was no sword in the hand of David. Then David ran and stood over the Philistine, and took his sword and drew it out of its sheath, and killed him, and cut off his head with it. When the Philistines saw that their champion was dead, they fled.

Edgar Degas (1834–1917)
'David and Goliath'

I SAMUEL
Chapter 17, Verses 50–51

Orazio Gentileschi
(1563–1639)
'David Contemplating the
Death of Goliath'

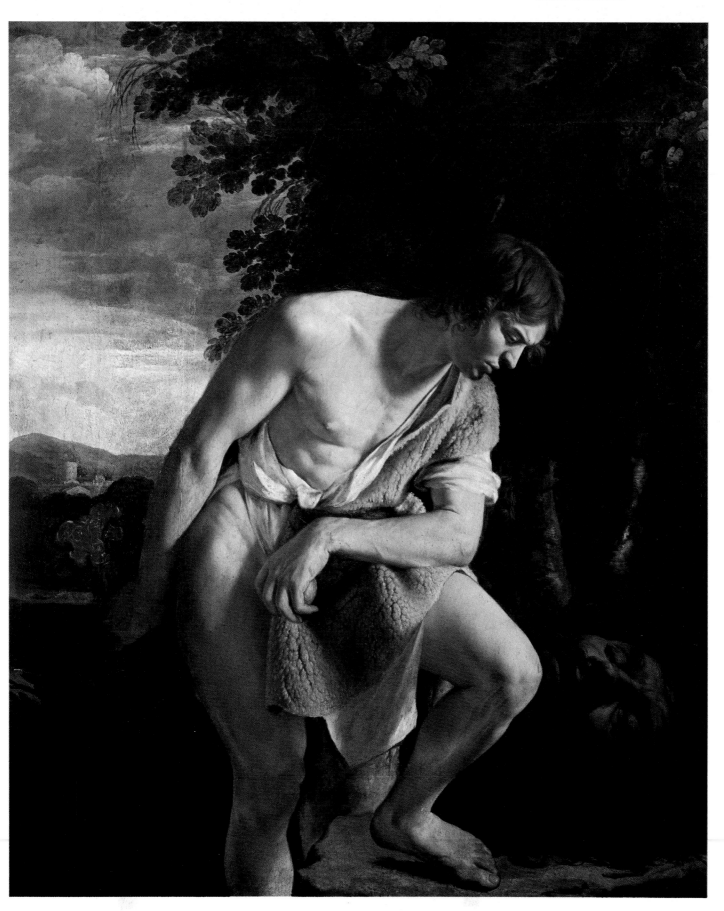

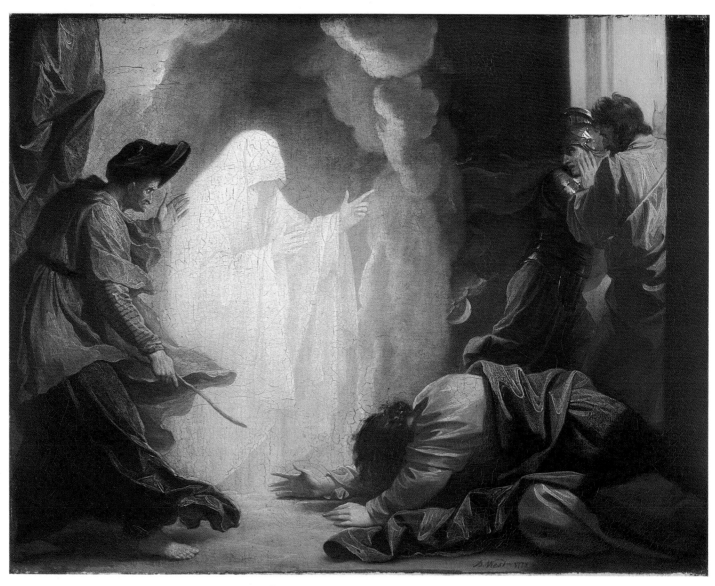

Then Saul said to his servants, "Seek out for me a woman who is a medium, that I may go to her and inquire of her." And his servants said to him, "Behold, there is a medium at Endor."

So Saul disguised himself and put on other garments, and went, he and two men with him; and they came to the woman by night. And he said, "Divine for me by a spirit, and bring up for me whomever I shall name to you." The woman said to him, "Surely you know what Saul has done, how he has cut off the mediums and the wizards from the land. Why then are you laying a snare for my life to bring about my death?" But Saul swore to her by the LORD, "As the LORD lives, no punishment shall come upon you for this thing." Then the woman said, "Whom shall I bring up for you?" He said, "Bring up Samuel for me." When the woman saw Samuel, she cried out with a loud voice; and the woman said to Saul, "Why have you deceived me? You are Saul." The king said to her, "Have no fear; what do you see?" And the woman said to Saul, "I see a god coming up out of the earth." He said to her, "What is his appearance?" And she said, "An old man is coming up; and he is wrapped in a robe." And Saul knew that it was Samuel, and he bowed with his face to the ground, and did obeisance.

Benjamin West (1738–1820)
'Saul and the Witch of Endor'

I SAMUEL
Chapter 28, Verses 7–14

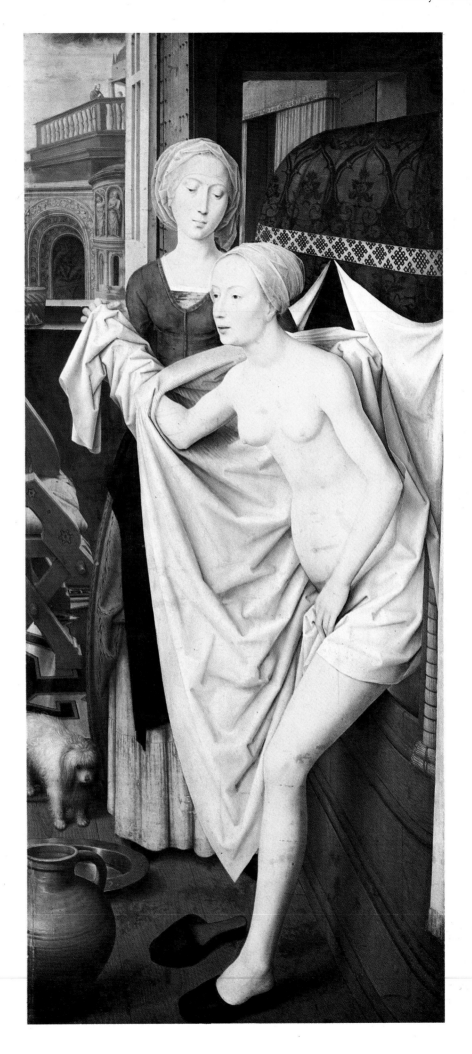

Hans Memling (1430/40–1494)
'David and Bathsheba'

It happened, late one afternoon, when David arose from his couch and was walking upon the roof of the king's house, that he saw from the roof a woman bathing; and the woman was very beautiful. And David sent and inquired about the woman. And one said, "Is not this Bathsheba, the daughter of Eliam, the wife of Uriah the Hittite?" So David sent messengers, and took her; and she came to him, and he lay with her. (Now she was purifying herself from her uncleanness.) Then she returned to her house.

II SAMUEL
Chapter 11, Verses 2–4

Rembrandt (1606–1669)
'Bathsheba'

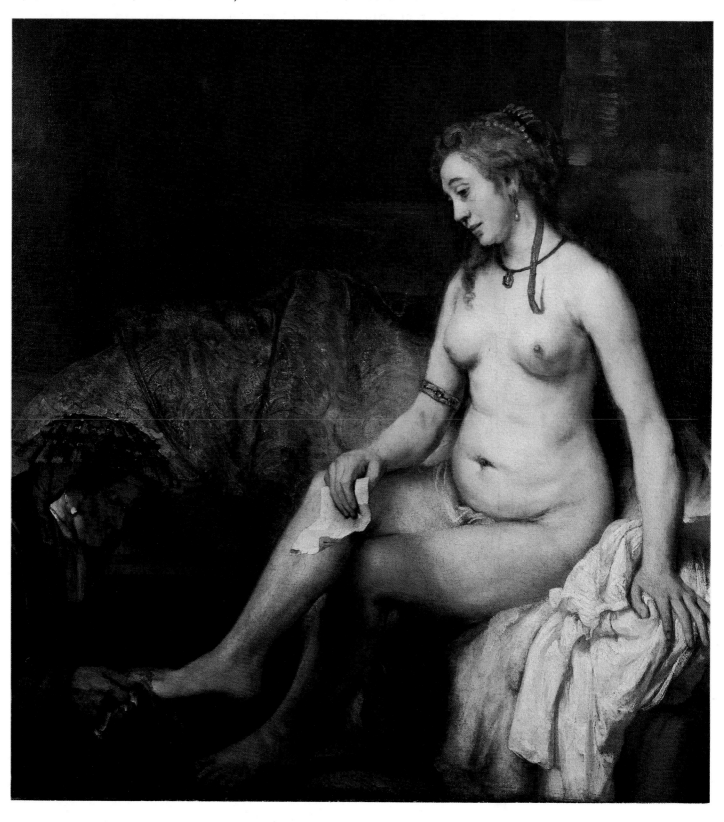

I KINGS
Chapter 3, Verses 16–28

Then two harlots came to the king, and stood before him. The one woman said, "Oh, my lord, this woman and I dwell in the same house; and I gave birth to a child while she was in the house. Then on the third day after I was delivered, this woman also gave birth; and we were alone; there was no one else with us in the house, only we two were in the house. And this woman's son died in the night, because she lay on it. And she arose at midnight, and took my son from beside me, while your maidservant slept, and laid it in her bosom, and laid her dead son in my bosom. When I rose in the morning to nurse my child, behold, it was dead; but when I looked at it closely in the morning, behold, it was not the child that I had borne." But the other woman said, "No, the living child is mine, and the dead child is yours." The first said, "No, the dead child is yours, and the living child is mine." Thus they spoke before the king.

Then the king said, "The one says, 'This is my son that is alive, and your son is dead'; and the other says, 'No; but your son is dead, and my son is the living one.'" And the king said, "Bring me a sword." So a sword was brought before the king. And the king said, "Divide the living child in two, and give half to the one, and half to the other." Then the woman whose son was alive said to the king, because her heart yearned for her son, "Oh, my lord, give her the living child, and by no means slay it." But the other said, "It shall be neither mine nor yours; divide it." Then the king answered and said, "Give the living child to the first woman, and by no means slay it; she is its mother." And all Israel heard of the judgment which the king had rendered; and they stood in awe of the king, because they perceived that the wisdom of God was in him, to render justice.

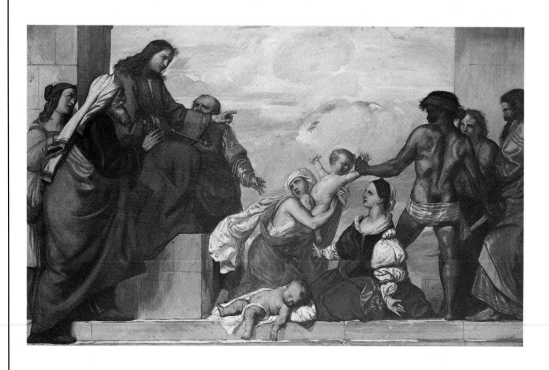

William Dyce (1806–1864)
'The Judgment of Solomon'

Sir Edward Poynter
(1839–1919)
'The Queen of Sheba Being
Received by Solomon'

Now when the queen of Sheba heard of the fame of Solomon concerning the name of the LORD, she came to test him with hard questions. She came to Jerusalem with a very great retinue, with camels bearing spices, and very much gold, and precious stones; and when she came to Solomon, she told him all that was on her mind. And Solomon answered all her questions; there was nothing hidden from the king which he could not explain to her. And when the queen of Sheba had seen all the wisdom of Solomon, the house that he had built, the food of his table, the seating of his officials, and the attendance of his servants, their clothing, his cupbearers, and his burnt offerings which he offered at the house of the LORD, there was no more spirit in her.

And she said to the king, "The report was true which I heard in my own land of your affairs and of your wisdom, but I did not believe the reports until I came and my own eyes had seen it; and, behold, the half was not told me; your wisdom and prosperity surpass the report which I heard. Happy are your wives! Happy are these your servants, who continually stand before you and hear your wisdom! Blessed be the LORD your God, who has delighted in you and set you on the throne of Israel! Because the LORD loved Israel for ever, he has made you king, that you may execute justice and righteousness." Then she gave the king a hundred and twenty talents of gold, and a very great quantity of spices, and precious stones; never again came such an abundance of spices as these which the queen of Sheba gave to King Solomon.

Moreover the fleet of Hiram, which brought gold from Ophir, brought from Ophir a very great amount of almug wood and precious stones. And the king made of the almug wood supports for the house of the LORD, and for the king's house, lyres also and harps for the singers; no such almug wood has come or been seen, to this day.

And King Solomon gave to the queen of Sheba all that she desired, whatever she asked besides what was given her by the bounty of King Solomon. So she turned and went back to her own land, with her servants.

I KINGS
Chapter 12, Verses 26–33

And Jeroboam said in his heart, "Now the kingdom will turn back to the house of David; if this people go up to offer sacrifices in the house of the LORD at Jerusalem, then the heart of this people will turn again to their lord, to Rehoboam king of Judah, and they will kill me and return to Rehoboam king of Judah." So the king took counsel, and made two calves of gold. And he said to the people, "You have gone up to Jerusalem long enough. Behold your gods, O Israel, who brought you up out of the land of Egypt." And he set one in Bethel, and the other he put in Dan. And this thing became a sin, for the people went to the one at Bethel and to the other as far as Dan. He also made houses on high places, and appointed priests from among all the people, who were not of the Levites. And Jeroboam appointed a feast on the fifteenth day of the eighth month like the feast that was in Judah, and he offered sacrifices upon the altar; so he did in Bethel, sacrificing to the calves that he had made. And he placed in Bethel the priests of the high places that he had made. He went up to the altar which he had made in Bethel on the fifteenth day in the eighth month, in the month which he had devised of his own heart; and he ordained a feast for the people of Israel, and went up to the altar to burn incense.

Jean-Honoré Fragonard
(1732–1806)
'Jeroboam Sacrificing to his Idols'

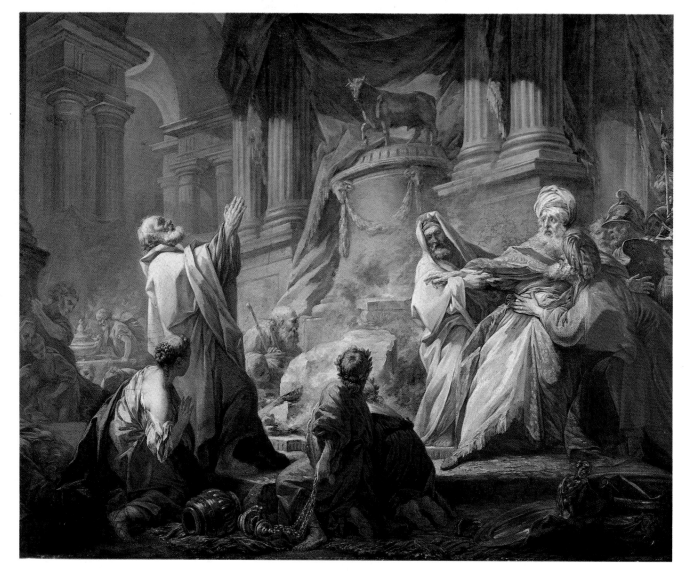

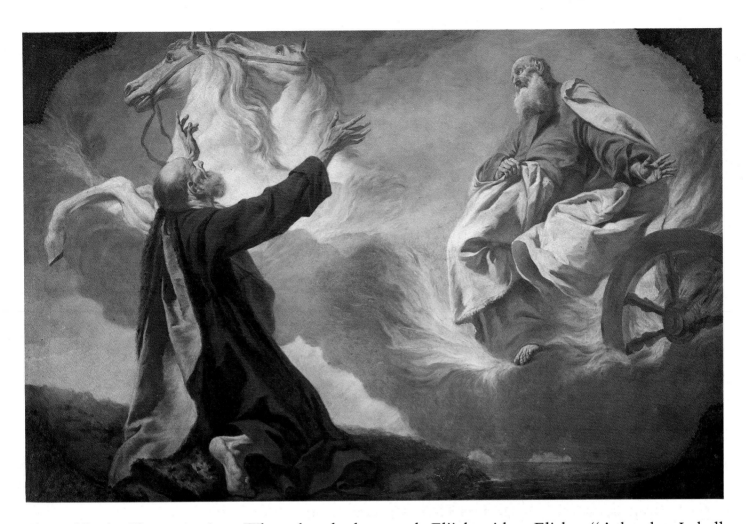

Giovanni Battista Piazzetta
(1682–1754)
'Elijah Taken Up in a Chariot of
Fire'

II KINGS
Chapter 2, Verses 9–12

When they had crossed, Elijah said to Elisha, "Ask what I shall do for you, before I am taken from you." And Elisha said, "I pray you, let me inherit a double share of your spirit." And he said, "You have asked a hard thing; yet, if you see me as I am being taken from you, it shall be so for you; but if you do not see me, it shall not be so." And as they still went on and talked, behold, a chariot of fire and horses of fire separated the two of them. And Elijah went up by a whirlwind into heaven. And Elisha saw it and he cried, "My father, my father! the chariots of Israel and its horsemen!" And he saw him no more.

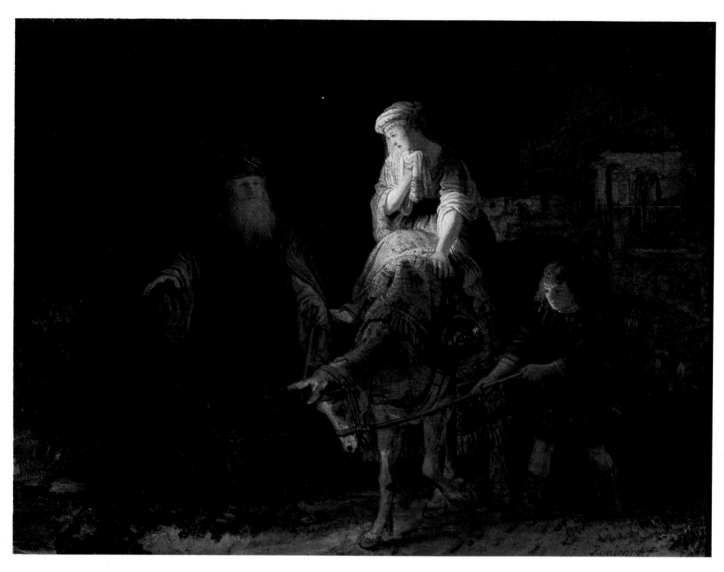

But the woman conceived, and she bore a son about that time the following spring, as Elisha had said to her.

When the child had grown, he went out one day to his father among the reapers. And he said to his father, "Oh, my head, my head!" The father said to his servant. "Carry him to his mother." And when he had lifted him, and brought him to his mother, the child sat on her lap till noon, and then he died. And she went up and laid him on the bed of the man of God, and shut the door upon him, and went out. Then she called to her husband, and said, "Send me one of the servants and one of the asses, that I may quickly go to the man of God, and come back again." And he said, "Why will you go to him today? It is neither new moon nor sabbath." She said, "It will be well." Then she saddled the ass, and she said to her servant, "Urge the beast on; do not slacken the pace for me unless I tell you."

Rembrandt (1606–1669)
'The Departure of the Shunammite Woman'

II KINGS
Chapter 4, Verses 17–24

When Elisha came into the house, he saw the child lying dead on his bed. So he went in and shut the door upon the two of them, and prayed to the LORD. Then he went up and lay upon the child, putting his mouth upon his mouth, his eyes upon his eyes, and his hands upon his hands; and as he stretched himself upon him, the flesh of the child became warm. Then he got up again, and walked once to and fro in the house, and went up, and stretched himself upon him; the child sneezed seven times, and the child opened his eyes. Then he summoned Gehazi and said, "Call this Shunammite." So he called her. And when she came to him, he said, "Take up your son." She came and fell at his feet, bowing to the ground; then she took up her son and went out.

II KINGS
Chapter 4, Verses 32–37

Lord Leighton (1830–1896)
'Elisha Healing the Shunammite Woman's Son'

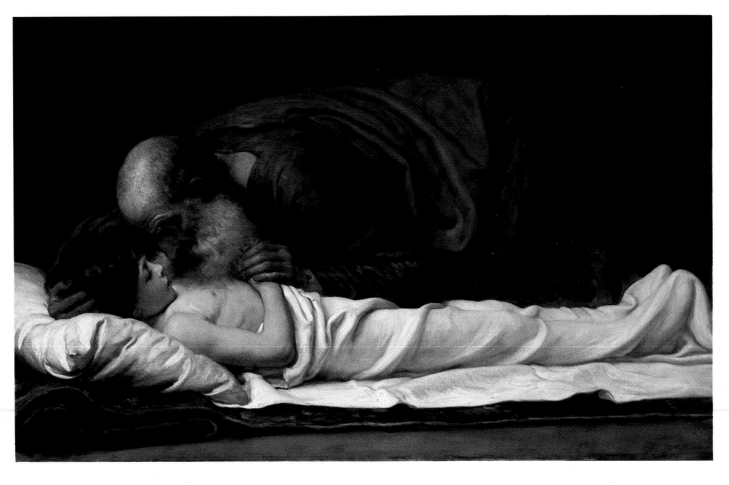

When Jehu came to Jezreel, Jezebel heard of it; and she painted her eyes, and adorned her head, and looked out of the window. And as Jehu entered the gate, she said, "Is it peace, you Zimri, murderer of your master?" And he lifted up his face to the window, and said, "Who is on my side? Who?" Two or three eunuchs looked out at him. He said, "Throw her down." So they threw her down; and some of her blood spattered on the wall and on the horses, and they trampled on her. Then he went in and ate and drank; and he said, "See now to this cursed woman, and bury her; for she is a king's daughter." But when they went to bury her, they found no more of her than the skull and the feet and the palms of her hands. When they came back and told him, he said, "This is the word of the LORD, which he spoke by his servant Elijah the Tishbite, 'In the territory of Jezreel the dogs shall eat the flesh of Jezebel; and the corpse of Jezebel shall be as dung upon the face of the field in the territory of Jezreel, so that no one can say, This is Jezebel.'"

Luca Giordano (1634–1705)
'The Death of Jezebel'

Filippino Lippi (*c.*1457–1504)
'Queen Vashti Leaving the Palace'

ESTHER
Chapter 1, Verses 2–4

In those days when King Ahasuerus sat on his royal throne in Susa the capital, in the third year of his reign he gave a banquet for all his princes and servants, the army chiefs of Persia and Media and the nobles and governors of the provinces being before him, while he showed the riches of his royal glory and the splendour and pomp of his majesty for many days, a hundred and eighty days.

And when these days were completed, the king gave for all the people present in Susa the capital, both great and small, a banquet lasting for seven days, in the court of the garden of the king's palace. There were white cotton curtains and blue hangings caught up with cords of fine linen and purple to silver rings and marble pillars, and also couches of gold and silver on a mosaic pavement of porphyry, marble, mother-of-pearl and precious stones. Drinks were served in golden goblets, goblets of different kinds, and the royal wine was lavished according to the bounty of the king. And drinking was according to the law, no one was compelled; for the king had given orders to all the officials of his palace to do as every man desired. Queen Vashti also gave a banquet for the women in the palace which belonged to King Ahasuerus.

On the seventh day, when the heart of the king was merry with wine, he commanded Mehuman, Biztha, Harbona, Bigtha and Abagtha, Zethar and Carkas, the seven eunuchs who served King Ahasuerus as chamberlains, to bring Queen Vashti before the king with her royal crown, in order to show the peoples and the princes her beauty; for she was fair to behold. But Queen Vashti refused to come at the king's command conveyed by the eunuchs. At this the king was enraged, and his anger burned within him.

Then the king said to the wise men who knew the times—for this was the king's procedure toward all who were versed in law and judgment, the men next to him being Carshena, Shethar, Admatha, Tarshish, Meres, Marsena, and Memucan, the seven princes of Persia and Media, who saw the king's face, and sat first in the kingdom—: "According to the law, what is to be done to Queen Vashti, because she has not performed the command of King Ahasuerus conveyed by the eunuchs?" Then Memucan said in presence of the king and the princes, "Not only to the king has Queen Vashti done wrong, but also to all the princes and all the peoples who are in all the provinces of King Ahasuerus. For this deed of the queen will be made known to all women, causing them to look with contempt upon their husbands, since they will say, 'King Ahasuerus commanded Queen Vashti to be brought before him, and she did not come.' This very day the ladies of Persia and Media who have heard of the queen's behaviour will be telling it to all the king's princes, and there will be contempt and wrath in plenty. If it please the king, let a royal order go forth from him, and let it be written among the laws of the Persians and the Medes so that it may not be altered, that Vashti is to come no more before King Ahasuerus; and let the king give her royal position to another who is better than she. So when the decree made by the king is proclaimed throughout all his kingdom, vast as it is, all women will give honour to their husbands, high and low."

So the king and Haman went in to feast with Queen Esther. And on the second day, as they were drinking wine, the king again said to Esther, "What is your petition, Queen Esther? It shall be granted you. And what is your request? Even to the half of my kingdom, it shall be fulfilled." Then Queen Esther answered, "If I have found favour in your sight, O king, and if it please the king, let my life be given me at my petition, and my people at my request. For we are sold, I and my people, to be destroyed, to be slain, and to be annihilated. If we had been sold merely as slaves, men and women, I would have held my peace; for our affliction is not to be compared with the loss to the king." Then King Ahasuerus said to Queen Esther, "Who is he, and where is he, that would presume to do this?" And Esther said, "A foe and enemy! This wicked Haman!" Then Haman was in terror before the king and the queen. And the king rose from the feast in wrath and went into the palace garden; but Haman stayed to beg his life from Queen Esther, for he saw that evil was determined against him by the king.

ESTHER
Chapter 7, Verses 1–7

Ernest Normand (1857–1923)
'Esther Denouncing Haman'

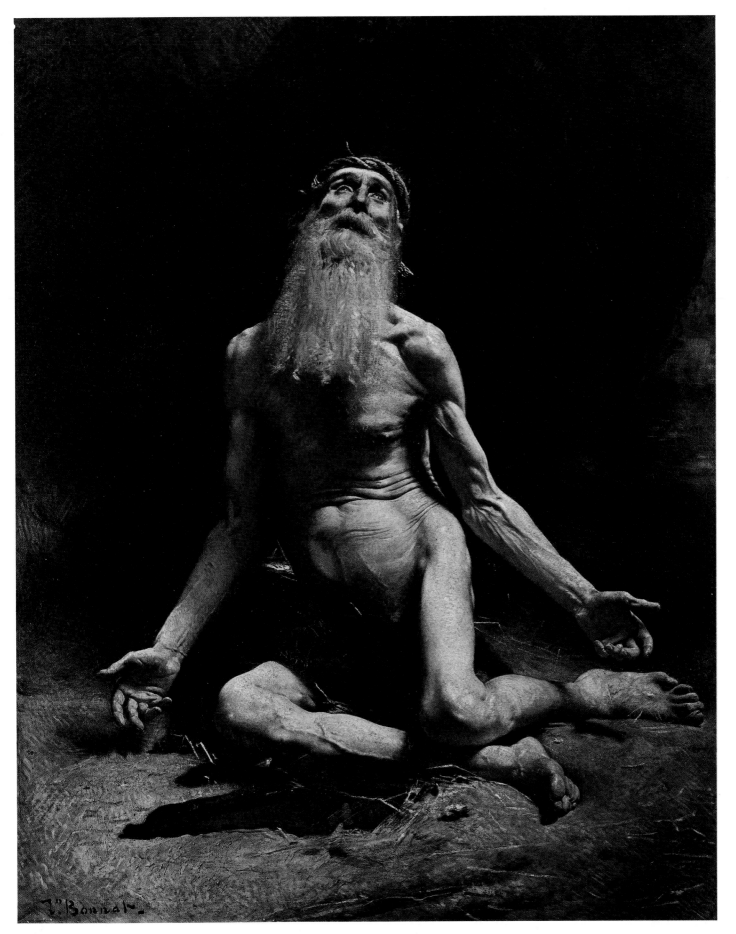

Léon Bonnat (1833–1922)
'Job'

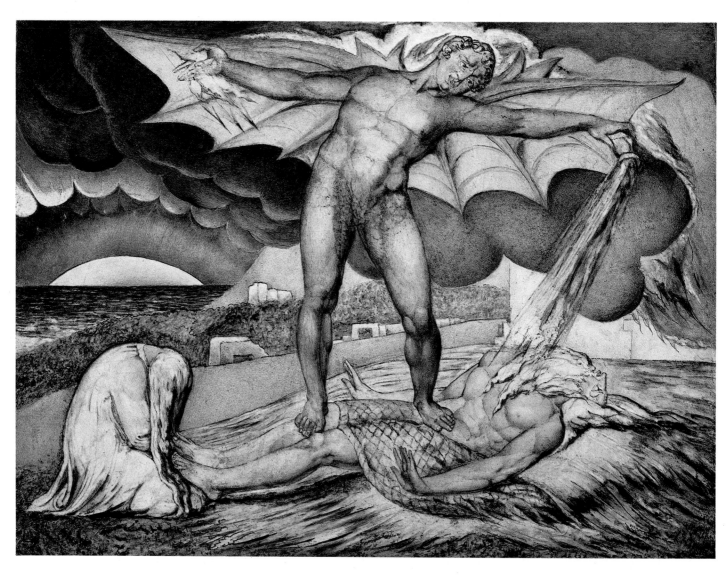

And the LORD said to Satan, "Have you considered my servant Job, that there is none like him on the earth, a blameless and upright man, who fears God and turns away from evil? He still holds fast his integrity, although you moved me against him, to destroy him without cause." Then Satan answered the LORD, "Skin for skin! All that a man has he will give for his life. But put forth thy hand now, and touch his bone and his flesh, and he will curse thee to thy face." And the LORD said to Satan, "Behold, he is in your power; only spare his life."

So Satan went forth from the presence of the LORD, and afflicted Job with loathsome sores from the sole of his foot to the crown of his head. And he took a potsherd with which to scrape himself, and sat among the ashes.

Then his wife said to him, "Do you still hold fast your integrity? Curse God, and die." But he said to her, "You speak as one of the foolish women would speak. Shall we receive good at the hand of God, and shall we not receive evil?" In all this Job did not sin with his lips.

William Blake (1757–1827)
'Satan Smiting Job with Sore Boils'

JOB
Chapter 2, Verses 3–10

Albrecht Dürer (1471–1528)
'Job and his Wife'

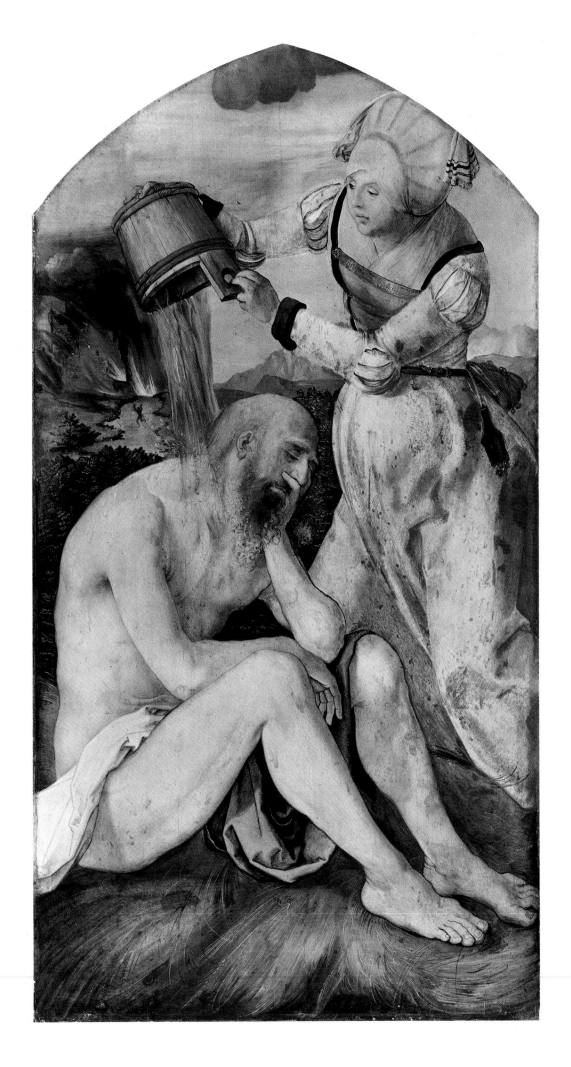

John Martin (1789–1854)
'Belshazzar's Feast'

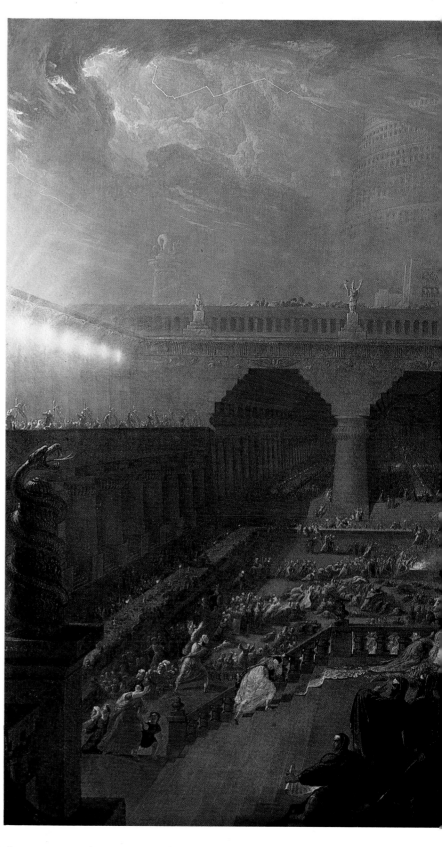

DANIEL
Chapter 5, Verses 1–7

King Belshazzar made a great feast for a thousand of his lords, and drank wine in front of the thousand.

Belshazzar, when he tasted the wine, commanded that the vessels of gold and of silver which Nebuchadnezzar his father had taken out of the temple in Jerusalem be brought, that the king and his lords, his wives, and his concubines might drink from them. Then they brought in the golden and silver vessels which had been taken out of the temple, the house of God in Jerusalem; and the king and

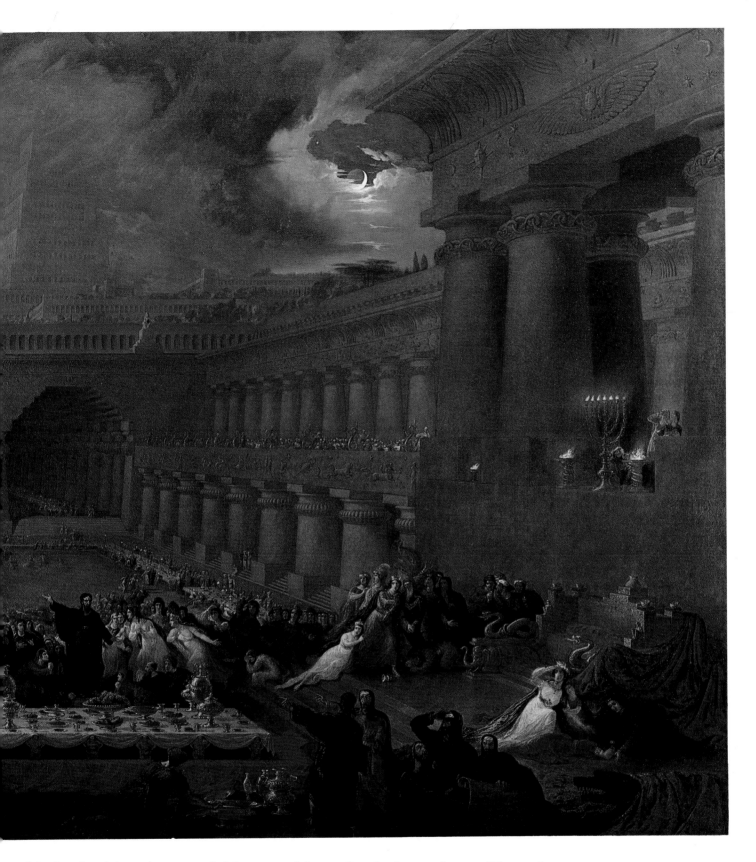

his lords, his wives, and his concubines drank from them. They drank wine, and praised the gods of gold and silver, bronze, iron, wood, and stone.

Immediately the fingers of a man's hand appeared and wrote on the plaster of the wall of the king's palace, opposite the lampstand; and the king saw the hand as it wrote. Then the king's colour changed, and his thoughts alarmed him; his limbs gave way, and his knees knocked together. The king cried aloud to bring in the

enchanters, the Chaldeans, and the astrologers. The king said to the wise men of Babylon, "Whoever reads this writing, and shows me its interpretation, shall be clothed with purple, and have a chain of gold about his neck and shall be the third ruler in the kingdom."

DANIEL Chapter 5, Verses 13–17

Then Daniel was brought in before the king. The king said to Daniel, "You are that Daniel, one of the exiles of Judah, whom the king my father brought from Judah. I have heard of you that the spirit of the holy gods is in you, and that light and understanding and excellent wisdom are found in you. Now the wise men, the enchanters, have been brought in before me to read this writing and make known to me its interpretation; but they could not show the interpretation of the matter. But I have heard that you can give interpretations and solve problems. Now if you can read the writing and make known to me its interpretation, you shall be clothed with purple, and have a chain of gold about your neck, and shall be the third ruler in the kingdom."

Then Daniel answered before the king, "Let your gifts be for yourself, and give your rewards to another; nevertheless I will read the writing to the king and make known to him the interpretation."

DANIEL Chapter 5, Verses 25–28

"And this is the writing that was inscribed: MENE, MENE, TEKEL, and PARSIN. This is the interpretation of the matter: MENE, God has numbered the days of your kingdom and brought it to an end; TEKEL, you have been weighed in the balances and found wanting; PERES, your kingdom is divided and given to the Medes and Persians."

DANIEL Chapter 6, Verses 10–13

When Daniel knew that the document had been signed, he went to his house where he had windows in his upper chamber open toward Jerusalem; and he got down upon his knees three times a day and prayed and gave thanks before his God, as he had done previously. Then these men came by agreement and found Daniel making petition and supplication before his God. Then they came near and said before the king, concerning the interdict, "O king! Did you not sign an interdict, that any man who makes petition to any god or man within thirty days except to you, O king, shall be cast into the den of lions?" The king answered, "The thing stands fast, according to the law of the Medes and Persians, which cannot be revoked." Then they answered before the king, "That Daniel, who is one of the exiles from Judah, pays no heed to you, O king,

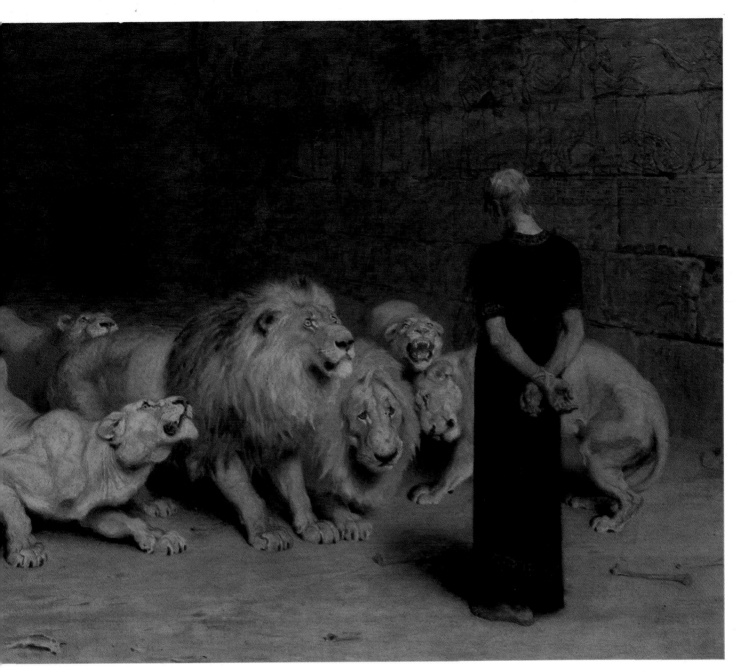

or the interdict you have signed, but makes his petition three times a day."

Then the king, when he heard these words, was much distressed, and set his mind to deliver Daniel; and he laboured till the sun went down to rescue him. Then these men came by agreement to the king, and said to the king, "Know, O king, that it is a law of the Medes and Persians that no interdict or ordinance which the king establishes can be changed."

Then the king commanded, and Daniel was brought and cast into the den of lions. The king said to Daniel, "May your God, whom you serve continually, deliver you!" And a stone was brought and laid upon the mouth of the den, and the king sealed it with his own signet and with the signet of his lords, that nothing might be changed concerning Daniel. Then the king went to his palace, and spent the night fasting; no diversions were brought to him, and sleep fled from him.

Briton Riviere (1840–1920)
'Daniel in the Lions' Den'

DANIEL
Chapter 6, Verses 13–18

DANIEL Chapter 6, Verses 19–24

Then, at break of day, the king arose and went in haste to the den of lions. When he came near to the den where Daniel was, he cried out in a tone of anguish and said to Daniel, "O Daniel, servant of the living God, has your God, whom you serve continually, been able to deliver you from the lions?" Then Daniel said to the king, "O king, live for ever! My God sent his angel and shut the lions' mouths, and they have not hurt me, because I was found blameless before him; and also before you, O king, I have done no wrong." Then the king was exceedingly glad, and commanded that Daniel be taken up out of the den. So Daniel was taken up out of the den, and no kind of hurt was found upon him, because he had trusted in his God. And the king commanded, and those men who had accused Daniel were brought and cast into the den of lions—they, their children, and their wives; and before they reached the bottom of the den the lions overpowered them and broke all their bones in pieces.

JONAH Chapter 1, Verses 7–17

And they said to one another, "Come, let us cast lots, that we may know on whose account this evil has come upon us." So they cast lots, and the lot fell upon Jonah. Then they said to him, "Tell us, on whose account this evil has come upon us? What is your occupation? And whence do you come? What is your country? And of what people are you?" And he said to them, "I am a Hebrew; and I fear the LORD, the God of heaven, who made the sea and the dry land." Then the men were exceedingly afraid, and said to him, "What is this that you have done!" For the men knew that he was fleeing from the presence of the LORD, because he had told them.

Then they said to him, "What shall we do to you, that the sea may quiet down for us?" For the sea grew more and more tempestuous. He said to them, "Take me up and throw me into the sea; then the sea will quiet down for you; for I know it is because of me that this great tempest has come upon you." Nevertheless the men rowed hard to bring the ship back to land, but they could not, for the sea grew more and more tempestuous against them. Therefore they cried to the LORD, "We beseech thee, O LORD, let us not perish for this man's life, and lay not on us innocent blood; for thou, O LORD, hast done as it pleased thee." So they took up Jonah and threw him into the sea; and the sea ceased from its raging. Then the men feared the LORD exceedingly, and they offered a sacrifice to the LORD and made vows.

And the LORD appointed a great fish to swallow up Jonah; and Jonah was in the belly of the fish three days and three nights.

Gaspard Dughet (1615–75)
'Jonah Being Thrown Overboard'

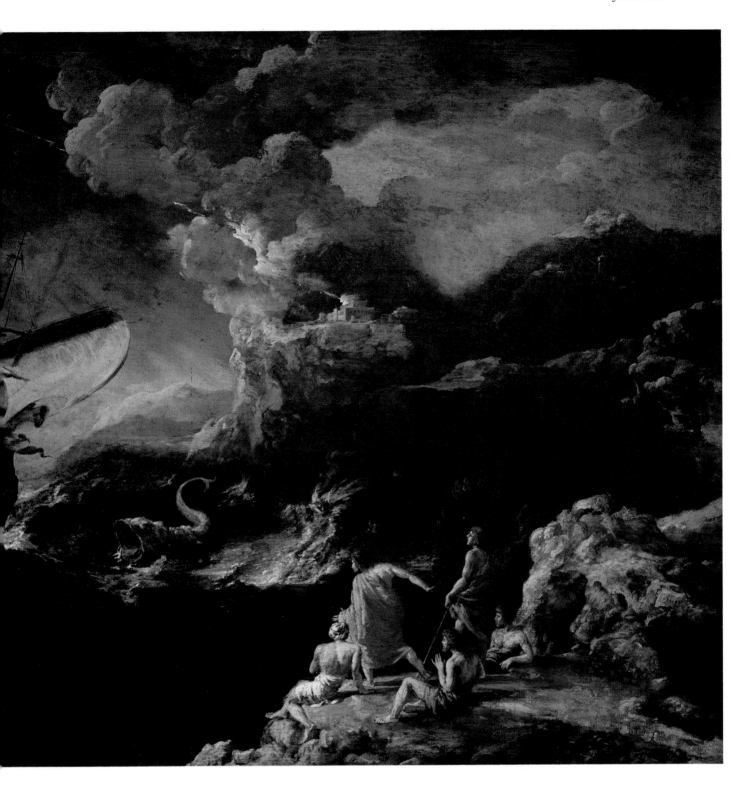

JONAH
Chapter 2, Verses 1–5

Then Jonah prayed to the LORD his God from the belly of the fish, saying,
"I called to the LORD, out of my distress, and he answered me;
out of the belly of Sheol I cried, and thou didst hear my voice.
For thou didst cast me into the deep,
into the heart of the seas,
and the flood was round about me;
all thy waves and thy billows passed over me.
Then I said, 'I am cast out from thy presence;
How shall I again look upon thy holy temple?'
The waters closed in over me, the deep was round about me;

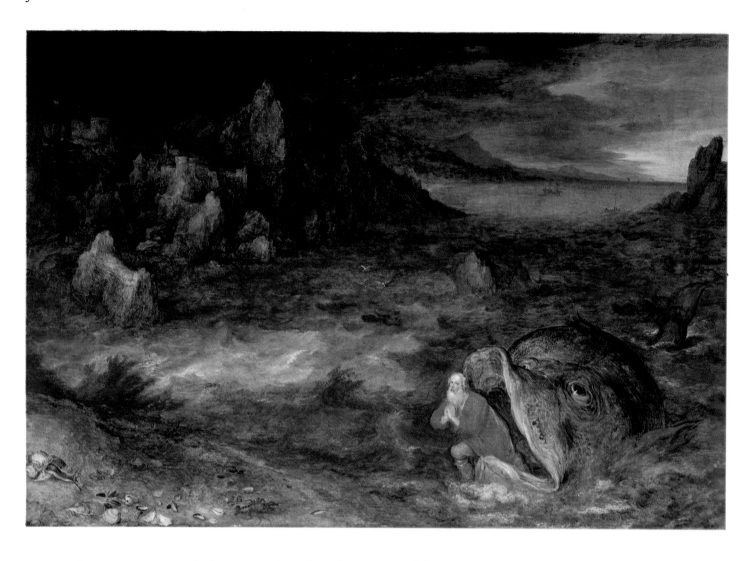

weeds were wrapped about my head at the roots of the
 mountains.
I went down to the land whose bars closed upon me for ever;
yet thou didst bring up my life from the Pit,
O LORD my God.
When my soul fainted within me, I remembered the LORD;
and my prayer came to thee, into thy holy temple.
Those who pay regard to vain idols forsake their true loyalty.
But I with the voice of thanksgiving will sacrifice to thee;
what I have vowed I will pay. Deliverance belongs to the LORD!''
And the LORD spoke to the fish, and it vomited out Jonah upon the
dry land.

Jan Bruegel the Elder
(1568–1625)
'Jonah Leaving the Whale'

JONAH
Chapter 2, Verses 5–10

The Apocrypha

Adam Elsheimer (1578–1610)
'Tobias and the Angel'

TOBIT
Chapter 6, Verses 1–4

TOBIT
Chapter 12, Verses 16–22

Now as they proceeded on their way they came at evening to the Tigris river and camped there. Then the young man went down to wash himself. A fish leaped up from the river and would have swallowed the young man; and the angel said to him, "Catch the fish." So the young man seized the fish and threw it up on the land. Then the angel said to him, "Cut open the fish and take the heart and liver and gall and put them away safely."

They were both alarmed; and they fell upon their faces, for they were afraid. But he said to them, "Do not be afraid; you will be safe. But praise God for ever. For I did not come as a favour on my part, but by the will of our God. Therefore praise him for ever. All these days I merely appeared to you and did not eat or drink, but you were seeing a vision. And now give thanks to God, for I am ascending to him who sent me. Write in a book everything that has happened." Then they stood up; but they saw him no more. So they confessed the great and wonderful works of God, and acknowledged that the angel of the Lord had appeared to them.

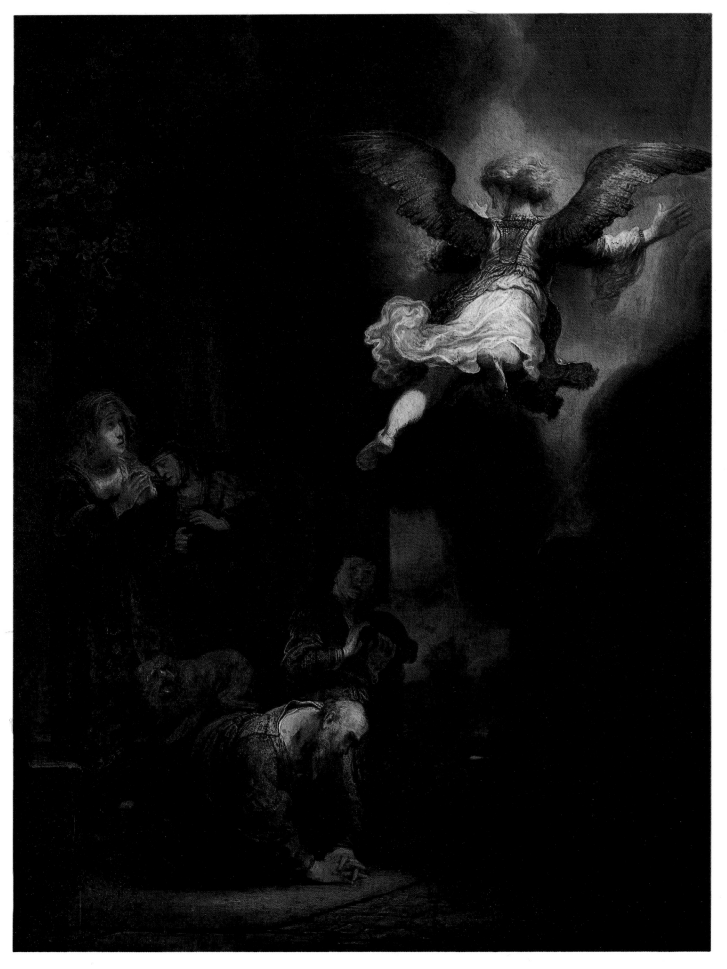

Rembrandt (1606–1669)
'The Angel Leaving the Family
of Tobit'

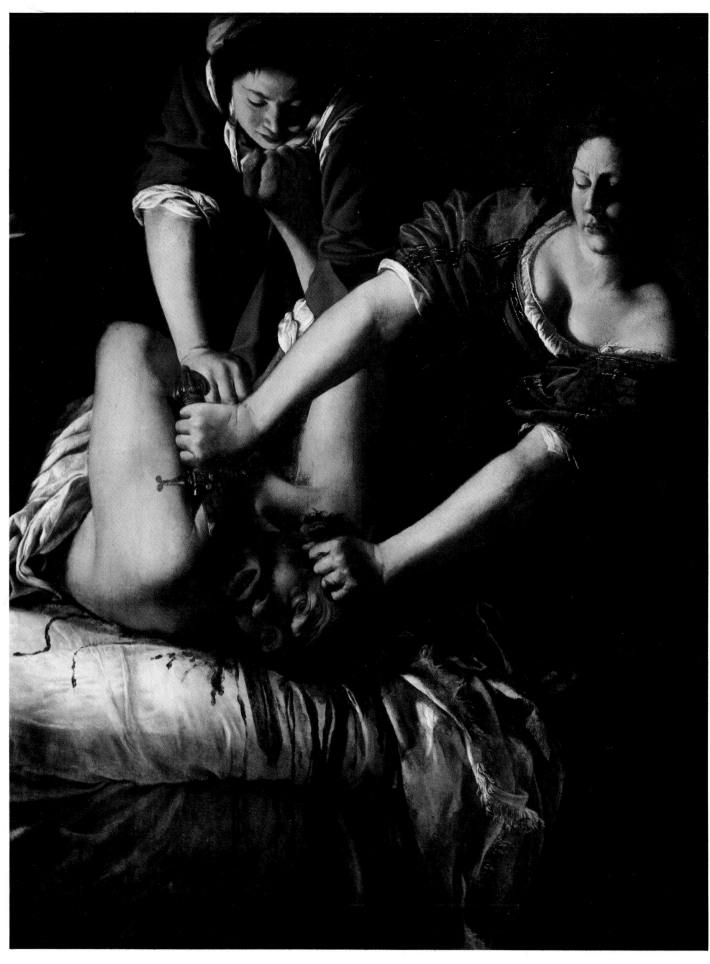

Artemisia Gentileschi
(1593–1652/3)
'Judith and Holofernes'

Then Judith came in and lay down, and Holofernes' heart was ravished with her and he was moved with great desire to possess her; for he had been waiting for an opportunity to deceive her, ever since the day he first saw her. So Holofernes said to her, "Drink now, and be merry with us!" Judith said, "I will drink now, my lord, because my life means more to me today than in all the days since I was born." Then she took and ate and drank before him what her maid had prepared. And Holofernes was greatly pleased with her, and drank a great quantity of wine, much more than he had ever drunk in any one day since he was born.

JUDITH
Chapter 12, Verses 16–20

When evening came, his slaves quickly withdrew, and Bagoas closed the tent from outside and shut out the attendants from his master's presence; and they went to bed, for they all were weary because the banquet had lasted long. So Judith was left alone in the tent, with Holofernes stretched out on his bed, for he was overcome with wine.

Now Judith had told her maid to stand outside the bedchamber and to wait for her to come out, as she did every day; for she said she would be going out for her prayers. And she had said the same thing to Bagoas. So every one went out, and no one, either small or great, was left in the bedchamber. Then Judith, standing beside his bed, said in her heart, "O Lord God of all might, look in this hour upon the work of my hands for the exaltation of Jerusalem. For now is the time to help thy inheritance, and to carry out my undertaking for the destruction of the enemies who have risen up against us."

She went up to the post at the end of the bed, above Holofernes' head, and took down his sword that hung there. She came close to his bed and took hold of the hair of his head, and said, "Give me strength this day, O Lord of Israel!" And she struck his neck twice with all her might, and severed his head from his body. Then she tumbled his body off the bed and pulled down the canopy from the posts; after a moment she went out, and gave Holofernes' head to her maid, who placed it in her food bag.

JUDITH
Chapter 13, Verses 1–10

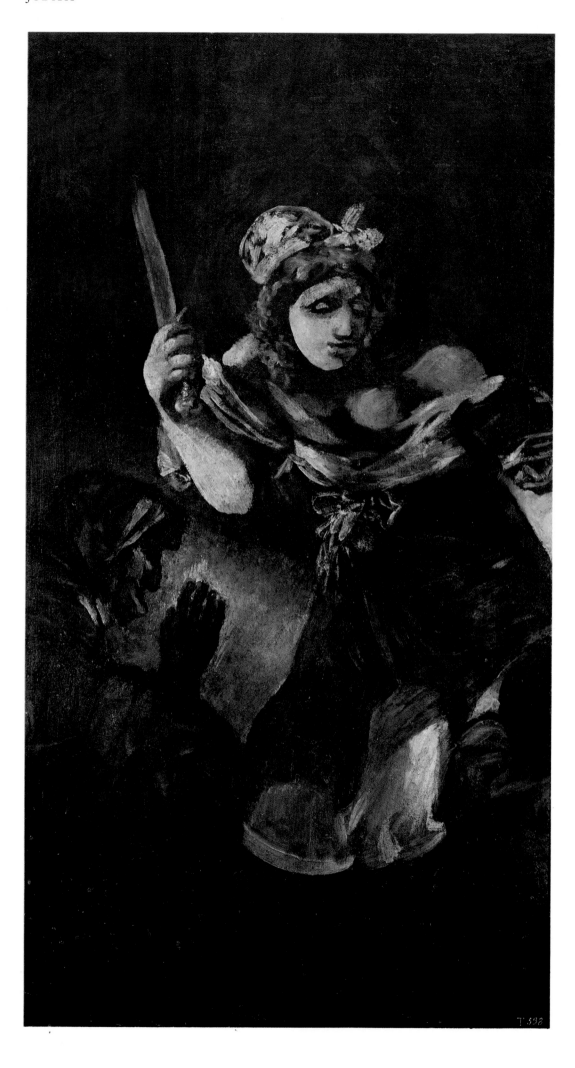

Lucas Cranach the Elder
(1472–1553)
Right 'Judith'

Francisco de Goya
(1746–1828)
Left 'Judith and Holofernes'

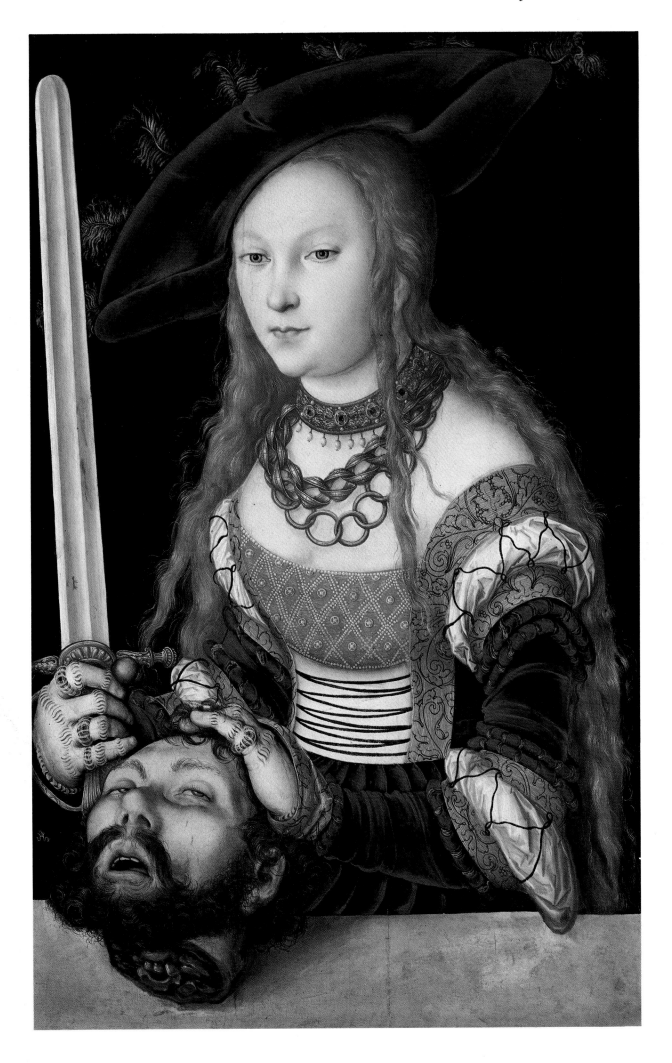

There was a man living in Babylon whose name was Joakim. And he took a wife named Susanna, the daugher of Hilkiah, a very beautiful woman and one who feared the Lord. Her parents were righteous, and had taught their daughter according to the law of Moses. Joakim was very rich, and had a spacious garden adjoining his house; and the Jews used to come to him because he was the most honoured of them all.

In that year two elders from the people were appointed as judges. Concerning them the Lord had said: "Iniquity came forth from Babylon, from elders who were judges, who were supposed to govern the people." These men were frequently at Joakim's house, and all who had suits at law came to them.

When the people departed at noon, Susanna would go into her husband's garden to walk. The two elders used to see her every day, going in and walking about, and they began to desire her. And they perverted their minds and turned their eyes from looking to Heaven or remembering righteous judgments. Both were overwhelmed with passion for her, but they did not tell each other of their distress, for they were ashamed to disclose their lustful desire to possess her. And they watched eagerly, day after day, to see her.

They said to each other, "Let us go home, for it is mealtime." And when they went out, they parted from each other. But turning back, they met again; and when each pressed the other for the reason, they confessed their lust. And then together they arranged for a time when they could find her alone.

Once, while they were watching for an opportune day, she went in as before with only two maids, and wished to bathe in the garden, for it was very hot. And no one was there except the two elders, who had hid themselves and were watching her. She said to her maids, "Bring me oil and ointments, and shut the garden doors so that I may bathe." They did as she said, shut the garden doors, and went out by the side doors to bring what they had been commanded; and they did not see the elders, because they were hidden.

When the maids had gone out, the two elders rose and ran to her, and said: "Look, the garden doors are shut, no one sees us, and we are in love with you; so give your consent, and lie with us. If you refuse, we will testify against you that a young man was with you, and this was why you sent your maids away."

Susanna sighed deeply, and said, "I am hemmed in on every side. For if I do this thing, it is death for me; and if I do not, I shall not escape your hands. I choose not to do it and to fall into your hands, rather than to sin in the sight of the Lord."

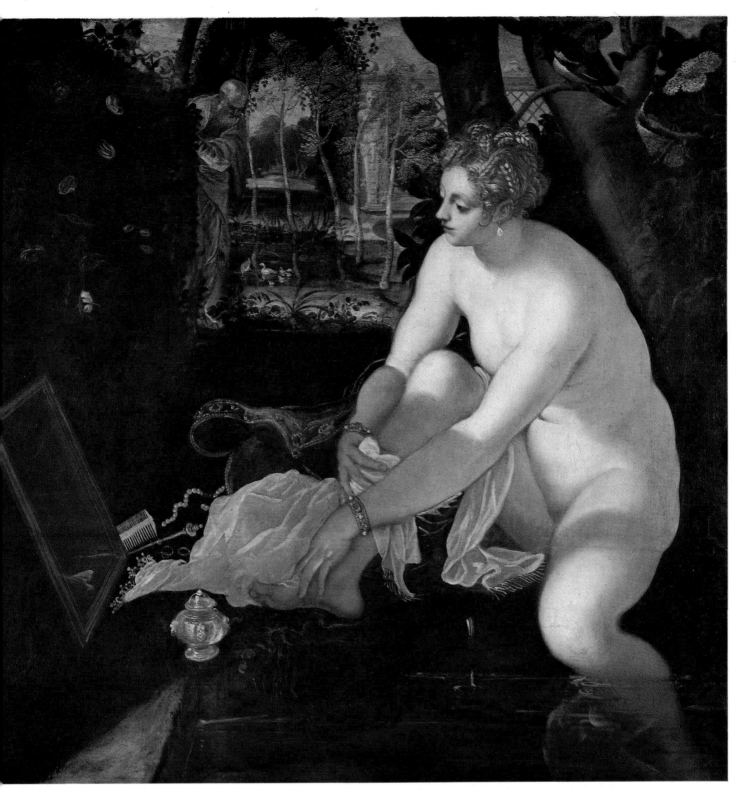

Tintoretto (1518–1594)
'Susanna and the Elders'

SUSANNA Verses 42–59

Then Susanna cried out with a loud voice, and said, "O eternal God, who dost discern what is secret, who art aware of all things before they come to be, thou knowest that these men have borne false witness against me. And now I am to die! Yet I have done none of the things that they have wickedly invented against me!"

The Lord heard her cry. And as she was being led away to be put to death, God aroused the holy spirit of a young lad named Daniel; and he cried with a loud voice, "I am innocent of the blood of this woman."

All the people turned to him, and said, "What is this that you have said?" Taking his stand in the midst of them, he said, "Are you such fools, you sons of Israel? Have you condemned a daughter of Israel without examination and without learning the facts? Return to the place of judgment. For these men have borne false witness against her."

Then all the people returned in haste. And the elders said to him, "Come, sit among us and inform us, for God has given you that right." And Daniel said to them, "Separate them far from each other, and I will examine them."

When they were separated from each other, he summoned one of them and said to him, "You old relic of wicked days, your sins have now come home, which you have committed in the past, pronouncing unjust judgments, condemning the innocent and letting the guilty go free, though the Lord said, 'Do not put to death an innocent and righteous person.' Now then, if you really saw her, tell me this: Under what tree did you see them being intimate with each other?" He answered, "Under a mastic tree." And Daniel said, "Very well! You have lied against your own head, for the angel of God has received the sentence from God and will immediately cut you in two."

Then he put him aside, and commanded them to bring the other. And he said to him, "You offspring of Canaan and not of Judah, beauty has deceived you and lust has perverted your heart. This is how you both have been dealing with the daughters of Israel, and they were intimate with you through fear; but a daughter of Judah would not endure your wickedness. Now then, tell me: Under what tree did you catch them being intimate with each other?" He answered, "Under an evergreen oak." And Daniel said to him, "Very well! You also have lied against your own head, for the angel of God is waiting with his sword to saw you in two, that he may destroy you both."

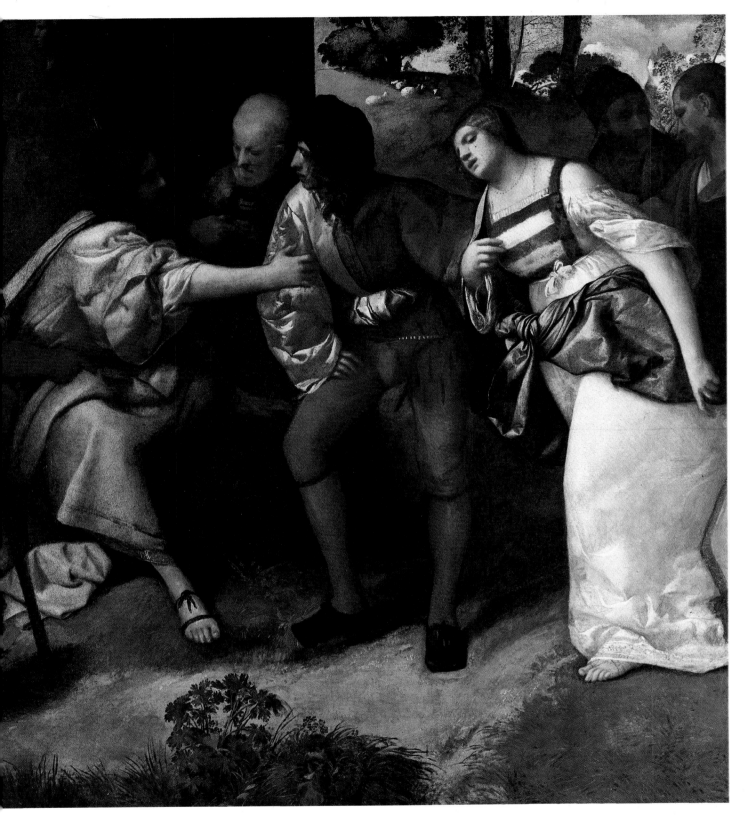

Giorgione (Giorgio da Castelfranco)
(1477/8–1510)
'Susanna and the Young Daniel'
(Traditionally 'The Adulteress Before Christ')

Artemisia Gentileschi
(1593–1652/3)
Overleaf 'Susanna and the Elders'

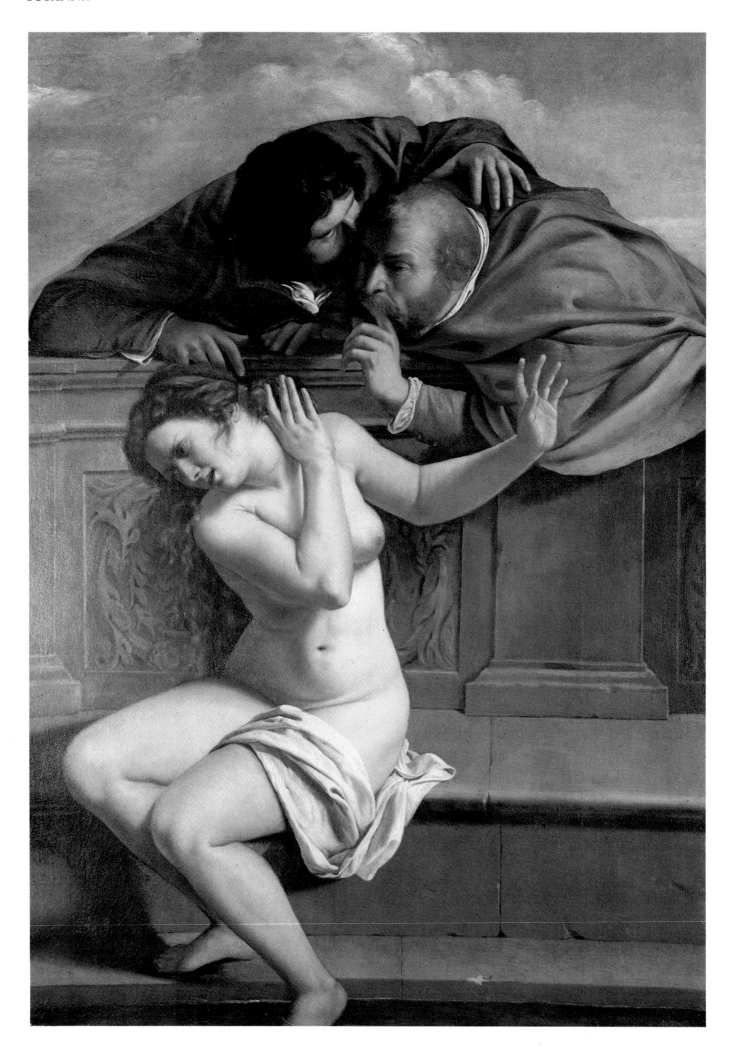

The New Testament

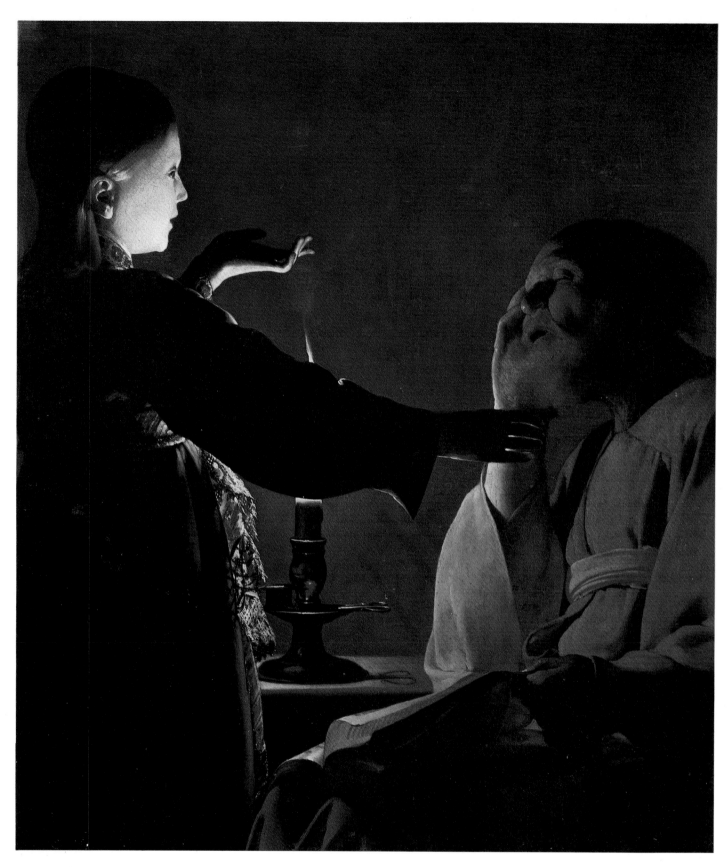

Georges de La Tour
(1593–1652)
'The Dream of Joseph'

Now the birth of Jesus Christ took place in this way. When his mother Mary had been betrothed to Joseph, before they came together she was found to be with child of the Holy Spirit; and her husband Joseph, being a just man and unwilling to put her to shame, resolved to divorce her quietly. But as he considered this, behold, an angel of the Lord appeared to him in a dream, saying, "Joseph, son of David, do not fear to take Mary your wife, for that which is conceived in her is of the Holy Spirit; she will bear a son, and you shall call his name Jesus, for he will save his people from their sins." All this took place to fulfil what the Lord had spoken by the prophet:

"Behold, a virgin shall conceive and bear a son,
and his name shall be called Emmanuel"

(which means, God with us). When Joseph woke from sleep, he did as the angel of the Lord commanded him; he took his wife, but knew her not until she had borne a son; and he called his name Jesus.

MATTHEW
Chapter 1, Verses 18–25

LUKE Chapter 1, Verses 26–38

In the sixth month the angel Gabriel was sent from God to a city of Galilee named Nazareth, to a virgin betrothed to a man whose name was Joseph, of the house of David; and the virgin's name was Mary. And he came to her and said, "Hail, O favoured one, the Lord is with you!" But she was greatly troubled at the saying, and considered in her mind what sort of greeting this might be. And the angel said to her, "Do not be afraid, Mary, for you have found favour with God. And behold, you will conceive in your womb and bear a son, and you shall call his name Jesus.

He will be great, and will be called the Son of the Most High;
and the Lord God will give to him the throne of his father David,
and he will reign over the house of Jacob for ever;
and of his kingdom there will be no end."

And Mary said to the angel, "How shall this be, since I have no husband?" And the angel said to her,

"The Holy Spirit will come upon you,
and the power of the Most High will overshadow you;
therefore the child to be born will be called holy,
the Son of God.

And behold, your kinswoman Elizabeth in her old age has also conceived a son; and this is the sixth month with her who was called barren. For with God nothing will be impossible." And Mary said, "Behold, I am the handmaid of the Lord; let it be to me according to your word." And the angel departed from her.

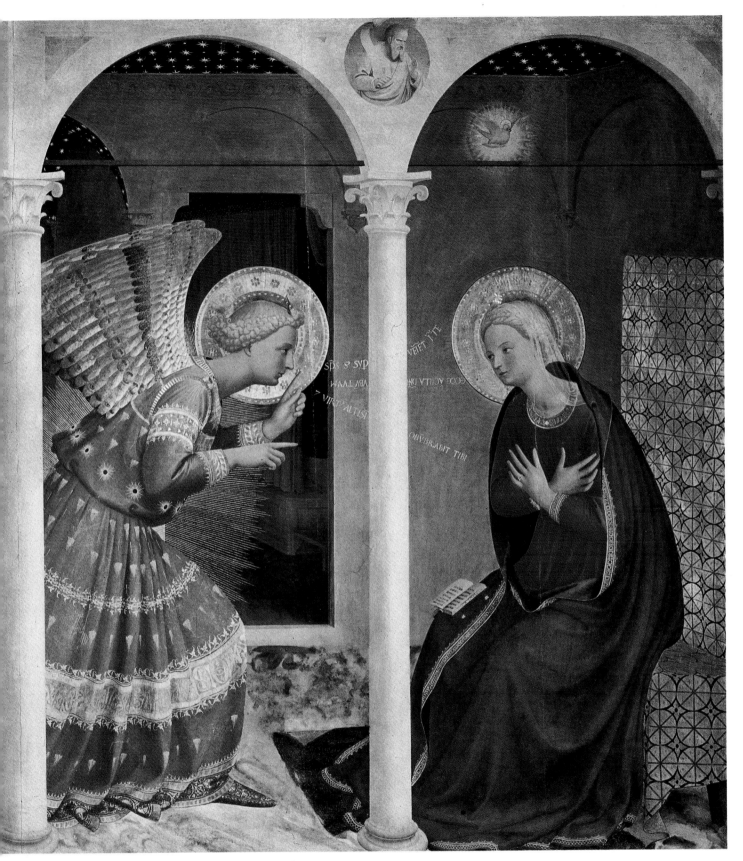

Fra Angelico (*c.*1400–1455)
'The Annunciation'

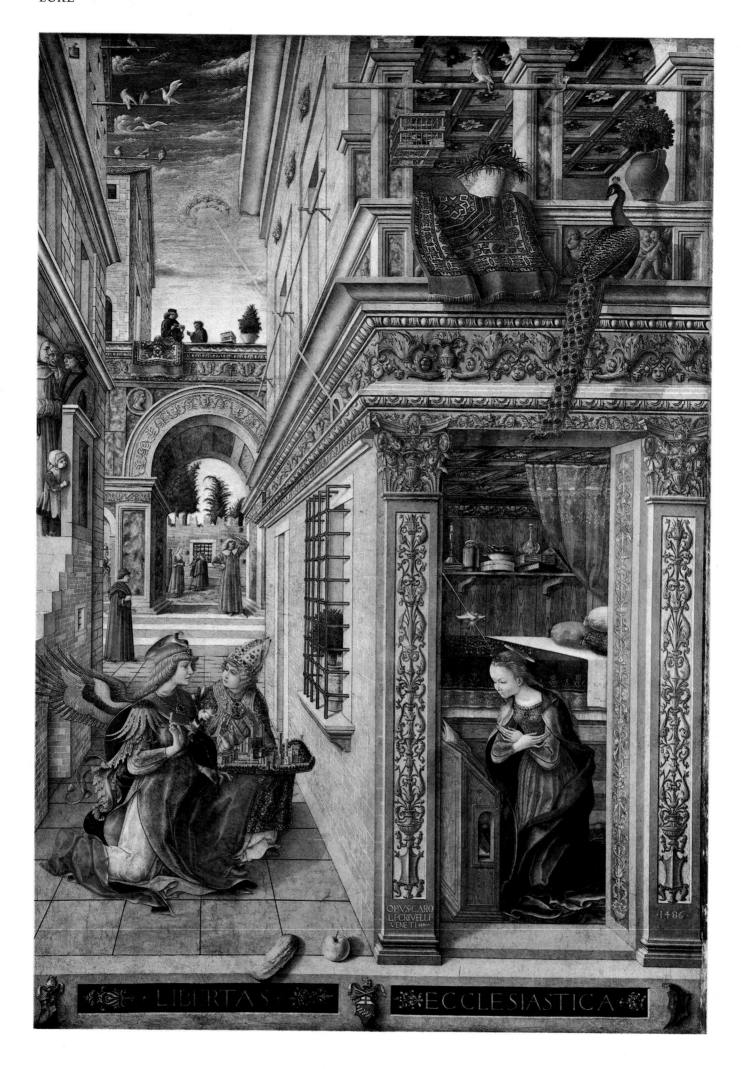

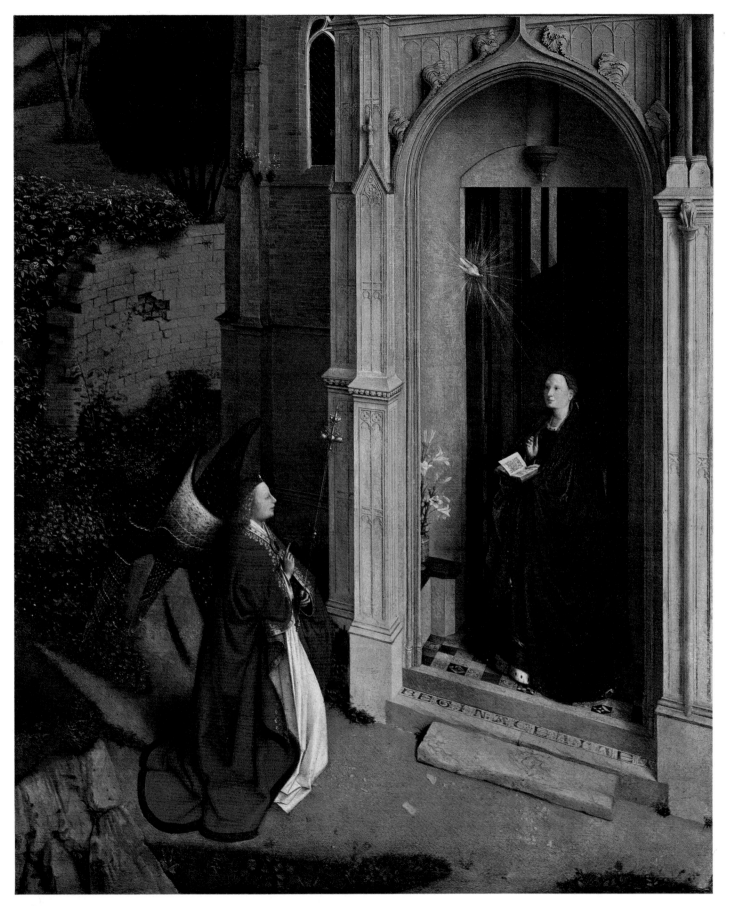

Hubert Van Eyck (attr.),
(d.1426)
Above 'The Annunciation'

Carlo Crivelli
(active 1457–1493)
Left 'The Annunciation'

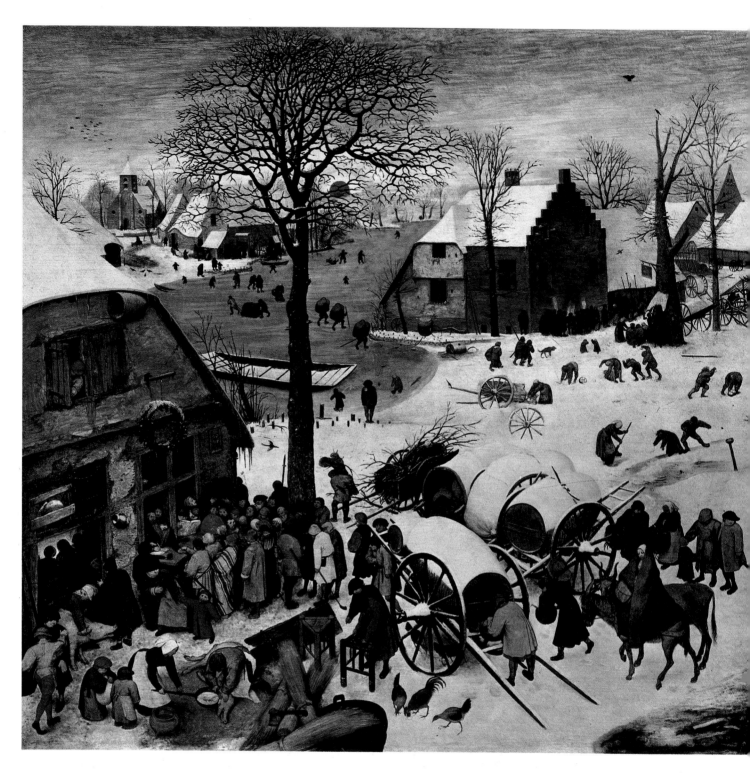

LUKE
Chapter 2, Verses 1–7

In those days a decree went out from Caesar Augustus that all the world should be enrolled. This was the first enrolment, when Quirinius was governor of Syria. And all went to be enrolled, each to his own city. And Joseph also went up from Galilee, from the city of Nazareth, to Judea, to the city of David, which is called Bethlehem, because he was of the house and lineage of David, to be enrolled with Mary, his betrothed, who was with child. And while they were there, the time came for her to be delivered. And she gave birth to her first-born son and wrapped him in swaddling cloths, and laid him in a manger, because there was no place for them in the inn.

Pieter Bruegel the Elder
(*c*.1525–1569)
'The Numbering at Bethlehem'

Jan Massys (or Metsys)
(1509–1575)
'Hospitality Refused to the
Virgin Mary and Joseph'

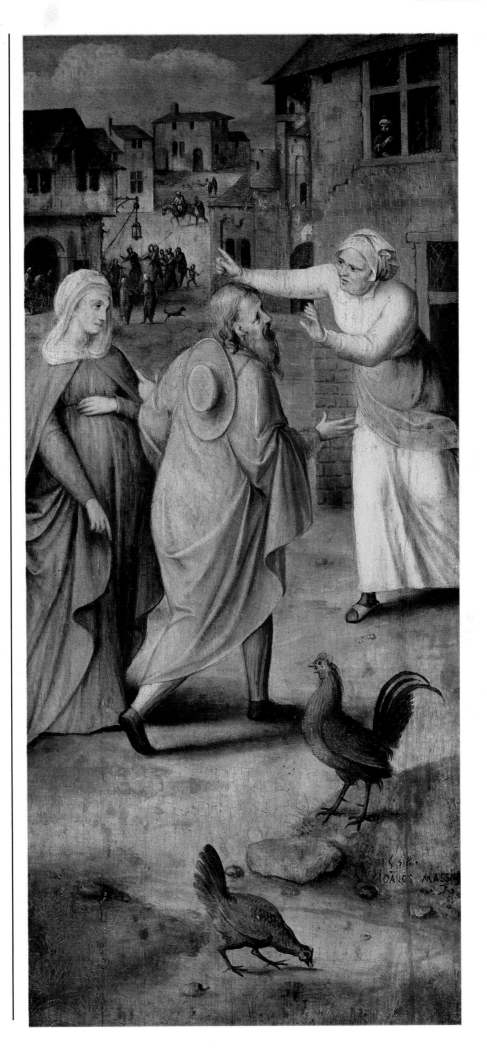

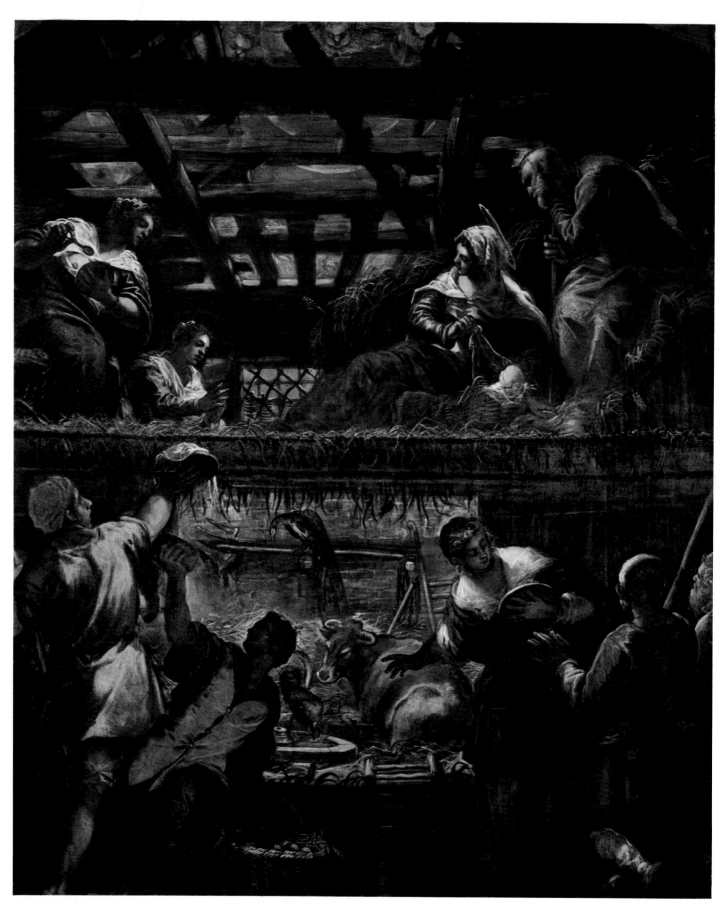

Tintoretto (1518–1594)
'The Nativity'

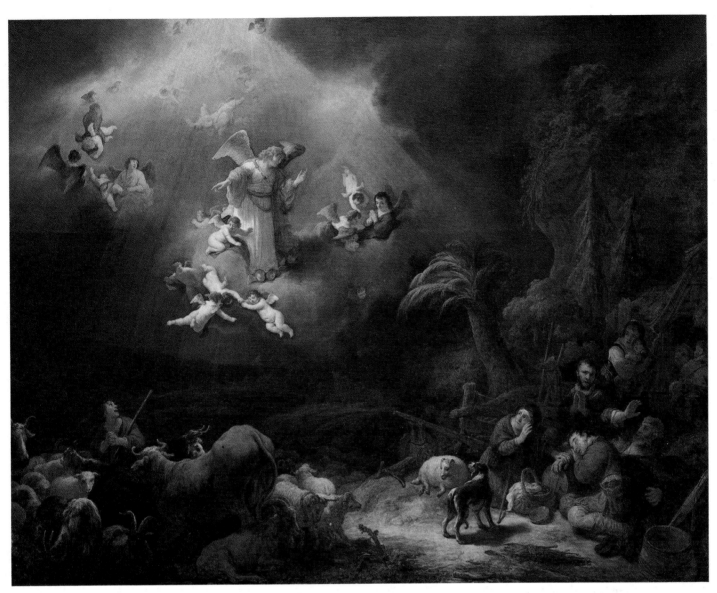

And in that region there were shepherds out in the field, keeping watch over their flock by night. And an angel of the Lord appeared to them, and the glory of the Lord shone around them, and they were filled with fear. And the angel said to them, "Be not afraid; for behold, I bring you good news of a great joy which will come to all the people; for to you is born this day in the city of David a Saviour, who is Christ the Lord. And this will be a sign for you: you will find a babe wrapped in swaddling cloths and lying in a manger." And suddenly there was with the angel a multitude of the heavenly host praising God and saying,

"Glory to God in the highest,
and on earth peace among men with whom he is pleased!"

When the angels went away from them into heaven, the shepherds said to one another, "Let us go over to Bethlehem and see this thing that has happened, which the Lord has made known to us." And they went with haste, and found Mary and Joseph, and the babe lying in a manger.

Govaert Flinck (1615–1660)
'The Angel Announcing the Birth of Jesus to the Shepherds'

LUKE
Chapter 2, Verses 8–16

Pieter Bruegel the Elder
(*c*.1525–1569).
Page 146 'The Adoration of the Magi'

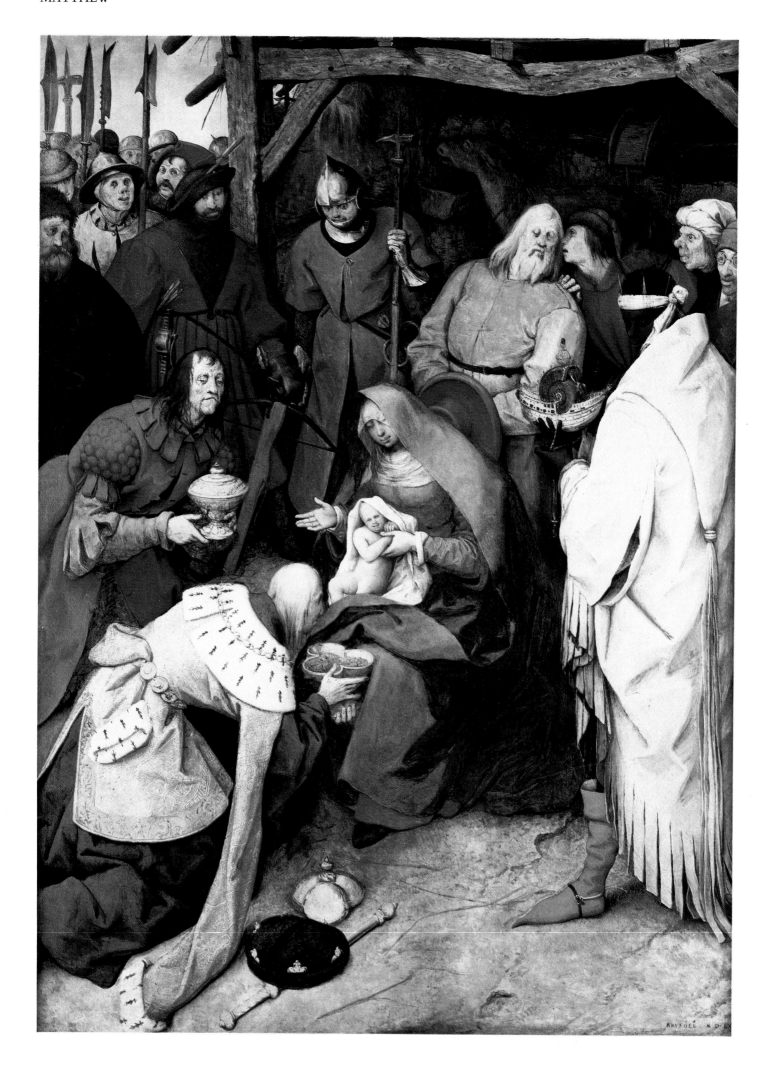

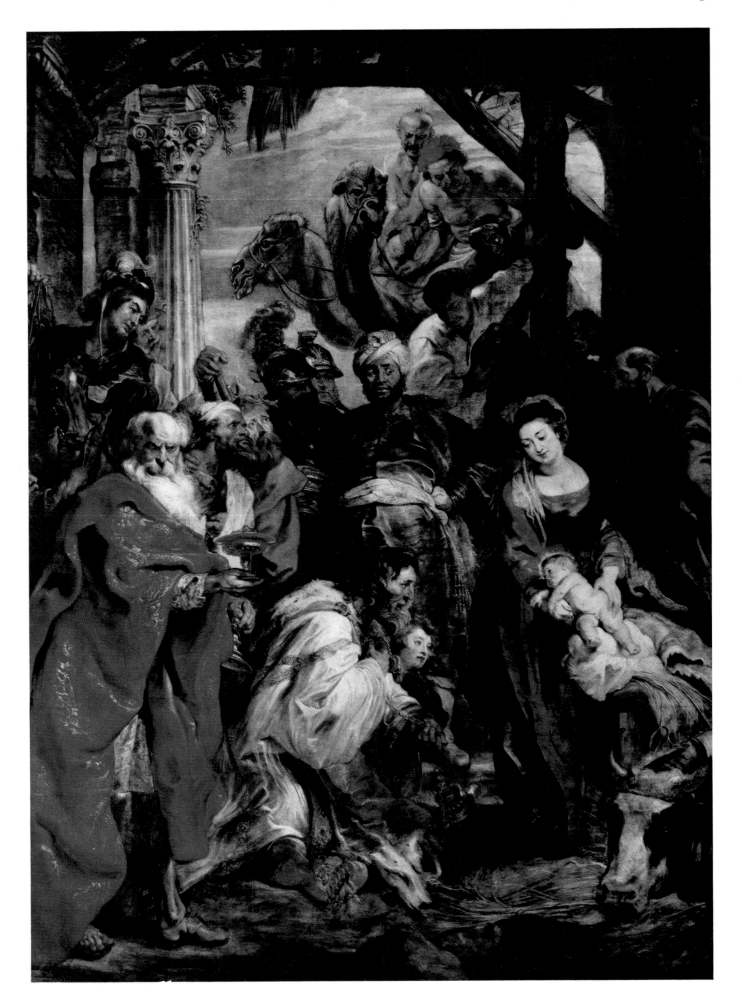

Januarius Zick (1730–1797)
'The Adoration of the Magi'

Rubens (1577–1640)
Page 147 'The Adoration of the
Magi'

MATTHEW
Chapter 2, Verses 1–12

Now when Jesus was born in Bethlehem of Judea in the days of Herod the king, behold, wise men from the East came to Jerusalem, saying, "Where is he who has been born king of the Jews? For we have seen his star in the East, and have come to worship him." When Herod the king heard this, he was troubled, and all Jerusalem with him; and assembling all the chief priests and scribes of the people, he inquired of them where the Christ was to be born. They told him, "In Bethlehem of Judea; for so it is written by the prophet:

'And you, O Bethlehem, in the land of Judah,
are by no means least among the rulers of Judah;
for from you shall come a ruler
who will govern my people Israel.'"

Then Herod summoned the wise men secretly and ascertained from them what time the star appeared; and he sent them to Bethlehem, saying, "Go and search diligently for the child, and when you have found him bring me word, that I too may come and worship him." When they had heard the king they went their way; and lo, the star which they had seen in the East went before them, till it came to rest over the place where the child was. When they saw the star, they rejoiced exceedingly with great joy; and going into the house they saw the child with Mary his mother, and they fell down and worshipped him. Then, opening their treasures, they offered him gifts, gold and frankincense and myrrh. And being

Adam Elsheimer (1578–1610)
'The Flight into Egypt'

MATTHEW
Chapter 2, Verses 12–18

warned in a dream not to return to Herod, they departed to their own country by another way.

Now when they had departed, behold, an angel of the Lord appeared to Joseph in a dream and said, "Rise, take the child and his mother, and flee to Egypt, and remain there till I tell you; for Herod is about to search for the child, to destroy him." And he rose and took the child and his mother by night, and departed to Egypt, and remained there until the death of Herod. This was to fulfil what the Lord had spoken by the prophet, "Out of Egypt have I called my son."

Then Herod, when he saw that he had been tricked by the wise men, was in a furious rage, and he sent and killed all the male children in Bethlehem and in all that region who were two years old or under, according to the time which he had ascertained from the wise men. Then was fulfilled what was spoken by the prophet Jeremiah:

"A voice was heard in Ramah,
wailing and loud lamentation,
Rachel weeping for her children;
she refused to be consoled,
because they were no more."

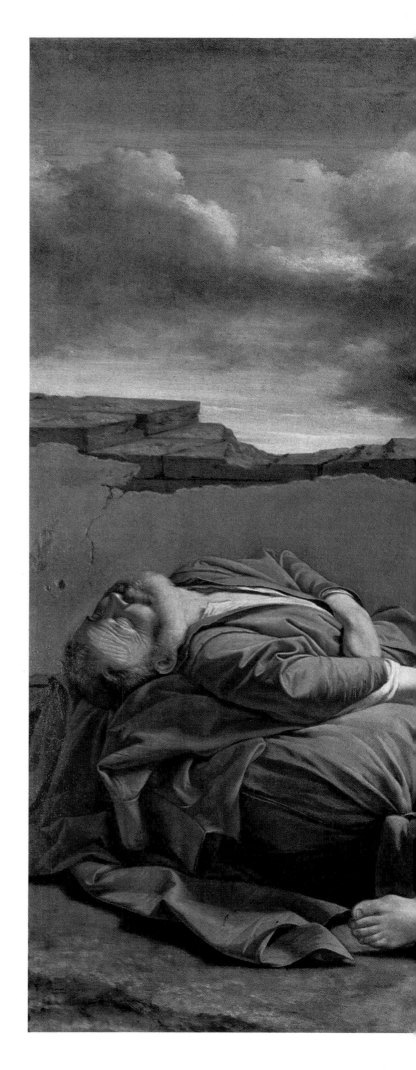

Orazio Gentileschi
(1563–1639)
'The Rest on the Flight into
Egypt'

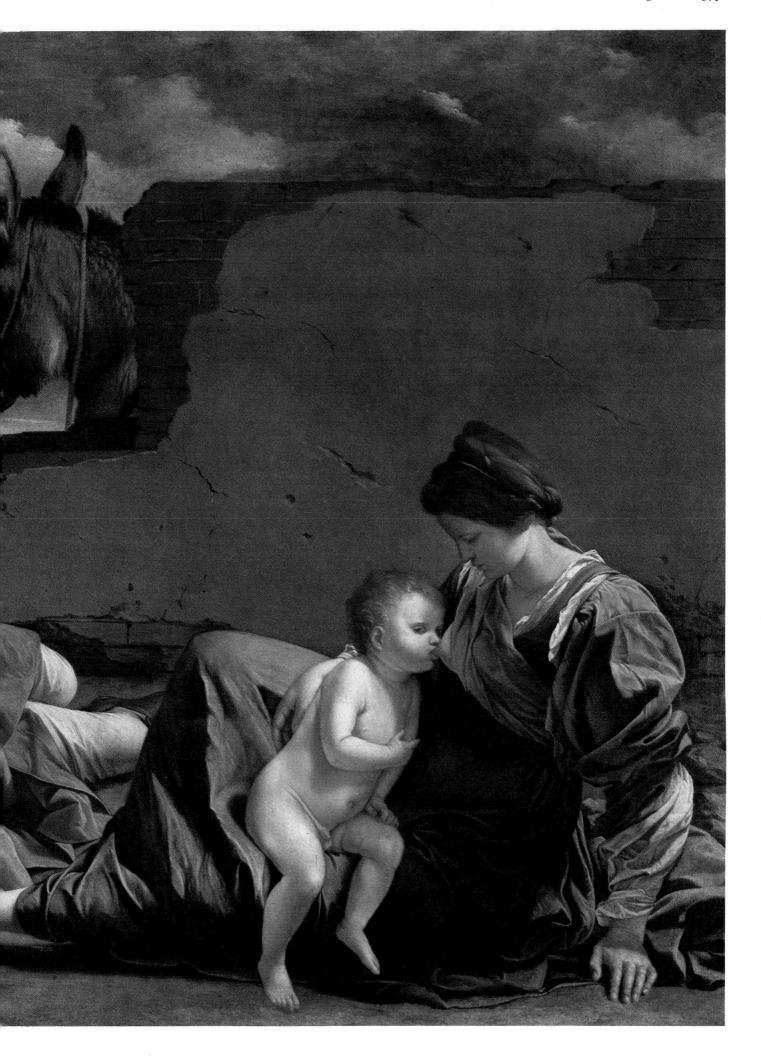

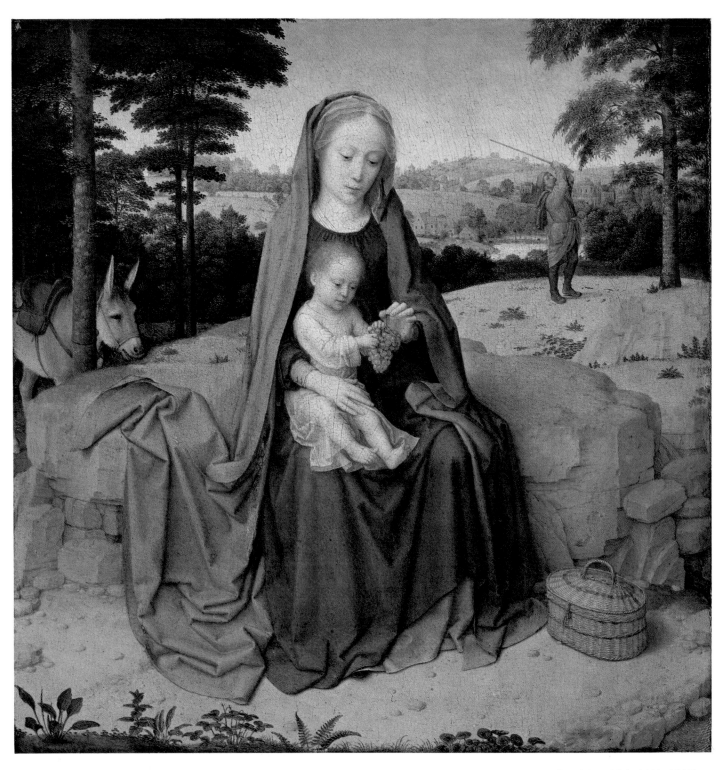

Gérard David (*c.*1460–1523)
'The Flight into Egypt'

**The Master of Schloss
Lichtenstein**
(active Austria, *c.*1525–1550)
'The Massacre of the Innocents'

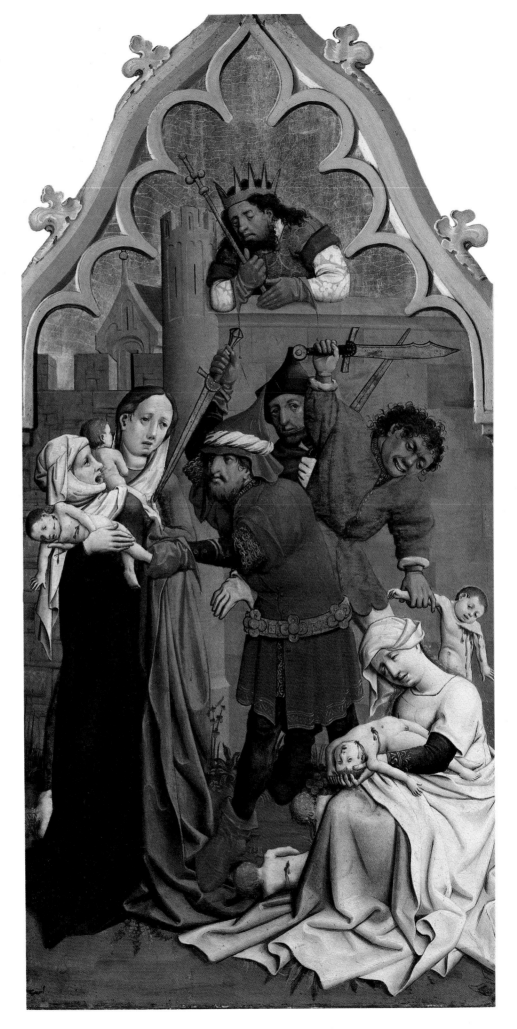

Studio of Giovanni Bellini
(*c*. late fourteenth century)
'The Circumcision'

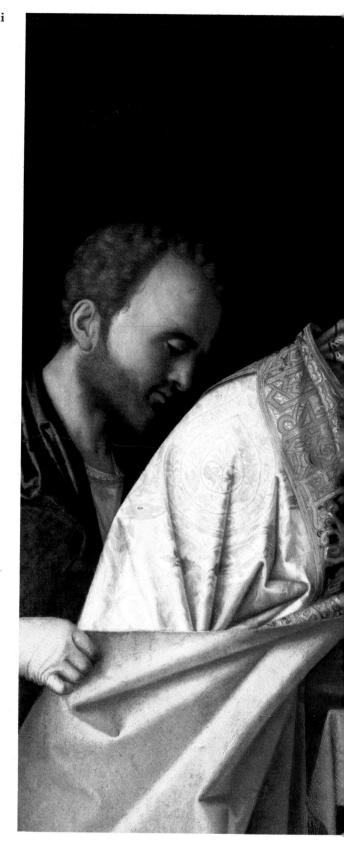

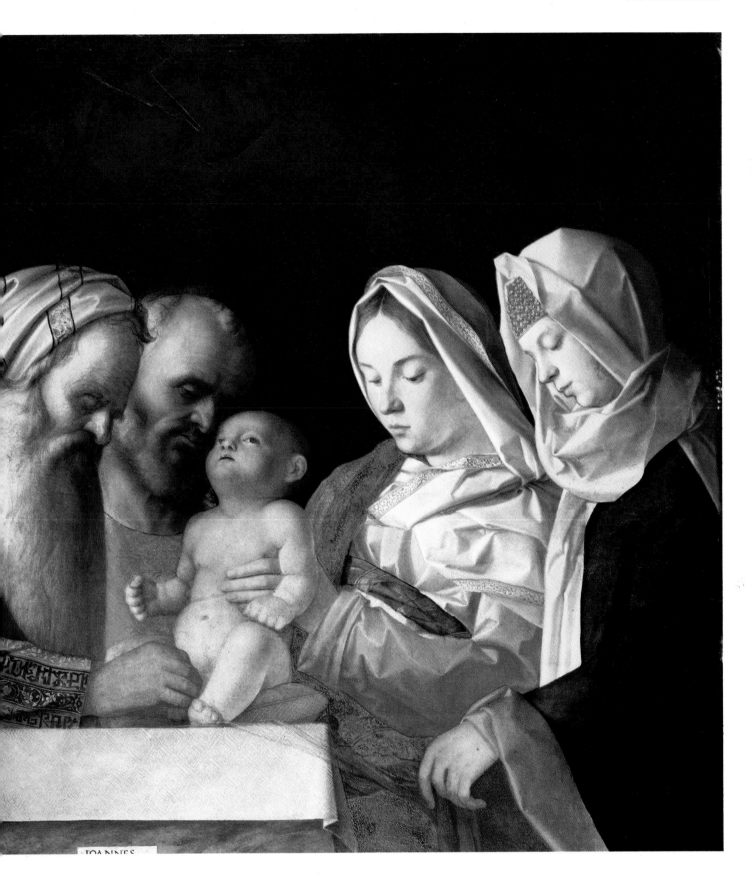

And at the end of eight days, when he was circumcised, he was called Jesus, the name given by the angel before he was conceived in the womb.

LUKE
Chapter 2, Verse 21

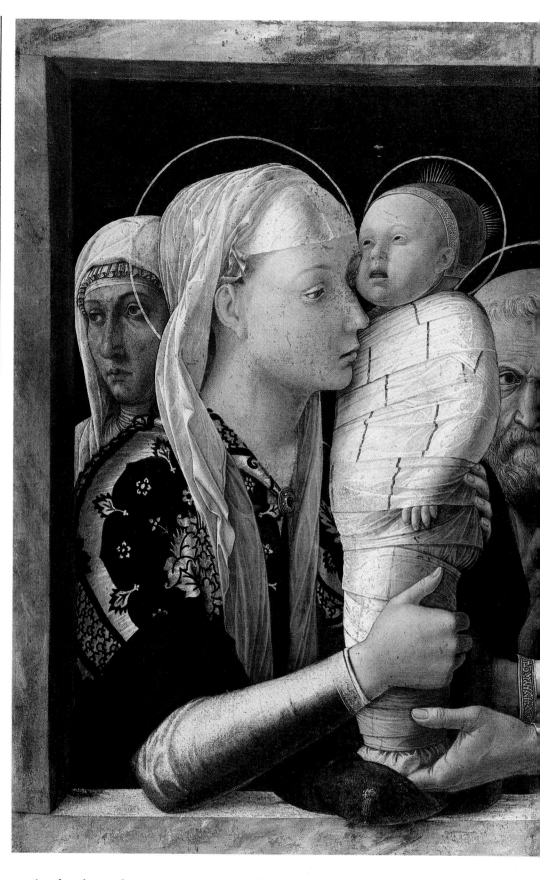

And when the time came for their purification according to the law of Moses, they brought him up to Jerusalem to present him to the Lord (as it is written in the law of the Lord, "Every male that opens the womb shall be called holy to the Lord").

Andrea Mantegna
(1430/31–1506)
'The Presentation in the
Temple'

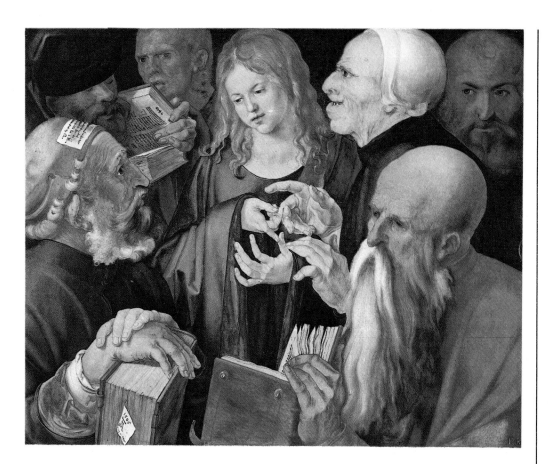

LUKE Chapter 2, Verses 40–47

And the child grew and became strong, filled with wisdom; and the favour of God was upon him.

Now his parents went to Jerusalem every year at the feast of the Passover. And when he was twelve years old, they went up according to custom; and when the feast was ended, as they were returning, the boy Jesus stayed behind in Jerusalem. His parents did not know it, but supposing him to be in the company they went a day's journey, and they sought him among their kinsfolk and acquaintances; and when they did not find him, they returned to Jerusalem, seeking him. After three days, they found him in the temple, sitting among the teachers, listening to them and asking them questions; and all who heard him were amazed at his understanding and his answers.

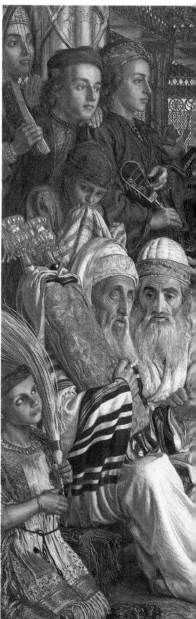

Albrecht Dürer (1471–1528)
'Christ with the Doctors'

And when they saw him they were astonished; and his mother said to him, "Son, why have you treated us so? Behold, your father and I have been looking for you anxiously." And he said to them, "How is it that you sought me? Did you not know that I must be in my Father's house?" And they did not understand the saying which he spoke to them. And he went down with them and came to Nazareth, and was obedient to them; and his mother kept all these things in her heart.

And Jesus increased in wisdom and in stature, and in favour with God and man.

LUKE
Chapter 2, Verses 48–52

William Holman Hunt
(1827–1910)
'Finding the Saviour in the Temple'

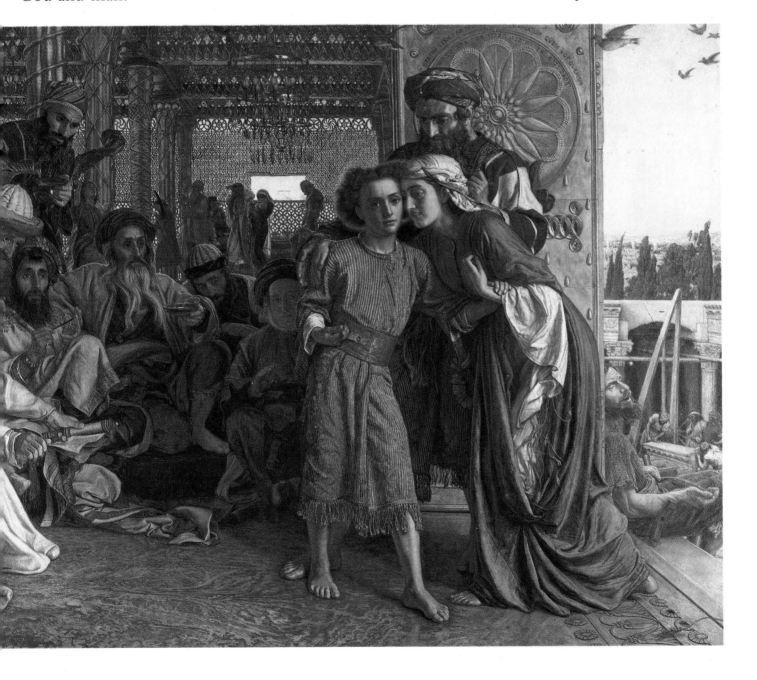

MARK
Chapter 1, Verses 1–11

The beginning of the gospel of Jesus Christ, the Son of God.
As it is written in Isaiah the prophet,
"Behold, I send my messenger before thy face,
who shall prepare thy way;
the voice of one crying in the wilderness:
Prepare the way of the Lord,
make his paths straight—"
John the baptizer appeared in the wilderness, preaching a baptism of repentance for the forgiveness of sins. And there went out to him all the country of Judea, and all the people of Jerusalem; and they were baptized by him in the river Jordan, confessing their sins. Now John was clothed with camel's hair, and had a leather girdle around his waist, and ate locusts and wild honey. And he preached, saying, "After me comes he who is mightier than I, the thong of whose sandals I am not worthy to stoop down and untie. I have baptized you with water; but he will baptize you with the Holy Spirit."

In those days Jesus came from Nazareth of Galilee and was baptized by John in the Jordan. And when he came up out of the water, immediately he saw the heavens opened and the Spirit descending upon him like a dove; and a voice came from heaven, "Thou art my beloved Son; with thee I am well pleased."

Joachim Patenier
(*c.*1480–1524)
'The Baptism of Christ'

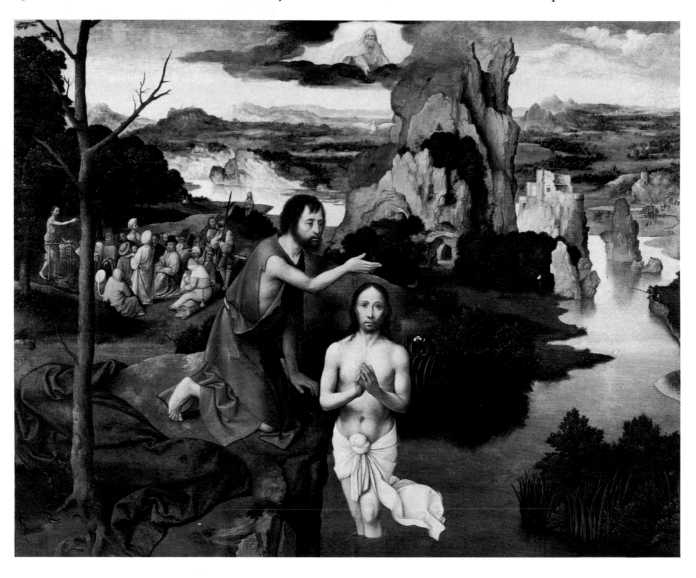

Piero della Francesca
(*c.*1416–1492)
'The Baptism of Christ'

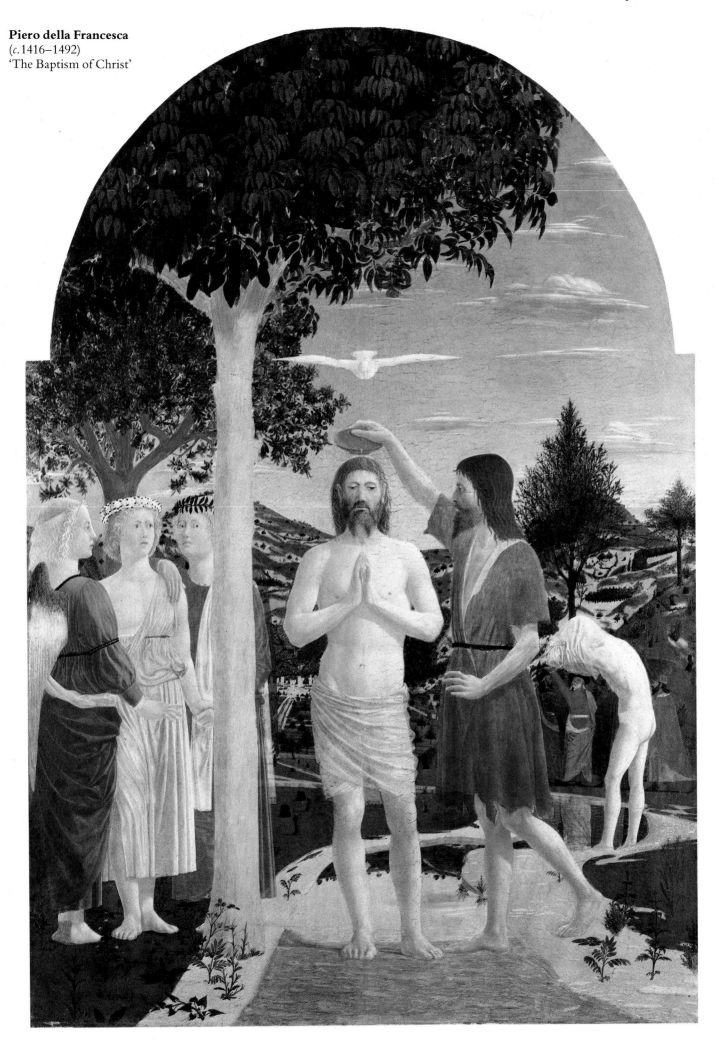

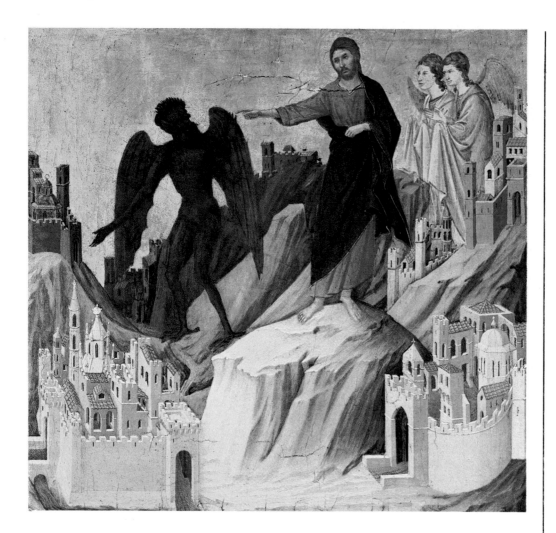

Duccio di Buoninsegna
(active 1278–1318)
'The Temptation of Christ'

Then Jesus was led up by the Spirit into the wilderness to be tempted by the devil. And he fasted forty days and forty nights, and afterward he was hungry. And the tempter came and said to him, "If you are the Son of God, command these stones to become loaves of bread." But he answered, "It is written,

'Man shall not live by bread alone,

but by every word that proceeds from the mouth of God.'"

Then the devil took him to the holy city, and set him on the pinnacle of the temple, and said to him, "If you are the Son of God, throw yourself down; for it is written,

'He will give his angels charge of you,' and

'On their hands they will bear you up,

lest you strike your foot against a stone.'"

Jesus said to him, "Again it is written, 'You shall not tempt the Lord your God.'" Again, the devil took him to a very high mountain, and showed him all the kingdoms of the world and the glory of them; and he said to him, "All these I will give you, if you will fall down and worship me." Then Jesus said to him, "Begone, Satan! for it is written, 'You shall worship the Lord your God and him only shall you serve.'"

Then the devil left him, and behold, angels came and ministered to him.

MATTHEW
Chapter 4, Verses 1–11

162

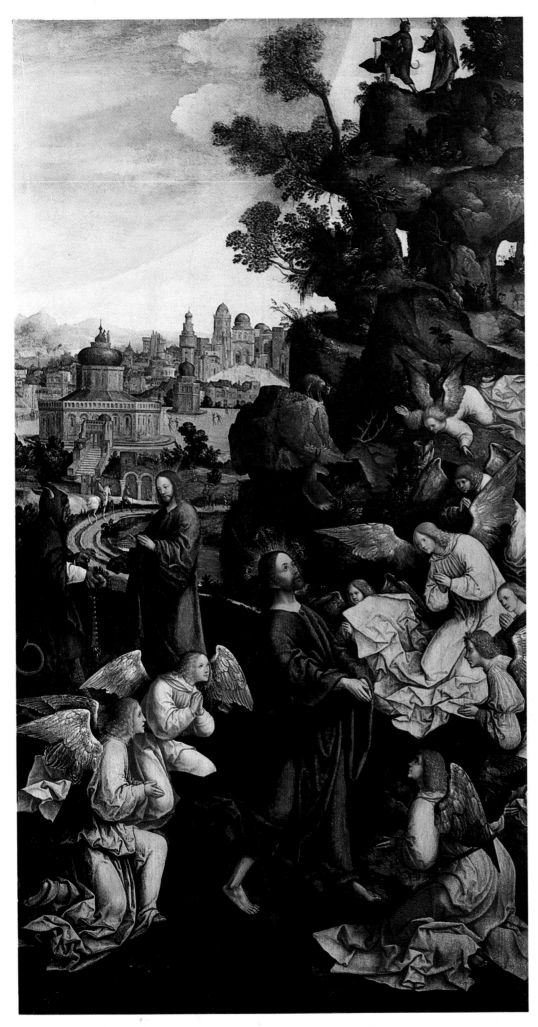

Jakob Cornelisz
(*c.*1470–1533)
'The Temptation of Christ'

LUKE Chapter 5, Verses 1–11

While the people pressed upon him to hear the word of God, he was standing by the lake of Gennesaret. And he saw two boats by the lake; but the fishermen had gone out of them and were washing their nets. Getting into one of the boats, which was Simon's, he asked him to put out a little from the land. And he sat down and taught the people from the boat. And when he had ceased speaking, he said to Simon, "Put out into the deep and let down your nets for a catch." And Simon answered, "Master, we toiled all night and took nothing! But at your word I will let down the nets." And when they had done this, they enclosed a great shoal of fish; and as their nets were breaking, they beckoned to their partners in the other boat to come and help them. And they came and filled both the boats, so that they began to sink. But when Simon Peter saw it, he fell down at Jesus' knees, saying, "Depart from me, for I am a sinful man, O Lord." For he was astonished, and all that were with him, at the catch of fish which they had taken; and so also were James and John, sons of Zebedee, who were partners with Simon. And Jesus said to Simon, "Do not be afraid; henceforth you will be catching men." And when they had brought their boats to land, they left everything and followed him.

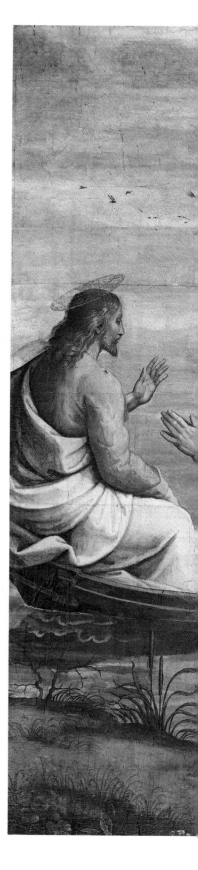

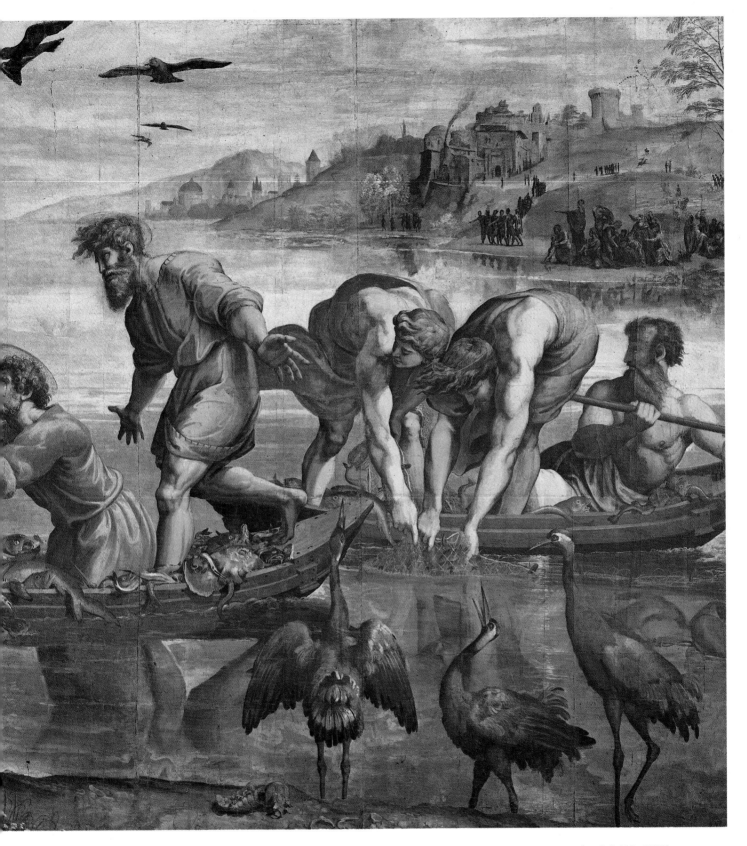

Raphael (1483–1520)
'The Miraculous Draught of
Fishes' (cartoon for tapestry)

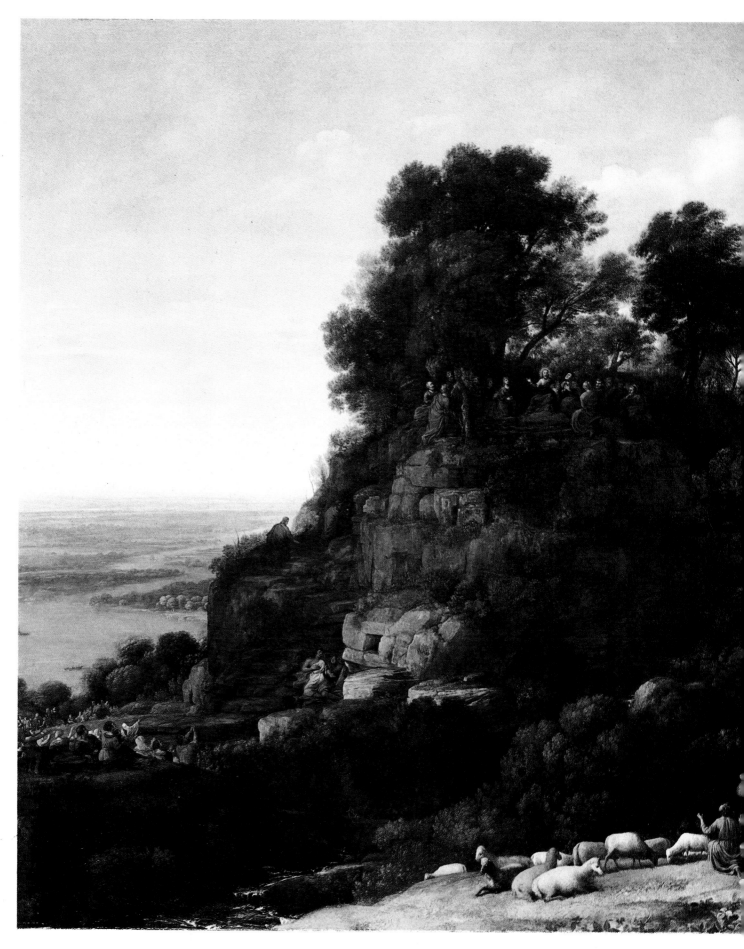

And great crowds followed him from Galilee and the Decapolis and Jerusalem and Judea and from beyond the Jordan.

Seeing the crowds, he went up on the mountain, and when he sat

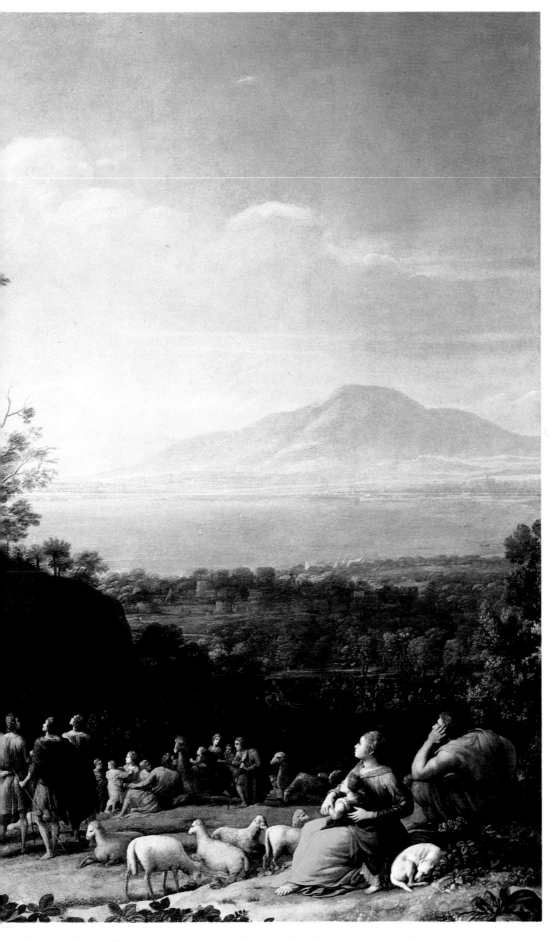

down his disciples came to him. And he opened his mouth and taught them, saying: "Blessed are the poor in spirit, for theirs is the kingdom of heaven."

MARK Chapter 5, Verses 1–19

They came to the other side of the sea, to the country of the Gerasenes. And when he had come out of the boat, there met him out of the tombs a man with an unclean spirit, who lived among the tombs; and no one could bind him any more, even with a chain; for he had often been bound with fetters and chains, but the chains he wrenched apart, and the fetters he broke in pieces; and no one had the strength to subdue him. Night and day among the tombs and on the mountains he was always crying out, and bruising himself with stones. And when he saw Jesus from afar, he ran and worshipped him; and crying out with a loud voice, he said, "What have you to do with me, Jesus, Son of the Most High God? I adjure you by God, do not torment me." For he had said to him, "Come out of the man, you unclean spirit!" And Jesus asked him, "What is your name?" He replied, "My name is Legion; for we are many." And he begged him eagerly not to send them out of the country. Now a great herd of swine was feeding there on the hillside; and they begged him, "Send us to the swine, let us enter them." So he gave them leave. And the unclean spirits came out, and entered the swine; and the herd, numbering about two thousand, rushed down the steep bank into the sea, and were drowned in the sea.

The herdsmen fled, and told it in the city and in the country. And people came to see what it was that had happened. And they came to Jesus, and saw the demoniac sitting there, clothed and in his right mind, the man who had had the legion; and they were afraid. And those who had seen it told what had happened to the demoniac and to the swine. And they began to beg Jesus to depart from their neighbourhood. And as he was getting into the boat, the man who had been possessed with demons begged him that he might be with him. But he refused, and said to him, "Go home to your friends, and tell them how much the Lord has done for you, and how he has had mercy on you."

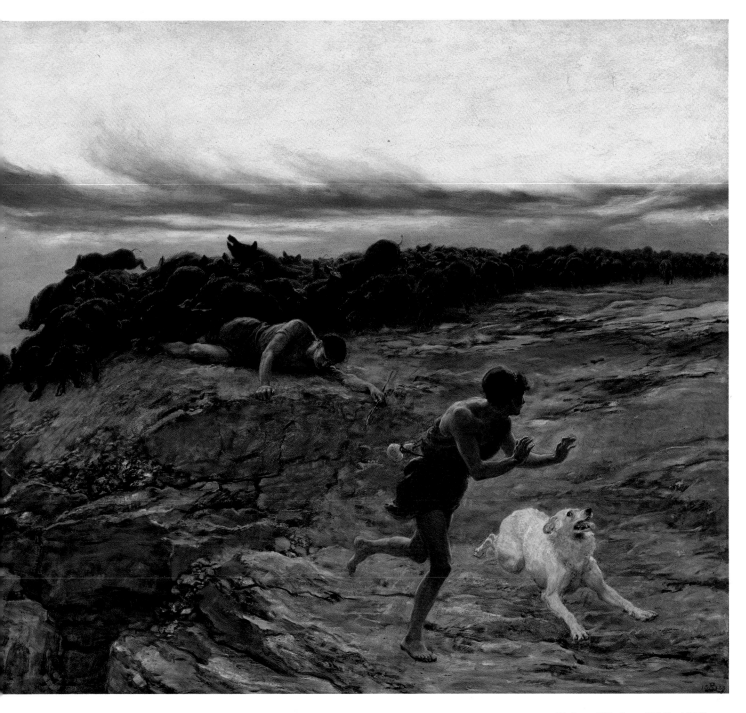

Briton Riviere (1840–1920)
'The Miracle of the Gadarene
Swine'

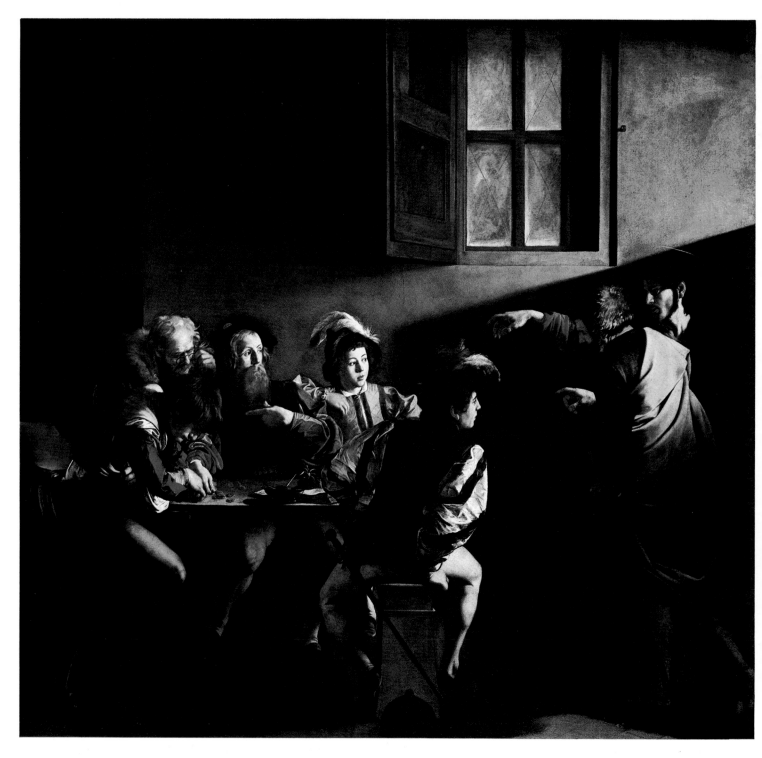

As Jesus passed on from there, he saw a man called Matthew sitting at the tax office; and he said to him, "Follow me," And he rose and followed him.

And as he sat at table in the house, behold, many tax collectors and sinners came and sat down with Jesus and his disciples. And when the Pharisees saw this, they said to his disciples, "Why does your teacher eat with tax collectors and sinners?" But when he heard it, he said, "Those who are well have no need of a physician, but those who are sick. Go and learn what this means, 'I desire mercy, and not sacrifice.' For I came not to call the righteous, but sinners."

Michelangelo Merisi da Caravaggio (1573–1610)
'The Calling of St Matthew'

MATTHEW
Chapter 9, Verses 9–13

The Master of the Darmstadt Passion (active *c.*1440)
'The Healing of the Widow's Son at Nain'

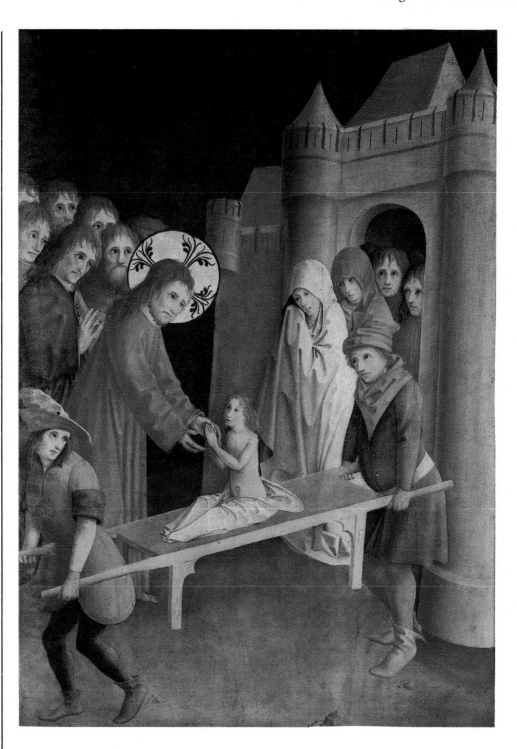

LUKE
Chapter 7, Verses 11–17

Soon afterward he went to a city called Nain, and his disciples and a great crowd went with him. As he drew near to the gate of the city, behold, a man who had died was being carried out, the only son of his mother, and she was a widow; and a large crowd from the city was with her. And when the Lord saw her, he had compassion on her and said to her, "Do not weep." And he came and touched the bier, and the bearers stood still. And he said, "Young man, I say to you, arise." And the dead man sat up, and began to speak. And he gave him to his mother. Fear seized them all; and they glorified God, saying, "A great prophet has arisen among us!" and "God has visited his people!" And this report concerning him spread through the whole of Judea and all the surrounding country.

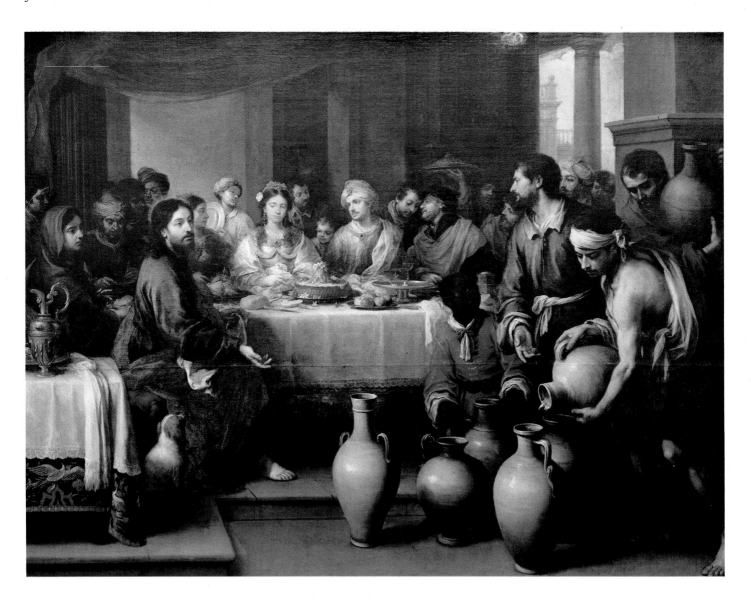

Bartolomé Esteban Murillo
(1618–1682)
'The Feast at Cana'

JOHN
Chapter 2, Verses 1–11

On the third day there was a marriage at Cana in Galilee, and the mother of Jesus was there; Jesus also was invited to the marriage, with his disciples. When the wine gave out, the mother of Jesus said to him, "They have no wine." And Jesus said to her, "O woman, what have you to do with me? My hour has not yet come." His mother said to the servants, "Do whatever he tells you." Now six stone jars were standing there, for the Jewish rites of purification, each holding twenty or thirty gallons. Jesus said to them, "Fill the jars with water." And they filled them up to the brim. He said to them, "Now draw some out, and take it to the steward of the feast." So they took it. When the steward of the feast tasted the water now become wine, and did not know where it came from (though the servants who had drawn the water knew), the steward of the feast called the bridegroom and said to him, "Every man serves the good wine first; and when men have drunk freely, then the poor wine; but you have kept the good wine until now." This, the first of his signs, Jesus did at Cana in Galilee, and manifested his glory; and his disciples believed in him.

Jan Joest van Kalkar
(*c*.1455/60–1519)
'Christ and the Woman of
Samaria'

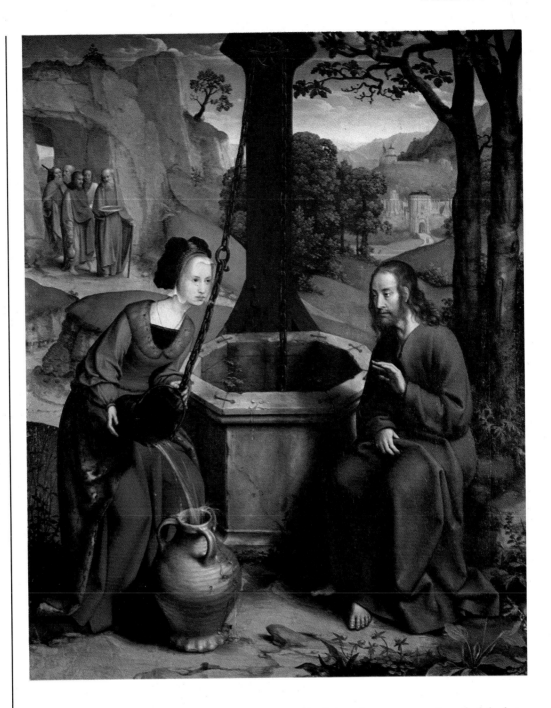

JOHN
Chapter 4, Verses 5–13

So he came to a city of Samaria called Sychar, near the field that Jacob gave to his son Joseph. Jacob's well was there, and so Jesus, wearied as he was with his journey, sat down beside the well. It was about the sixth hour.

There came a woman of Samaria to draw water. Jesus said to her, "Give me a drink." For his disciples had gone away into the city to buy food. The Samaritan woman said to him, "How is it that you, a Jew, ask a drink of me, a woman of Samaria?" For Jews have no dealings with Samaritans. Jesus answered her, "If you knew the gift of God, and who it is that is saying to you, 'Give me a drink,' you would have asked him, and he would have given you living water." The woman said to him, "Sir, you have nothing to draw with, and the well is deep; where do you get that living water? Are you greater than our father Jacob, who gave us the well, and drank from it himself, and his sons, and his cattle?" Jesus said to her, "Every

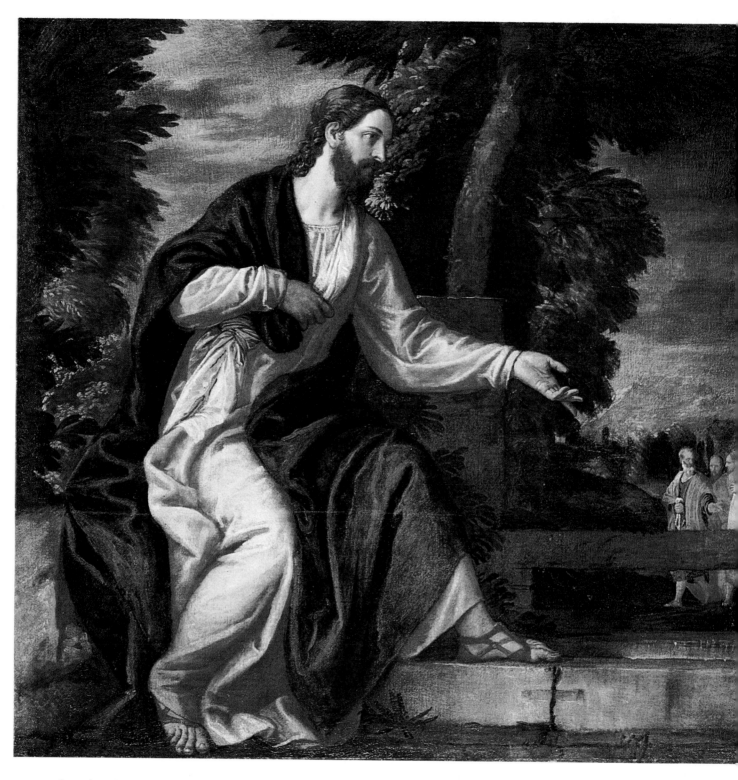

one who drinks of this water will thirst again, but whoever drinks of the water that I shall give him will never thirst; the water that I shall give him will become in him a spring of water welling up to eternal life." The woman said to him, "Sir, give me this water, that I may not thirst, nor come here to draw."

Jesus said to her, "Go, call your husband, and come here." The woman answered him, "I have no husband." Jesus said to .her, "You are right in saying, 'I have no husband'; for you have had five husbands, and he whom you now have is not your husband; this you said truly." The woman said to him, "Sir, I perceive that you are a prophet. Our fathers worshipped on this mountain; and you

Paolo Veronese (*c.*1528–1588) 'Christ and the Woman of Samaria'

JOHN
Chapter 4, Verses 13–20

174

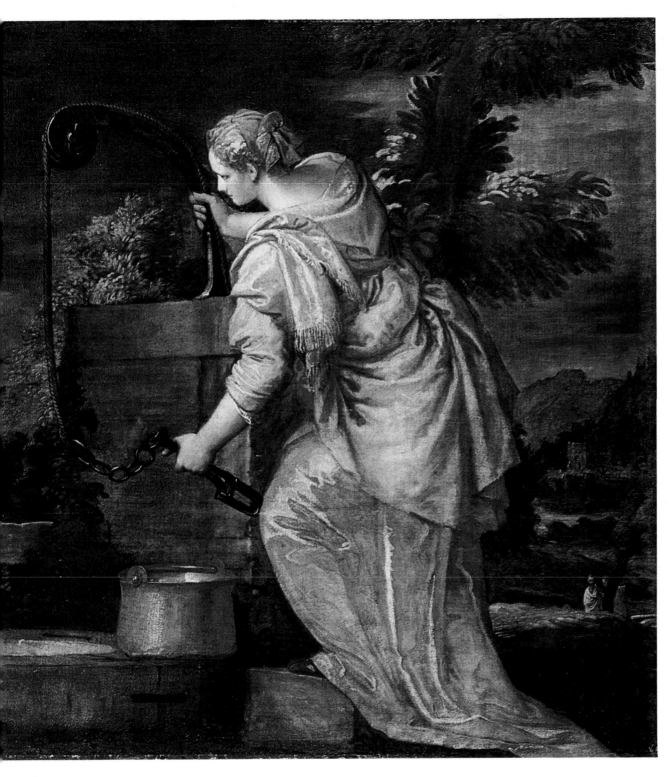

say that in Jerusalem is the place where men ought to worship." Jesus said to her, "Woman, believe me, the hour is coming when neither on this mountain nor in Jerusalem will you worship the Father. You worship what you do not know; we worship what we know, for salvation is from the Jews. But the hour is coming, and now is, when the true worshippers will worship the Father in Spirit and truth, for such the Father seeks to worship him. God is spirit, and those who worship him must worship in spirit and truth." The woman said to him, "I know that Messiah is coming (he who is called Christ); when he comes, he will show us all things." Jesus said to her, "I who speak to you am he."

JOHN
Chapter 4, Verses 20–26

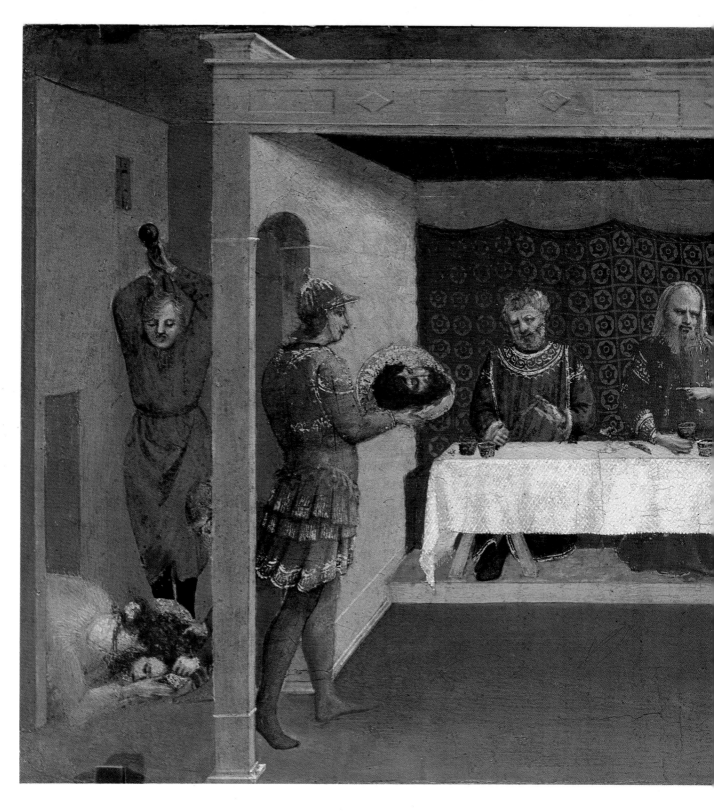

MATTHEW
Chapter 14, Verses 1–12

At that time Herod the tetrarch heard about the fame of Jesus; and he said to his servants, "This is John the Baptist, he has been raised from the dead; that is why these powers are at work in him." For Herod had seized John and bound him and put him in prison, for the sake of Herodias, his brother Philip's wife; because John said to him, "It is not lawful for you to have her." And though he wanted to put him to death, he feared the people, because they held him to be a prophet. But when Herod's birthday came, the daughter of Herodias danced before the company, and pleased Herod, so that he

School of Fra Angelico
(fifteenth century)
'Salome'

Netherlandish School (*c.*1500)
'John the Baptist'

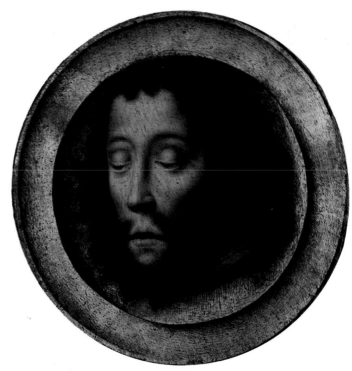

promised with an oath to give her whatever she might ask. Prompted by her mother, she said, "Give me the head of John the Baptist here on a platter." And the king was sorry; but because of his oaths and his guests he commanded it to be given; he sent and had John beheaded in the prison, and his head was brought on a platter and given to the girl, and she brought it to her mother. And his disciples came and took the body and buried it; and they went and told Jesus.

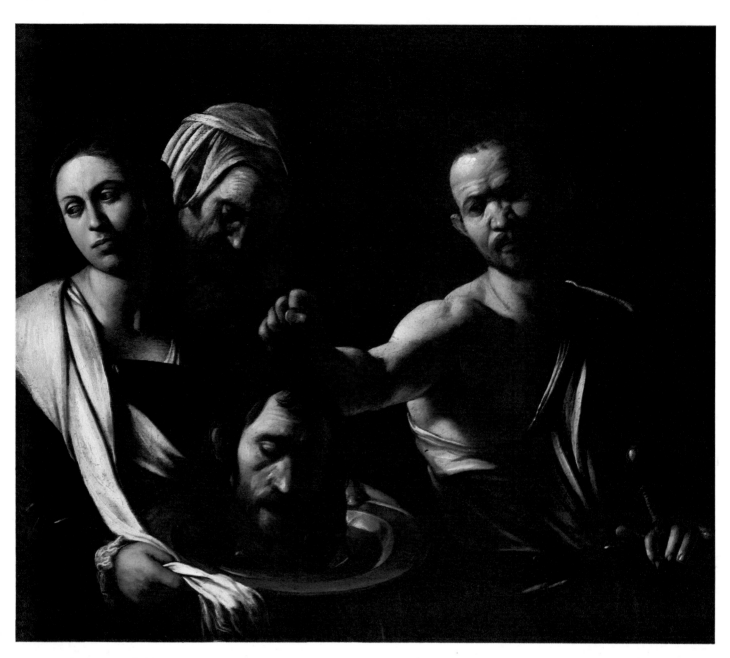

Caravaggio (1573–1610)
'Salome'

MATTHEW
Chapter 14, Verses 22–31

Then he made the disciples get into the boat and go before him to the other side, while he dismissed the crowds. And after he had dismissed the crowds, he went up on the mountain by himself to pray. When evening came, he was there alone, but the boat by this time was many furlongs distant from the land, beaten by the waves; for the wind was against them. And in the fourth watch of the night he came to them, walking on the sea. But when the disciples saw him walking on the sea, they were terrified, saying, "It is a ghost!" And they cried out for fear. But immediately he spoke to them, saying, "Take heart, it is I; have no fear."

And Peter answered him, "Lord, if it is you, bid me come to you on the water." He said, "Come." So Peter got out of the boat and walked on the water and came to Jesus; but when he saw the wind, he was afraid, and beginning to sink he cried out, "Lord, save me." Jesus immediately reached out his hand and caught him, saying to him, "O man of little faith, why did you doubt?"

Philipp Otto Runge
(1777–1810)
'Christ Walks on the Water, Peter Sinks'

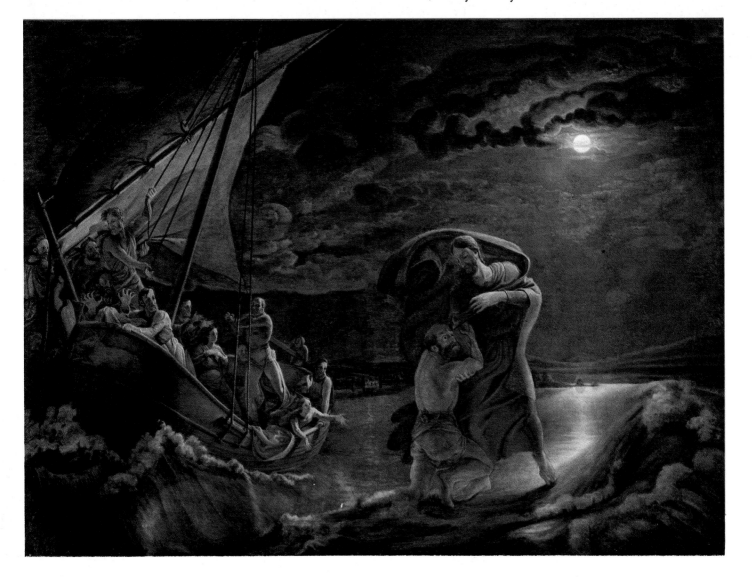

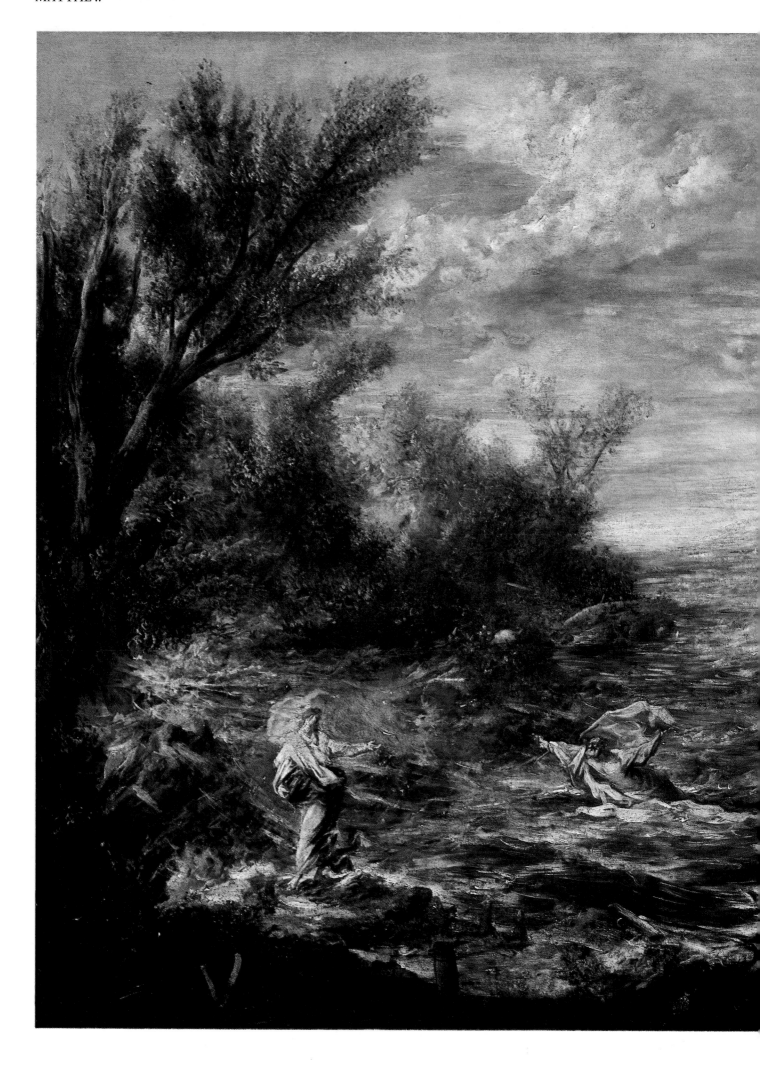

Alessandro Magnasco
(1667–1749)
'Christ Walking on the Water'

And after six days Jesus took with him Peter and James and John his brother, and led them up a high mountain apart. And he was transfigured before them, and his face shone like the sun, and his garments became white as light. And behold, there appeared to them Moses and Elijah, talking with him. And Peter said to Jesus, "Lord, it is well that we are here; if you wish, I will make three booths here, one for you and one for Moses and one for Elijah." He was still speaking, when lo, a bright cloud overshadowed them, and a voice from the cloud said, "This is my beloved Son, with whom I am well pleased; listen to him." When the disciples heard this, they fell on their faces, and were filled with awe. But Jesus came and touched them, saying, "Rise, and have no fear." And when they lifted up their eyes, they saw no one but Jesus only.

And as they were coming down the mountain, Jesus commanded them, "Tell no one the vision, until the Son of man is raised from the dead."

MATTHEW
Chapter 17, Verses 1–9

Raphael (1483–1520)
Right 'The Transfiguration'

Giovanni Bellini
(*c.*1430–1516)
Below 'The Transfiguration'

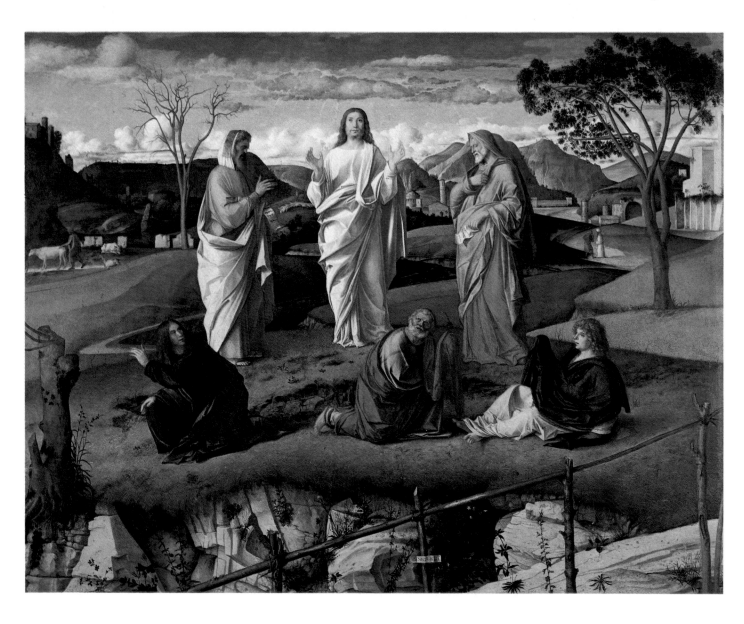

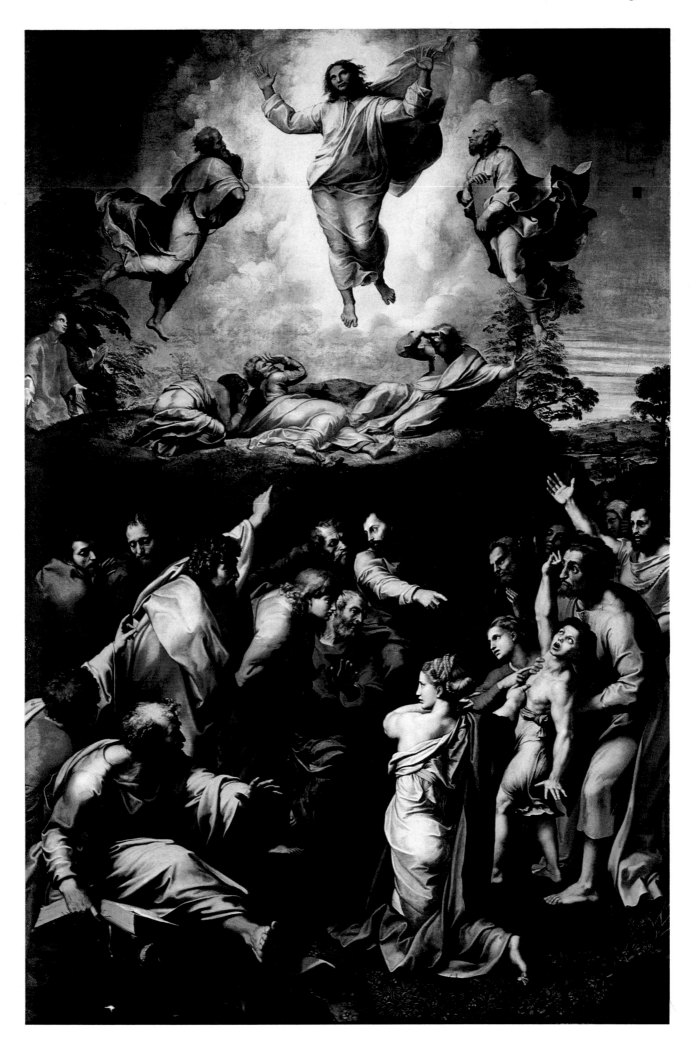

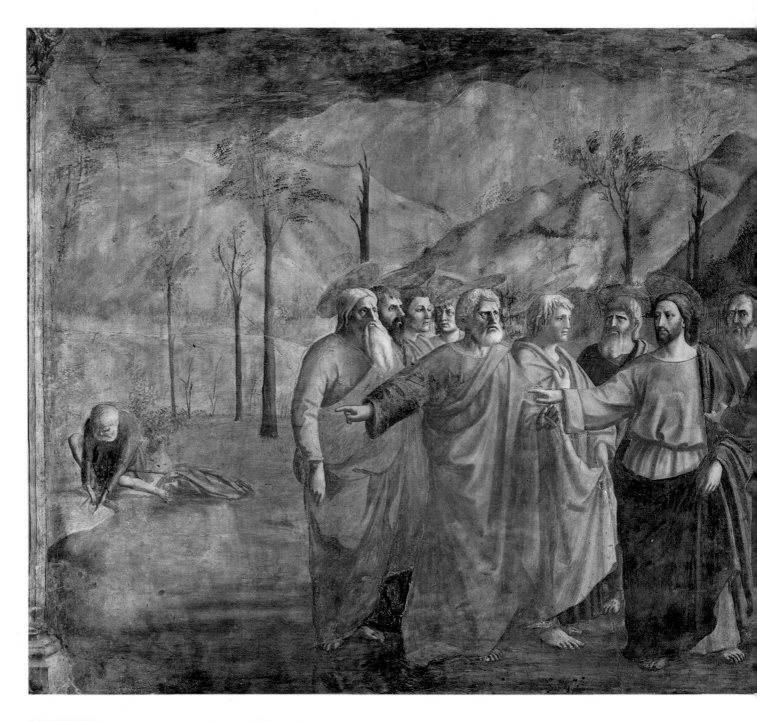

MATTHEW
Chapter 17, Verses 24–27

When they came to Capernaum, the collectors of the half-shekel tax went up to Peter and said, "Does not your teacher pay the tax?" He said, "Yes." And when he came home, Jesus spoke to him first, saying, "What do you think, Simon? From whom do kings of the earth take toll or tribute? From their sons or from others?" And when he said, "From others," Jesus said to him, "Then the sons are free. However, not to give offence to them, go to the sea and cast a hook, and take the first fish that comes up, and when you open its mouth you will find a shekel; take that and give it to them for me and for yourself."

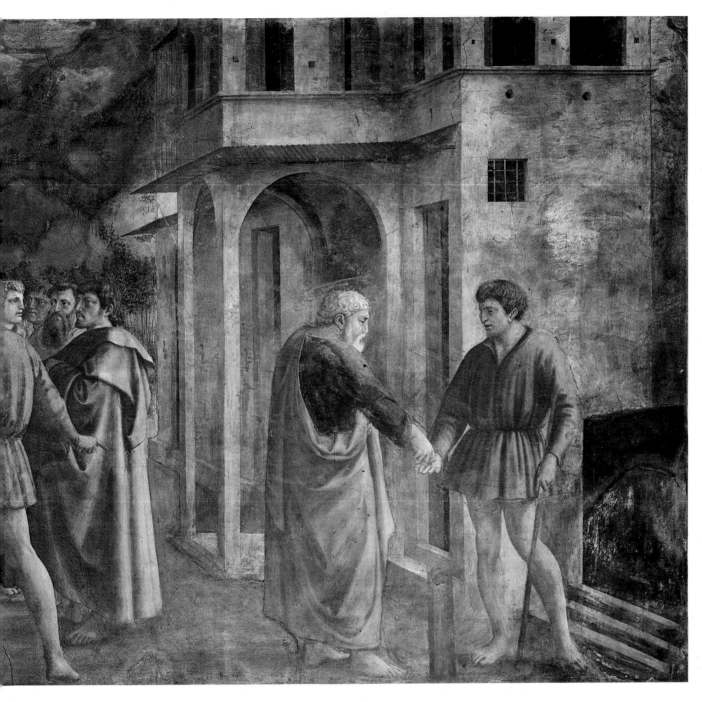

Masaccio (1401–1428)
'The Tribute Money'

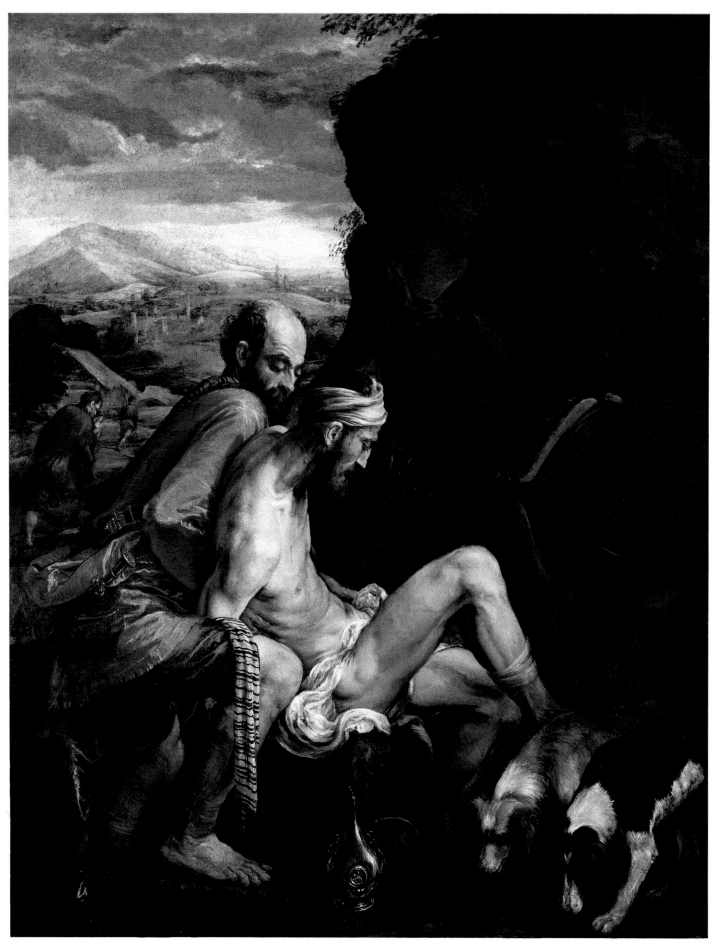

Jacopo Bassano
(1517/18–1592)
'The Good Samaritan'

Luca Giordano (1634–1705)
'The Good Samaritan'

LUKE
Chapter 10, Verses 25–37

And behold, a lawyer stood up to put him to the test, saying, "Teacher, what shall I do to inherit eternal life?" He said to him, "What is written in the law? How do you read?" And he answered, "You shall love the Lord your God with all your heart, and with all your soul, and with all your strength, and with all your mind; and your neighbour as yourself." And he said to him, "You have answered right; do this, and you will live."

But he, desiring to justify himself, said to Jesus, "And who is my neighbour?" Jesus replied, "A man was going down from Jerusalem to Jericho, and he fell among robbers, who stripped him and beat him, and departed, leaving him half dead. Now by chance a priest was going down that road; and when he saw him he passed by on the other side. So likewise a Levite, when he came to the place and saw him, passed by on the other side. But a Samaritan, as he journeyed, came to where he was; and when he saw him, he had compassion, and went to him and bound up his wounds, pouring on oil and wine; then he set him on his own beast and brought him to an inn, and took care of him. And the next day he took out two denarii and gave them to the innkeeper, saying, 'Take care of him; and whatever more you spend, I will repay you when I come back.' Which of these three, do you think, proved neighbour to the man who fell among the robbers?" He said, "The one who showed mercy on him." And Jesus said to him, "Go and do likewise."

Diego Velázquez (1599–1660)
'Christ in the House of Mary
and Martha'

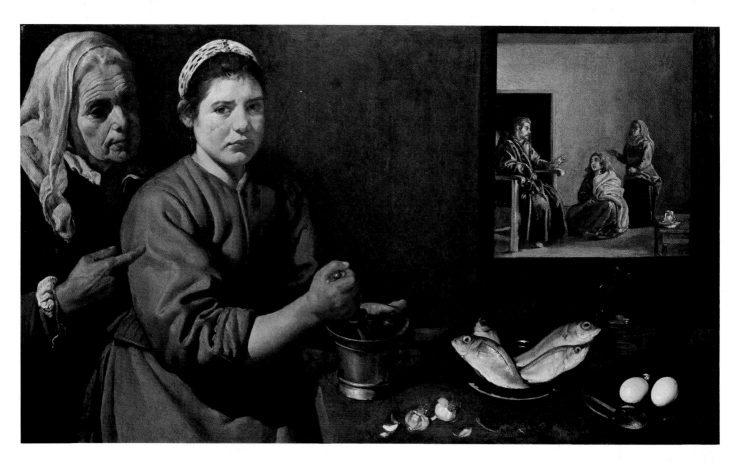

LUKE
Chapter 10, Verses 38–42

Now as they went on their way, he entered a village; and a woman named Martha received him into her house. And she had a sister called Mary, who sat at the Lord's feet and listened to his teaching. But Martha was distracted with much serving; and she went to him and said, "Lord, do you not care that my sister has left me to serve alone? Tell her then to help me." But the Lord answered her, "Martha, Martha, you are anxious and troubled about many things; one thing is needful. Mary has chosen the good portion, which shall not be taken away from her."

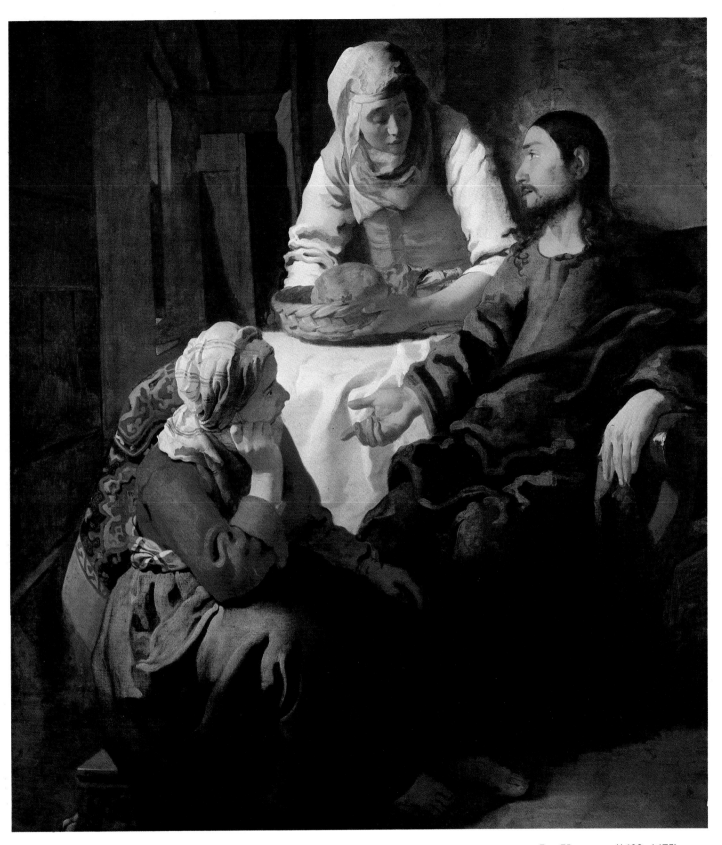

Jan Vermeer (1632–1675)
'Christ with Mary and Martha'

LUKE Chapter 15, Verses 11–32

And he said, "There was a man who had two sons; and the younger of them said to his father, 'Father, give me the share of property that falls to me.' And he divided his living between them. Not many days later, the younger son gathered all he had and took his journey into a far country, and there he squandered his property in loose living. And when he had spent everything, a great famine arose in that country, and he began to be in want. So he went and joined himself to one of the citizens of that country, who sent him into his fields to feed swine. And he would gladly have fed on the pods that the swine ate; and no one gave him anything. But when he came to himself he said, 'How many of my father's hired servants have bread enough and to spare, but I perish here with hunger! I will arise and go to my father, and I will say to him, "Father, I have sinned against heaven and before you; I am no longer worthy to be called your son; treat me as one of your hired servants."' And he arose and came to his father. But while he was yet at a distance, his father saw him and had compassion, and ran and embraced him and kissed him. And the son said to him, 'Father, I have sinned against heaven and before you; I am no longer worthy to be called your son.' But the father said to his servants, 'Bring quickly the best robe, and put it on him; and put a ring on his hand, and shoes on his feet; and bring the fatted calf and kill it, and let us eat and make merry; for this my son was dead, and is alive again; he was lost, and is found.' And they began to make merry.

"Now his elder son was in the field; and as he came and drew near to the house, he heard music and dancing. And he called one of the servants and asked what this meant. And he said to him, 'Your brother has come, and your father has killed the fatted calf, because he has received him safe and sound.' But he was angry and refused to go in. His father came out and entreated him, but he answered his father, 'Lo, these many years I have served you, and I never disobeyed your command; yet you never gave me a kid, that I might make merry with my friends. But when this son of yours came, who has devoured your living with harlots, you killed for him the fatted calf!' And he said to him, 'Son, you are always with me, and all that is mine is yours. It was fitting to make merry and be glad, for this your brother was dead, and is alive; he was lost, and is found.'"

Rubens (1577–1640)
'The Prodigal Son'

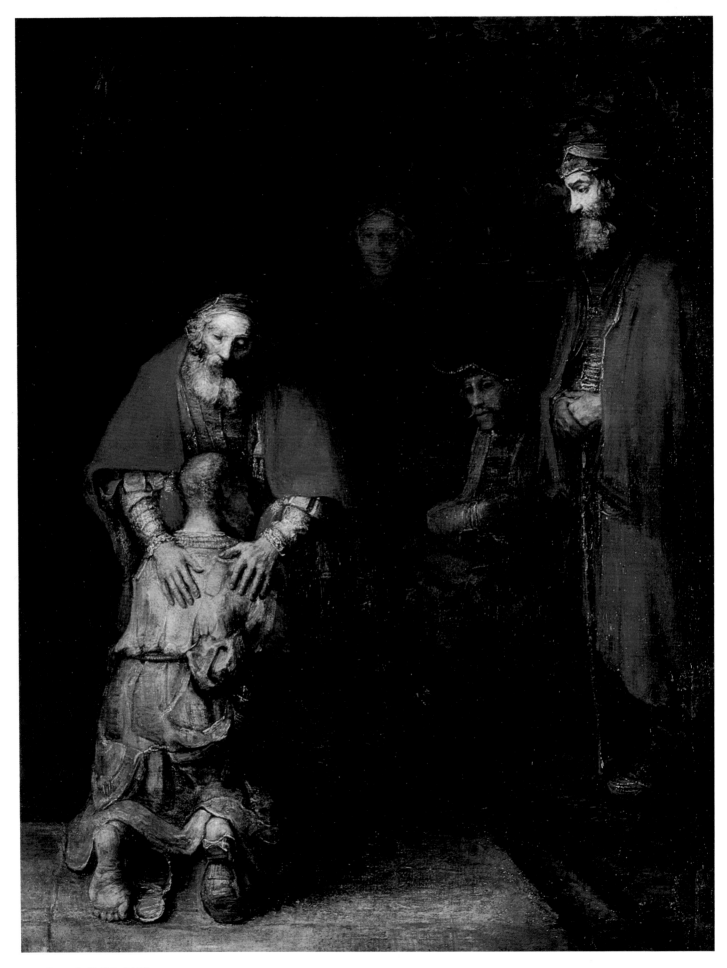

Rembrandt (1606–1669)
'The Return of the Prodigal
Son'

William Blake (1757–1827)
'The Wise and Foolish Virgins'

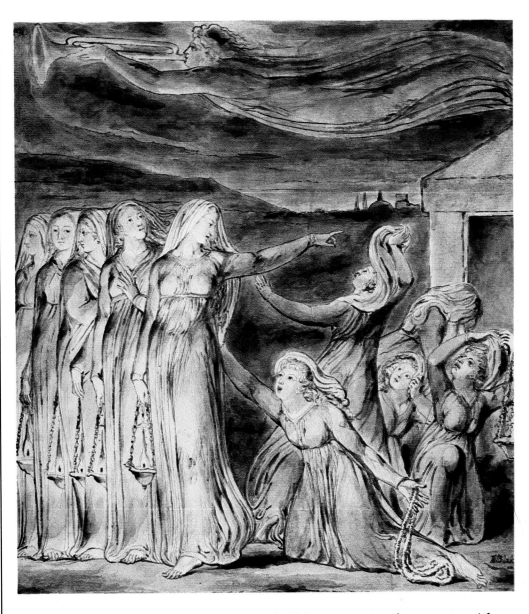

MATTHEW
Chapter 25, Verses 1–13

"Then the kingdom of heaven shall be compared to ten maidens who took their lamps and went to meet the bridegroom. Five of them were foolish, and five were wise. For when the foolish took their lamps, they took no oil with them; but the wise took flasks of oil with their lamps. As the bridegroom was delayed, they all slumbered and slept. But at midnight there was a cry, 'Behold, the bridegroom! Come out to meet him.' Then all those maidens rose and trimmed their lamps. And the foolish said to the wise, 'Give us some of your oil, for our lamps are going out.' But the wise replied, 'Perhaps there will not be enough for us and for you; go rather to the dealers and buy for yourselves.' And while they went to buy, the bridegroom came, and those who were ready went in with him to the marriage feast; and the door was shut. Afterward the other maidens came also, saying, 'Lord, lord, open to us.' But he replied, 'Truly, I say to you, I do not know you.' Watch therefore, for you know neither the day nor the hour."

JOHN Chapter 8, Verses 3–11

The scribes and the Pharisees brought a woman who had been caught in adultery, and placing her in the midst they said to him, "Teacher, this woman has been caught in the act of adultery. Now in the law Moses commanded us to stone such. What do you say about her?" This they said to test him, that they might have some charge to bring against him. Jesus bent down and wrote with his finger on the ground. And as they continued to ask him, he stood up and said to them, "Let him who is without sin among you be the first to throw a stone at her." And once more he bent down and wrote with his finger on the ground. But when they heard it, they went away, one by one, beginning with the eldest, and Jesus was left alone with the woman standing before him. Jesus looked up and said to her, "Woman, where are they? Has no one condemned you?" She said, "No one, Lord." And Jesus said, "Neither do I condemn you; go, and do not sin again."

Jean-Louis Forain (1852–1931)
'The Adulteress'

Pieter Bruegel the Elder
(*c*.1525–1569)
'Christ and the Woman Taken in Adultery'

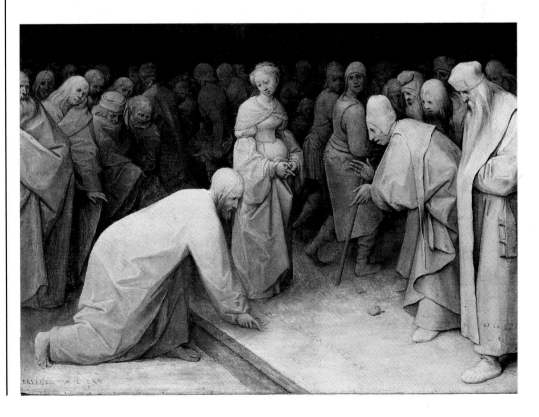

George Frederick Watts
(1817–1904)
'For He Had Great Possessions'

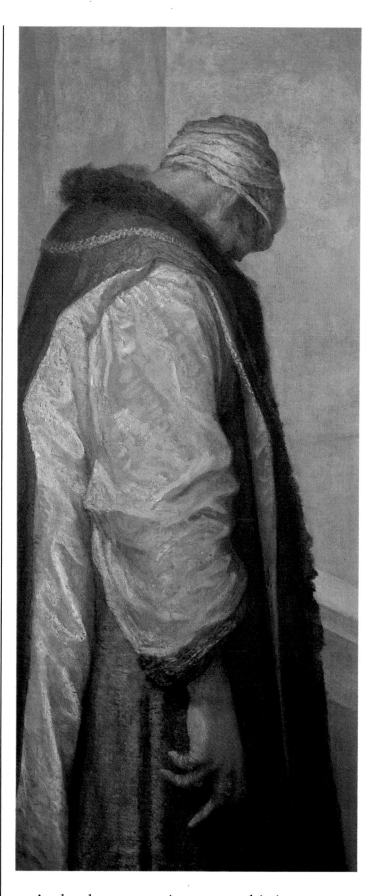

MARK
Chapter 10, Verses 17–19

And as he was setting out on his journey, a man ran up and knelt before him, and asked him, "Good Teacher, what must I do to inherit eternal life?" And Jesus said to him, "Why do you call me good? No one is good but God alone. You know the commandments: 'Do not kill, Do not commit adultery, Do not steal, Do not bear false witness, Do not defraud, Honour your father and

MARK
Chapter 10, Verses 20–22

mother.'" And he said to him, "Teacher, all these I have observed from my youth." And Jesus looking upon him loved him, and said to him, "You lack one thing; go, sell what you have, and give to the poor, and you will have treasure in heaven; and come, follow me." At that saying his countenance fell, and he went away sorrowful; for he had great possessions.

Caravaggio (1573–1610)
'The Conversion of the Magdalen'

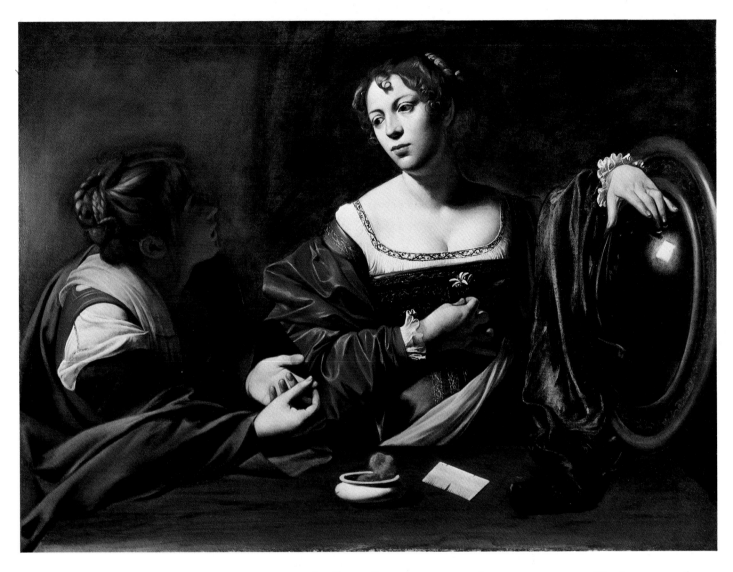

JOHN
Chapter 12, Verses 1–8

Six days before the Passover, Jesus came to Bethany, where Lazarus was, whom Jesus had raised from the dead. There they made him a supper; Martha served, and Lazarus was one of those at table with him. Mary took a pound of costly ointment of pure nard and anointed the feet of Jesus and wiped his feet with her hair; and the house was filled with the fragrance of the ointment. But Judas Iscariot, one of the disciples (he who was to betray him), said, "Why was this ointment not sold for three hundred denarii and given to the poor?" This he said, not that he cared for the poor but because he was a thief, and as he had the money box he used to take what was put into it. Jesus said, "Let her alone, let her keep it for the day of my burial. The poor you always have with you, but you do not always have me."

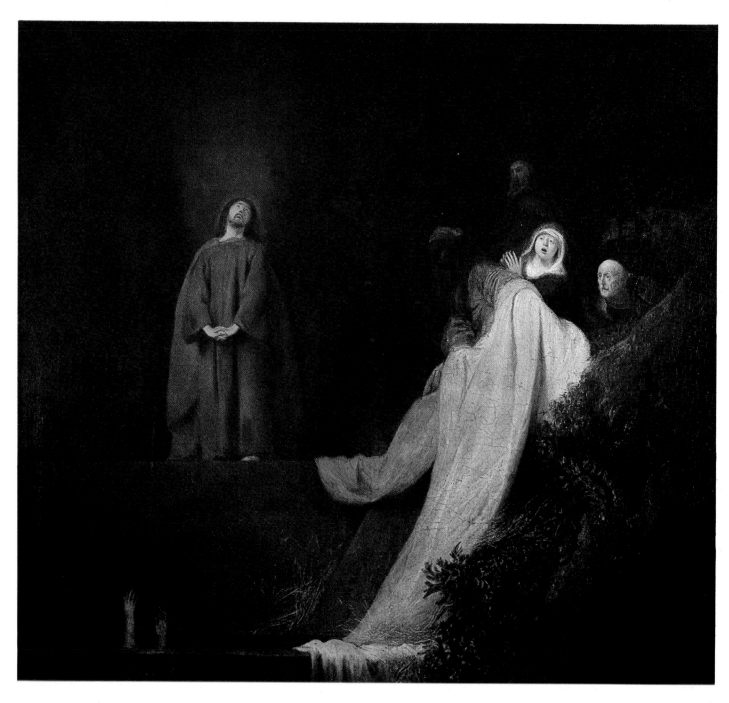

Jan Lievens (1607–1674)
'The Raising of Lazarus'

JOHN
Chapter 11, Verses 1–9

Now a certain man was ill, Lazarus of Bethany, the village of Mary and her sister Martha. It was Mary who anointed the Lord with ointment and wiped her feet with her hair, whose brother Lazarus was ill. So the sisters sent to him, saying, "Lord, he whom you love is ill." But when Jesus heard it he said, "This illness is not unto death; it is for the glory of God, so that the Son of God may be glorified by means of it."

Now Jesus loved Martha and her sister and Lazarus. So when he heard that he was ill, he stayed two days longer in the place where he was. Then after this he said to the disciples, "Let us go into Judea again." The disciples said to him, "Rabbi, the Jews were but now seeking to stone you, and are you going there again?" Jesus answered, "Are there not twelve hours in the day? If any one walks in the day, he does not stumble, because he sees the light of this

world. But if any one walks in the night, he stumbles, because the light is not in him." Thus he spoke, and then he said to them, "Our friend Lazarus has fallen asleep, but I go to awake him out of sleep." The disciples said to him, "Lord, if he has fallen asleep, he will recover." Now Jesus had spoken of his death, but they thought that he meant taking rest in sleep. Then Jesus told them plainly, "Lazarus is dead; and for your sake I am glad that I was not there, so that you may believe. But let us go to him." Thomas, called the Twin, said to his fellow disciples, "Let us also go, that we may die with him."

Now when Jesus came, he found that Lazarus had already been in the tomb four days. Bethany was near Jerusalem, about two miles off, and many of the Jews had come to Martha and Mary to console

JOHN
Chapter 11, Verses 10–19

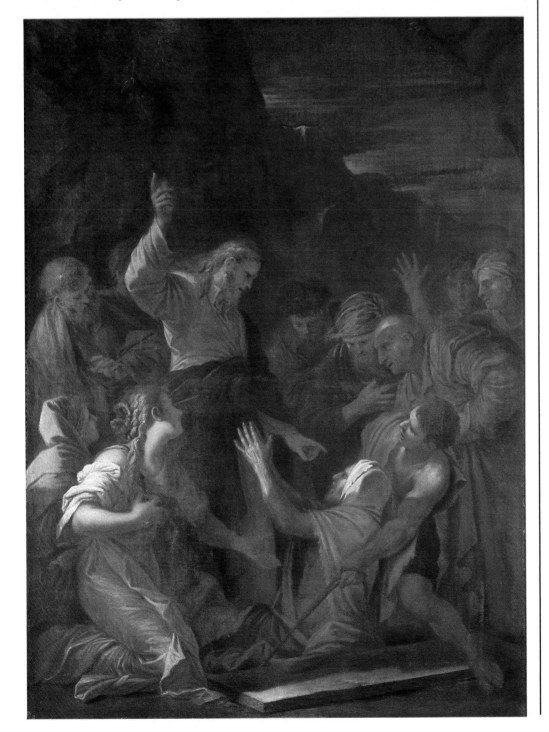

Salvator Rosa (1615–1673)
'The Raising of Lazarus'

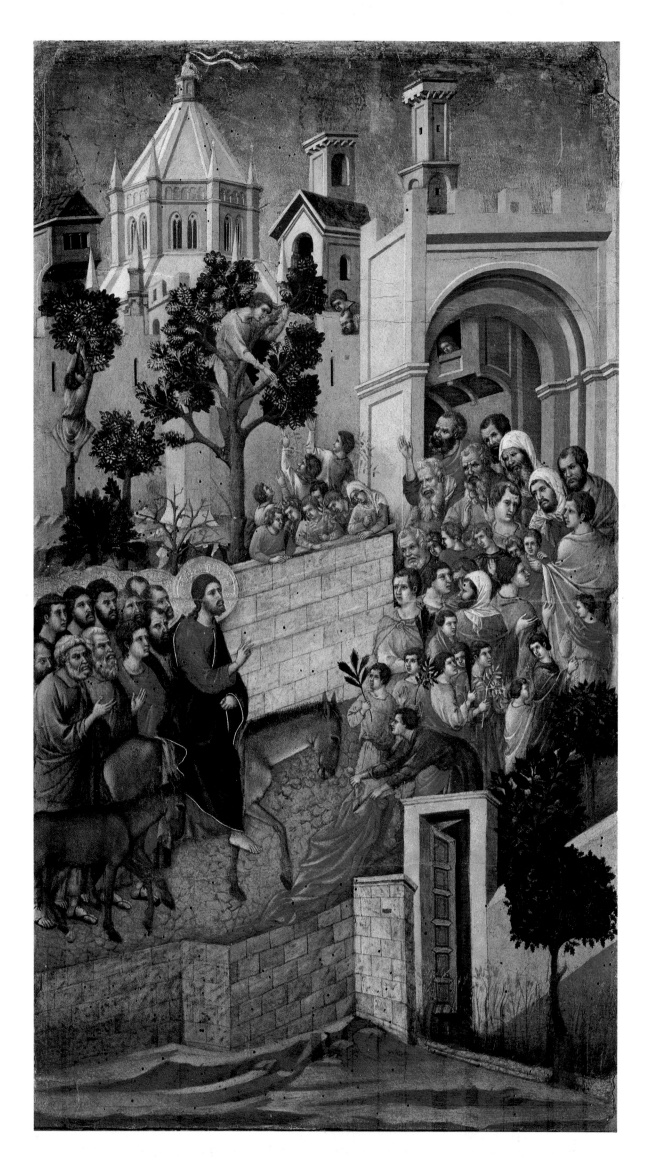

them concerning their brother. When Martha heard that Jesus was coming, she went and met him, while Mary sat in the house. Martha said to Jesus, "Lord, if you had been here, my brother would not have died. And even now I know that whatever you ask from God, God will give you." Jesus said to her. "Your brother will rise again." Martha said to him, "I know that he will rise again in the resurrection at the last day." Jesus said to her, "I am the resurrection and the life; he who believes in me, though he die, yet shall he live, and whoever lives and believes in me, shall never die. Do you believe this?" She said to him, "Yes, Lord; I believe that you are the Christ, the Son of God, he who is coming into the world."

When she had said this, she went and called her sister Mary, saying quietly, "The Teacher is here and is calling for you." And when she heard it, she rose quickly and went to him. Now Jesus had not yet come to the village, but was still in the place where Martha had met him. When the Jews who were with her in the house, consoling her, saw Mary rise quickly and go out, they followed her, supposing that she was going to the tomb to weep there. Then Mary, when she came where Jesus was and saw him, fell at his feet, saying to him, "Lord, if you had been here, my brother would not have died." When Jesus saw her weeping, and the Jews who came with her also weeping, he was deeply moved in spirit and troubled; and he said, "Where have you laid him?" They said to him, "Lord, come and see." Jesus wept. So the Jews said, "See how he loved him!" But some of them said, "Could not he who opened the eyes of the blind man have kept this man from dying?"

Then Jesus, deeply moved again, came to the tomb; it was a cave, and a stone lay upon it. Jesus said, "Take away the stone." Martha, the sister of the dead man, said to him, "Lord, by this time there will be an odour, for he has been dead four days." Jesus said to her, "Did I not tell you that if you would believe you would see the glory of God?" So they took away the stone. And Jesus lifted up his eyes and said, "Father, I thank thee that thou hast heard me. I knew that thou hearest me always, but I have said this on account of the people standing by, that they may believe that thou didst send me." When he had said this, he cried with a loud voice, "Lazarus, come out." The dead man came out, his hands and feet bound with bandages, and his face wrapped with a cloth. Jesus said to them, "Unbind him, and let him go."

And when they drew near to Jerusalem, to Bethphage and Bethany, at the Mount of Olives, he sent two of his disciples, and said to them, "Go into the village opposite you, and immediately as you enter it you will find a colt tied, on which no one has ever sat; untie it and bring it. If any one says to you, 'Why are you doing this?' say, 'The Lord has need of it and will send it back here

MARK
Chapter 11, Verses 3–11

El Greco (Domenikos Theotokopoulos) (1541–1614) 'Christ Driving the Money-Changers from the Temple'

immediately.'" And they went away, and found a colt tied at the door out in the open street; and they untied it. And those who stood there said to them, "What are you doing, untying the colt?" And they told them what Jesus had said; and they let them go. And they brought the colt to Jesus, and threw their garments on it; and he sat upon it. And many spread their garments on the road, and others spread leafy branches which they had cut from the fields. And those who went before and those who followed cried out, "Hosanna! Blessed is he who comes in the name of the Lord! Blessed is the kingdom of our father David that is coming! Hosanna in the highest!"

And he entered Jerusalem, and went into the temple.

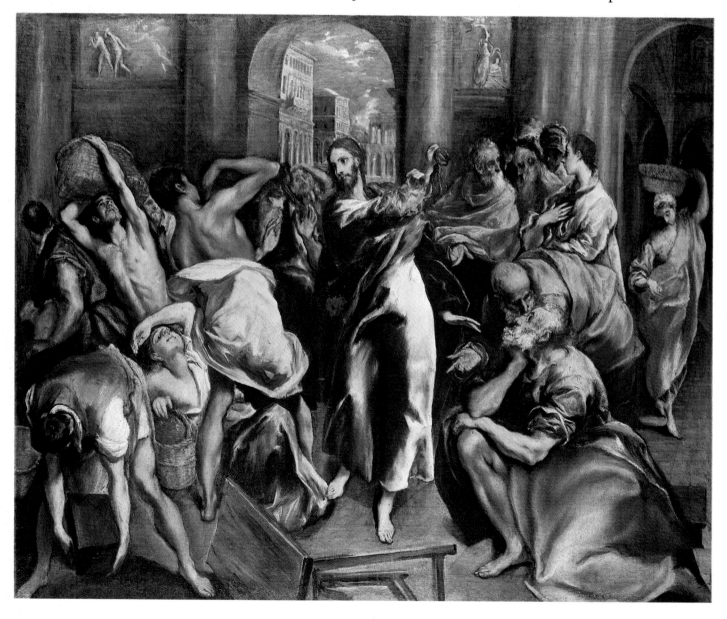

Giovanni Benedetto Castiglione (*c*.1610–1665) 'Christ Driving the Money-Changers from the Temple'

MARK
Chapter 11, Verses 15–18

And they came to Jerusalem. And he entered the temple and began to drive out those who sold and those who bought in the temple, and he overturned the tables of the money-changers and the seats of those who sold pigeons; and he would not allow any one to carry anything through the temple. And he taught, and said to them, "Is it not written, 'My house shall be called a house of prayer for all the nations'? But you have made it a den of robbers." And the chief priests and the scribes heard it and sought a way to destroy him; for they feared him, because all the multitude was astonished at his teaching.

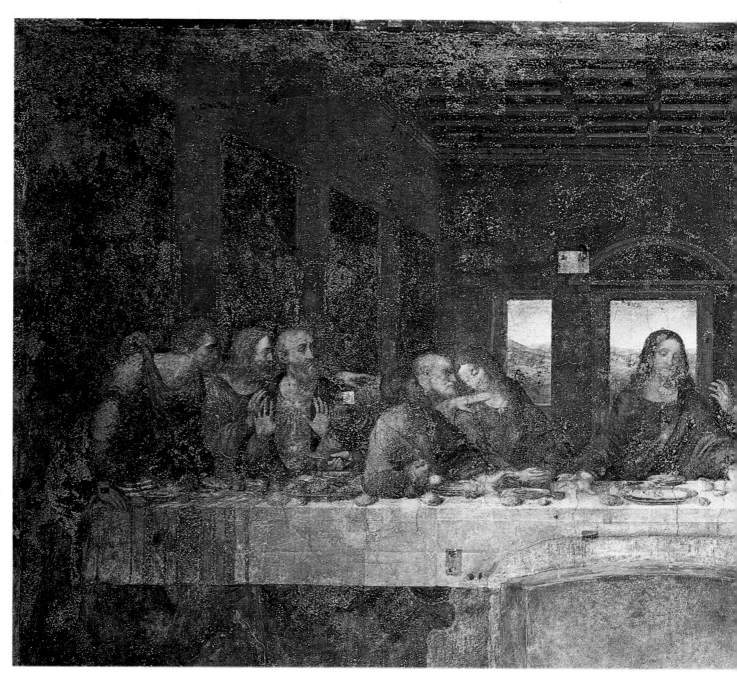

MATTHEW
Chapter 26, Verses 20–29

When it was evening, he sat at table with the twelve disciples; and as they were eating, he said, "Truly, I say to you, one of you will betray me." And they were very sorrowful, and began to say to him one after another, "Is it I, Lord?" He answered, "He who has dipped his hand in the dish with me, will betray me. The Son of man goes as it is written of him, but woe to that man by whom the Son of man is betrayed! It would have been better for that man if he had not been born." Judas, who betrayed him, said, "Is it I, Master?" He said to him, "You have said so."

Now as they were eating, Jesus took bread, and blessed, and broke it, and gave it to the disciples and said, "Take, eat; this is my body." And he took a cup, and when he had given thanks he gave it to them, saying, "Drink of it, all of you; for this is my blood of the covenant, which is poured out for many for the forgiveness of sins. I tell you I shall not drink again of this fruit of the vine until that day when I drink it new with you in my Father's kingdom."

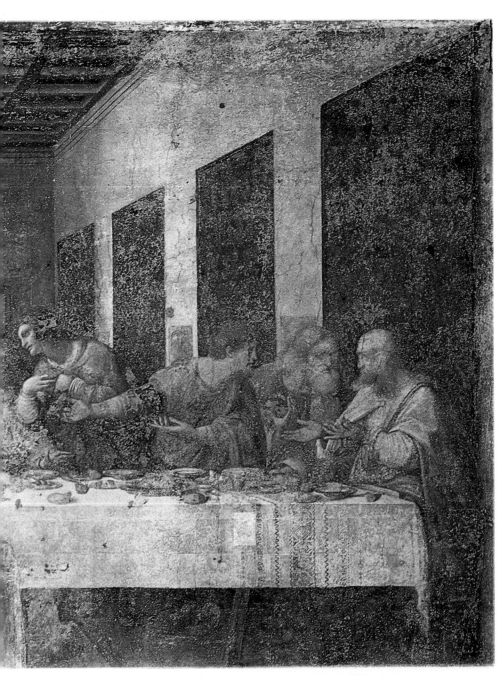

Leonardo da Vinci
(1452–1519)
'The Last Supper'

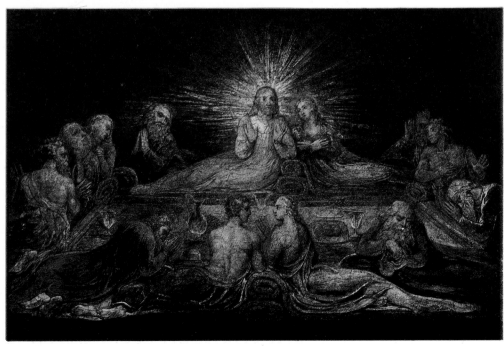

William Blake (1757–1827)
'The Last Supper'

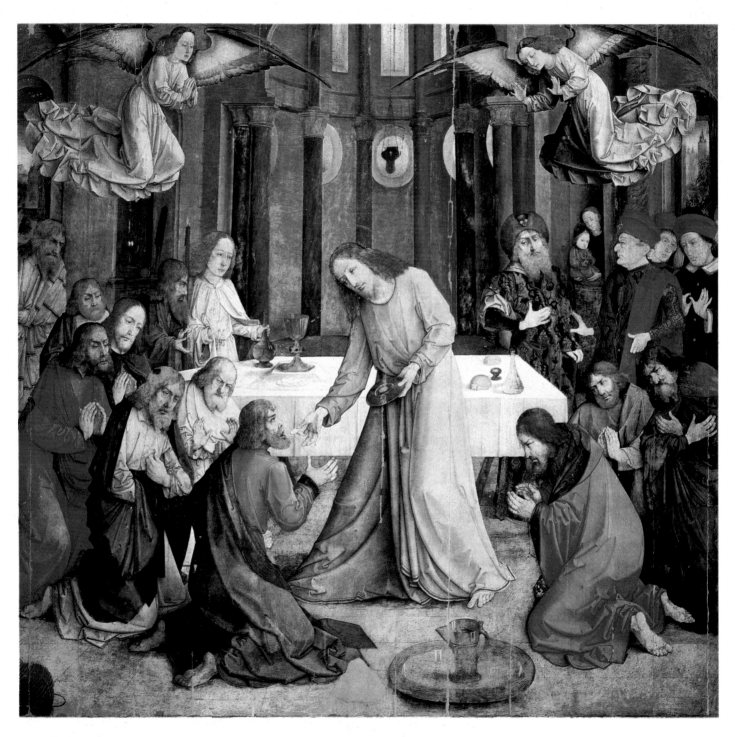

Justus of Ghent
(active Urbino, 1473–1475)
'The Communion of the
Apostles'

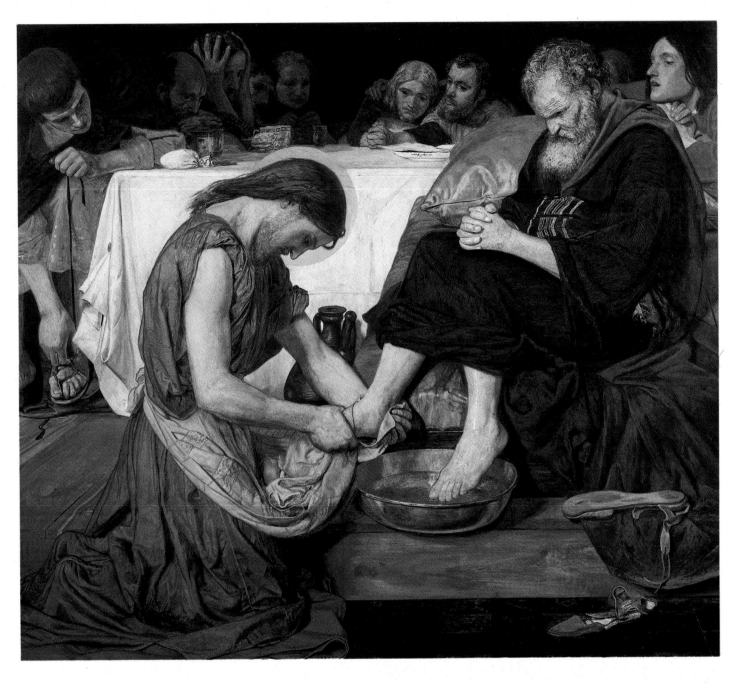

Ford Madox Brown
(1821–1893)
'Christ Washing Peter's Feet'

JOHN
Chapter 13, Verses 3–9

Jesus, knowing that the Father had given all things into his hands, and that he had come from God and was going to God, rose from supper, laid aside his garments, and girded himself with a towel. Then he poured water into a basin, and began to wash the disciples' feet, and to wipe them with the towel with which he was girded. He came to Simon Peter; and Peter said to him, "Lord, do you wash my feet?" Jesus answered him, "What I am doing you do not know now, but afterward you will understand." Peter said to him, "You shall never wash my feet." Jesus answered him, "If I do not wash you, you have no part in me." Simon Peter said to him, "Lord, not my feet only but also my hands and my head!"

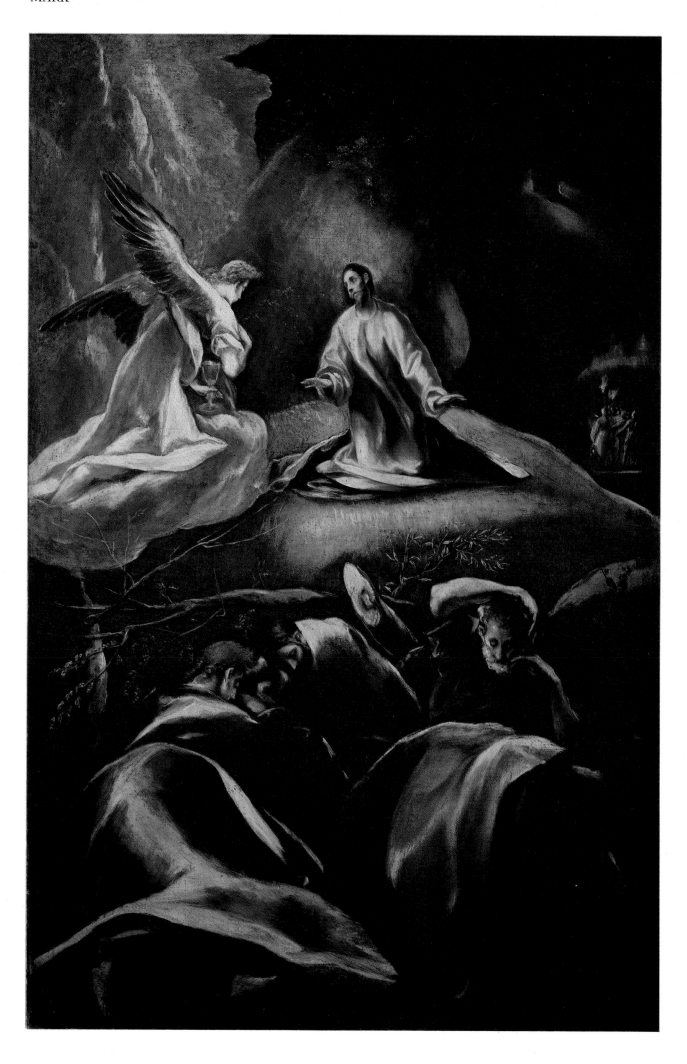

MARK
Chapter 14, Verses 32–42

And they went to a place which was called Gethsemane; and he said to his disciples, "Sit here, while I pray." And he took with him Peter and James and John, and began to be greatly distressed and troubled. And he said to them, "My soul is very sorrowful, even to death; remain here, and watch." And going a little farther, he fell on the ground and prayed that, if it were possible, the hour might pass from him. And he said, "Abba, Father, all things are possible to thee; remove this cup from me; yet not what I will, but what thou wilt." And he came and found them sleeping, and he said to Peter, "Simon, are you asleep? Could you not watch one hour?

Giovanni Bellini
(c.1430–1516)
'The Agony in the Garden'

Watch and pray that you may not enter into temptation; the spirit indeed is willing, but the flesh is weak." And again he went away and prayed, saying the same words. And again he came and found them sleeping, for their eyes were very heavy; and they did not know what to answer him. And he came the third time, and said to them, "Are you still sleeping and taking your rest? It is enough; the hour has come; the Son of man is betrayed into the hands of sinners. Rise, let us be going; see, my betrayer is at hand."

El Greco (1541–1614)
'The Agony in the Garden'

While he was still speaking, Judas came, one of the twelve, and with him a great crowd with swords and clubs, from the chief priests and the elders of the people. Now the betrayer had given them a sign, saying, "The one I shall kiss is the man; seize him." And he came up to Jesus at once and said, "Hail, Master!" And he kissed him. Jesus said to him, "Friend, why are you here?" Then they came up and laid hands on Jesus and seized him. And behold, one of those who were with Jesus stretched out his hand and drew his sword, and struck the slave of the high priest, and cut off his ear. Then Jesus said to him, "Put your sword back into its place; for all who take the sword will perish by the sword. Do you think that I cannot appeal to my Father, and he will at once send me more than twelve legions of angels? But how then should the scriptures be fulfilled, that it must be so?" At that hour Jesus said to the crowds,

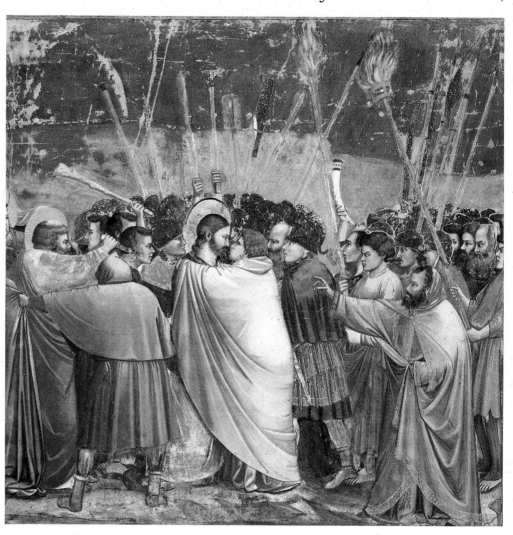

Giotto di Bondone
(1266/76–1337)
'The Betrayal of Christ'

"Have you come out as against a robber, with swords and clubs to capture me? Day after day I sat in the temple teaching, and you did not seize me. But all this has taken place, that the scriptures of the prophets might be fulfilled." Then all the disciples forsook him, and fled.

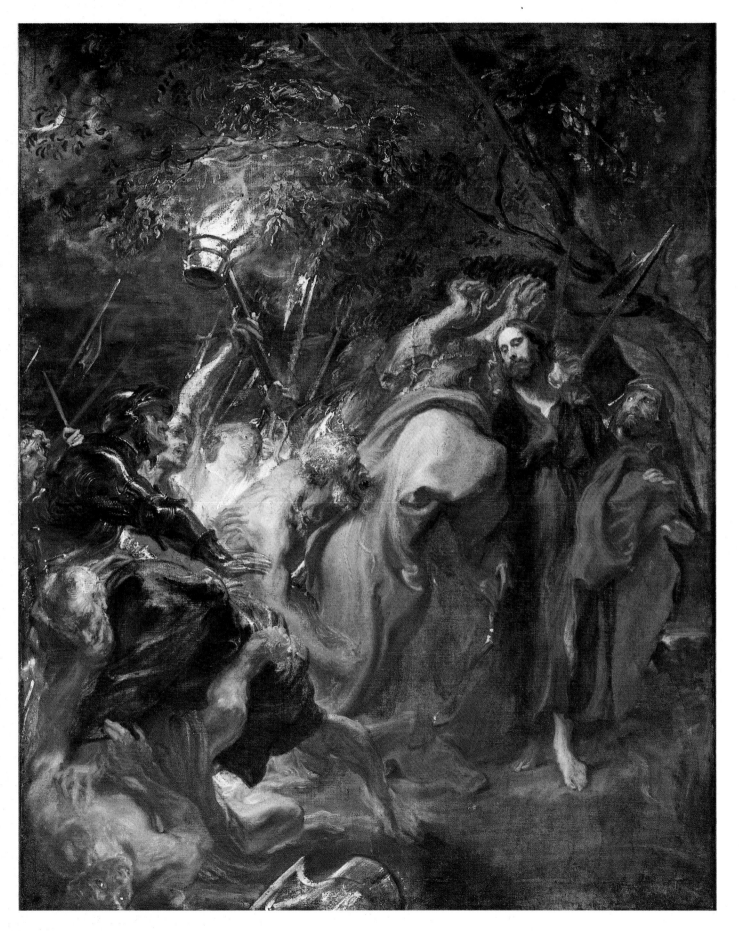

Anthony Van Dyck
(1599–1641)
'The Betrayal of Christ'

Albrecht Altdorfer
(1480–1538)
'Christ Before Caiaphas'

Gerrit van Honthorst
(1590–1656)
Opposite 'Christ Before
Caiaphas'

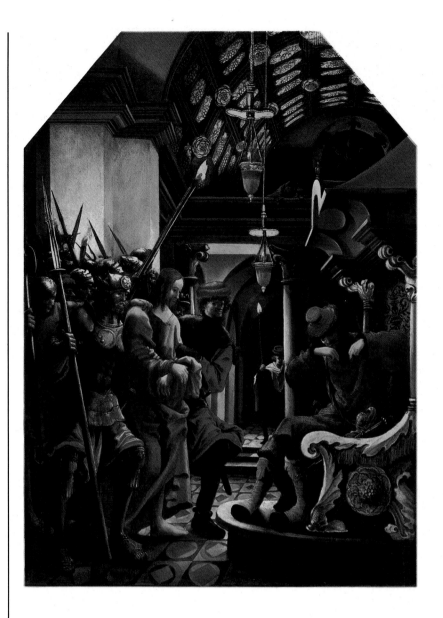

MATTHEW
Chapter 26, Verses 57–66

Then those who had seized Jesus led him to Caiaphas the high priest, where the scribes and the elders had gathered. But Peter followed him at a distance, as far as the courtyard of the high priest, and going inside he sat with the guards to see the end. Now the chief priests and the whole council sought false testimony against Jesus that they might put him to death, but they found none, though many false witnesses came forward. At last two came forward and said, "This fellow said, 'I am able to destroy the temple of God, and to build it in three days.'" And the high priest stood up and said, "Have you no answer to make? What is it that these men testify against you?" But Jesus was silent. And the high priest said to him, "I adjure you by the living God, tell us if you are the Christ, the Son of God." Jesus said to him, "You have said so. But I tell you, hereafter you will see the Son of man seated at the right hand of Power, and coming on the clouds of heaven." Then the high priest tore his robes, and said, "He has uttered blasphemy. Why do we still need witnesses? You have now heard his blasphemy. What is your judgment?" They answered, "He deserves death."

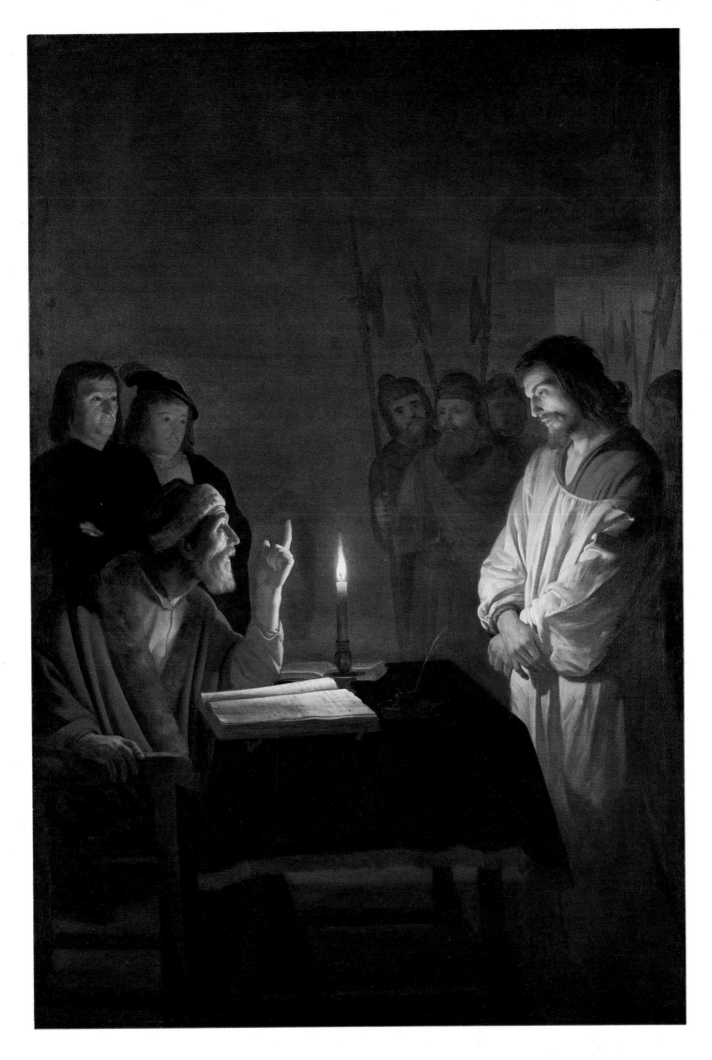

LUKE Chapter 22, Verses 54–62

Then they seized him and led him away, bringing him into the high priest's house. Peter followed at a distance; and when they had kindled a fire in the middle of the courtyard and sat down together, Peter sat among them. Then a maid, seeing him as he sat in the light and gazing at him, said, "This man also was with him." But he denied it, saying, "Woman, I do not know him." And a little later some one else saw him and said, "You also are one of them." But Peter said, "Man, I am not." And after an interval of about an hour still another insisted, saying, "Certainly this man also was with him; for he is a Galilean." But Peter said, "Man, I do not know what you are saying." And immediately, while he was still speaking, the cock crowed. And the Lord turned and looked at Peter. And Peter remembered the word of the Lord, how he had said to him, "Before the cock crows today, you will deny me three times." And he went out and wept bitterly.

Anonymous Italian, Caravaggesque
(early seventeenth century)
'Peter's Denial'

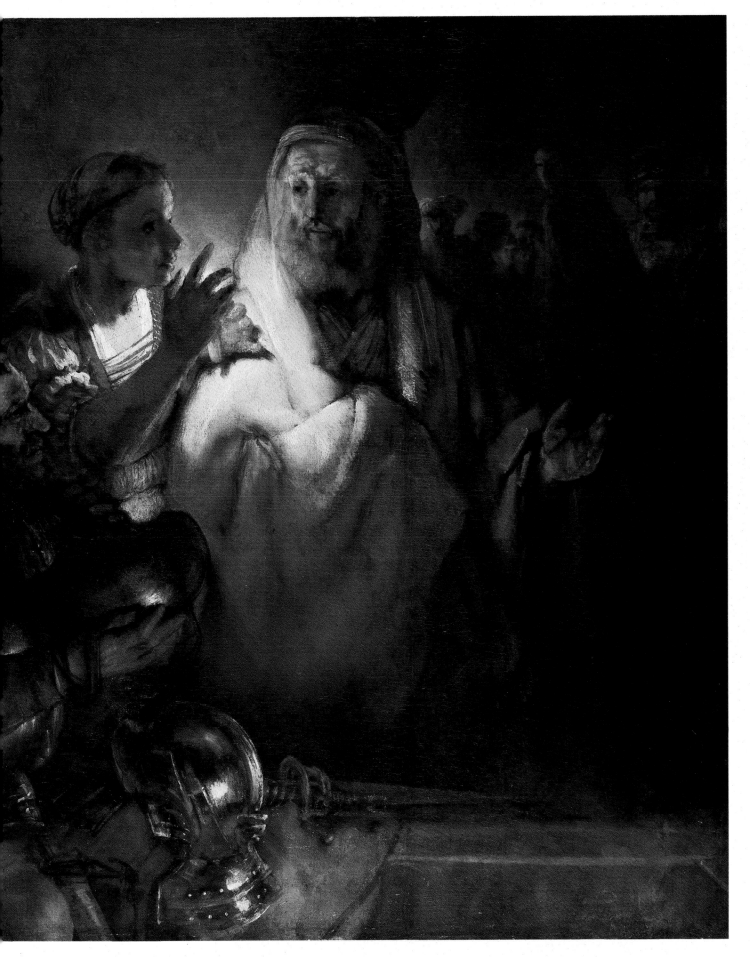

Rembrandt (1606–1669)
'The Denial of Peter'

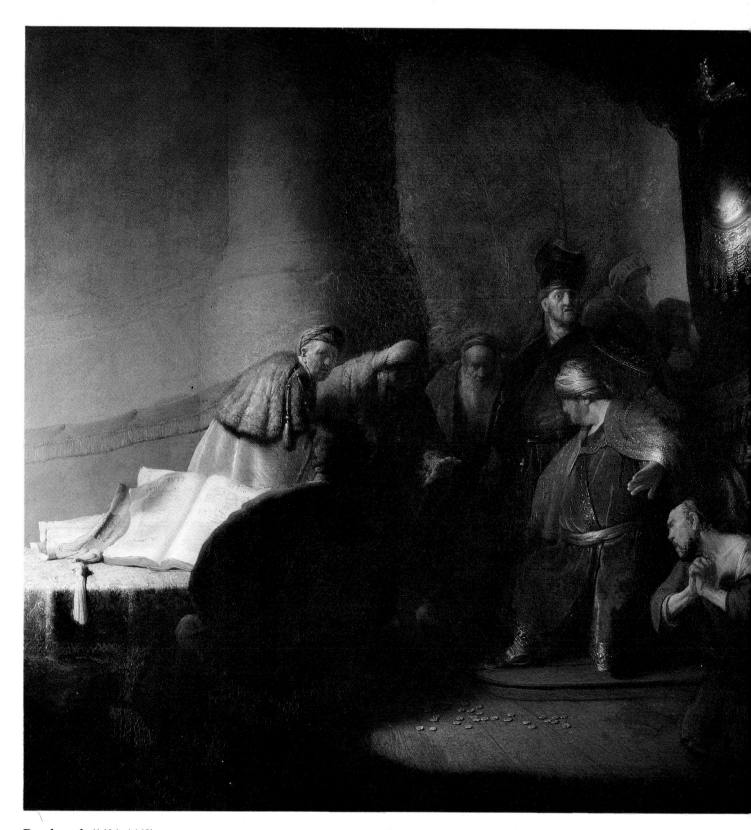

Rembrandt (1606–1669)
'Judas Returning the Thirty
Pieces of Silver'

When morning came, all the chief priests and the elders of the people took counsel against Jesus to put him to death; and they bound him and led him away and delivered him to Pilate the governor.

When Judas, his betrayer, saw that he was condemned, he repented and brought back the thirty pieces of silver to the chief priests and the elders, saying, "I have sinned in betraying innocent blood." They said, "What is that to us? See to it yourself." And throwing down the pieces of silver in the temple, he departed; and he went and hanged himself.

But the chief priests, taking the pieces of silver, said, "It is not lawful to put them into the treasury, since they are blood money." So they took counsel, and bought with them the potter's field, to bury strangers in. Therefore that field has been called the Field of Blood to this day.

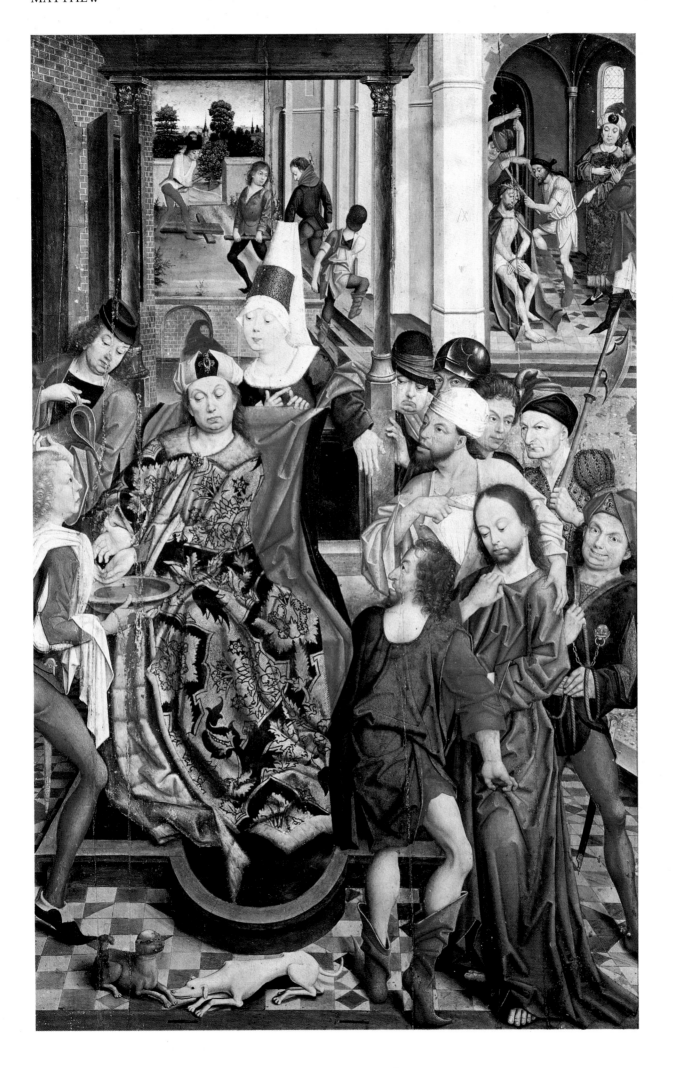

Now Jesus stood before the governor; and the governor asked him, "Are you the King of the Jews?" Jesus said, "You have said so." But when he was accused by the chief priests and elders, he made no answer. Then Pilate said to him, "Do you not hear how many things they testify against you?" But he gave him no answer, not even to a single charge; so that the governor wondered greatly.

Now at the feast the governor was accustomed to release for the crowd any one prisoner whom they wanted. And they had then a notorious prisoner, called Barabbas. So when they had gathered, Pilate said to them, "Whom do you want me to release for you, Barabbas or Jesus who is called Christ?" For he knew that it was out of envy that they had delivered him up. Besides, while he was sitting on the judgment seat, his wife sent word to him, "Have nothing to do with that righteous man, for I have suffered much over him today in a dream." Now the chief priests and the elders persuaded the people to ask for Barabbas and destroy Jesus. The governor again said to them, "Which of the two do you want me to release for you?" And they said, "Barabbas." Pilate said to them, "Then what shall I do with Jesus who is called Christ?" They all said, "Let him be crucified." And he said, "Why, what evil has he done?" But they shouted all the more, "Let him be crucified."

So when Pilate saw that he was gaining nothing, but rather that a riot was beginning, he took water and washed his hands before the crowd, saying, "I am innocent of this man's blood; see to it yourselves." And all the people answered, "His blood be on us and on our children!" Then he released for them Barabbas, and having scourged Jesus, delivered him to be crucified.

Derick Baegert (1440–1515)
'Christ Before Pilate'

Then the soldiers of the governor took Jesus into the praetorium, and they gathered the whole battalion before him. And they stripped him and put a scarlet robe upon him, and plaiting a crown of thorns they put it on his head, and put a reed in his right hand. And kneeling before him they mocked him, saying, "Hail, King of the Jews!" And they spat upon him, and took the reed and struck him on the head. And when they had mocked him, they stripped him of the robe, and put his own clothes off him, and led him away to crucify him.

MATTHEW
Chapter 27, Verses 27–31

Jorg Breu (1475/6–1537)
'The Crowning with Thorns'

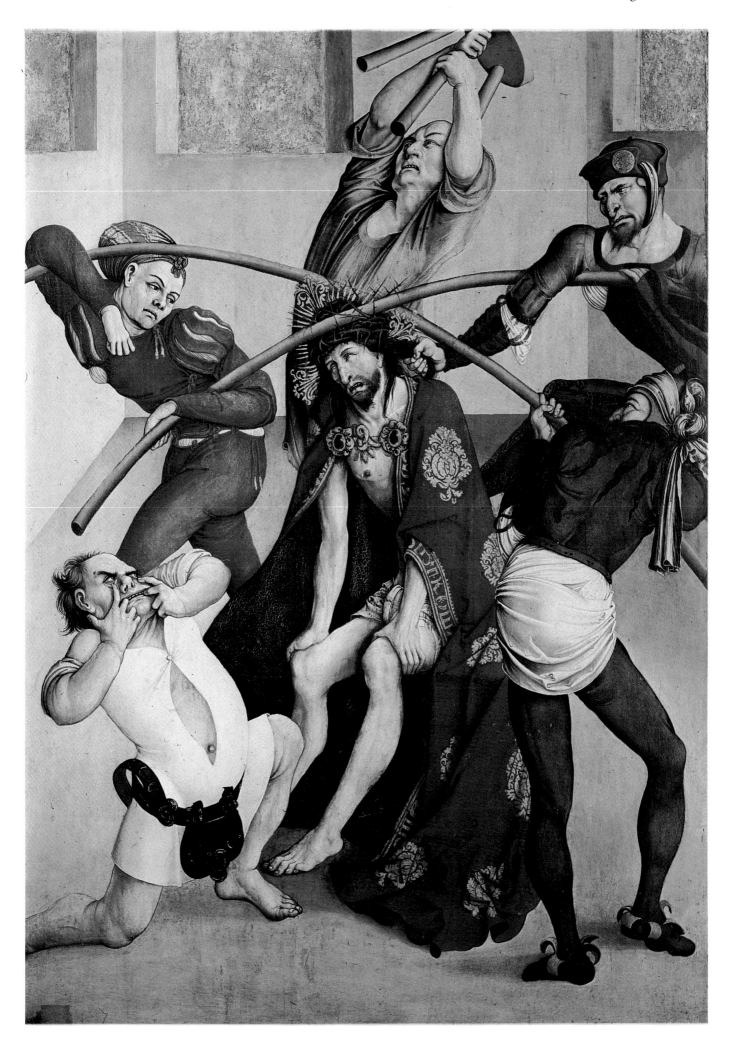

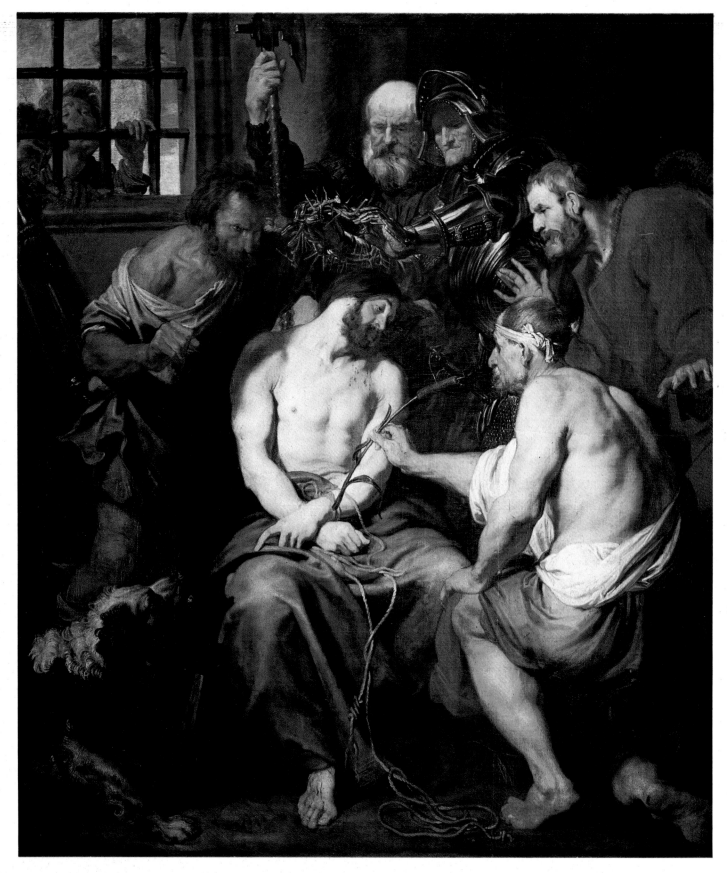

Anthony Van Dyck
(1599–1641)
Above 'The Crowning with
Thorns'

Titian (Tiziano Vecellio)
(1488/9–1576)
Opposite 'The Crowning with
Thorns'

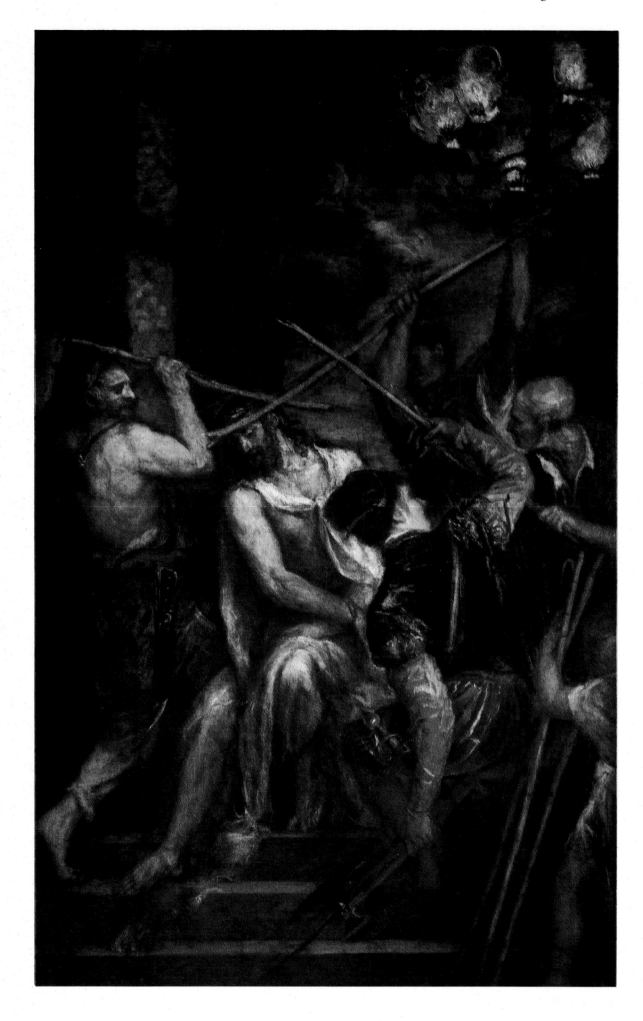

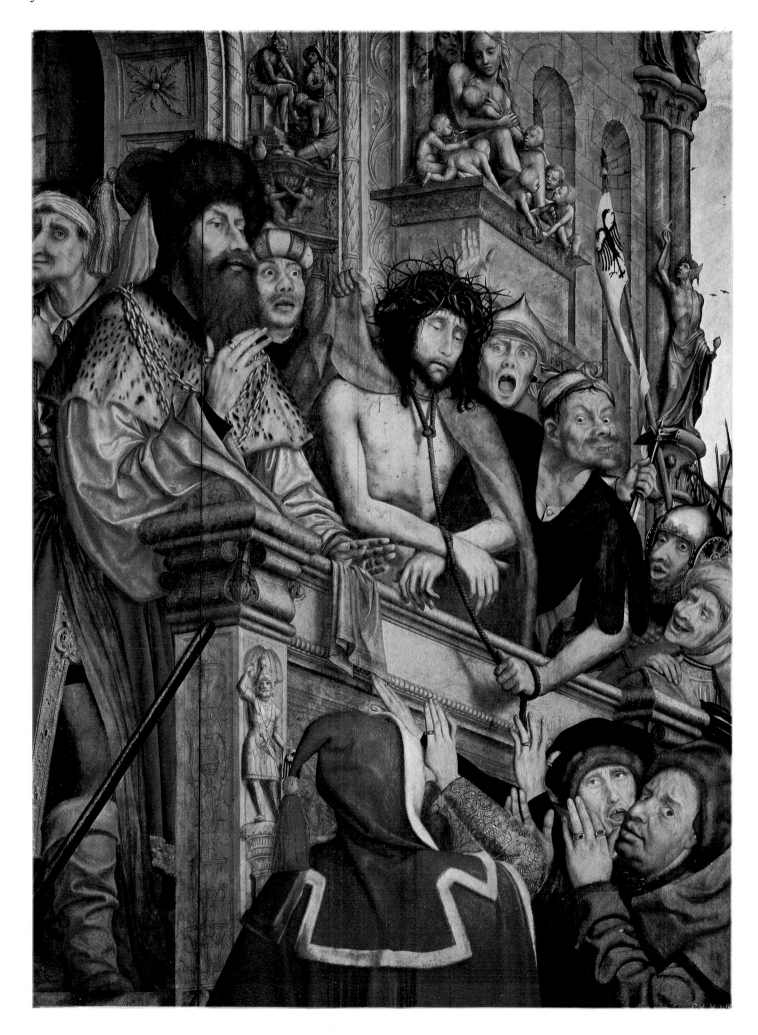

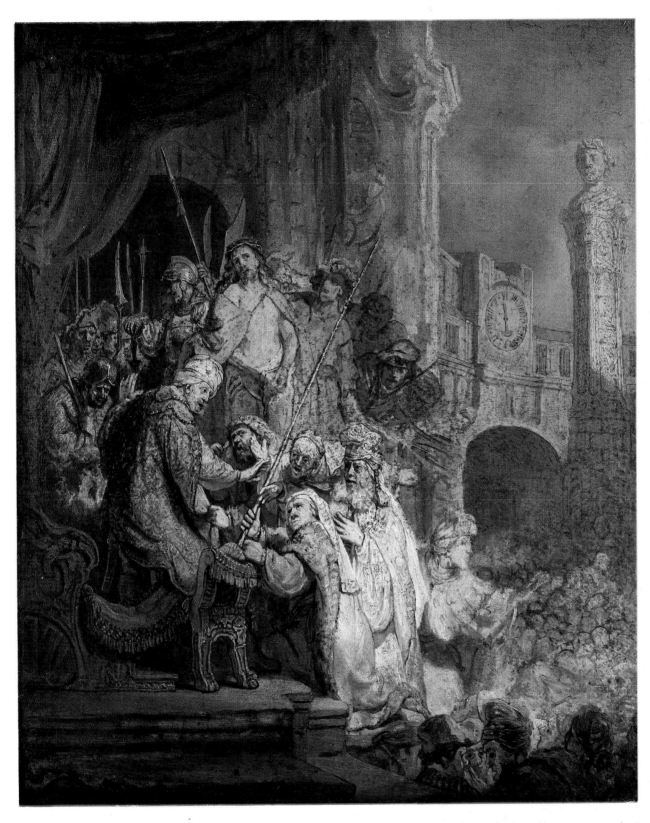

Rembrandt (1606–1669)
Above 'Christ Presented to the People'

JOHN
Chapter 19, Verses 4–7

Quentin Massys (or Metsys)
(1464/5–1530)
Left 'Ecce Homo'

Pilate went out again, and said to them, "See, I am bringing him out to you, that you may know that I find no crime in him." So Jesus came out, wearing the crown of thorns and the purple robe. Pilate said to them, "Behold the man!" When the chief priests and the officers saw him, they cried out, "Crucify him, crucify him!" Pilate said to them, "Take him yourselves and crucify him, for I find no crime in him." The Jews answered him, "We have a law, and by that law he ought to die, because he has made himself the Son of God."

**Mathias Grünewald (Mathis
Gothart Neithart)**
(*c.*1460–1528)
'Christ Carrying the Cross'

Hieronymus Bosch
(*c.*1450–1516)
'Christ Carrying the Cross'

MARK
Chapter 15, Verses 21–23

And they compelled a passer-by, Simon of Cyrene, who was coming in from the country, the father of Alexander and Rufus, to carry his cross. And they brought him to the place called Golgotha (which means the place of a skull). And they offered him wine mingled with myrrh; but he did not take it.

Masaccio (1401–1428)
Page 228 'The Crucifixion'

Rubens (1577–1640)
Page 229 'The Crucifixion'

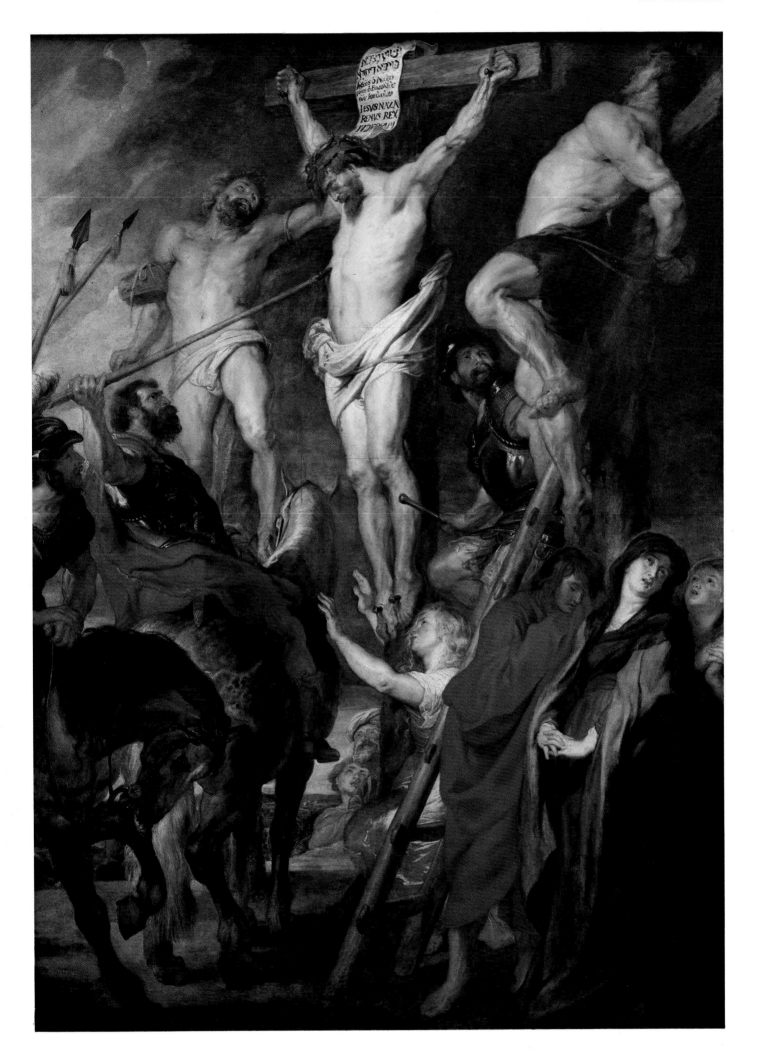

MARK Chapter 15, Verses 24–39

And they crucified him, and divided his garments among them, casting lots for them, to decide what each should take. And it was the third hour, when they crucified him. And the inscription of the charge against him read, "The King of the Jews." And with him they crucified two robbers, one on his right and one on his left. And those who passed by derided him, wagging their heads, and saying, "Aha! You who would destroy the temple and build it in three days, save yourself, and come down from the cross!" So also the chief priests mocked him to one another with the scribes, saying, "He saved others; he cannot save himself. Let the Christ, the King of Israel, come down now from the cross, that we may see and believe." Those who were crucified with him also reviled him.

And when the sixth hour had come, there was darkness over the whole land until the ninth hour. And at the ninth hour Jesus cried with a loud voice, "Eloi, Eloi, lama sabachthani?" which means "My God, my God, why hast thou forsaken me?" And some of the bystanders hearing it said, "Behold, he is calling Elijah." And one ran and, filling a sponge full of vinegar, put it on a reed and gave it to him to drink, saying, "Wait, let us see whether Elijah will come to take him down." And Jesus uttered a loud cry, and breathed his last. And the curtain of the temple was torn in two, from top to bottom. And when the centurion, who stood facing him, saw that he thus breathed his last, he said, "Truly this man was the Son of God!"

JOHN Chapter 19, Verses 31–37

Since it was the day of Preparation, in order to prevent the bodies from remaining on the cross on the sabbath (for that sabbath was a high day), the Jews asked Pilate that their legs might be broken, and that they might be taken away. So the soldiers came and broke the legs of the first, and of the other who had been crucified with him; but when they came to Jesus and saw that he was already dead, they did not break his legs. But one of the soldiers pierced his side with a spear, and at once there came out blood and water. He who saw it has borne witness—his testimony is true, and he knows that he tells the truth—that you also may believe. For these things took place that the scripture might be fulfilled, "Not a bone of him shall be broken." And again another scripture says, "They shall look on him whom they have pierced."

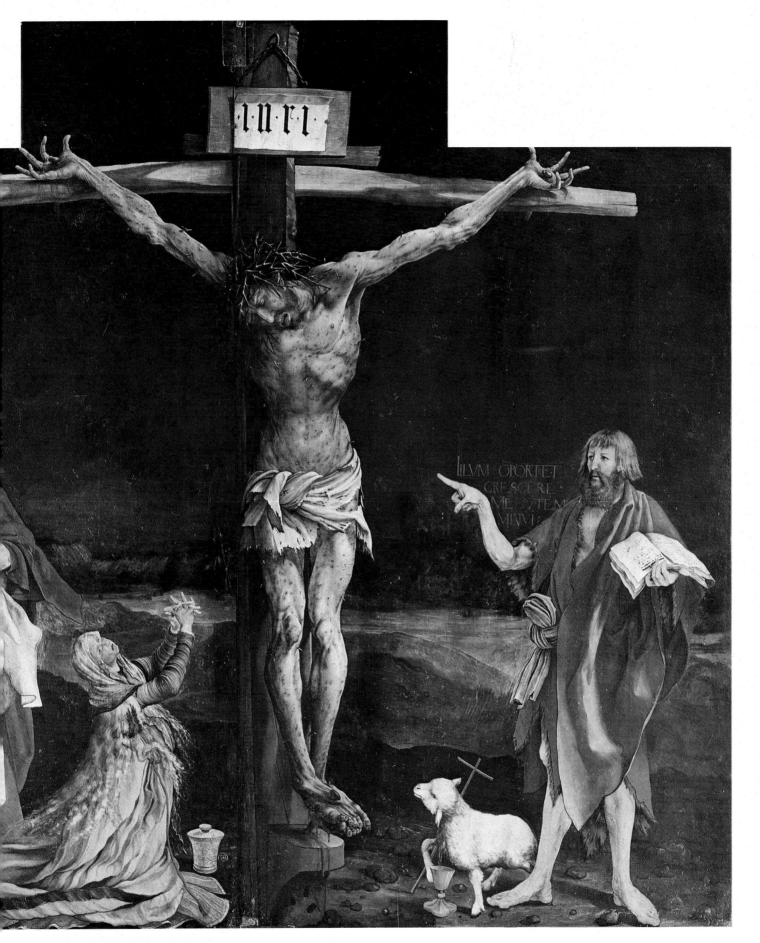

Mathias Grünewald
(*c.*1460–1528)
'The Crucifixion'

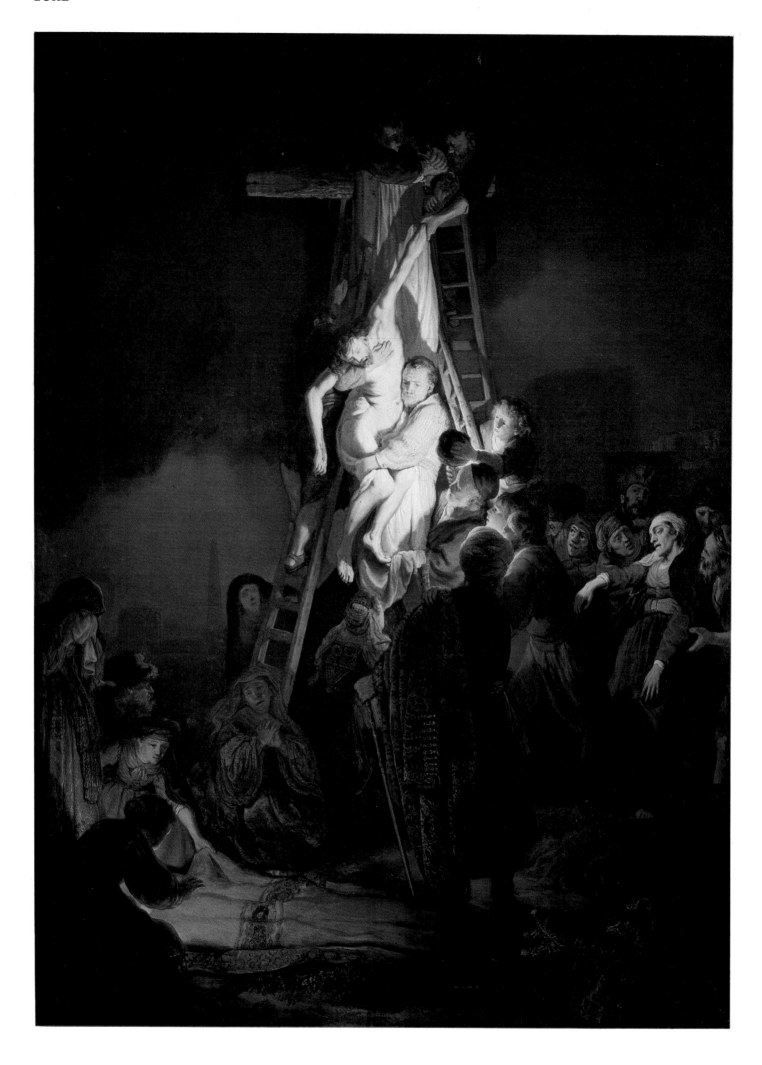

Rembrandt (1606–1669)
Left 'The Descent from the
Cross'

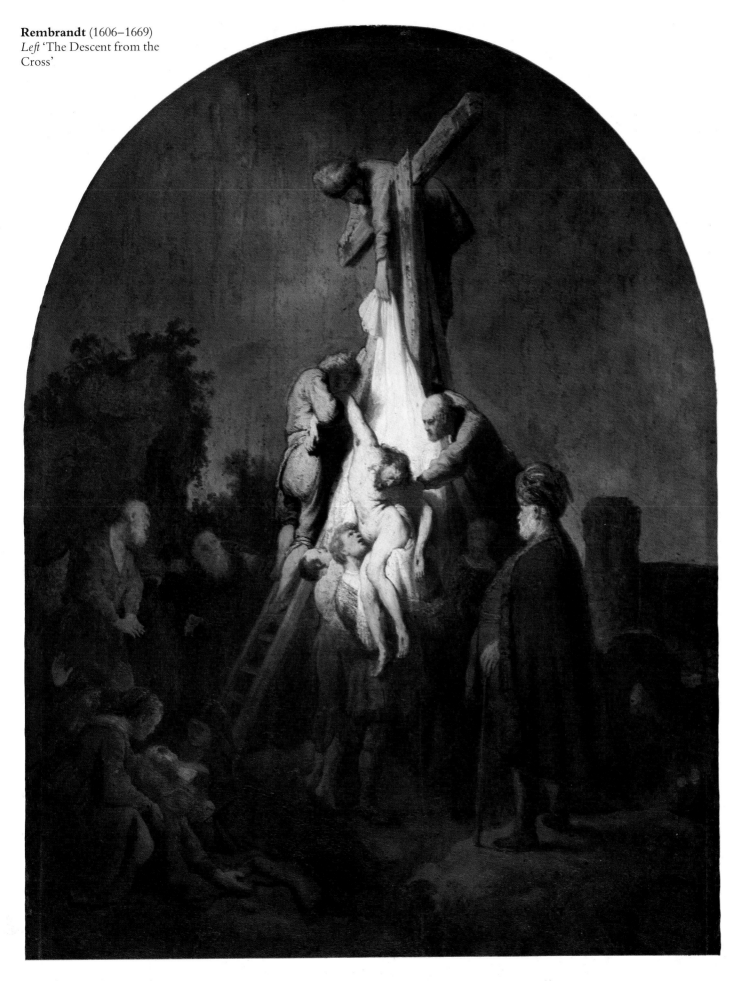

Rembrandt (1606–1669)
Above 'The Descent from the
Cross'

233

The Master of the Virgo Inter Virgines
(active *c*.1470–1500)
'The Deposition'

LUKE
Chapter 23, Verses 50–56

The Master of the St Bartholomew Altarpiece
(active 1475–1510)
'The Deposition'

Now there was a man named Joseph from the Jewish town of Arimathea. He was a member of the council, a good and righteous man, who had not consented to their purpose and deed, and he was looking for the kingdom of God. This man went to Pilate and asked for the body of Jesus. Then he took it down and wrapped it in a linen shroud, and laid him in a rock-hewn tomb, where no one had ever yet been laid. It was the day of Preparation, and the sabbath was beginning. The women who had come with him from Galilee followed, and saw the tomb, and how his body was laid; then they returned, and prepared spices and ointments.

On the sabbath they rested according to the commandment.

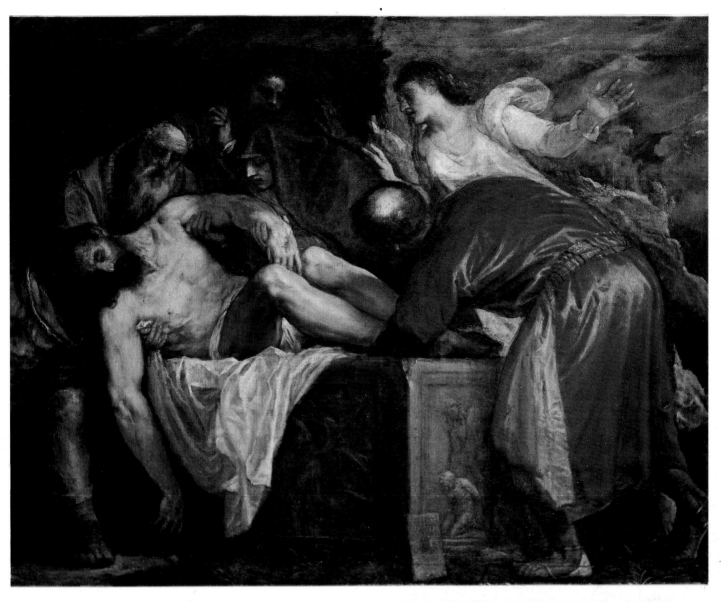

Titian (1488/9–1576)
Above 'The Entombment'

Rubens (1577–1640)
Right 'The Entombment'

Jacopo Bassano
(1517/18–1592)
Left 'The Entombment'

Next day, that is, after the day of Preparation, the chief priests and the Pharisees gathered before Pilate and said, "Sir, we remember how that impostor said, while he was still alive, 'After three days I will rise again.' Therefore order the sepulchre to be made secure until the third day, lest his disciples go and steal him away, and tell the people, 'He has risen from the dead,' and the last fraud will be worse than the first." Pilate said to them, "You have a guard of soldiers; go, make it as secure as you can." So they went and made the sepulchre secure by sealing the stone and setting a guard.

Now after the sabbath, toward the dawn of the first day of the week, Mary Magdalene and the other Mary went to see the sepulchre. And behold, there was a great earthquake; for an angel of the Lord descended from heaven and came and rolled back the stone, and sat upon it. His appearance was like lightning, and his raiment white as snow. And for fear of him the guards trembled and became like dead men.

Benjamin Gerritz Cuyp
(1612–1652)
'The Angel Opening the
Sepulchre'

MATTHEW
Chapter 27, Verses 62–66

MATTHEW
Chapter 28, Verses 1–4

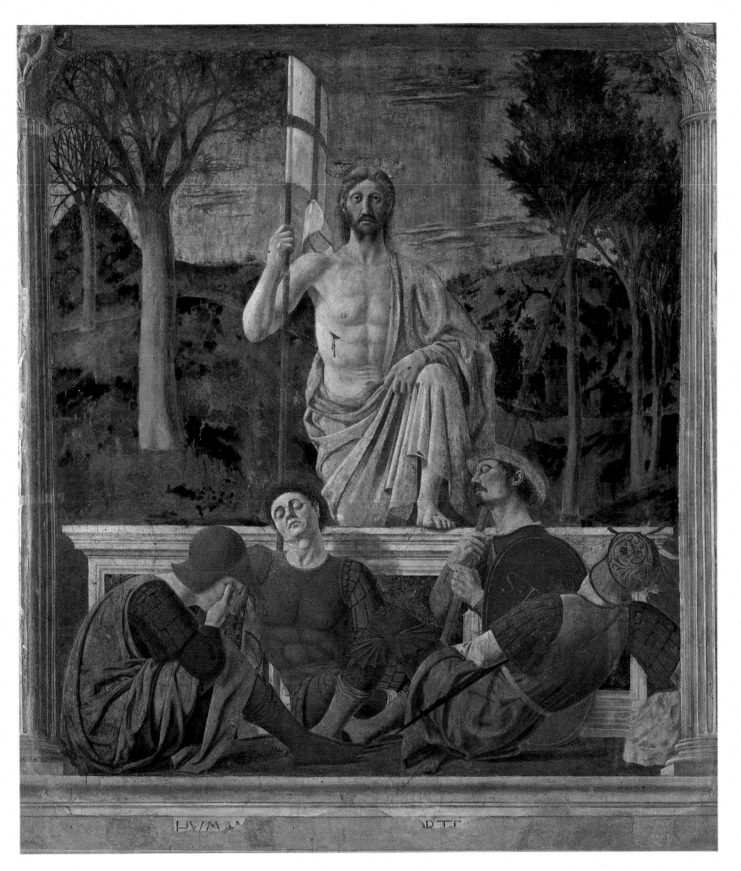

Piero della Francesca
(*c*.1416–1492)
'The Resurrection'

But Mary stood weeping outside the tomb, and as she wept she stooped to look into the tomb; and she saw two angels in white, sitting where the body of Jesus had lain, one at the head and one at the feet. They said to her, "Woman, why are you weeping?" She said to them, "Because they have taken away my Lord, and I do not know where they have laid him." Saying this, she turned round and saw Jesus standing, but she did not know that it was Jesus. Jesus said to her, "Woman, why are you weeping? Whom do you seek?" Supposing him to be the gardener, she said to him, "Sir, if you have carried him away, tell me where you have laid him, and I will take him away." Jesus said to her, "Mary." She turned and said to him in Hebrew, "Rabboni!" (which means Teacher). Jesus said to her, "Do not hold me, for I have not yet ascended to the Father; but go to my brethren and say to them, I am ascending to my Father and your Father, to my God and your God."

JOHN
Chapter 20, Verses 11–17

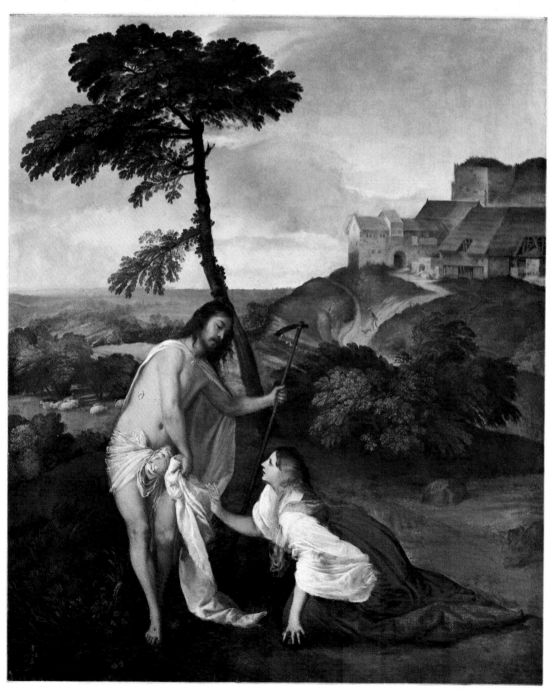

Titian (1488/9–1576)
'Noli Me Tangere'

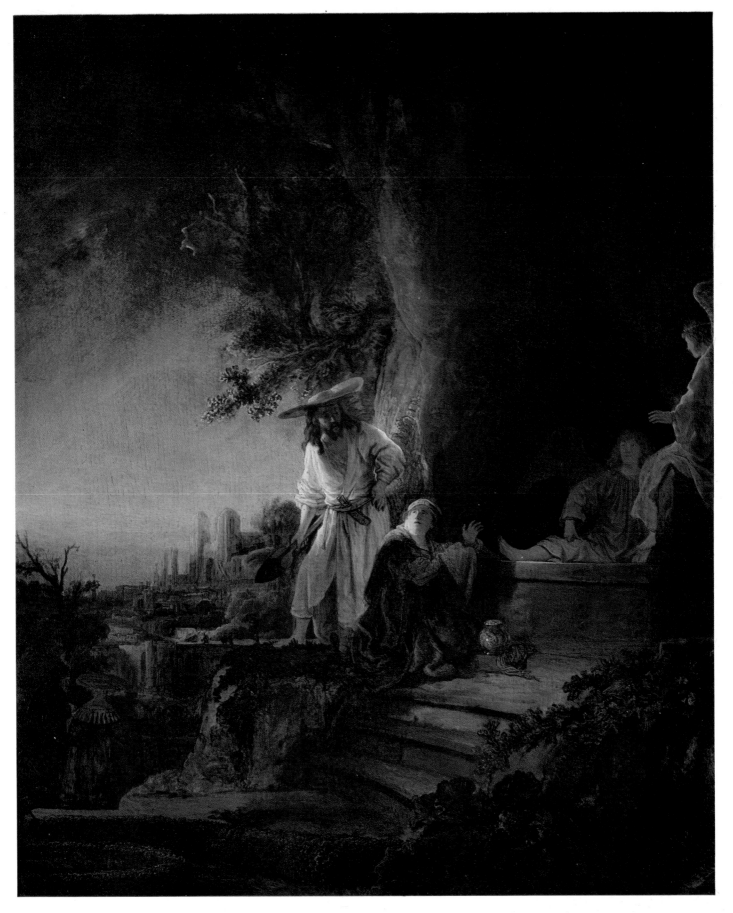

Rembrandt (1606–1669)
'The Risen Christ Appearing to
the Magdalen'

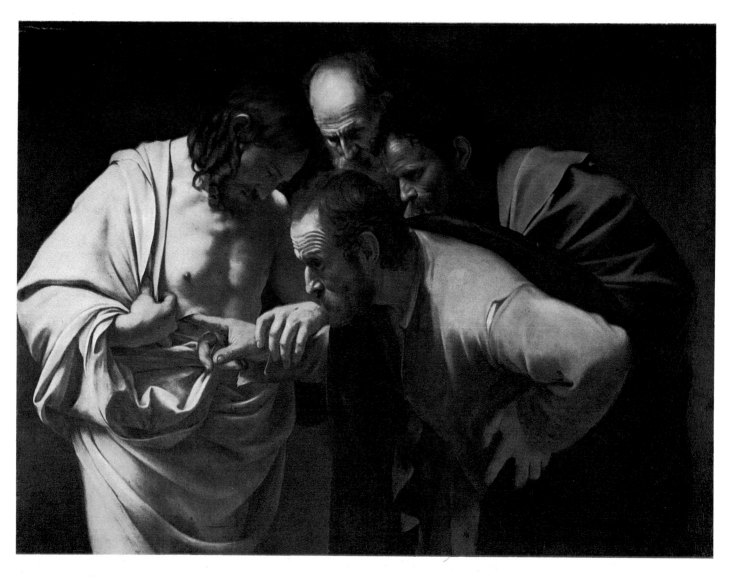

Now Thomas, one of the twelve, called the Twin, was not with them when Jesus came. So the other disciples told him, "We have seen the Lord." But he said to them, "Unless I see in his hands the print of the nails, and place my finger in the mark of the nails, and place my hands in his side, I will not believe."

Eight days later, his disciples were again in the house, and Thomas was with them. The doors were shut, but Jesus came and stood among them, and said, "Peace be with you." Then he said to Thomas, "Put your finger here, and see my hands, and put out your hand, and place it in my side; do not be faithless, but believing." Thomas answered him, "My Lord and my God!" Jesus said to him, "Have you believed because you have seen me? Blessed are those who have not seen and yet believe."

Caravaggio (1573–1610)
'Doubting Thomas'

JOHN
Chapter 20, Verses 24–29

Scarsellino (Ippolito Scarsella) (*c.*1550–1620)

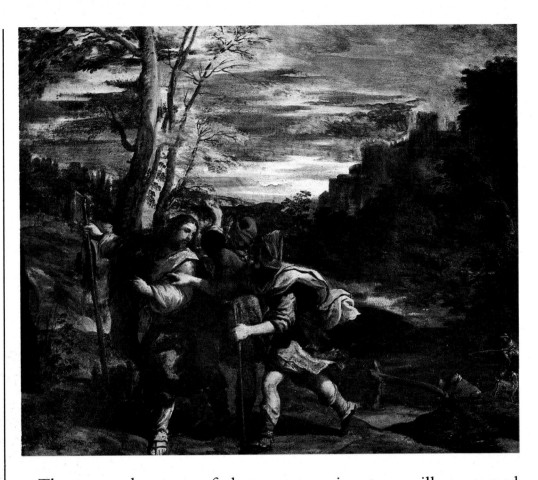

LUKE
Chapter 24, Verses 13–26

That very day two of them were going to a village named Emmaus, about seven miles from Jerusalem, and talking with each other about all these things that had happened. While they were talking and discussing together, Jesus himself drew near and went with them. But their eyes were kept from recognizing him. And he said to them, "What is this conversation which you are holding with each other as you walk?" And they stood still, looking sad. Then one of them, named Cleopas, answered him, "Are you the only visitor to Jerusalem who does not know the things that have happened there in these days?" And he said to them, "What things?" And they said to him, "Concerning Jesus of Nazareth, who was a prophet mighty in deed and word before God and all the people, and how our chief priests and rulers delivered him up to be condemned to death, and crucified him. But we had hoped that he was the one to redeem Israel. Yes, and besides all this, it is now the third day since this happened. Moreover, some women of our company amazed us. They were at the tomb early in the morning and did not find his body; and they came back saying that they had even seen a vision of angels, who said that he was alive. Some of those who were with us went to the tomb, and found it just as the women had said; but him they did not see." And he said to them, "O foolish men, and slow of heart to believe all that the prophets have spoken! Was it not necessary that the Christ should suffer these things and enter into his glory?"

LUKE Chapter 24, Verses 28–35

So they drew near to the village to which they were going. He appeared to be going further, but they constrained him, saying, "Stay with us, for it is toward evening and the day is now far spent." So he went in to stay with them. When he was at table with them, he took the bread and blessed, and broke it, and gave it to them. And their eyes were opened and they recognized him; and he vanished out of their sight. They said to each other, "Did not our hearts burn within us while he talked to us on the road, while he opened to us the scriptures?" And they rose that same hour and returned to Jerusalem; and they found the eleven gathered together and those who were with them, who said, "The Lord has risen indeed, and has appeared to Simon!" Then they told what had happened on the road, and how he was known to them in the breaking of the bread.

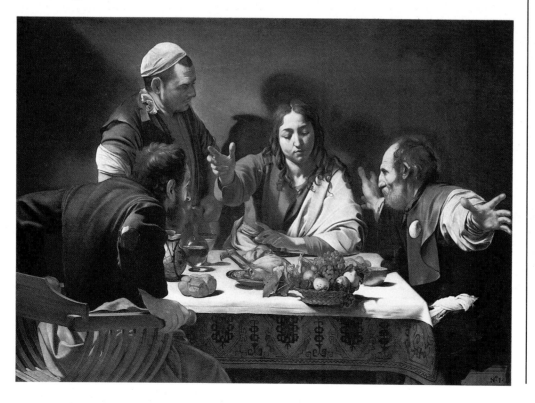

Rembrandt (1606–1669)
'The Supper at Emmaus'

Caravaggio (1573–1610)
'The Supper at Emmaus'

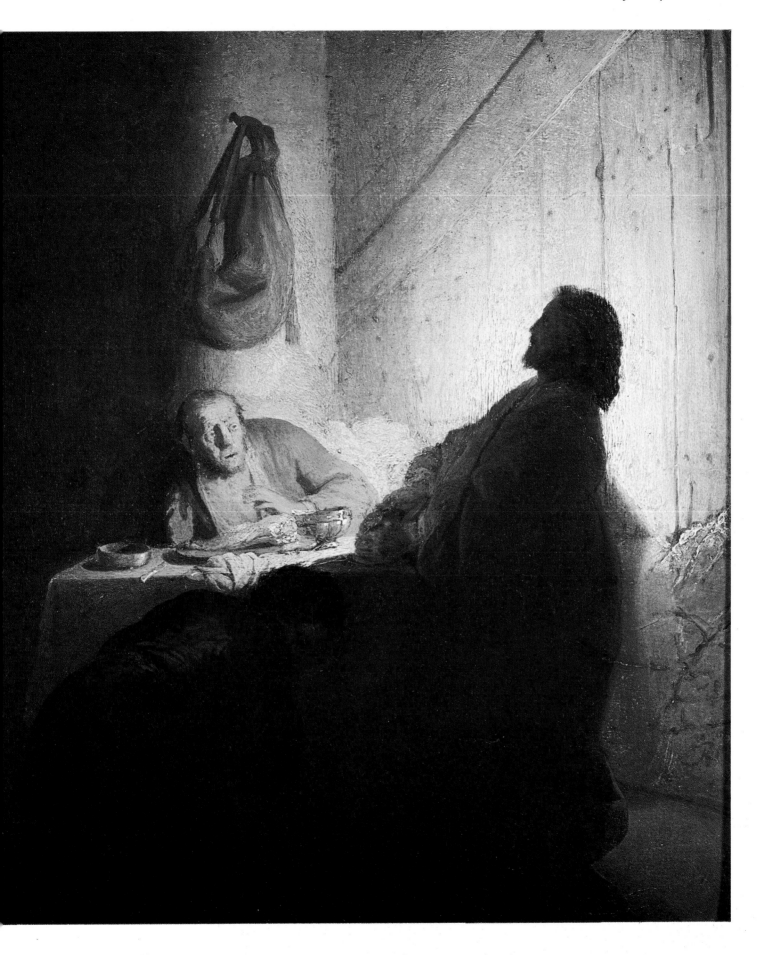

LUKE
Chapter 24, Verses 50–53

Then he led them out as far as Bethany, and lifting up his hands he blessed them. While he blessed them, he parted from them, and was carried up into heaven. And they returned to Jerusalem with great joy, and were continually in the temple blessing God.

Rembrandt (1606–1669)
'The Ascension'

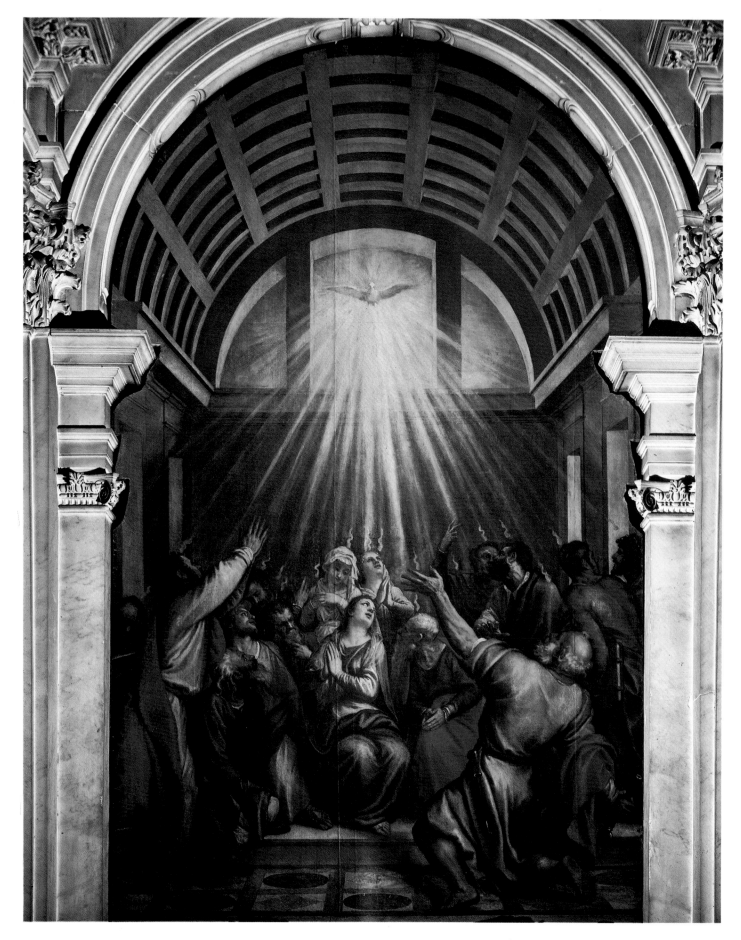

Titian (1488/9–1576)
'The Pentecost'

When the day of Pentecost had come, they were all together in one place. And suddenly a sound came from heaven like the rush of a mighty wind, and it filled all the house where they were sitting. And there appeared to them tongues as of fire, distributed and resting on each one of them. And they were all filled with the Holy Spirit and began to speak in other tongues, as the Spirit gave them utterance.

Now there were dwelling in Jerusalem Jews, devout men from every nation under heaven. And at this sound the multitude came together, and they were bewildered, because each one heard them speaking in his own language. And they were amazed and wondered, saying, "Are not all these who are speaking Galileans? And how is it that we hear, each of us in his own native language? Parthians and Medes and Elamites and residents of Mesopotamia, Judea and Cappadocia, Pontus and Asia, Phrygia and Pamphylia, Egypt and the parts of Libya belonging to Cyrene, and visitors from Rome, both Jews and proselytes, Cretans and Arabians, we hear them telling in our own tongues the mighty works of God."

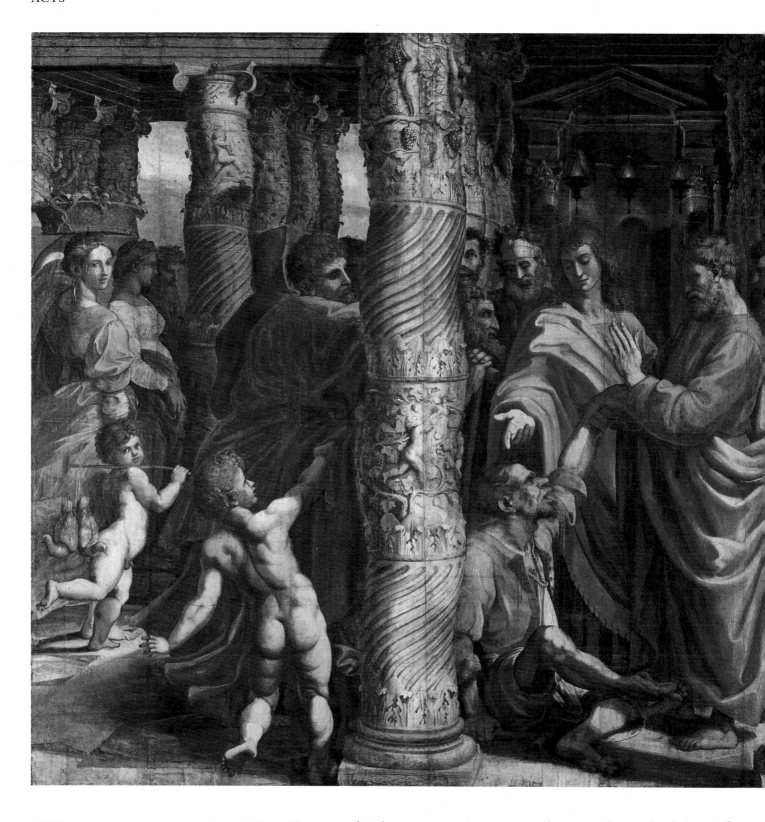

ACTS
Chapter 3, Verses 1–10

Now Peter and John were going up to the temple at the hour of prayer, the ninth hour. And a man lame from birth was being carried, whom they laid daily at that gate of the temple which is called Beautiful to ask alms of those who entered the temple. Seeing Peter and John about to go into the temple, he asked for alms. And Peter directed his gaze at him, with John, and said, "Look at us." And he fixed his attention upon them, expecting to receive something from them. But Peter said, "I have no silver and gold,

Raphael (1483–1520)
'The Healing of the Lame Man
in the Temple'

but I give you what I have; in the name of Jesus Christ of Nazareth,
walk." And he took him by the right hand and raised him up; and
immediately his feet and ankles were made strong. And leaping up
he stood and walked and entered the temple with them, walking
and leaping and praising God. And all the people saw him walking
and praising God, and recognized him as the one who sat for alms
at the Beautiful Gate of the temple; and they were filled with
wonder and amazement at what had happened to him.

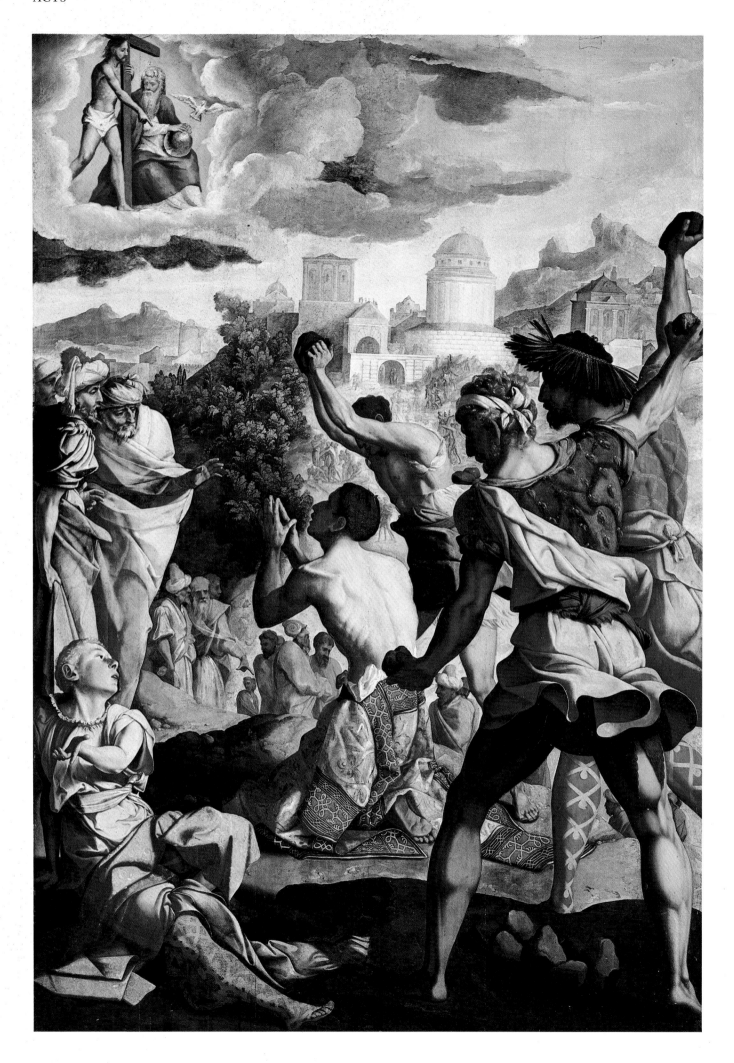

Eugène Delacroix (1798–1863)
'St Stephen's Followers Taking
Possession of his Body'

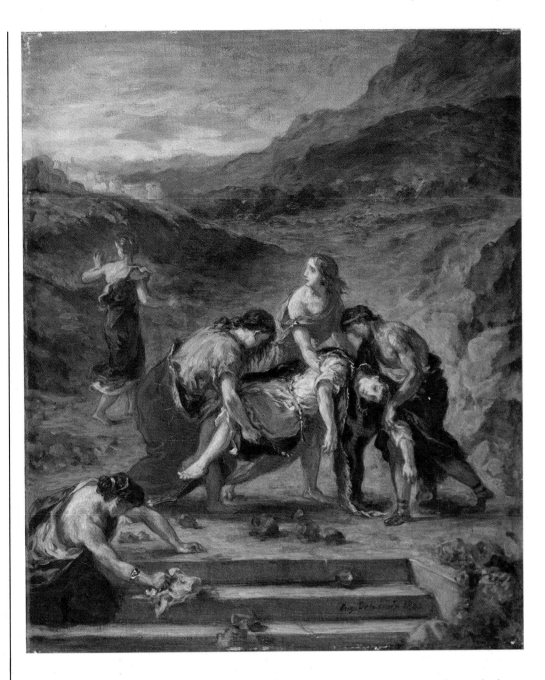

ACTS
Chapter 7, Verses 54–60

Now when they heard these things they were enraged, and they ground their teeth against him. But he, full of the Holy Spirit, gazed into heaven and saw the glory of God, and Jesus standing at the right hand of God; and he said, "Behold, I see the heavens opened, and the Son of man standing at the right hand of God." But they cried out with a loud voice and stopped their ears and pushed together upon him. Then they cast him out of the city and stoned him; and the witnesses laid down their garments at the feet of a young man named Saul. And as they were stoning Stephen, he prayed, "Lord Jesus, receive my spirit." And he knelt down and cried with a loud voice, "Lord, do not hold this sin against them." And when he had said this, he fell asleep.

Jan van Scorel (1495–1562)
'The Stoning of St Stephen'

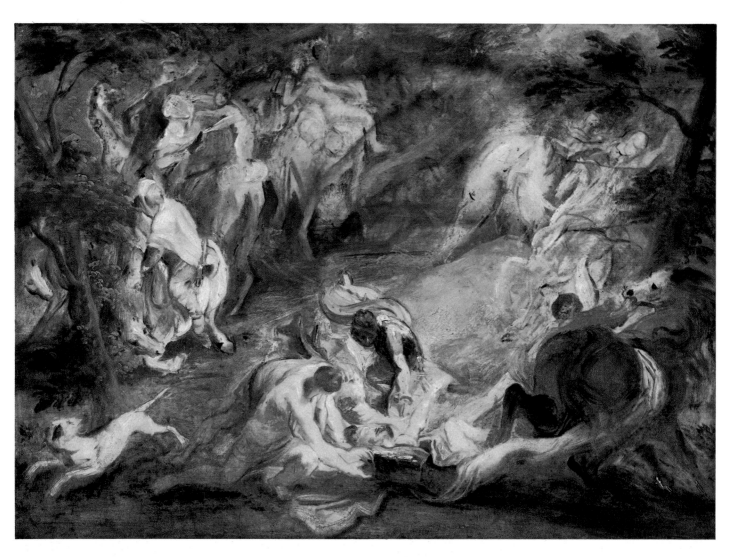

Rubens (1577–1640)
Sketch for a 'Conversion of St
Paul'

ACTS
Chapter 9, Verses 1–9

But Saul, still breathing threats and murder against the disciples of the Lord, went to the high priest and asked him for letters to the synagogues at Damascus, so that if he found any belonging to the Way, men or women, he might bring them bound to Jerusalem. Now as he journeyed he approached Damascus, and suddenly a light from heaven flashed about him. And he fell to the ground and heard a voice saying to him, "Saul, Saul, why do you persecute me?" And he said, "Who are you, Lord?" And he said, "I am Jesus, whom you are persecuting; but rise and enter the city, and you will be told what you are to do." The men who were travelling with him stood speechless, hearing the voice but seeing no one. Saul arose from the ground; and when his eyes were opened, he could see nothing; so they led him by the hand and brought him into Damascus. And for three days he was without sight, and neither ate nor drank.

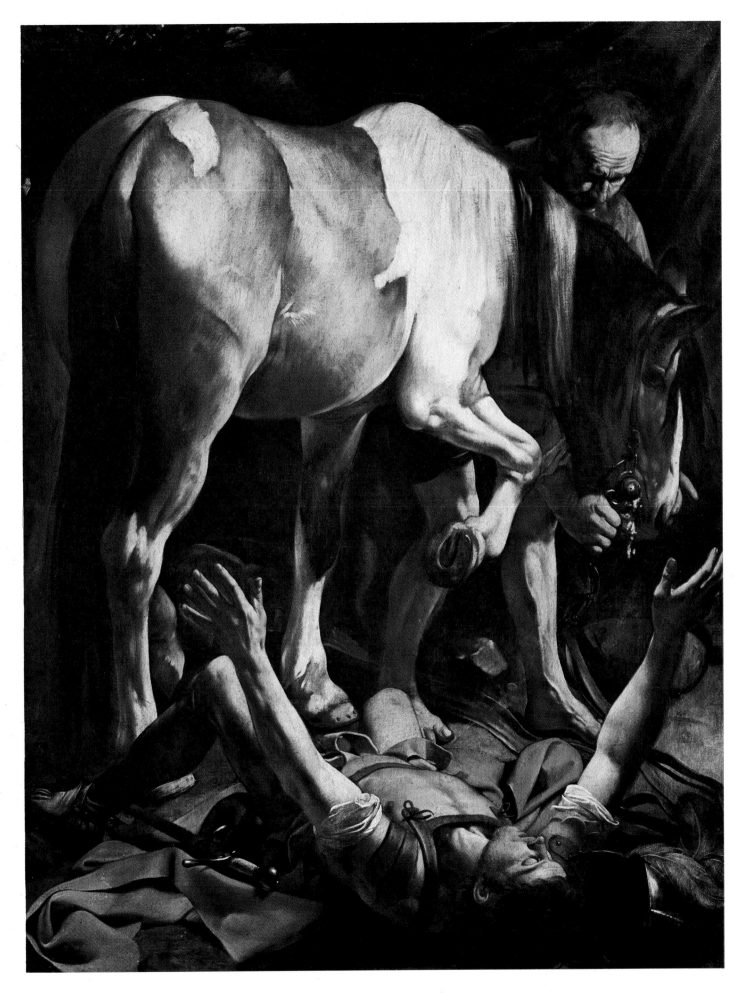

Caravaggio (1573–1610)
'The Conversion of St Paul'

ACTS Chapter 12, Verses 6–9

The very night when Herod was about to bring him out, Peter was sleeping between two soldiers, bound with two chains, and sentries before the door were guarding the prison; and behold, an angel of the Lord appeared, and a light shone in the cell; and he struck Peter on the side and woke him, saying. "Get up quickly." And the chains fell off his hands. And the angel said to him, "Dress yourself and put on your sandals." And he did so. And he said to him, "Wrap your mantle around you and follow me." And he went out and followed him; he did not know that what was done by the angel was real, but thought he was seeing a vision.

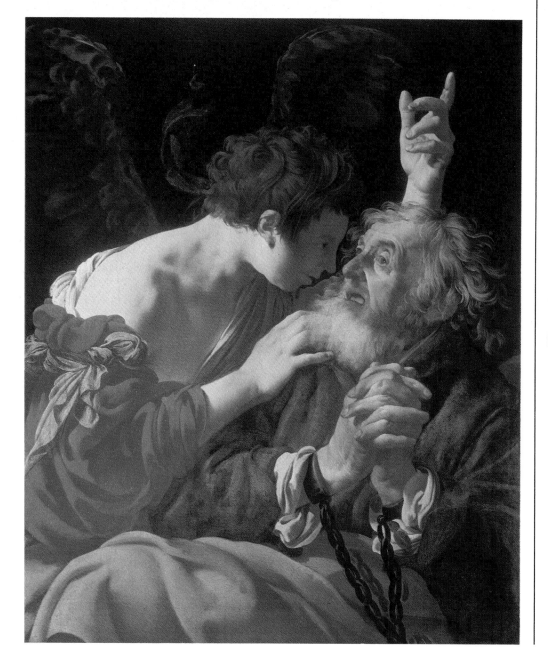

Hendrick Ter Brugghen
(1588–1629)
'The Angel with St Peter in Prison'

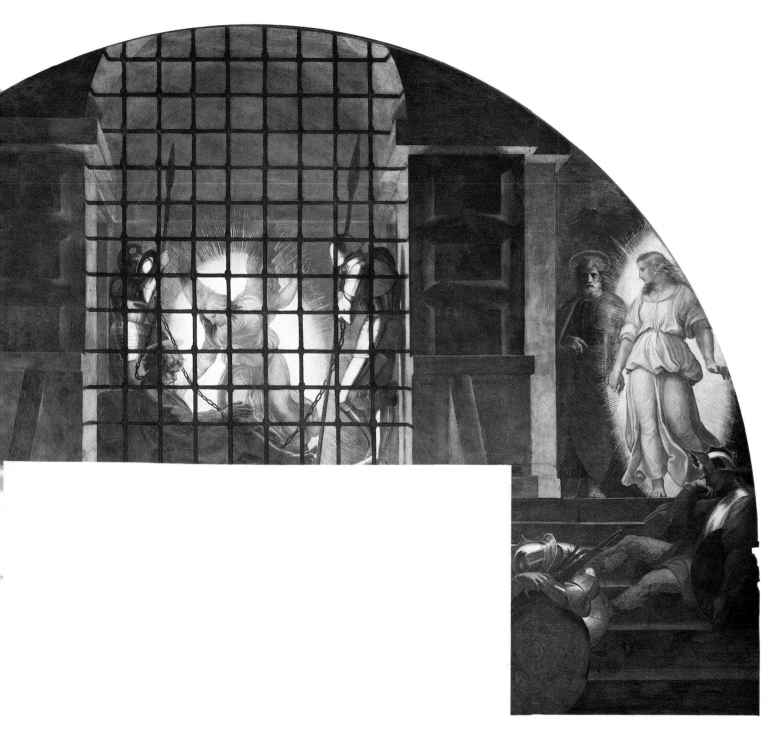

Raphael (1483–1520)
'The Freeing of St Peter'

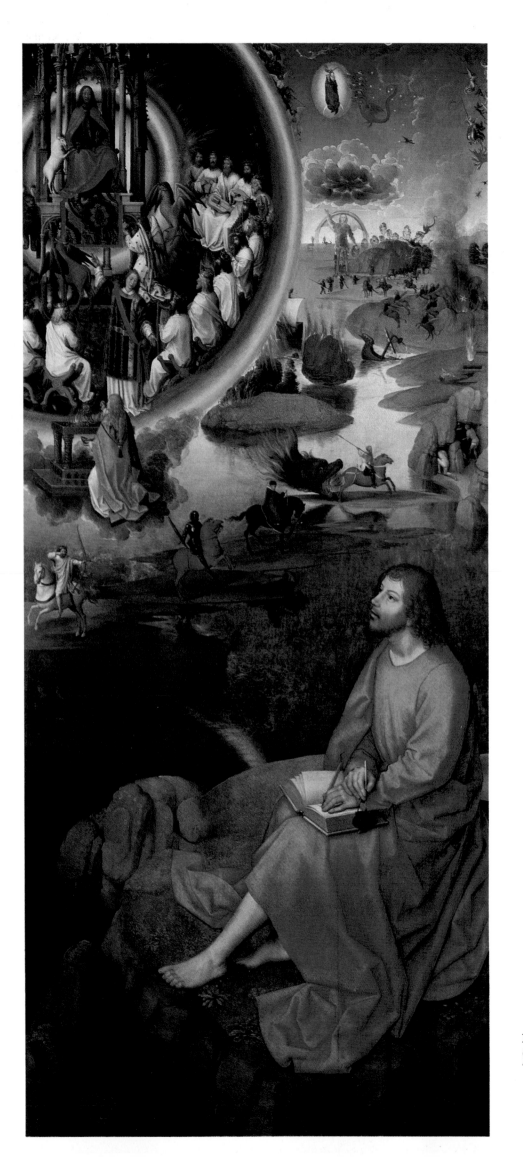

Hans Memling
(1430/40–1494)
'The Vision of St John'

Velázquez (1599–1660)
'St John on Patmos'

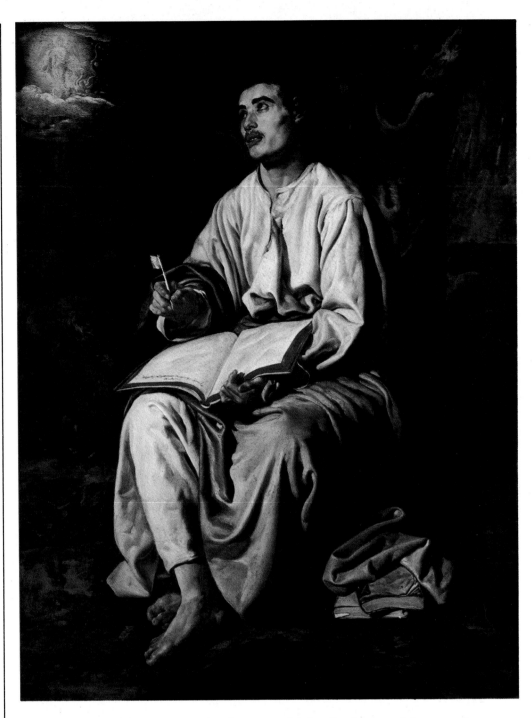

REVELATION
Chapter 1, Verses 1–3

The revelation of Jesus Christ, which God gave him to show to his servants what must soon take place; and he made it known by sending his angel to his servant John, who bore witness to the word of God and to the testimony of Jesus Christ, even to all that he saw. Blessed is he who reads aloud the words of the prophecy, and blessed are those who hear, and who keep what is written therein; for the time is near.

When he opened the fourth seal, I heard the voice of the fourth living creature say, "Come!" And I saw, and behold, a pale horse, and its rider's name was Death, and Hades followed him; and they were given power over a fourth of the earth, to kill with sword and with famine and with pestilence and by wild beasts of the earth.

J.M.W. Turner (1775–1851)
'Death on a Pale Horse'

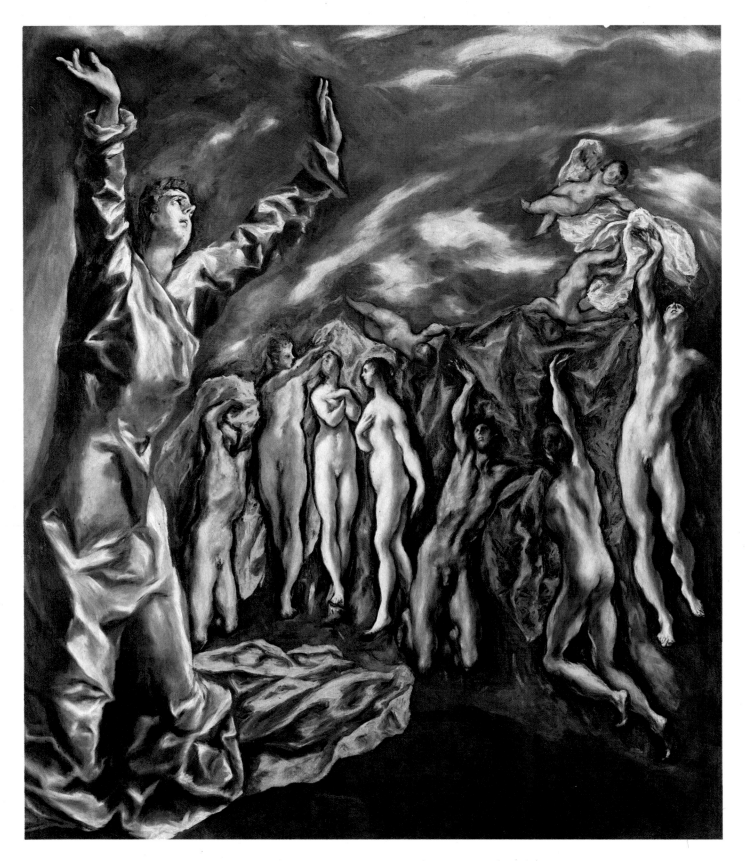

El Greco (1541–1614)
'The Opening of the Fifth Seal'

REVELATION
Chapter 6, Verses 9–11

When he opened the fifth seal, I saw under the altar the souls of those who had been slain for the word of God and for the witness they had borne; they cried out with a loud voice, "O Sovereign Lord, holy and true, how long before thou wilt judge and avenge our blood on those who dwell upon the earth?" Then they were each given a white robe and told to rest a little longer, until the number of their fellow servants and their brethren should be complete, who were to be killed as they themselves had been.

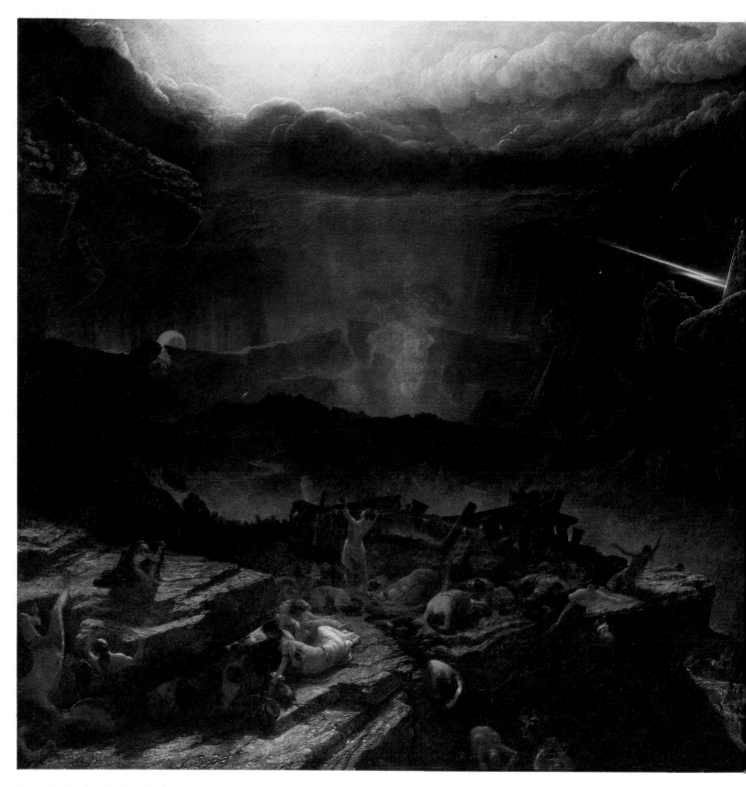

Francis Danby (1793–1861)
'The Opening of the Sixth Seal'

REVELATION Chapter 6, Verses 12–17

When he opened the sixth seal, I looked, and behold, there was a great earthquake; and the sun became black as sackcloth, the full moon became like blood, and the stars of the sky fell to the earth as the fig tree sheds its winter fruit when shaken by a gale; the sky vanished like a scroll that is rolled up, and every mountain and island was removed from its place. Then the kings of the earth and the great men and the generals and the rich and the strong, and every one, slave and free, hid in the caves and among the rocks of the mountains, calling to the mountains and rocks, "Fall on us and hide us from the face of him who is seated on the throne, and from the wrath of the Lamb; for the great day of their wrath has come, and who can stand before it?"

Jan (*c*.1395–1441) **and Hubert**
(d.1426) **Van Eyck**
'The Adoration of the Holy
Lamb'

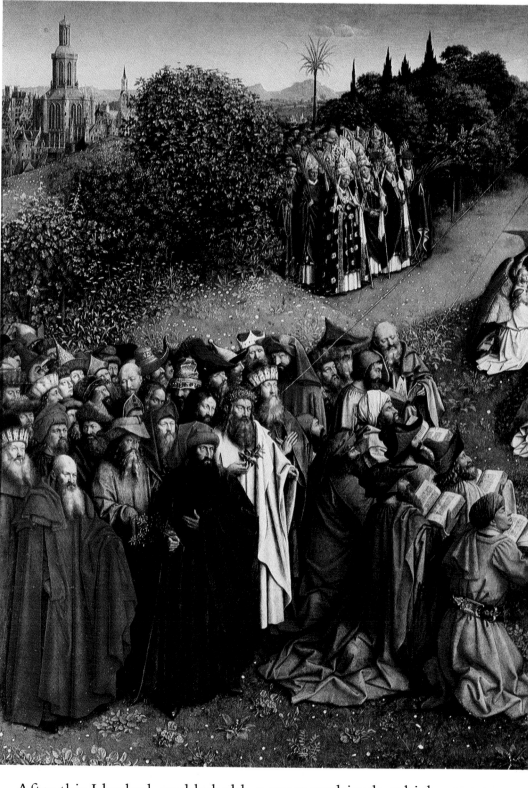

REVELATION
Chapter 7, Verses 9–12

After this I looked, and behold, a great multitude which no man could number, from every nation, from all tribes and peoples and tongues, standing before the throne and before the Lamb, clothed in white robes, with palm branches in their hands, and crying out with a loud voice, "Salvation belongs to our God who sits upon the throne, and to the Lamb!" And all the angels stood round the

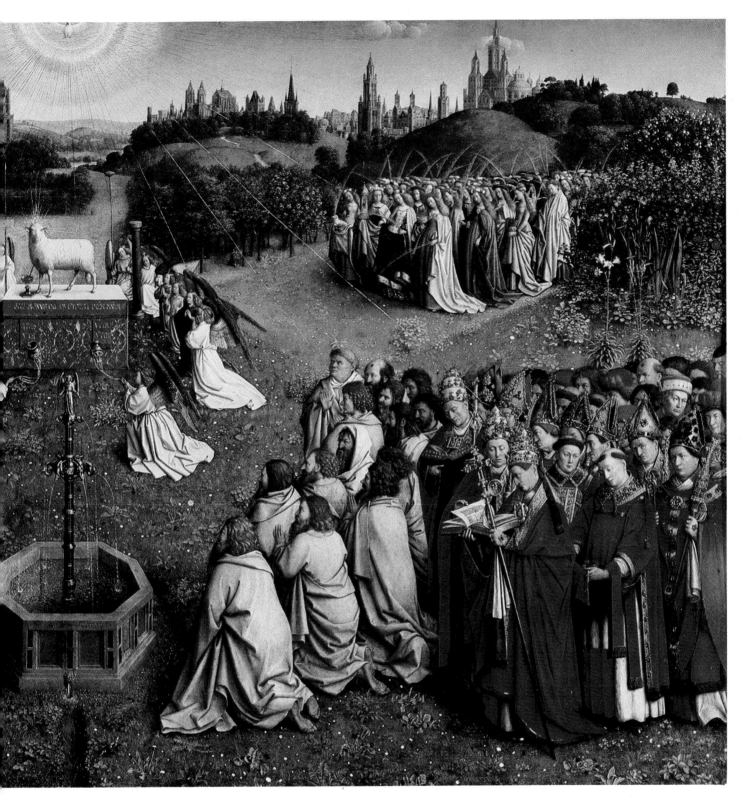

throne and round the elders and the four living creatures, and they
fell on their faces before the throne and worshipped God, saying,
"Amen! Blessing and glory and wisdom and thanksgiving and
honour and power and might be to our God for ever and ever!
Amen."

REVELATION Chapter 19, Verses 17–18

Then I saw an angel standing in the sun, and with a loud voice he called to all the birds that fly in mid-heaven, "Come, gather for the great supper of God, to eat the flesh of kings, the flesh of captains, the flesh of mighty men, the flesh of horses and their riders, and the flesh of all men, both free and slave, both small and great.

J.M.W. Turner (1775–1851)
'The Angel Standing in the Sun'

Hans Memling
(1430/40–1494)
Pages 270–71 'The Last Judgment'

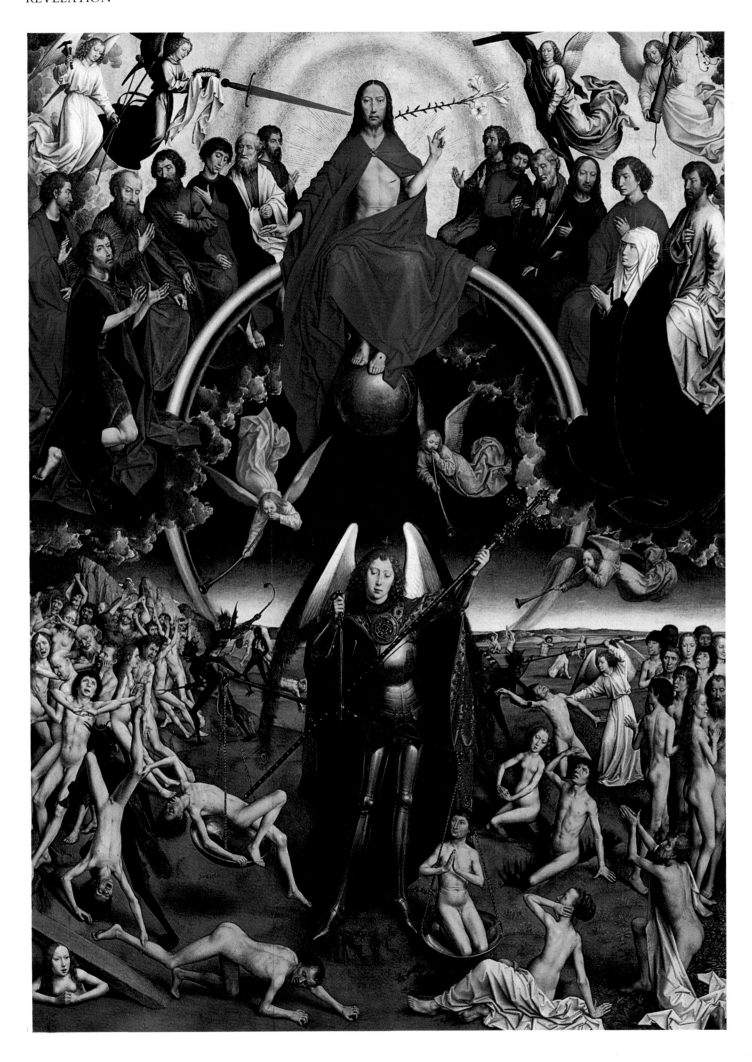

Then I saw a great white throne and him who sat upon it; from his presence earth and sky fled away, and no place was found for them. And I saw the dead, great and small, standing before the throne, and books were opened. Also another book was opened, which is the book of life. And the dead were judged by what was written in the books, by what they had done. And the sea gave up the dead in it, Death and Hades gave up the dead in them, and all were judged by what they had done. Then Death and Hades were thrown into the lake of fire. This is the second death, the lake of fire; and if any one's name was not found written in the book of life, he was thrown into the lake of fire.

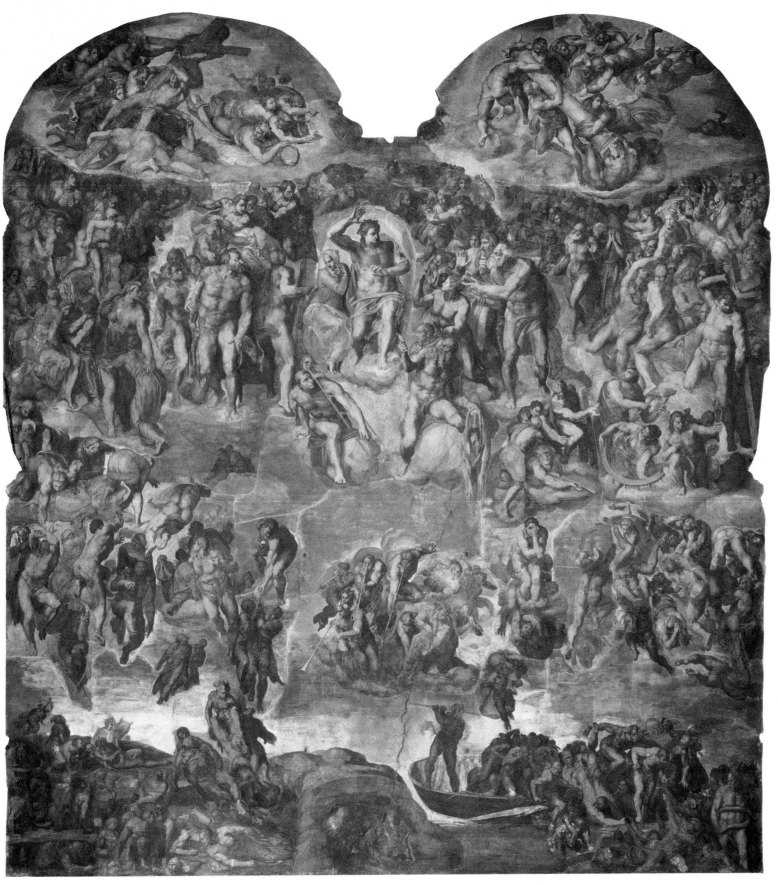

Michelangelo (1475–1564)
'The Last Judgment'

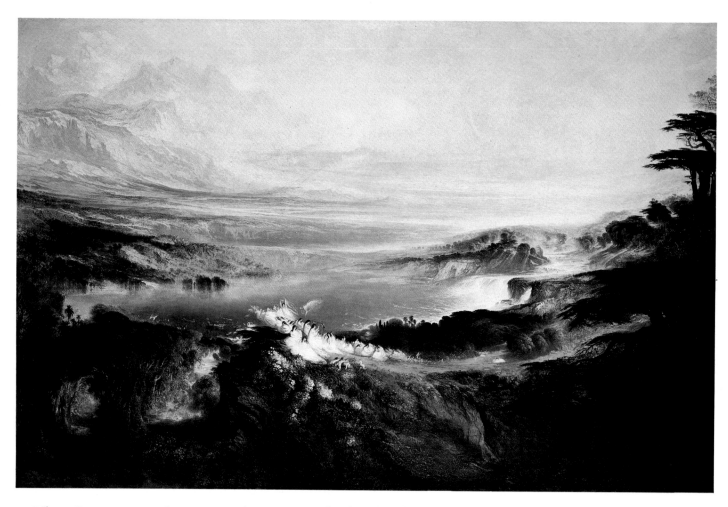

Then I saw a new heaven and a new earth; for the first heaven and the first earth had passed away, and the sea was no more. And I saw the holy city, new Jerusalem, coming down out of heaven from God, prepared as a bride adorned for her husband; and I heard a loud voice from the throne saying, "Behold, the dwelling of God is with men. He will dwell with them, and they shall be his people, and God himself will be with them; he will wipe away every tear from their eyes, and death shall be no more, neither shall there be mourning nor crying nor pain any more, for the former things have passed away."

And he who sat upon the throne said, "Behold, I make all things new." Also he said, "Write this, for these words are trustworthy and true." And he said to me, "It is done! I am the Alpha and the Omega, the beginning and the end. To the thirsty I will give from the fountain of the water of life without payment. He who conquers shall have this heritage, and I will be his God and he shall be my son."

John Martin (1789–1854)
'The Plains of Heaven'

REVELATION
Chapter 21, Verses 1–7

Annotations to Illustrations

10 GERARD DAVID (*c*.1460-1523)
'Jewish Judges and Roman Soldiers' (Musée Royal des Beaux-Arts, Antwerp, Belgium)

Lawrence Gowing points out in his introductory essay that this picture underlines the responsibility of both Jew and Gentile for Christ's death and also shows how perfectly natural artists of another age found it to represent the happenings of 14 or more centuries before them in terms of their own times without any of the teasing ironies or awkwardness that marked the end of narrative biblical painting in the twentieth century. The picture speaks of the unforced identification of painters, their patrons and their public with the biblical narrative, something which it is difficult for us to assimilate however much we know it to be true.

Nothing much is known of the life of Gerard David except that he was born in Oudewater, near Gouda, in the Netherlands and that he became Dean of the painter's guild in Bruges in 1501. He was capable of producing pictures of an extraordinary gentleness and also of the starkest realism. This duality of approach combined with great refinement of execution makes him an exceptional master of unfailing interest.

This picture is the left wing of an early altarpiece of David's, the centre panel of which is the 'Christ Nailed to the Cross' now in the National Gallery, London. The right wing, which represents St John and four Holy Women mourning, is with this left wing in the same museum in Antwerp.

18 HIERONYMUS BOSCH (*c*.1450-1516)
'The Creation', side panels of 'The Garden of Earthly Delights' (Prado, Madrid)

When the side panels of one of the most fantastical extravaganzas in painting, 'The Garden of Earthly Delights', are closed you can see the simple, almost monochrome, image of the beginning of all the riotous complexity to be revealed within and it is a pity that visitors to the Prado cannot first see it closed and then open up the great altarpiece for themselves. It is the most compelling image of the Creation in all art, giving us a greater sense of a nascent world than any other. In a transparent sphere the elements are beginning to be separated and earth, water, air, and significantly the phantasmagoria which are such an important part of the pictures inside, are coming into being under the supervision of The Almighty, who is holding His book containing the Word, and also what we can imagine might be a telescope for Him to observe the progress of His Creation in detail (or perhaps it is a ruler). A quotation from the Psalm 33:9, written across the bottom of the panels, tells us 'For he spoke and it came to be; he commanded, and it stood forth.'

Bosch was born in 'sHertogenbosch in northern Brabant (now a province of Belgium) and both his father and grandfather were painters. He was a member of the religious Brotherhood of Our Lady and although it has been suggested that he belonged to a heretical sect, the Adamites (who indulged in strange rituals in the nude), there is no firm evidence for it. He was a deeply moral and religious painter and his keen fascination with the grotesque and fantastic should not hide the fact that most of his work is an indictment of the folly and vanity of the human race, even if it can also suggest to us that he might have thought that God made it impossibly difficult for us to be otherwise.

20 MICHELANGELO BUONARROTI (1475-1564)
'The Creation of Adam' (Fresco on the ceiling of the Sistine Chapel in the Vatican, Rome)

This is justly one of the most famous images in all art, and has come to be accepted as the supreme expression of both God's grandeur as Creator and man's potential immortality before the Fall. Adam's body has already been fashioned, and life imparted to it through God's finger, as if with an electric spark. But in a curious way Michelangelo has made it seem more like a collusion between God and Adam than his creation, or a pre-arranged demonstration that has been rehearsed. Michelangelo's

urge to create a new race of men is demonstrated all over the Sistine Chapel ceiling and in sculptures like his marble 'David'. Why this does not seem to us like an insane hubris may be partly because we sense his underlying realization that the greatest human creative genius can make nothing truly substantial at all, and that to compete with God only underlines His supremacy. We do not look at the great ceiling to find biblical illustration, or even great individual images apart from this one, but more because, as Goethe wrote, 'No one who has not seen the Sistine Chapel can have a clear idea of what a human being can achieve'. It is a kind of abstraction of the whole idea of artistic creation, and if its point is partly to demonstrate the limits of human creativity, with 'The Last Judgment' (page 273) it also shows its power more forcefully than any other work from the hand of one man.

The Sistine Chapel ceiling, though, owes its general feeling as much to the fashionable Neo-Platonist philosophy of its time, with its harking back to pre-Christian antiquity, as to the Bible. Michelangelo's most Christian works are undoubtedly his late sculptures of the *Pietà* and the many marvellous small drawings of New Testament subjects, including the Crucifixion that he produced when on the brink of old age and beyond.

21 WILLIAM BLAKE (1757-1827)
'Elohim Creating Adam' (Tate Gallery, London)

William Blake was apprenticed to an engraver, and this left a permanent, and some would say not entirely beneficial, mark on his whole visual *oeuvre*. He was also, most are agreed, a great poet as well as a wonderfully liberated and highly idiosyncratic religious thinker. The Bible was of overwhelming importance to Blake and although, like most others, he did not often illustrate it literally his deviations from the text were always for quite deliberately interpretive and creative reasons. His engravings for the Book of Job rank with almost any cycle of biblical prints and have been admired by people otherwise averse to his art, amongst them the critic John Ruskin.

Blake's critics have seen in him, it could seem rather unjustly, a distressing example of a fatal English amalgamation of literature and visual art, as well as an inadequate and eccentric draughtsman and technician. He saw the work of Michelangelo (whom he regarded as the supreme painter) only in the form of engravings, and the fact that he saw so little high-quality Renaissance painting in the original must have also misled him as an artist. His use of a fresco-like technique on an absurdly small scale underlines the anomalous nature of his work as a painter. Nevertheless he has, in all his aspects, become part of the English-speaking consciousness and conscience, and no book of biblical imagery could possibly exclude him.

'Elohim Creating Adam' is interesting to compare with Michelangelo's fresco on the same subject (opposite). It is closer to the biblical text in that Adam is being created from the earth but David Bindman, the Blake authority, points out that here the Fall has already been ordained and that it is also, in part, an allegory of the tyranny of 'Religion'. Adam's painful awakening is not of one being born to a possibly eternal Garden of Eden, and there is a worm something like the Serpent already with him.

Blake's mixed monotype and water-colour technique (as here) was achieved by printing from a design prepared in distemper on millboard and then finishing the 'colour-printed drawing' by hand. Some of his most memorable images were made using this technique and his famous 'Hecate' and 'Newton' were part of a series of works executed in this manner. Michelangelo, against the odds, might well have appreciated the result.

22 WILLIAM BLAKE (1757-1827)
'Adam Naming the Beasts' (Pollok House, Glasgow)

Though it is just conceivable that Blake thought that Adam helped lay the foundation of the Fall by choosing the name of the Serpent, in this

picture both Adam and Serpent seem entirely unaware of their future relationship. Adam, after the painful emergence depicted by the same artist (on the previous page), is now a secure and innocent Lord of Creation, and the procession of rather primitively drawn animals and the English oak tree are very different from the exotic menageries and vegetation of most other artists' versions of Paradise. Blake also painted a companion 'Eve Naming the Birds' and two other rather 'Gothic' pictures in tempera, all of which probably formed a decorative scheme for his steadfast patron, Thomas Butts. The part illustrated here expresses very well Blake's own essential sweetness and nobility of character.

23 MICHELANGELO BUONARROTI (1475-1564)
'The Creation of Eve' (Fresco on the ceiling of the Sistine Chapel in the Vatican, Rome)

Michelangelo had a quite extraordinary lack of feeling for the way women look. Only a very few images apart from the Virgin of the *Pieta* in St. Peter's, Rome, make you feel a real feminine presence. Henry Fuseli curiously once wrote 'His women are moulds of generation' to which Benjamin Robert Haydon retorted 'His women may be moulds of generation but certainly not of love'. With 'The Creation of Eve', though, he has made a conscientious effort to make a woman's body look real, though God appears to be as dubious about the result as Michelangelo perhaps felt himself.

The subject has produced no very great masterpiece of painting, only a few curious images in manuscript illumination and pictures like the romantic and nebulous attempt by G.F.Watts in the Tate Gallery, London. The Bible text here is in any case very difficult to illustrate literally, even more so than that of the Creation of Adam and the World.

25 JACOPO (DA PONTE) BASSANO (1517/18-1592)
'The Earthly Paradise' (Doria Gallery, Rome)

Bassano was the son of a painter and an almost exact contemporary of Tintoretto, and although he lived very nearly all his life in his native city Bassano, in Northern Italy, he can be considered as one of the great Venetian Mannerists, along with – and not all that much lower than – Veronese and Tintoretto. The Bible was a major preoccupation with this artist and he covered a large repertoire of its stories, running a busy workshop where his sons helped him turn out many repetitions of subjects which were strongly in demand. His art springs from his native countryside and is particularly notable for his affectionate interest in animals. Most of his landscapes are in a half-light which often becomes deep twilight. There is a lyric and elegiac thread running through much of his work and it helps to make his biblical paintings particularly affecting, as you can see in his other pictures illustrated here (pages 35, 36, 186 and 236). He sometimes understates to a remarkable degree and once painted an 'Annunciation to the Shepherds' in the Uffizi, Florence, where the presence of an angel or angels is barely perceptible.

In this 'Paradise' – and from it you must assume that he really liked the weather in his pictures – he has made a place in which not everyone would be entirely happy. It has a very different atmosphere to most other Edens, and Adam's solicitous inclination towards Eve is very rare, as is his showing of Eve in back view. They both seem unaware of the painter's intrusion, whereas most Adams and Eves are made to look as if they had agreed to pose for the artist, albeit sometimes a little unwillingly.

26 LUCAS CRANACH THE ELDER (1472-1553)
'Adam and Eve' (Courtauld Institute Galleries, London/Lee Collection)

Cranach was born in Upper Franconia in the German Empire and his first surviving works were painted in Vienna and included many portraits and religious subjects. In his early thirties he went to work for Frederick the Wise, Elector of Saxony, and spent the rest of his life in Wittenberg (now in East Germany) where he was twice Burgomaster. He became a friend of Martin Luther and painted his portrait several times, and through their association produced some pictures underlining Protestant doctrine. Most of the many nudes for which he is most famous were painted in his late fifties. They generally seem very bright ladies and full of what are known as woman's wiles. His stylistic lack of refinement aids him in this, and makes you imagine that he must have been an amusing and slightly improper man in a fairly good-natured way. There is a 'Temptation of Eve' in Brussels in which it seems it is Eve who is corrupting a completely demoralized Serpent.

This 'Adam and Eve' is a feast for the eye and although very beautiful in its formality, it still has mocking undertones. Adam is defeated and showing it, while Eve has no qualms about her role as saboteur. It might seem a little surprising to us now that a close friend of Martin Luther's could persist in using the Fall as a basis for his man/woman pleasantries, but he very often did so.

28 THOMAS COLE (1801-1848)
'The Expulsion from the Garden of Eden' (Museum of Fine Arts, Boston/ M. and N. Karolik Collection)

Thomas Cole was born in Lancashire, England, and emigrated with his family to the United States in his late teens. He studied in Ohio and Pennsylvania, then he moved to New York, having had little success in his attempt to make a career as a portrait painter. A journey up the Hudson River inspired him to make several landscapes which were well received and became the foundation of the Hudson River School. Then a journey back to Europe brought him in contact with John Martin, who became a powerful influence on him. On his return to America, apart from the 'Expulsion', he painted two epic series, 'The Course of Empire' and 'The Voyage of Life', in which he combined Martin's visionary influence with his own virtuosity as a Romantic landscape painter. After another visit to Europe he developed a theory of Nature as the visible expression of God and retired to the Catskill Mountains to paint pictures in accordance with it.

'The Expulsion' was derived from a combination of two mezzotints of Martin's for 'Paradise Lost' and it is a good imitation of his style though perhaps somewhat less laborious and therefore less intense. It is nevertheless a very dramatic illustration and the contrast between Eden and the storm-wracked, wolf-inhabited, world outside it is sensational enough. Adam and Eve walk hand in hand and Adam seems to be making a gesture of defiance in reply to the incandescent reproof of the angel whom the artist has ingeniously concealed from view. Thomas Cole showed something of the quality which made Martin a great illustrator of the Bible – a convinced belief in the divinely ordained insecurity of earthly life.

29 MASACCIO (TOMMASO 'DI GIOVANNI') (1401-1428)
'The Expulsion from Eden' (Fresco from the Brancacci Chapel, S.Maria del Carmine, Florence)

Masaccio is one of several major painters, Raphael, Giorgione and Seurat amongst them, to be cut off by death in their prime. He died at the age of 27 in Rome. The present very high regard in which he is held was not fully established until this century, and in the period immediately after his death only a few realized his importance. This was partly owing to confusion over attributions between him and the painter Masolino with whom Masaccio worked and who was 20 years older than he. It is now agreed in main what part of the frescos in the Brancacci Chapel were by Masaccio, and he has emerged as the revolutionary master painter.

'The Expulsion' has, like the rest of the painting there, suffered with time and Adam and Eve's leafy aprons were painted by another hand. It nevertheless proclaims itself as one of the great pioneer works of European art. There was (and is) simply nothing else like it, as no other image we have of the calamity conveys so well the sense of loss and shame that the Bible story calls for, although it could be said that the nearly contemporary portraits of Adam and Eve by Van Eyck are equally expressive in their static way. But considering when Masaccio painted them, their postures and movements are extraordinarily realistic and expressive of their feelings. Adam is numb with despair and Eve seems to be foreseeing the whole future travail of Womankind. It is sobering to be told that the Chapel, which includes other great frescos such as Masaccio's 'The Tribute Money' (pages 184-5) would have been wantonly demolished in the seventeenth century, but for the protests of the painters of Florence.

30 PETER PAUL RUBENS (1577-1640)
'Cain Slaying Abel' (Courtauld Institute Galleries, London/Princes Gate Collection)

From the age of 34 Rubens lived and worked in a marvellously congenial small palace in Antwerp, Belgium, and the studio which was part of it became a cornucopia of all kinds of paintings, some executed mainly by assistants and looking like it, but also very many great (and lesser) works from his own indefatigable hand. He is not very much liked today, being suspected by too many of a rather mindless and vulgar indulgence in the enjoyment of painterly energy and virtuosity for its own sake and in the pleasures of a kind of female flesh which is no longer considered as beautiful or desirable as it once was. Indeed he has probably even had the label 'sexist' stuck on him by the less thoughtful members of the 'women's movement'. But his art, including its view of women, is enlightened and reflective and his 'Allegory of Peace and War' (in the National Gallery, London) could well be adopted as a banner for both the 'peace' and 'women's' movements. He was a highly intelligent and articulate man and his greatest portraits, landscapes, allegories and Christian paintings have a place at the very summit of European art and civilization.

Rubens was born in Westphalia, Germany, of parents exiled from Antwerp, but returned there on the death of his father. After serving his apprenticeship with undistinguished painters he went to Italy for eight years where he stayed mainly in Mantua, and like Mantegna before him became court painter to the Duke of Mantua. He also began his

distinguished diplomatic career by going to see Philip III of Spain on a mission for his patron. On his return to Antwerp he married Isabella Brandt and set up his sumptuous workshop, soon becoming one of the most prodigious painters who ever lived. Some 14 years later he resumed his diplomatic career and was sent first to England where Charles I knighted him and then to Spain where he was ennobled by Philip IV and where he also met and admired Velázquez. His first wife had died in 1626 and in 1630 he married the 16-year-old Hélène Fourment who bore him five children and of whom he painted some marvellous portraits including the supreme 'Hélène Fourment in a Fur Wrap'. He died at the age of 63 after perhaps the most consistently successful and happy life ever granted to a great artist.

'Cain Slaying Abel' was painted not long after his return to Antwerp from Italy and clearly shows the influence of Michelangelo and other Italian Renaissance masters that Rubens had avidly studied there. Although it is not painted in Rubens's most coherent style, a dramatic sense of physical shock and murderous determination is vividly conveyed. Abel, although a killer of sacrificial animals had perhaps never imagined violence between human beings, while Cain might have been nourishing his homicidal fantasy for some time on the spectacle of his brother's sanguinary devotions. We can witness this second Fall, at least as distressing and so much uglier than the first, with the same equivocal feelings experienced by an audience in any kind of gladiatorial arena.

31 WILLIAM BLAKE (1757-1827)
'The Body of Abel Discovered by Adam and Eve' (Tate Gallery, London)

Painters have naturally been drawn to fill in the details of stories not actually described in the text of the Bible and Blake would go further and seek to delineate a symbolic and metaphysical essence arising from his personal reflections on the story. He has made a vivid image of Cain's guilt and his terror of the flames of Divine wrath. Adam and Eve are distraught and appalled as the clouds above them take the form of something like the Hand of God, and even the mountains assume unnatural shapes to express the outrage of all creation. It is as vivid as his picture of Job (page 114).

33 FERNAND CORMON (1845-1924)
'The Flight of Cain' (Musée d'Orsay, Paris)

There were several 'Prehistoric' fantasies shown at the Paris Salon in the late nineteenth century but this is perhaps the only biblical one. Its author, who for some reason changed his name from Fernand Anne Piestre, was for a time a very successful and famous painter. He first showed at the Salon in 1863 and eventually became a member of the Institut and Professor at the Ecole des Beaux Arts, and was also commissioned to decorate the Museum of Natural History and the Petit Palais in Paris. Toulouse-Lautrec and Matisse were (briefly) among his pupils at his own studio. This huge picture (some 23 feet/7 metres wide) was shown in 1880 and acquired by the State, since when it has spent a lot of time in the basement of the Musée du Luxembourg. At the time of writing it is waiting to be put on show at the Musée d'Orsay which is being built on the site of the old Gare d'Orsay in Paris.

'The Flight of Cain' is a very vigorous composition but seems in parts carefully executed in a curious way, as if a scenic artist had painted it from a designer's livelier small gouache painting. It consequently does not quite look its size and its audacity falls a little short of fulfilment. God's curse has obliged Cain to hunt and live on the meat that Abel had found so much Divine favour with, and an axe indicates that we are in the Stone Age. The matriarch rides on her litter, while a young woman is gallantly carried by one of the tribe, of whom the men outnumber the women. Cain himself is leading his tribe on their flight through the wilderness and looks impressively tenacious. Works like this inevitably get reduced to the ranks of historical curiosities, but lately, as in the case of John Martin, their ability to stir our imaginations and delineate the limits of art are being better appreciated, and they are getting something like their due.

34 HANS BALDUNG (GRIEN) (1484/5-1545)
'The Deluge' (Neue Residenz, Bamberg, West Germany)

Baldung, whose parents were prominent citizens of Strasbourg, became a favoured assistant of Dürer's. As well as painting he designed stained-glass windows and was also a notable engraver. His secular paintings are often concerned with death and eroticism (there are several examples of 'Death and the Maiden') and a morbid sensuality pervades much of his work.

In this picture he has deliberately designed one of the most unseaworthy Arks ever painted, modelling it on a strong-box of his time, and stamping his own monogram on it. It is rare for a painter (Uccello was another) to show the divinely unfavoured mass of the human race unsuccessfully struggling to board the Ark and Baldung seems to have taken positive pleasure in the idea. There appear to be boats about but they evidently weren't sound enough to survive and

there are all sorts of domestic flotsam bobbing on the waves along with the doomed. It is the kind of sardonic view of the subject that you might expect from this repellent but talented artist.

35 JACOPO (DA PONTE) BASSANO (1517/18-1592)
'The Building of the Ark' (Musée des Beaux-Arts, Marseille, France)

In complete contrast to Baldung (opposite), Bassano's picture is imbued with human warmth and an abiding love of the domestic scene. In the curious twilight that is Bassano's own, Noah's family prepares for the holocaust as if they were building a small barn for their ordinary farm.

36 JACOPO (DA PONTE) BASSANO (1517/18-1592)
'The Animals Entering the Ark' (By Gracious Permission of Her Majesty Queen Elizabeth, The Queen Mother)

In this picture Bassano has been able to indulge his love of painting animals to the full. Although he includes exotic ones like unicorns, camels and giraffes, he does not take as much pleasure in them as other artists often did. The familiar animals were good enough for him, and they are all being received onto the Ark by an Italian farmer's wife.

37 ANNE-LOUIS GIRODET TRIOSON (or GIRODET DE ROUCY) (1767-1824)
'The Deluge' (Louvre, Paris)

Girodet Trioson was a pupil of J-L. David and in 1789 he won the Prix de Rome with 'Endymion Sleeping', an extraordinary hermaphroditic figure bathed in greenish moonlight. It is difficult to imagine what his classical master thought of it. Girodet painted a lot of portraits and several large compositions but gave up painting in 1812 to write what are said to be boring poems on the subject of beauty.

'The Deluge' is a very large picture, it could be considered quite unnecessarily so, and it is also perhaps a little mad. Girodet was certainly something of a Romantic before his time and it makes you wonder whether Géricault's curiously understated picture of the same subject painted a few years later was a positive reaction against Girodet's reckless excess.

38 JOHN MARTIN (1789-1854)
'The Deluge' (Yale Centre for British Art, New Haven, Conn.)

John Martin was one of the most committed illustrators of the Old Testament that there has ever been. Born into a large impoverished family in the Tyne Valley in Northern England, he started his career by learning heraldic painting from a coach-builder in Newcastle, later studying with an Italian artist there whom he followed to London, where for a while he painted china. At the age of 23 he painted his first really characteristic picture, 'Sadak Seeking the Waters of Oblivion' (discovered in Sweden in 1983), soon to be followed by 'Joshua Commanding the Sun to Stand Still over Gibeon' (page 85) and 'Belshazzar's Feast' (pages 116-17) which made him famous and later caused the French to coin the adjective 'Martinien'.

This artist's interest in the cataclysms of the Old Testament was more than a shallow appetite for the sensational and was closely related to his deep concern with human insecurity and what we now call ecological problems. He spent much of his time and money devising schemes to purify the River Thames and recycle sewage, which were taken seriously and only remained unimplemented because they were considered too expensive. This was all, like his art, an expression of the most intense kind of nineteenth-century English Protestant feeling, and it gives his work a poignancy and validity not achieved by Francis Danby, his chief contemporary rival in visionary disaster, whose own pallid 'Deluge' hangs in the Tate Gallery.

Martin's 'Deluge' is one of his best works and was his own favourite among his pictures. It was thought out historically and scientifically, as all his great set pieces were. The pamphlet which accompanied the showing of the picture at the British Institute in 1826 describes the height of the mountains which he determined from his own researches into the location of Noah at the time of the Flood. He also decided that the cataclysm was brought about by a Divinely-engineered conjunction of the sun, the moon and a comet, and the French naturalist and geologist Baron Cuvier agreed with him. The Ark is very difficult to locate in the picture and is high above the turmoil having been built by Noah on a mountain peak. The detail of the human chaos below is extraordinary and in the mezzotint which he made of the painting later (many would say that his mezzotints are his best works) he included the 969-year-old Methuselah. 'Mr Martin strictly adheres to the evidence of Holy Writ,' noted the accompanying pamphlet.

Later in his life Martin's reputation went into eclipse, but he revived it by producing first a curious picture 'The Coronation of Queen Victoria', and then his three 'Judgment' paintings which went on a long and successful tour of Britain and the United States. 'The Last Judgment' itself is a little ludicrous but 'The Great Day of His Wrath' and 'The

Plains of Heaven' (page 274) are very successful essays in his popular apocalyptic style, and gave much innocent pleasure and imaginative stimulation to the thousands of people who paid to see them as if going to a cinema epic. But in this century, although his mezzotints influenced D.W.Griffith who paraphrased a giant set for his epic 'Intolerance' from those of 'Belshazzar's Feast' and 'The Fall of Babylon', his reputation sank to abysmal depths and in 1935 the three 'Judgment' paintings (which are now a popular attraction again at the Tate Gallery, London) fetched a total of £7.00 at auction. Martin now seems to be finding something like his proper level of appreciation. If compared to the great painters of his time, he without doubt falls a long way below them but as an illustrator of his obsessions and as an artist concerned with warning and exhortation as much as any earlier painter of the Last Judgment was he achieves a little of the grandeur that struck him so forcibly as he read his Bible and pondered the wonder of Creation and its built-in hazards.

40 JOHN MARTIN (1789-1854)
'The Assuaging of the Waters' (The Church of Scotland, Edinburgh)

Martin's viewpoint in this picture is through a porthole, or from the deck of the Ark which has been settled for some time on one of the peaks of Ararat. The dove has found 'a resting place for the sole of her foot' and the raven has its claws in the body of the drowned Serpent, which is coiled around the tree from the Garden of Eden. Martin wrote that he had chosen 'that period after the Deluge, when I suppose the sun to have first burst forth over the broad expanse of the waters gently rippled by the breeze, which is blowing the storm clouds seaward'. The radiance and increasing calm are well conveyed in spite of its (to us) rather kitsch undertones, and Martin's rendering of the rocks and seashells is reminiscent of the drawings of Ruskin – who despised Martin's work so much. Martin has over-romantically allowed a pair of water lilies to survive the Deluge but has made a picture that makes you feel that underneath his preaching posture and the limitations of his painterly talent (of which he was probably well aware), was an artist who would have liked nothing better than to have painted from nature very well – with plenty of exalted feeling, of course.

41 GIOVANNI BELLINI (c. 1430-1516)
'The Drunkenness of Noah' (Musée des Beaux-Arts, Besançon, France)

Bellini was the virtual founder of the Venetian School of painting and a decisive influence on Giorgione and Titian. He was remarkable in that he learned from his pupils, particularly Giorgione, and his development was one of the most extended stylistic progresses in the history of art. He was the son of Jacopo Bellini – who was his first teacher – and his brother Gentile was also a very talented painter. Giovanni's sister married Mantegna, from whom he also learned much, and they sometimes painted the same subject around the same time (see note for page 156 on Mantegna's 'Presentation in the Temple'); Bellini's 'Agony in the Garden' (page 209) is an example of this. He was a Christian painter of the most affecting natural piety, but most of his pictures were devotional, of the Madonna both alone with her Child and with saints and angels. Some have thought his altarpiece of the 'Madonna Enthroned with Saints' in S. Zaccaria in Venice the most beautiful picture of its kind in the world.

In his eighties Bellini sprang one or two marvellous surprises, including this beautifully painted and life-embracing picture of the first intoxication in the Bible, recorded rather surprisingly of the head of the family thought fit to survive the Flood.

42 PIETER BRUEGEL THE ELDER (c. 1525-1569)
'The Tower of Babel' (Kunsthistorisches Museum, Vienna)

Bruegel was born either in Breda or a Flemish village called Bruegel. He was designated a Master in the Antwerp Guild of Painters in 1551 and the next year made his first visit to Italy which was probably most important to him for the drawings of the Alps he made on the return journey. He then made his reputation as a designer for the Antwerp engraving trade and was very much influenced by Hieronymus Bosch and his moral attitude which Bruegel combined with what can be called a loving disenchantment with humanity. Though not a great many of his pictures have survived, his output was varied and vital, making many permutations of people, landscape, anecdote and architecture. He perhaps put into pictures more of human life and all that surrounds and accompanies it than any other artist has ever done. To all those who care for their kind he must surely be accounted one of the greatest of all painters. But in spite of his phenomenal technical mastery and the admiration of Rubens and many others, after his death his reputation went into relative eclipse until the late nineteenth century owing to what was seen as the less than idealistic 'coarseness' of his subject matter and attitude towards it.

'The Tower of Babel' is the grandest and most skilful architectural fantasy ever painted, incorporating an amazing wealth of human and technical anecdote. It is, as is the Bible story, about human pride and its futility. Rome was considered the paradigm of proud cities and the

tower is based on Roman models, knowledge of which Bruegel would certainly have gained from the Colosseum and the other buildings he saw in Rome. King Nimrod, to whom some builders are grovelling, is an image equally critical of pride and servility. No great painting has ever demonstrated such an interest in a mass of human beings at work and the biblical message is tempered by Bruegel's sympathetic concern with ordinary humanity and every detail of their daily lives.

45 ALBRECHT DÜRER (1471-1528)
'Lot and His Daughters' (National Gallery of Art, Washington)

Dürer, as at least two of his three pictures in this collection demonstrate, became something of a humorist in paint when not engaged on work of real importance to him. He was born in Nuremberg of a family of goldsmiths and was a very precocious draughtsman who was always during his lifetime more famous for his graphic work than his paintings. He is considered to be the artist who had the greatest responsibility for bringing the art of the Italian Renaissance to Germany and the North. He travelled in the Low Countries before going to Italy, where Venetian painting was a revelation to him and provoked him to start making his personal synthesis of the alien styles. While in Venice he became a friend and admirer of Giovanni Bellini.

He painted many portraits and self-portraits and made some of the greatest woodcuts ever engraved as well as several large and important devotional works. He also made some astonishingly naturalistic and historically important drawings of landscape, plants and animals. But he produced few pictures illustrating stories from the Bible; those that exist seem to have been conceived in a lighter vein than the rest of his work and 'Lot and His Daughters' demonstrates this well (it was painted on the back of a decorous Madonna and Child).

There has never been a really weighty painting about Lot and his family, perhaps because the story has always generated embarrassment and only pictures like Turner's (on the next page) which are more concerned with atmospheric background manage to seem entirely serious. Dürer's picture appears entirely frivolous but it is pleasantly so, and it must have taken him only an hour or so to paint. Lot has been deeply shocked by his experience in Sodom and the loss of his wife, who seems a very smoke-stained pillar of salt. You would not guess the sequel from the daughters' obedient demeanour and the respectful distance at which they are following him. But Lot has chosen to carry the drink rather than the money, thus perhaps hinting at the weakness his girls would soon exploit. The picture demonstrates the remarkable latitude for humour that even the greatest painters have sometimes taken with the Bible and also that the greater the painter, the better the joke.

46 JOSEPH MALLORD WILLIAM TURNER (1775-1851)
'The Destruction of Sodom' (Tate Gallery, London)

The artistic development and personality of Turner are of such complexity that they could only be summarized, if at all, in thousands of words however well they were chosen. He is now acknowledged to be England's greatest painter, but few people care to follow him in anything like all the journeys of his painterly imagination and most would, under cross-examination, admit only to liking or seeing the point of less than half his huge *oeuvre*. But thanks mainly to his talent for topographical drawings and the sale of engravings that were made from them he managed to make himself the richest and most independent artist of his time as well as the most misunderstood and occasionally even scorned one. His only peer among English painters, Constable, saw some of the point though, however worrying he found him at the same time. 'He is stark mad with ability,' Constable once wrote in 1828 to his good friend Archdeacon Fisher, 'Turner has some golden visions, glorious and beautiful, but they are only visions, still they are art, and one could live and die with such pictures in one's house.'

Turner had very little influence on anyone, and not much on Monet and Pissaro who saw and half-admired his work later in the century in London. He was not insular, though, and travelled extensively in France, Holland, Germany, Belgium, Switzerland and Italy, learning what suited him from Rembrandt, Watteau and the Venetians among others. He is commonly said to be a forerunner of Impressionism but his work has much less in common with them than appears the case on first sight. He seems to have seen the world in the end rather as the scientist's word 'biosphere' describes it – a mixture of light, heat, gas, water, earth, life and death without straight lines, right-angles or even any complete clarity of atmosphere. Yet he was Professor of perspective at the Royal Academy and well grounded in architecture. And he could show as much interest in physical substance, geometry and darkness as in what Constable in another passage of the letter quoted earlier called 'tinted steam'.

In 'The Destruction of Sodom' the buildings are arranged in a few simple, flat planes like a stage-set. It is a sombre, atmospheric and painterly picture and very different from John Martin's rather ineffectively dramatic picture of the same subject. Painted around 1805, this painting was never sold and on his death in 1851 became part of the

Turner bequest. The fleeing figures – Lot's wife is also indicated but difficult to distinguish – are very different from those by Dürer (on the previous page), and Turner would probably not have been amused by, or admired, that style.

48 JAN MASSYS (OR METSYS) (1509-1575)
'Lot and His Daughters' (Municipal Museum, Cognac, France)

Lot betrays a sense of foreboding, and his daughters an air of cool calculation in this highly meretricious picture of a subject which has never inspired great painting. Jan was the younger son of Quentin Massys who, like Pieter Bruegel the Elder, was a vastly superior artist to his sons.

49 JEAN-BAPTISTE CAMILLE COROT (1796-1875)
'Hagar in the Wilderness' (Metropolitan Museum of Art, New York/Rogers Fund)

Corot was born in Paris where both his parents kept shops, and intended that their son should do the same. But when he was 26 they were forced to realize that they would have to give him a small income if he were to devote his time to painting. He went to Rome in 1825 and worked, as painters from all over Europe were doing, in the open air, showing little attachment to any school either then or later. On leaving Italy he travelled all over France and went to Switzerland, Holland and London. He painted different sorts of pictures for the Salon and for himself and was at one time much criticized for it. The Salon kind, though, are not at all without merit and they financed his personal generosity to his fellow artists. He is credited with nearly 3000 pictures and is generally considered to be the benign spirit of French nineteenth-century painting, his influence being widespread and important but not specific. He painted few religious paintings, though surprisingly a 'Destruction of Sodom' was one of them. His most ambitious project in the field was a series of 14 paintings of the Stations of the Cross for a church at Rosny-sur-Seine in North West France which he visited over several summers.

'Hagar' was exhibited at the Salon in 1835 when Corot was in his late thirties and it attracted considerable attention. The landscape is based on studies made in the Sabine mountains, near Rome, but the trees and boulders are derived from sketches done in the Forest of Fontainebleau. It is a direct, simple and rather beautiful picture, both as a landscape and an expression of Hagar's predicament. The female figure was to concern Corot more and more as he grew older.

50 FRANCESCO COZZA (1605-1682)
'Hagar in the Wilderness' (Rijksmuseum, Amsterdam)

There is an ease and clarity of execution in this picture making it a natural companion to the Corot (on the previous page), which was painted 200 years later, both the direct manner of the painting and the character of the landscape having quite a lot in common with him. Cozza came from Calabria in the South of Italy and became a pupil of Domenichino (one of the most important artists of the Bolognese School) in Rome where he spent most of his life painting frescos and altarpieces.

The angel in this picture is rather how you can imagine one might appear in daylight and is almost aerodynamically convincing. Painters have been, for very understandable reasons, generally reluctant to paint really bare wilderness or desert and apart from a few Italian primitives – who could make it charming – they only started trying to be more truthful in the late nineteenth century, when their pursuit of topographical veracity was often the only virtue in their pictures or, as in the case of William Holman Hunt's 'Scapegoat', dominated the painting at the expense of its subject.

53 REMBRANDT VAN RIJN (1606-1669)
'Abraham and Isaac' (Hermitage, Leningrad)

Not everyone concedes, though some certainly will, that Rembrandt was the greatest painter who ever lived, that is if the title could be claimed for any single artist. But there is no doubt at all that any book of paintings illustrating Bible stories would be infinitely more diminished by his absence from it than by anyone else's. And although he made many masterpieces on New Testament subjects, several of which are in this book, it is his extraordinary feeling for the Old Testament that distinguishes him from all others. His comparatively humble origins and interest in the Jews of Amsterdam certainly helped form his sympathies but no facts or anecdotes can account for his art any more than they can for Shakespeare's. Although many more pictures by him are in this book than by any other artist their selection had to be carefully rationed to prevent him dominating it too much at the expense of other major painters.

'Abraham and Isaac' shows the brilliance of his own deliberately earthbound version of the Baroque, when he was approaching 30, and it is one of several examples of his unprecedented success in freezing split-seconds as a camera does. The picture has great grandeur combined with an unblinking realism. Rembrandt seems to acknowledge that God's

way of testing Abraham is fair and right, and, as in the scripture, Abraham has not hesitated. There is no false pathos in the Patriarch's demeanour, as there is in many other pictures of the subject, and his hand clamped on Isaac's face is intended as much to subdue him physically as to hide his eyes from the knife. Isaac's beautifully-painted and vulnerable flesh is perhaps too fine and well-nourished for the land of Moriah – but the picture is a marvellous proclamation of Rembrandt's unique combination of pictorial and illustrative skill, as well as affirming yet again his intensely personal relationship with the Bible.

The story of Rembrandt's precocity, rise to success and riches, followed by bankruptcy and a continuing decline in his fortunes, matched by an ever-deepening greatness in his work, has often been told, and in the process has also been distorted and exaggerated. The record shows that even after his financial collapse and with his own painters' union conspiring to keep him down, he received important commissions, continued teaching and was always respected.

The selection of his biblical pictures for this book shows his extraordinarily consistent though very varied greatness from 'The Supper at Emmaus' (page 245) and 'Judas Returning the Thirty Pieces of Silver' (page 216), painted in his early twenties, to 'The Return of the Prodigal Son' (page 192) and 'The Denial of Peter' (page 215) from his last years. There is nothing remotely like this body of work in all Christian art. The Church did not employ him as decorator or propagandist, and his Bible paintings are neither testaments of conformity nor pious affirmations of belief. Rembrandt simply saw them as the best of all possible vehicles for the expression of fundamental human truths.

55 GOVAERT FLINCK (1615-1660)
'Isaac Blessing Jacob' (Rijksmuseum, Amsterdam)

Flinck was a pupil of Rembrandt's and could imitate him so well that he is said to have sold some of his pictures as being by his master. He later became a successful portrait painter and also painted decorations for Amsterdam Town Hall. You would think it a little difficult to pass this picture off as a Rembrandt, but it is a good painting of his school and has considerable charm and accomplishment as a 'contemporization' of this curious story. The clothes are particularly attractive, though you don't imagine anything like the nice gloves Jacob is wearing here when you read the text. The characters of all three protagonists are well contrived and Jacob is a smart boy being well backed up by Rebecca his mother, both of them deceiving the old patriach with consummate ease.

56 J.M.W. TURNER (1775-1851)
'Jacob's Dream' (Tate Gallery, London)

Turner has taken some liberties with the biblical text in this picture as he has done with two of his other pictures illustrated here (on pages 260-61 and 269). Joseph seems to have his family with him and is conversing with an angel rather than with God himself. The painting was a part of Turner's great and for a long time half-neglected bequest to the nation. It is curious in once having had a very early date put on it (the 1810s) which was later rejected for the more likely 1830s. But this might mean, and it is an interesting thought, that it was occasionally worked on over 20 or more years.

Turner peopled a few other pictures with such insubstantial beings, including the figures of 'Queen Mab's Grotto', the phosphorescent wraiths in 'The Parting of Hero and Leander', the spectral audience for the Great Western Railway's 'Rain, Steam and Speed', and finally the figures being consumed by light and heat in 'The Angel Standing in the Sun' (page 269). He had used the back of 'Jacob's Dream' as an impromptu palette but that kind of neglect did not necessarily mean that he despised it, as even some of his most important pictures found in his studio on his death had been very ill-used. Perhaps the picture needed to wait (though not quite so long as it did) to find a proper appreciation of how Turner used Titian's example in a way that need no longer seem a little ludicrous. It is a painting that repays repeated inspection.

57 JOSE DE RIBERA (1591-1652)
'Jacob's Dream' (Prado, Madrid)

Ribera was born in Valencia in Spain but went to Italy at an early age and never returned there. After visiting Parma and Bologna he went first to Rome, and then in 1616 to Naples, where he settled. In Rome he had come into contact with Caravaggism (see note for page 170) and although he is considered to have been one of the great Caravaggists himself, he rapidly absorbed the master's message into a potent compound of his own. In Naples he worked under the patronage of the Spanish Viceroys and became the most famous artist in the city. He felt the influence of Velázquez whom he met there and also of Van Dyck without ever sacrificing any of his powerful individuality and he is considered, among other things, one of the greatest Baroque painters. It has been alleged that he was part of a kind of painter's Mafia in Naples which struck terror into artists who were outside it, and the general

atmosphere of Neapolitan painting of the early seventeenth century does not make such an idea at all unlikely. Ribera's feeling for physical reality was remarkably intense and his renderings of male flesh under stress leave a particularly ineradicable impression.

'Jacob' Dream' is for Ribera an exceptionally calm picture. It is a subtle and understated rendering of the subject, and the feeling of the suspension of ordinary life and sleep which is conveyed by the light on the solid Jacob's face make the picture a marvellously earthbound account of a supernatural event. The insubstantiality of the angels is extreme and effective and has an unlikely affinity with the picture (opposite) by Turner.

58 WILLIAM DYCE (1806-1864)
'Jacob and Rachel' (Leicestershire Museum and Art Gallery, Leicester)

Dyce was born in Aberdeen, Scotland, and on leaving school went to the Royal Academy Schools in London, but he soon left for Rome, staying there for nine months. Two years later he went back to Rome and painted a Madonna under the influence of the German Nazarenes, who, though they now seem a rather gutless version of the Pre-Raphaelite Brotherhood, became a strong influence on them, largely through the agency of Dyce. He himself soon became a Royal Academician and a favourite painter of the Prince Consort, who had him commissioned to paint decorations in the new Houses of Parliament as well as some frescos in Buckingham Palace and at Osborne House, the royal residence on the Isle of Wight. In his later years he painted more secular subjects and with a greater concentration on natural detail, the most famous and no doubt best of which is 'Pegwell Bay' (in the Tate Gallery, London). Dyce was also a composer of church music and a designer of stained-glass, and was very active in the public affairs of art. He declined the Presidency of the Royal Academy in 1850.

Three versions exist of 'Jacob and Rachel'. There is a full-length one in Hamburg, but this half-length in which much of the pastoral detail is eliminated seems to convey a greater intensity of feeling. Dyce, like Jacob, was engaged for a long time, and he painted the subject to celebrate his long-delayed marriage. It expresses a more real romantic ardour than any other picture of the subject and it is very well painted. The sentiment does not cloy and the costumes are lovingly rendered, the waist scarves suggesting that the couple will certainly one day be joined together. Dyce was asked by Mr Gladstone to paint a fourth version but, although wishing to please him, he could not bring himself to repeat the subject again.

59 SALVATOR ROSA (1615-1673)
'Jacob and the Angel' (Trustees of the Chatsworth Settlement, Derbyshire)

Salvator Rosa was born in Naples a year before Ribera arrived there, and may have been his pupil for a short time. He not only had a talent for painting, but was also a good musician and poet. Though he began his career in Naples he soon went to Florence, where he stayed for nine years and then to Rome, where he spent the rest of his life. Although he started by attaching himself to a group of painters in Rome who specialized in unromanticized scenes of low life, he turned away from them first towards a Poussin-based Classicism, then disintegrated into a kind of anti-Classicism (very freely painted yet still remaining attached to its classical source). But eventually he became the prototype of the Romantic artist and proclaimed himself as such in his self-portrait in the National Gallery in London. He was an essential influence on Magnasco (pages 180-81).

This 'Jacob and the Angel' is not a great painting but is vigorous and to the point. The subject is one to which, perhaps, painters have not done full justice. Rembrandt painted a strange one which made it seem that the angel had asked Jacob to carry him somewhere, and Delacroix put the subject onto a wall at S. Sulpice in Paris. Salvator Rosa has caused the dramatic struggle of God and man to be witnessed by two indifferent cows (somewhat difficult to distinguish in the background on the right of the picture).

60 REMBRANDT VAN RIJN (1606-1669)
'Joseph Telling His Dream' (Rijksmuseum, Amsterdam)

This picture, like that of 'Christ Presented to the People' by the same artist (page 225) is a study for an etching and in this case even more satisfying than the end result. It is curious in that its composition and feeling in general are very different to the resulting print. In the etching Joseph's brothers are shown to be reacting almost as positively as in the biblical text to his precocious and vexing divinations, but in the sketch Rembrandt has not found it necessary to bring the design anywhere near its conclusion and it is just a study of an old man on the verge of telling an over-talkative young boy to stop his chatter, in spite of being at the same time reluctantly impressed with his descriptive powers. It is certainly a masterpiece of evocation.

It is interesting to note that the models for both Israel (Jacob) and his son Joseph are almost certainly the same ones as Rembrandt used for the figures of Abraham and the Angel in his 'Abraham and Isaac' (page 53).

61 FORD MADOX BROWN (1821-1893)
'The Coat of Many Colours' (Walker Art Gallery, Liverpool)

Ford Madox Brown is best known for his moral, and essentially radical, pictures 'Work' and the remarkable 'The Last of England', which latter painting constitutes a reproach to a country which could oblige middle-class people to seek their livelihoods elsewhere. He was closely associated with the Pre-Raphaelite Brotherhood but never actually became a member.

'The Coat of Many Colours' is one of his handful of biblical paintings and perhaps the most vivid one of its kind. It was painted, with interruptions, in about 18 months and based on a design he made for a mixed collection of biblical engravings, the landscape background being taken from a water-colour of Palestine by another hand. All the figures were painted from models and the artist made Levi's necklace himself. He described details of the picture in a catalogue note – how cruel Simeon looks at his father guiltily, 'already prepared to bluster', and how the dog sniffs the blood, which he recognizes as not belonging to man, while Issachar the fool sucks the head of his shepherd's crook. The crouching figure is Jacob's youngest son, Benjamin, and the ladder behind a symbol of Jacob's dream of the angels on the ladder. Although the picture does not carry the wealth of detail of Holman Hunt's 'Finding the Saviour in the Temple' (page 159) what it has is more lively and interesting. The picture confirms once more that in the nineteenth century the Old Testament was more real to British artists than to those of any other country.

62a ORAZIO GENTILESCHI (1563-1639)
'Joseph and Potiphar's Wife' (By Gracious Permission of Her Majesty The Queen)

Gentileschi was born in Pisa in North West Italy and was one of the followers of Caravaggio who knew him personally, and also one of the few who declined to follow him all the way, taking more from his early works which depended on high colouring than on his later much more influential chiaroscuro. He worked in Rome, Turin, the Marches in Central Italy and Genoa before going to France in the service of Maria de'Medici where he influenced many French and visiting Dutch artists. But Rubens's presence in Paris when painting his huge cycle of paintings for the Queen oppressed him and he accepted an invitation from Charles I to go to London. Most of his large decorations at Greenwich, Somerset House in London and elsewhere have not survived but some of his reinterpretations of his earlier works which are still with us are of very high quality. He is nowadays gaining fame as the father of Artemisia Gentileschi, whom he encouraged to become a formidable painter (see pages 126 and 134).

'Joseph and Potiphar's Wife' was probably painted specially for Charles I and was sold by Cromwell's Commonwealth, later being regained for the British Royal Collection at the Restoration. It is beautifully designed and painted and demonstrates Gentileschi's use of drapery for investing the figures and the painting with gravity and poise rather than grace or Baroque animation. You can look at his costumes and curtains as at cliff faces or other geological formations made beautiful by light and colour. Joseph as he leaves the room with a rather formal, even balletic, pause, looks back at Potiphar's wife as if he has nearly been tempted but did not think she quite merited him, and it seems as if he might even be leaving his cloak as a condescending souvenir, but that was almost certainly not intended. Perhaps it does not do justice to Joseph's virtue or the possible attractions of Potiphar's wife but it is an excellent and absorbing painting which very well demonstrates Gentileschi's highly individual talent.

62b MASTER OF THE JOSEPH LEGEND (active Brussels, 1500) 'Joseph and Potiphar's Wife' (Alte Pinakothek, Munich)

This is a much less impressive work than the other two pictures of the subject shown here but it demonstrates an earlier German approach with narrative details. Joseph is just a good boy in a fix and Potiphar's wife is simply the kind of lady all boys are supposed to avoid. Her husband is made to appear not much more than rather pained by the incident. Only Rembrandt in the three pictures of the subject entirely avoids the common prurience of painters when tackling this kind of biblical subject.

63 REMBRANDT VAN RIJN (1606-1669)
'Joseph Accused by Potiphar's Wife' (National Gallery of Art, Washington)

The wife of Potiphar has here arrayed herself in her most alluring pink peignoir, but to little effect. Joseph seems rather sorry for her and to wish that the polite relations that had so far been maintained between them could be resumed without fuss, but he knows that it cannot be so. Potiphar may well have had this kind of problem before and probably saw quite clearly that Joseph would inevitably become vulnerable to his wife's seductive scheming. Rembrandt has made a sensitive drama of the

pathos underlying the usually straightforward spicy tale of the scarlet woman and the virtuous youth. He painted another version of the scene with Joseph looking more alarmed, and although some think it a better painting, it does not have the subtle nuances of this one. Rembrandt as always broadens and deepens the story.

64 BARON FRANCOIS-PASCAL GERARD (1770-1837)
'Joseph Recognized by His Brethren' (Musée des Beaux-Arts, Angers, France)

Gérard was a competent draughtsman at the age of 12, and when he had responded with enthusiasm to the showing of J-L. David's 'The Oath of the Horatii', he had no difficulty in gaining entrance to the artist's studio as a pupil, winning the Prix de Rome jointly with Girodet Trioson (see his 'The Deluge', page 37) in 1789. Gérard was only a moderately successful artist until the rise of Napoleon when he became his official portrait painter. His most famous First Empire portrait, however, is probably that of Madame Récamier. He also made some large decorations and painted the Victory at Austerlitz on the ceiling of the Paris Tuileries for Napoleon. The Emperor's fall did no damage whatever to his career and he was soon made a Baron by Louis XVIII. He continued as an indefatigable painter of portraits, particularly royal ones ('A King of Painters and Painter of Kings'), as well as of historical subjects until his sight began to fail and the age of Classicism approached its end. He had maintained a lively Salon over 30 years where music was the main attraction and he had earlier encouraged young painters including Ingres, who was ten years his junior.

'Joseph Recognized by His Brethren' is a very early work and perhaps only a curiosity of Davidian Classicism applied to the Old Testament. In comparison with later biblical reconstructions in both England and France the research does not seem to have been very thorough, and it perhaps does not make a very worthy conclusion to the most satisfying success story of the Old Testament.

65 RAPHAEL (RAFFAELLO SANZIO) (1483-1520)
'The Finding of Moses' (Vatican Loggia, Rome)

Although always attributed to Raphael, this is the last decorative scheme executed by his workshop in the Vatican and Raphael's brush is unlikely ever to have touched the picture. His assistant Giulio Romano painted it from sketches by his master or even entirely invented the composition. The whole cycle of illustrations to the Old Testament in the Loggia is the most exuberant and carefree of all biblical-narrative series, sometimes verging, though always with charm, on the insouciant and sometimes also conveying a remarkably timeless painterly quality.

The text of Exodus does not describe quite such a cheerful, and no doubt noisy, awakening for the infant Moses.

66 FREDERICK DILLON (1823-1900)
'The Finding of Moses' (Private Collection)

Now hardly remembered at all, Frederick Dillon was an English topographical painter of private means, and he seems to have been an interesting person. He was not very successful though, showing pictures at the Royal Academy but never becoming an Academician. Many of his paintings and drawings were fruits of wide travels, and he visited Egypt several times. He also knew Japan well and wrote an introduction to a catalogue of an exhibition of Chinese and Japanese art in London in 1878. He was apparently a man of radical sympathies, being a friend of the Italian nationalist Mazzini and assisting exiles from the Hungarian revolution.

This twilight picture of Moses' discovery is an inspired illustration by a minor artist and is in striking contrast to the transfer of the scene to sumptuous European settings favoured by Veronese and other masters. The deserted shore comes as a surprise and the distance between Pharaoh's daughter and her maid is original and telling. It is a small gem of modest art and committed illustration.

68 DOMENICO FETTI (c. 1589-1623)
'Moses and the Burning Bush' (Kunsthistorisches Museum, Vienna)

You can imagine commissioning all sorts of painters in history to paint – and succeed in painting – an exciting picture of this very famous appearance of God to Man, but few were asked to undertake it and none managed to make of it an unforgettable image. Fetti was a painter who developed affinities with several others in this collection – Tintoretto, Caravaggio, Rubens, Veronese and Elsheimer, and his painting seems at once hybrid and individual. He was connected with the Gonzaga court in Mantua and lived in Rome and Venice where he finished his short life, either a victim of 'malignant fevers' or following some 'disorderly incidents'.

This picture is a good one but falls short of complete success in evoking the presence of Jehovah in the flames or capturing an unequivocal sense of destiny in the figure of Moses.

71 DAVID ROBERTS (1796-1864)
'The Departure of the Israelites' (Birmingham City Art Gallery, West Midlands)

Amongst many other scenic achievements, David Roberts designed the sets for the first London production of Mozart's Il Seraglio. He had been a housepainter before becoming a scenic artist and worked at first for travelling circuses. He was a brilliant architectural and topographical draughtsman and became a Royal Academician as well as one of the Commissioners for the Great Exhibition of 1851. He also produced six volumes of brilliant chromolithographs from water-colours, called Views in the Holy Land, Syria, Idumea, Arabia and Egypt (1842-1849).

This painting of 'The Departure of the Israelites' represents a marriage of the scenic artist's talent with his architectural and topographical experience and it is impressively professional. But although the foreground figures are fairly well attempted, as the huge host of the Israelites recedes, we begin to feel that we may be looking at the Hanging Gardens of Babylon rather than a mass of people. However impressive the picture is, though, it underlines John Martin's superiority in this kind of illustration by reason of the imaginative fervour he communicates, which seems lacking in Roberts despite the latter's skill.

72 TINTORETTO (JACOPO ROBUSTI) (1518-1594)
'Moses with the Pillar of Fire' (Scuola di S. Rocco, Venice)

Next to Michelangelo and perhaps before Rubens, the painter who most made his own physical energy into what is in effect a major subject of his own art, is Tintoretto. He was born and lived all his life in Venice and although he certainly absorbed a great deal from Titian, who shared with him a sense of mutual rivalry, his style was also formed from sources outside Venice which were Mannerist in character, owing as much to Michelangelo as to his great Venetian contemporary and forbears. He was a painter as dedicated to large-scale spectacle as any who ever lived and was responsible (with some assistance) for the biggest single oil painting in the world, which he painted for the Doge's Palace in Venice.

As an illustrator of the New Testament Tintoretto was sometimes a little too spectacular (at least for some tastes). No one perhaps can quite sufficiently relate his extraordinary 'Last Supper' with the account in the Gospels and his 'Christ Washing the Disciples' Feet' is rather like a rehearsal for a play involving the incident at some monster National Theatre. Many people would probably agree that some of the works in the Scuola di S. Rocco in Venice combine the Bible and Tintoretto's huge vitality most effectively and that on the whole his manner is more suited to Old Testament subjects than to New. (But then we do include here his 'Nativity' on page 144, and there are others.)

'Moses With the Pillar of Fire' shows Tintoretto's speed and audacity in one single image and it speaks the language of painting as we understand it today. It is difficult to imagine Jehovah bringing His great beacon into being but perhaps He did it as Tintoretto painted this picture – with a few huge gestures.

73 LUCAS CRANACH THE ELDER (1472-1553)
'The Submersion of Pharaoh's Army' (Alte Pinakothek, Munich)

In a rocky northern landscape, Pharaoh's German army is foundering in a sea of foam that looks like modern detergent, though the wagonners on the extreme right evidently expect to survive. A bearded and haloed Moses reassures the Children of Israel who on the whole don't look too worried or surprised. The picture expresses Cranach's waggishness at its most extreme. Francis Danby (see note for page 264), who painted a very large and seriously spectacular picture of the subject, would have felt great contempt for it, as would many more painters of any period. But it has, like Dürer's view of Lot's family (page 45), the quality of a great painter's caprice.

74 SAMUEL COLMAN (active 1816-1840)
'The Delivery of Israel out of Egypt' (Birmingham City Art Gallery, West Midlands)

Little is known of Samuel Colman except that he worked in Bristol for a time and certainly saw the apocalyptic works of John Martin and Francis Danby. Someone once, with little perception, put John Martin's signature on this picture. It must be Colman's finest surviving work, as some others seem like cramped and primitive Martins (there is a bad Colman of 'Belshazzar's Feast' which may have been painted early in his working life).

This picture seems quite independent of Martin and if anything it brings to mind the work of the Belgian Symbolists at the turn of the last century. Instead of merely great walls of water crashing down on the Egyptians it seems that Jehovah has put rocks in there too, and Colman, unlike Cranach (on the previous page), has given no one much chance of escape. Moses and the Israelites must have had a very steep climb from the bed of the Red Sea and the great leader of the Children of Israel can be seen right in the centre under the pillar of fire, with a huge encampment stretching away from him on either side. The only curiously silly touch is a pair of Egyptian soldiers trying to retrieve some

gold plate in the foreground. Perhaps Colman borrowed them from Martin's 'The Fall of Nineveh' where they might have had more chance of success. It is a large picture, over six feet (nearly two metres) wide, and a remarkable curiosity of English painting.

75 DIERIC BOUTS (c.1415-1475)
'The Gathering of the Manna' (Church of St Pierre, Louvain, Belgium)

Little is known of Bouts, except that he was born in the Low Countries in Haarlem and settled later in Louvain, Brabant, where he married a lady with a good dowry. The main influence in his work is that of Van Eyck though Rogier van der Weyden's presence can be felt too. Bouts was a most accomplished master of the Flemish School whose surviving works are nearly all of sacred subjects which show a mastery of landscape and still life.

A polyptych of 'The Last Supper' includes this painting of 'The Gathering of the Manna', together with three other Old Testament paintings which are equally decorous in spirit. Apart from real iconographic puzzles, the sheer strangeness of some painters' personal decisions defies analysis. Why for instance do these very comfortably-off Flemish Israelites, whom you could suppose to be Bouts' wife's family, possess only two exquisite baskets between them and have to depend on such precious vessels to gather the Manna? And is Moses the beardless young man praying in the cave on the top right-hand side, and if so why is he there? There are several curious illustrations of this miracle in painting and a grand Tintoretto in the Scuola di S. Rocco in Venice which is too much like his 'Moses Striking Water from the Rock' (page 79) to include also in this collection.

77 NICOLAS POUSSIN (1594-1665)
'The Worship of the Golden Calf' (The National Gallery, London)

Apart from a period in the eighteenth century, Poussin had a great and continuous influence on painting which lasted in a direct sense until Cézanne, and he is still considered by many painters the paradigm of the artist as a bringer of order. After a less than brilliant beginning to his career in Paris, he went to Rome where after an equally shaky start he became ill, married his nurse and acquired a brother-in-law, Gaspard Dughet (see his 'Jonah Being Thrown Overboard' on page 121), as a pupil and follower. He then started on his career of easel-painting for a series of discriminating private collectors. This way of working was only once seriously interrupted, by a summons to France by Louis XIII which ended in his flight back to Rome when he was offered only large-scale commissions. Although he had earlier aspired to such work it had by now become abhorrent to him. He spent the rest of his life in Rome.

Poussin executed a number of paintings relating to the Bible and Christianity but, as 'The Worship of the Golden Calf' and many others show, the Pagan world of antiquity was never far away and his 'classical' landscape was not at all biblical in feeling. He cannot really be counted as an illustrator of the Bible at all, but as this picture represents a temporary conversion of the Israelites to what was, in effect, Paganism it has some validity and is also very beautiful. As the Children of Israel taste their new-found Dionysian pleasures, Moses can be seen to have descended – as yet unobserved – from the mountain (top left) and to be casting his tablets down in rage and disgust. Poussin's near-contemporary Rembrandt provides a close-up in a more biblical spirit with the picture on the following page.

78 REMBRANDT VAN RIJN (1606-1669)
'Moses Breaking the Tables of the Law' (Staatliche Museen, West Berlin)

The figure of Moses has been tackled with real confidence by only a very few artists. Michelangelo's sculpture is the first image that comes to most people's mind, and Tintoretto is another who can take in his stride the most awesome of all the Almighty's human confidants.

Rembrandt, with his extraordinary rapport with Jewish people, shows Moses – as he does most other things – as being of the artist's own real world and none the less impressive for that. It has been suggested that this picture was meant to represent Moses showing the second tables of the law to his people, but it is much more likely that the accepted title of the picture (quoted here) is correct. This painting has unfortunately been cut down from its original size.

79 TINTORETTO (JACOPO ROBUSTI) (1518-1594)
'Moses Striking the Rock' (Scuola di S. Rocco, Venice)

This is one of the grandest designs in the upper rooms of the Scuola di S. Rocco. The imperious Moses has struck the rock and the arc of water stresses his responsibility for it by framing him while God the Father (apparently supported by an enormous bubble) is watching. The animation of the multitude is marvellously realized and their yearning is no doubt supposed to represent a spiritual thirst as well as their thirst for water. A space has been driven through the painting, on the right, where horsemen are suggested against the sky. This is Venetian Mannerism with strong support from Florence and as powerful as such painting can be.

80 PETER PAUL RUBENS (1577-1640)
'The Brazen Serpent' (National Gallery, London)

Rubens has here painted one of his many masterly compositions in the Flemish High-Baroque style that he brought to its peak. The writhing anguish of the figures is eloquently conveyed with the snake-bites looking as painful and poisonous as they must have felt. But you know that Moses and Aaron will solve the problem, as they firmly and patiently deal with yet another affliction of their hapless flock.

81 REMBRANDT VAN RIJN (1606-1669)
'Balaam and his Ass' (Musée Cognacq-Jay, Paris)

There are not many pictures of this curious and amusing story and this very early Rembrandt is the best, among other things making more of the talking she-ass than any of the alternatives. Rembrandt is here shown as the extrovert miller's son amusing himself rather than the complex one etching his own frowning countenance or simply the genius painting great pictures like the one of 'Judas Returning the Thirty Pieces of Silver' (page 216).

83 GUSTAVE MOREAU (1826-1898)
'Moses Sheds his Sandals in Sight of the Holy Land' (Musée Moreau, Paris)

The most exotic and 'decadent' of the French Symbolist painters, Moreau lived most of his life in Paris and Delacroix was the first painter to affect him strongly. But the great Romantic's influence was soon superseded by that of Théodore Chassériau, also a Romantic but of a more voluptuous persuasion. After Chassériau's death in 1856, Moreau spent two years in Italy where he copied the masters, notably Carpaccio and Mantegna. On his return to Paris he exhibited at the Salon pictures such as 'The Young Man and Death' and 'Young Thracian Girl Carrying the Head of Orpheus' whose titles give the flavour of the preoccupations that would last his whole life. He worked steadily with mixed success until 1888 when he was appointed to the Académie des Beaux-Arts, later being made Professor. The pupils there on whom he had personal influence included Rouault, Matisse and Marquet. Most of his paintings are of his exotic fantasy world – bejewelled, theatrical, oppressive and haunted by the spectre of the *femme fatale*. When he died he left his studio to the State and Rouault was its first curator. To experience fully the artistic personality of Moreau it is necessary to visit it.

This picture of Moses shedding his sandals (a gesture in Palestine equivalent to the baring of the head in Europe) shows that Moreau was essentially a 'fin de siècle' artist even in 1856. There may be something a little risible about Moses' ash-whitened head and his glacial halo which are no doubt intended to convey the great patriach's disappointment and shame. But the image, as we smile, earns some kind of grudging respect in rather the same way as the moody but never amusing decorations of Burne-Jones do, and these last were also in some respects advanced for their time.

Moreau was generally much more preoccupied with pagan mythology than the Bible, which shows itself in his obsession with Salome's dance rather than with the very few central Christian subjects he attempted. It is interesting that Rouault, who never completely shook off Moreau's influence, became the only French twentieth-century artist of stature for whom Christianity was a principal concern.

85 JOHN MARTIN (1789-1854)
'Joshua Commanding the Sun to Stand Still over Gibeon' (Freemasons' Hall, United Grand Lodge of England, London)

This picture was Martin's first attempt at an epic vision of Divine intervention in human affairs and it attracted much attention at the Royal Academy in 1816. It did not sell, either there or at the British Institution the next year where it won a second prize of £100. What offended its critics most was the scale of the tiny figures in its enormous setting and they would have preferred to have seen Joshua in close-up, as they had wanted to see the victor of Waterloo depicted in the innumerable portraits of him at the same period. As William Feaver, the only authority on Martin, has put it: 'Martin had, it seemed, made mannikins of mankind; he had overlooked human dignity and underrated human passions by concentrating on the sublimities of thunderstorm and earthquake.' The critics suspected that Martin was incapable of painting a full-size figure to their satisfaction, and he certainly never proved them wrong.

Admittedly the picture, as might be expected of a first effort at epic grandeur, is certainly not his best, but it can be seen as a heroic and partly successful attempt to make an entirely new kind of biblical painting, and its character is the result of something more than Martin's ineptitude with the human figure. Martin always saw Man as small and helpless, though not at all contemptible in relation to the huge forces that fashioned – and continue to control – the universe. The source of inspiration for the sky must have been Turner's masterpiece 'Hannibal Crossing the Alps', with its own dwarfed army. Whatever its worth

this picture launched Martin's career as a painter who brought an entirely new and exciting dimension to biblical painting, if it did also betray some of the weaknesses that never left him.

86 LEON BONNAT (1833-1922)
'Samson Killing the Lion' (Musée Bonnat, Bayonne, France)

Léon Bonnat is now almost forgotten even in France, though his 'Job' (page 113) is still to be seen in the Louvre. But once he was very successful indeed, made a great deal of money, and was a Professor at the Ecole des Beaux-Arts in Paris. His father was a bookseller in Madrid and his early work, much of it religious, shows Spanish influence, particularly that of Ribera (see page 57). J.K. Huysmans, the French novelist, commented adversely on the gloomy lighting in his pictures: 'Wine-coloured and murky, a light passing through dirty windows.' In the 1870s Bonnat turned to portraits and a critic later commented: 'He painted, against backgrounds abominably soaked in tobacco juice, all the faces and all the profiles of the social register.' His success in the face of such dissent enabled him to amass a good collection of other artists' work which he bequeathed to his native city, Bayonne. It includes many old master drawings including works by Goya, Rembrandt and Ingres and is housed in the Musée Bonnat there.

'Samson Killing the Lion' is a sketch for a large finished work which cannot be traced. Yet it is more than the preparation for a typical Salon picture and has an unpretentious freedom and objectivity that are far from mechanical. Young Samson is taking the risky course of putting his hand in the lion's mouth to tear its jaws asunder. A Rubens sketch of this rare subject in the Nationalmuseum, Stockholm, is predictable and rather undistinguished.

87 JORG BREU (1475/6–1537)
'The Story of Samson' (Kunstsammlung, Basel, Switzerland)

The slaughter of the Philistines has been rather understated here, when compared to some other pictures of Breu's time. Little is known about him but he has a very distinctive and lively style. Although the picture includes Delilah's betrayal and the pulling down of the Temple (not very convincing mechanically), it unfortunately omits other anecdotes which might make it even more interesting. Breu seems to have liked the deliberate, offensive grimace which can be seen again in his 'Crowning with Thorns' (page 221). He worked mainly in Augsburg, Bavaria, and was a painter of the Danube School, sharing its preoccupation with landscape.

88 PETER PAUL RUBENS (1577-1640)
'Samson and Delilah' (National Gallery, London)

This stunning picture was the means by which Rubens announced himself to Antwerp as the great mature painter he had become during his eight years' absence in Italy. There is no suggestion of an ingenious setting out of his wares about the painting, rather the feeling of a man confidently knocking on a great door, knowing that it will straight away be opened to him. He did not hesitate to represent Delilah unmistakably as a whore and the setting quite frankly as a brothel (with the madam herself a keen protagonist). The furnishings are not quite tawdry but rather coarsely ostentatious – the atmosphere palpably sensual with the contrast of Delilah's white skin and Samson's sunburned back deliberately chosen for erotic evocation. Delilah's gesture with her hand is a subtle one of only momentary pity and memory and the trio's confidence that they have unmanned the giant is in deliberate contrast to the unease of the soldiers outside who cannot feel sure that they have. The influence of Michelangelo and Adam Elsheimer, Rubens's German friend in Rome, has been traced in this work, and a preparatory 'modello' exists in America. But the picture's triumph is that it seems to have come into being without reflection, like a thunderclap.

This painting was commissioned by a rich citizen of Antwerp, Nicolaas Rockox, who was to be Ruben's friend for life and who also commissioned the great *Coup de Lance* 'Crucifixion' (page 229). In asking Rubens to paint this 'Samson and Delilah' he had started the artist's royal progress as a painter, which was only to end in the year they both died.

90 SOLOMON J. SOLOMON (1860-1927)
'Samson and Delilah' (Walker Art Gallery, Liverpool)

The French Salon painters at the end of the nineteenth century were on the whole better at this kind of shamelessly theatrical historical reconstruction and you would not expect anything quite like this from Sir Edward Poynter (page 102) or Sir Lawrence Alma Tadema. But Solomon J. Solomon in what is now his only well-known picture pulled off a first-class British effort in the French *'pompier'* (overblown, historical-academic) tradition. In contrast to the Rubens on the previous page, Delilah does not feel quite sure that the conspiracy has succeeded here and also looks as if she might have played her part for quite a small favour. Rembrandt made her seem equally craven in his picture of the same subject in the Stadelsches Kunstinstitut in Frankfurt.

92 AERT (ARENT) DE GELDER (1645-1727)
'Ruth and Boaz' (National Museum, Budapest)

The somewhat indecorous character of this painting as a biblical illustration could be explained by the accepted practice in seventeenth-century Holland of married (or marrying) couples commissioning dual portraits dressed in the guise of biblical characters – betrothed pairs even being known to have been depicted as the Angel Gabriel with the Virgin Annunciate. It is more than possible that the picture shown here was a commission of this kind. Rembrandt's great 'Jewish Bride' is related to the genre as it suggests a possible connection with a drawing he made of 'Isaac and Rebecca'. 'Ruth and Boaz' cannot be said to show much concern with biblical feeling and as an illustration of the story it needs, if it does not ask for, our indulgence. But it is an uninhibited picture of rude charm and spirited, painterly skill made especially interesting by the social convention, sometimes ecclesiastically sanctioned, from which it arose.

93 GERRIT DOU (1613-1675)
'Eli Instructing Samuel' (Rijksmuseum, Amsterdam)

Dou became Rembrandt's first pupil in 1628 in Leyden (Leiden) in the Netherlands, and collaborated with him on at least one picture. When Rembrandt left for Amsterdam he began to develop a very highly finished style of his own, painting domestic interiors with figures and still life with a meticulous skill that earned him a lot of money. His pictures continued to fetch large sums in the eighteenth and nineteenth centuries when some even declared him to be greater than Rembrandt.

This glimpse of the dedicated young Samuel is beautifully executed and the sentiment cloys only a very little. The Calling of Samuel has always been a typical Sunday School story and Sir Joshua Reynolds painted a winsome picture of the subject which was once very popular. Dou's picture would make anyone pause in the Rijksmuseum – before hurrying on to the the next Rembrandt.

94 REMBRANDT VAN RIJN (1606-1669)
'Saul and David' (Mauritshuis, The Hague)

There are a number of pleasures awaiting the chance visitor to the Mauritshuis but none so captivating or surprising as the first sight of this picture. The oriental finery that Rembrandt enjoyed so much is both beautiful to look at and slightly absurd, and Saul's appearance as he wipes away his tears on the curtain is both sinister and ludicrous. David is a serious young Israelite musician entirely preoccupied with his duty as a performer, and the symbolic dark space between them suggests that the consoling sound is the only thing that connects them. It is a picture that manages at the same time to be moving, amusing and beautiful.

The attribution of this picture has been questioned but it is really only of academic interest whether one Rembrandt authority's assertion that it is by someone else is true or false, though we would of course like to praise the right painter.

96 EDGAR DEGAS (1834-1917)
'David and Goliath' (Fitzwilliam Museum, Cambridge)

Degas was one of the greatest painters who was ever called an Impressionist, and indeed one of the greatest of all nineteenth-century painters. He came from a rich banking family and was taught strictly in the tradition of Ingres, whom he revered all his life. He painted several historical pictures in his youth and then concentrated for a while on portraits, going on to subjects such as the racecourse, the theatre, the ballet and perhaps most characteristically the female nude depicted as if caught unawares. He was the first painter unequivocally to embrace photography as an enhancement of the painter's vision and was a keen photographer himself. When, later in his life, his eyesight began to fail he did some remarkable small sculptures of dancers and horses. He also brought the art of pastel to a peak (and muscularity) which no one else could have imagined or foreseen.

This oil sketch of David and Goliath was made in the 1860s and no other related work has come to light, though he may well have intended to make a more finished painting of the subject. It is an extraordinary curiosity and lay for a long time in the basement of the Fitzwilliam Museum until 1979, since when it has been regularly on view. There is nothing quite like it in subject or treatment, as there seems to be no other picture of David at the moment of wielding his sling against Goliath, or perhaps it should be said just afterwards as close inspection seems to reveal blood on the giant's forehead even though the sling is still in the air and he has yet to fall. Goliath is also much further away from David than you would expect for fullest possible dramatic effect and what indication there is of the watching armies implies that they are giving the contest a wide berth. Like all great draughtsmen, Degas could not make the most cursory pencil or brushmark without defining something real. The picture's closest relation in this book is the Rembrandt of 'Joseph Telling his Dream' (page 60) and the Degas is just as vital even if thrown off yet more rapidly.

97 ORAZIO GENTILESCHI (1563-1639)
'David Contemplating the Death of Goliath' (Spada Gallery, Rome)

In contrast to Degas's painting opposite, in this picture the young David comes sharply into focus after his victory, and Gentileschi represents him as a noble and reflective youth who will quite soon become a king. But the head of Goliath being in shadow seems to imply that the episode, in David's mind, is already moving rapidly into the past and that what he is really contemplating are the responsibilities of the future. The artist has made what is basically a very fine male nude, and the clothing such as it is has the significant substance and composition that we can expect from this artist. David is grasping the stone that killed Goliath and holding his sword.

Although it has been suggested that the background has been painted by another hand, only the figure of David being by Gentileschi, it has been well enough done. There is another smaller version by him of the subject in the Nationalgalerie, West Berlin.

98 BENJAMIN WEST (1738-1820)
'Saul and the Witch of Endor' (Wadsworth Atheneum, Hartford, Conn.)

Benjamin West always claimed that American Indians had taught him to colour his drawings with earth using a brush made of cat's hair. Born in Massachusetts, he was the first white American master painter and ironically ended up as the President of the Royal Academy in London. He studied only very briefly in America and then went to Rome where he was subjected to Neo-Classical theory. Three years later he was in London becoming a historical painter, 'The Death of Wolfe' being his first great success. Later he moved away from Classicism and his 'Death on a Pale Horse' prefigures French nineteenth-century Romanticism. He painted large decorations in Windsor Castle and his Presidency of the Royal Academy confirmed him as a major pillar of the British establishment.

'Saul and the Witch of Endor' was painted in 1777 and Classicism can already be seen to be receding into the past. The text had inspired a great and greatly ominous picture by Salvator Rosa, an image that was remembered by Goya. West, in spite of a certain naivety, had an instinct for some of the deepest purposes that were moving in art in his time.

99 HANS MEMLING (1430/40-1494)
'David and Bathsheba' (Staatsgalerie, Stuttgart)

Very little is known about the early life of Memling except that he was born in Germany. After that the first known record of him was made when he officially became a citizen of Bruges. He was probably a pupil of Rogier van der Weyden's but this is not certain. His reputation was once greater than Rogier's and Van Eyck's because of his more facile virtuosity and larger output. He was also better known in Italy, and important in showing Flemish art to the Italians. Now he would probably be ranked below those supreme painters but he is still acknowledged as a great master of his art and school.

Bathsheba in this picture is a beautiful Northern nude who looks as if she could be the intelligent wife of an army officer – as indeed she was (and there are reliefs depicting armed combat on the building outside). The personalities of both Bathsheba and her maid are well characterized, and the latter's dispassionate solicitude is effectively conveyed. The most subtle of all Memling's virtuosity is shown in the tiny droplets of water on Bathsheba's legs.

100 REMBRANDT VAN RIJN (1606-1669)
'Bathsheba' (Louvre, Paris)

It might at first seem mistaken to have included Rembrandt's 'Bathsheba' in this book as it could be thought to be more about Hendrickje Stoffels (whom Kenneth Clark called 'one of the sweetest companions a great artist ever had') than Bathsheba in the Bible. Hendrickje, the model for the future mother of Solomon, lived with Rembrandt after the death of his wife Saskia, and with his son Titus formed a company to manage his affairs and save him from his union, the Guild of St Luke. If a beautiful married woman ('her round, solid body, which is seen with such love that it becomes beautiful,' as Clark describes it) receives a letter from an all-powerful and charismatic young king, how is she likely to feel and look? Quite likely as Hendrickje does may be the answer, if she is a sensible and thoughtful person.

The composition was evolved from two antique reliefs and in Clark's words, 'It is the supreme example of how his study of classic art does not deflect him from his search for truth'. It is surely also the greatest picture of its biblical subject.

101 WILLIAM DYCE (1806-1864)
'The Judgment of Solomon' (National Gallery of Scotland)

A few heavyweight artists have tackled this classic subject, and in Renaissance Siena it was a speciality of Matteo di Giovanni. But High Baroque versions with the executioner brandishing the baby and his

sword with nonchalance, and the good and bad harlot mothers flinging themselves around – as they are often made to do in such pictures – are somehow unconvincing. This slight picture in tempera on paper cannot be called one of Dyce's few unequivocal triumphs, but it has some of the qualities of gentleness and grace with which he could nearly always infuse his work. There is nothing that seems absolutely right about it, and putting the bad mother in dark clothes does seem a rather weak device. It has a feeling, though, often lacking in other versions, of the judicial wisdom and benevolence of Solomon.

102 SIR EDWARD POYNTER (1839-1919)
'The Queen of Sheba Being Received by Solomon' (National Gallery of New South Wales, Sydney)

Poynter was trained in Paris in the company of Whistler but could hardly have found much in common with this artist. Du Maurier, in a famous illustration to his novel 'Trilby' pictured Poynter as the industrious apprentice, in contrast to Whistler's debonair frivolity. Poynter became the first Slade Professor in the University of London and one of the most successful Victorian painters of historical and biblical subjects which became increasingly well-researched and executed. 'Israel in Egypt' is probably the best-known and the largest. He also became involved in extensive decorative schemes in the Houses of Parliament. Later he painted only classical genre scenes in the manner of Sir Lawrence Alma Tadema, who perhaps had more imagination and flair than Poynter.

This picture of the celebrated meeting of Solomon and the legendary, Queen has not been seen outside Australia since it was sent there in 1892. It represents one of the highest points of the English kind of 'Salon' painting which prefigured wide-screen Hollywood epics. The detail of the architecture, costumes, jewellery and furnishings is impressively accomplished but the human element seems more dubious. Ironically the type of 'glamour girl' with which Hollywood was to people its sets has been remarkably well predicted, and however decorative these girls are they don't carry much historical or human conviction. But it is a spectacular work which tells us something about biblical times and is a better *illustration* than the paintings of the subject by many greater artists.

104 JEAN HONORE FRAGONARD (1732-1806)
'Jeroboam Sacrificing to his Idols' (Ecole des Beaux-Arts, Paris)

Fragonard is probably best known, in Britain at least, for his picture 'The Swing' in the Wallace Collection, London, and it can cause him to be (rather unwisely) dismissed as a frivolous Rococo confectioner who makes his artistic father Boucher seem to have the gravity of a Poussin. He is, though, much more interesting and substantial than that. Fragonard was born in Grasse in the South of France and taken to live in Paris as a child. His parents wanted him to be a notary's clerk but he showed his talent for painting early, and on the recommendation of Boucher was sent to study with Chardin, the great eighteenth-century still-life and genre painter. Understandably now, this idea was not a success and he returned to Boucher, whose favourite pupil he then became. At the age of 20 he won the Prix de Rome with the picture reproduced here and painted many precociously skilful essays in the 'Grand Manner'. He matured as a painter in Rome and on returning to Paris began a brilliant career in which he gradually abandoned historical painting and large-scale decoration for smaller *galant* genre scenes, landscapes, portraits and allegory.

The story of his development, success and eclipse by the rise of Neo-Classicism and the Revolution is a long and complex one, but it is now widely considered that he is one of the greatest painters of his age. 'Jeroboam' is a work of high-spirited, youthful talent, and yet another demonstration of just how shamelessly far away from any convincing biblical feeling artists of certain periods have been prepared to stray.

105 GIOVANNI BATTISTA PIAZZETTA (1682-1754)
'Elijah Taken Up in a Chariot of Fire' (National Gallery of Art, Washington)

There is often a (possibly unconscious) sense of the absurd in some painters' depictions of certain kinds of miracle. It is of course perfectly understandable for Elijah to look anxious about his God-given transport, considering its composition, and it appears that Elisha feels the same, but it seems as if the artist has taken pleasure in making their reaction one of discomfiture if not panic.

Piazzetta was a painter of great individuality, who though some 13 years older than Tiepolo, had very early perceived the possibilities of the Rococo style which soon came to dominate Venetian painting. His art was at its best when most concerned with the colours of the shadows on human skin and his most successful subjects were fortune telling, sentimental encounters at twilight and other such magnetic mysteries.

106 REMBRANDT VAN RIJN (1606-1669)
'The Departure of the Shunammite Woman' (Victoria and Albert Museum, London)

Until 1966 this picture was considered to be of 'The Dismissal of Hagar'. It shows Rembrandt in his gentlest vein and immediately engages our sympathy, though an absence of any convincingly natural light source is curiously insistent.

107 LORD LEIGHTON (1830-1896)
'Elisha Healing the Shunammite Woman's Son' (Leighton House, London)

Lord Leighton died the day after he was elevated to the peerage, after a very successful career which had earlier seen his first Academy picture bought by Queen Victoria. The son of a rich doctor, he was from the age of ten brought up and trained entirely on the Continent, studying in Florence and Frankfurt. He didn't settle in London until he was 29 years old. Ten years later his success enabled him to build a splendid house and studio in Kensington which is now a museum. In 1878 he became President of the Royal Academy as Thackeray had suggested he would a quarter of a century earlier. He was a paragon of all the most admired virtues of his day: charming, handsome, sociable, learned, a linguist and a good administrator, and the temperature of the pronounced eroticism in much of his work was cool enough to be utterly respectable. He worked hard, and his art, for all it lacks for us today, developed into a full account of his potential, which is not without its impressive aspects.

'Elisha Healing the Shunammite Woman's Son' is not typical of his biblical pictures, which sometimes seem forced and less happy than his 'Classical' subjects. It is painted with a gentle and relaxed accomplishment and in unusually subdued colour for Leighton. The deathly tinge on the boy's skin is well imagined and it is a picture altogether worthy of the artist.

109 LUCA GIORDANO (1634-1705)
'The Death of Jezebel' (Private Collection)

Giordano was one of the most prolific and fastest working painters in history, both absorbing many influences and adumbrating future styles. The first major influence on him was Ribera (1591-1652) in his native Naples. He then went to Rome, Florence and Venice, falling under the influence of the great sixteenth-century Venetians and the Roman High-Baroque painter Pietro da Cortona. He painted huge fresco cycles in Naples, Monte Cassino (destroyed in the Second World War) and Florence, and was in 1692 summoned to Spain by Charles II where he undertook vast decorative schemes in the Escorial, worked in Toledo Cathedral and painted dozens of pictures. His nickname 'Luca fa Presto' was well earned. He spent ten years in Spain and then returned to Naples where his last works, executed with undiminished energy, prefigure Romanticism and the Rococo.

'The Death of Jezebel' was probably painted about 1680, in Giordano's full maturity. It is a brutish subject painted with ruthless Neapolitan Baroque brio. The dogs are menacing and red-eyed, the horse unhappy, and Jehu looks horrified but implacable. The other figures seem rather superfluous to the sanguinary drama.

110 FILIPPINO LIPPO (c.1458-1504)
'Queen Vashti Leaving the Palace' (The Horne Museum, Florence)

The story of Vashti's disobedience is a very entertaining anecdote of a wife's defiance of her husband and we cannot help being on her side. She is a more sympathetic figure than Esther though she did not have her successor's awesome and beneficent destiny to fulfil. Filippino Lippo obviously felt the same and her charming solitary exit from the palace makes you think that King Ahasuerus, whatever he gained with Esther, lost a lady well worth keeping when he lost his patience with his Queen.

The artist was the son of Fra Filippo Lippo, both a monk and an important painter, and the offspring of his father's scandalous relationship with a nun whom, however, he was allowed to marry. Fra Filippo was his first teacher as a boy but on his death he studied under Botticelli. 'Queen Vashti' is part of a series, 'Scenes From the Life of Esther', which Filippino painted in his early twenties. He moved away from Botticelli's influence when he undertook to finish the Brancacci Chapel at S. Maria del Carmine, Florence, which Masaccio had left uncompleted on his death. Filippino's later style was exuberant and decorative, with borrowings from classical art, and can be said to have looked forward to Mannerism.

112 ERNEST NORMAND (1857-1923)
'Esther Denouncing Haman' (Sunderland Museum and Art Gallery, Tyne and Wear County Council Museums)

Normand was a painter of historical subjects, genre and portraits of the second rank compared to Poynter, but a competent practitioner of his style. He studied at the Royal Academy Schools in London, and in Paris, and although he often exhibited at the Academy never became a Royal Academician. He married an artist, Henrietta Rae, who painted nudes very like his own and they lived in London. He painted among other biblical subjects one of 'Vashti Deposed'.

'Esther Denouncing Haman' is not bad of its kind. There are quite a lot of older pictures of the banquet but none of them is a very convincing or entertaining illustration. Like a competent film director, Normand has made Esther's gesture, Haman's reaction to it and King Ahasuerus' interest in what is happening dramatically convincing, though it seems as if the scene is being shot at some minor English studio rather than in Hollywood when compared to Poynter's 'Queen of Sheba' (page 102).

113 LEON BONNAT (1833-1922)
'Job' (Louvre, Paris)

The criticism of Bonnat (see note on Bonnat for page 86): 'He painted against backgrounds abominably soaked with tobacco juice..') must be reiterated here, but it is an extraordinary Salon painting of its time. Bonnat has painted a candid nude looking like one of the regiment of old men who used to to find employment as models in the heyday of the life class. It makes you feel uncomfortable but perhaps not quite in the way that Bonnat intended. The crown of rope is bizarre and suggests that King Lear was in Bonnat's mind as well as Job.

114 WILLIAM BLAKE (1757-1827)
'Satan Smiting Job with Sore Boils' (Tate Gallery, London)

One of Blake's greatest works is his set of engravings for the Book of Job and if the selection for this book included graphic art one or two of them would certainly have been reproduced here. This late coloured-print (derived from the engravings) is one of his most famous and striking designs and well conveys Job's ordeal. It doesn't seem possible to attach any specific meaning to the configuration of the sunset and it probably simply indicates that Satan's presence is bound to distort all Nature. The ruined outbuildings are curious and effective. It is thought that for Blake the boils represented Job's shame concerning his carnal desires.

115 ALBRECHT DÜRER (1471-1528)
'Job and his Wife' (Stadelsches Kunstinstitut, Frankfurt)

Dürer in waggish vein again makes a domestic comedy of Job's dejection. The flames in the background are very like those of burning Sodom (page 45) but it is a more solid work, nice, and lambent with colour. The running figure looks more like a monkey than a human being and may be a demon. Dürer's devotional paintings generally avoid playfulness but this adjunct to one has not succeeded in doing so.

This painting forms the left wing of an altarpiece of which the centre panel is lost. The right wing shows two musicians, a drummer and a piper, who look as if they have come to console Job with music but regard it as a hopeless task.

117 JOHN MARTIN (1789-1854)
'Belshazzar's Feast (Collection of Mr and Mrs Joseph M. Tanenbaum, Toronto)

'I mean to paint it, and the picture shall make more noise than any picture ever did before,' Martin wrote to his friend C.R. Leslie (painter and biographer of artists), and when Sir David Wilkie saw it he commented: 'All he has been attempting in his former pictures is here brought to maturity . . .'

When 'Belshazzar's Feast' was hung on a scarlet wall at the British Institution in London, it had to be railed off from the gaping crowds and the exhibition's run was extended by three weeks. The Duke of Buckingham offered 800 guineas for it but a speculator offered more and persuaded 5000 people to pay a shilling to see it in a shop in the Strand when the show closed. Martin's prediction had proved very near the mark and the picture was and is an extraordinary work. In the mid-1970s it was hanging in the Ombudsman's office in London, the owner (a descendant of Martin's) having lent it to the government for safe keeping. It was in a sorry state, being both dirty and hanging loose on its stretcher. Now, however, it is in Canada, cleaned and restored and looking as shocking as it ever did.

The boldness of the one-point perspective and the monstrous size of the banqueting hall are shamelessly dramatic (Martin calculated the hall's depth at one mile and chose to have it built 'of the same costly stone throughout: red and exceedingly well-polished porphyry'). He put the heavens in correct order – the moon 'in immediate conjunction with the planet Astarte, and just three days old, marks the very point in time at which the Chaldeans used to hold their annual feasts'. And Daniel was coached in his gesture to the seemingly gas-generated incandescence of the writing on the wall by Mrs Siddons and Charles Young, the latter a famous Hamlet of the day. The pamphlet Martin published with this picture furnished more sensational detail.

This must be one of the most impressive and spirited illustrations ever painted. You can very easily understand why some connoisseurs and artists hated it (and probably still do) but a lot of their strictures were

irrelevant to its intentions. Martin's painting, with its shameless melodrama, is surely nearer to the physical and imaginative essence of the extraordinary myth than anyone else's had ever been before, and it also offers little encouragement to anyone attempting the subject again.

119 BRITON RIVIERE (1840-1920)
'Daniel in the Lions' Den' (Walker Art Gallery, Liverpool)

This subject is not nearly as common as you might guess in painting, and at least two great painters who have attempted it have somehow got it wrong. It seems that the most important thing about the story is Daniel's complete faith that he will be protected by God. Delacroix gave him very little character at all and with Rubens, whose huge painting (probably a studio work) hangs in the National Gallery, Washington, the lions are – surprisingly from him – not very well painted, with Daniel sitting among them and looking upwards, paralysed by fear. An Old Testament anthology which does not include this story is not quite what most people feel entitled to expect, so it was left to an obscure British painter of animals to represent the subject here. Briton Riviere, who has also provided this book with another picture 'The Miracle of the Gadarene Swine' (page 169), liked to put animals in his work, particularly dogs. 'Sympathy', painted in 1875, shows a small girl in disgrace being comforted by her pet dog. According to Rosemary Treble's programme note for the 'Great Victorian Pictures' exhibition in 1978, this picture at the 1872 Royal Academy 'confirmed Riviere as Landseer's heir' and it also helped him to get his R.A. in 1880.

Although by no means a marvellous painting the attitude of the lions, with some trying futile snarls, others appearing almost afraid (and another deeply depressed), are quite well imagined. Daniel's demeanour is all you expect of him. Riviere painted another picture which is not bad either, called 'Daniel's Answer to the King' which shows him looking up to where Nebuchadnezzar is calling to him and with the lions lined up impotently behind him.

121 GASPARD DUGHET (1615-1675)
'Jonah Being Thrown Overboard' (By Gracious Permission of Her Majesty The Queen)

Dughet was Poussin's brother-in-law and 15 years old when he became so. Poussin encouraged him to paint and he followed him in painting landscapes with figures, though the figures were never as important as they often were to his teacher. His style lies somewhere in between that of Poussin and Claude, less classical and severe than the former and not so concerned with light as the latter. He used a more rugged landscape than either and he also favoured waterfalls and cascades.

This picture is a very good example of Dughet's work and was much admired in the late-eighteenth century as an example of the 'sublime'. It is his only known sea piece which is surprising considering how naturally lively it is and how he liked inland water. It has been suggested but by no means generally accepted that Poussin painted the figures. The dramatic light on the watching figures is very successful and the whole picture is vital and unlaboured, with the lightning seeming to hiss through the wet clouds. You can imagine Turner admiring it.

122 JAN BRUEGEL THE ELDER (1568-1625)
'Jonah Leaving the Whale' (Alte Pinakothek, Munich)

This is another subject to which artists have not been attracted nearly as often as you might think. Jan Bruegel, whith his much-admired though lightweight talent, has made a very charming illustration. The whale has certainly not enjoyed Jonah's stay and the latter's piety is as impressive as his red shirt. The setting and details are done with the artist's customary facility and desire to please.

Jan was Pieter Bruegel's youngest son and was taught, perhaps significantly by his grandmother. He specialized in flowers and woodland scenes, populated with exotic animals and rich in fruit and vegetation, which he often made into Gardens of Eden. He was a close friend of Rubens and painted a Paradise with him which is in the Mauritshuis in The Hague. It is appropriate and does not seem entirely complimentary that he was dubbed both 'Velvet' and 'Paradise' Bruegel.

124 ADAM ELSHEIMER (1578-1610)
'Tobias and the Angel' (National Gallery, London)

Pictures called 'Tobias and the Angel' are seldom true to the text and this one is no exception. As we can read, Tobias should have eaten the fish and be bringing only the gall bladder home to restore his father's sight. There are hundreds of pictures of the journey home and no painter seems to pay any attention to this fact or, perhaps even worse, that the angel only reveals himself as such at the end of the story. You can't help liking both Tobias' and his companion's haircuts and wondering whether the fish had bitten Tobias's arm as he seems to be nursing it in a sling. Among the many good pictures available, Elsheimer's wins with its unassuming charm and beautifully painted landscape.

Elsheimer had a short life and a very small output, largely due to attacks of melancholia making him incapable of work. He was much-admired by both Rubens and Rembrandt, and his beautifully glowing

and spacious landscapes are considered to have paved the way for Claude, the French seventeenth-century landscape artist who worked mainly in Italy, see his 'The Sermon on the Mount' (pages 166-7). Rubens wrote, in grief at Elsheimer's death, that he 'had no equal in small figures, in landscapes, and in many subjects. He has died in the flower of his studies...'

125 REMBRANDT VAN RIJN (1606-1669)
'The Angel Leaving the Family of Tobit' (Louvre, Paris)

Kenneth Clark, in his short and excellent work *An Introduction to Rembrandt,* wrote that this was the moment that Rembrandt loved most in all Bible stories, the whole of the Book of Tobit being very dear to him. He wrote that Rembrandt felt most deeply about the moments when ordinary mortals realize that there has been a Divine presence amongst them. Tobias' companion in spite of the wings he displays in all pictures of the catching of the fish and the journey back, has until this moment been regarded by the whole family simply as an ordinary if mysterious friend. Now all has ended happily. Tobias is married. Tobit is healed of his blindness, and most gratifying of all, it is the Angel Gabriel from God who has been responsible for their good fortune and Rembrandt himself rejoices with them.

126 ARTEMISIA GENTILESCHI (1593-1652/3)
'Judith and Holofernes' (Capodimonte Museum, Naples)

Artemisia Gentileschi has become much better known in the last decade or so than ever before. This has been largely due to the interest in female artists' reputations by the 'women's movement'. But in any case she deserves our attention as a painter in her own right although her sex – and her subject matter in relation to it – inevitably heighten her interest for some people today, as it did for her contemporaries.

She was the daughter of Orazio Gentileschi who taught her to paint when he was most under the influence of Caravaggio, but she became more of a Caravaggist than he ever did. A very important incident in her life was her alleged (and almost certain) rape by an entrepreneur of painting in Naples called Tassi. Orazio brought charges against him and he was imprisoned for eight months but then released. The incident must have affected her deeply, and also her public image. Soon afterwards she was married, but only briefly, and thenceforth lived an independent life as a painter. If she was naturally drawn to a subject of male oppression and female counter-attack, so then were the public, particularly as far as her work was concerned, and she was asked to paint many versions of 'Judith and Holofernes' and also subjects like 'Susanna and the Elders' (page 134).

In an exhibition 'Painting in Naples from Caravaggio to Giordano' which toured Europe and America in 1982-3, her pictures, while not the greatest in the show (why should they be, with Caravaggio, Ribera and Giordano there in force?) stood up extremely well. Although her self-portrait looked very remarkable it was 'Judith and Holofernes' which seemed the strongest. It was certainly derived from Caravaggio's picture of the same subject in Rome, and like it shows the decapitation only half completed. But it also has important differences and is, in a way, stronger as an illustration. Caravaggio's 'Judith' is an alluring but also forbiddingly ruthless figure, and he made of her an image both erotic and misogynistic. Judith, although presented in the Apocrypha as an intrepid Israelite heroine, was mostly depicted in art as Woman at her most calculating and cold, and many painters made her look no nicer than Salome. Artemisia made no judgments and offered little sado-masochistic titillation. For her, Judith was simply a tough and capable woman doing her duty as best she could – and that did not include decapitation at one stroke.

Like most painters, Artemisia goes against the text and includes the maid in the scene. Another figure often helps a composition of this kind, but perhaps the idea of a murderous female conspiracy produces more shudders than a single murderess, and the painter was no more averse to providing them than her male counterparts.

128 LUCAS CRANACH THE ELDER (1472-1553)
'Judith' (Kunsthistorisches Museum, Vienna)

Cranach's ladies are generally playful if often a little wicked. Here, though, he has made Judith into some implacable lady from a German court, if not from among its courtesans.

129 FRANCISCO DE GOYA (1746-1828)
'Judith and Holofernes' (Prado, Madrid)

This is nearly as rapid a painting as Degas' 'David' (page 96) and shows a curious El Greco-like formalization that runs through the artist's late 'Black Paintings' of which it is one. Judith's sword does not look at all practical and Holofernes is barely indicated. Her implacable purpose is all that matters.

Goya was the greatest Spanish painter since Velázquez. He started working in a Rococo style with elements of Neo-Classicism but always

with an unmistakable personal stamp. Then as court painter to Spanish kings he established himself as one of history's greatest portrait painters, and became with his extraordinary original etching cycles, the greatest agitator against war and the most sardonic commentator on human folly that art has ever seen. In his seventies he painted the 'Black Paintings' on the walls of his house near Madrid. They are an overwhelmingly powerful testament of a painter's grim disgust with the world and of his personal and artistic tenacity. His radicalism obliged him to end his days in France, where, stone-deaf and in his eighties he painted several pictures, including a beautiful lyrical portrait, 'The Milkmaid of Bordeaux'.

131 TINTORETTO (JACOPO ROBUSTI) (1518-1594)
'Susanna and The Elders' (Kunsthistorisches Museum, Vienna)

One of Tintoretto's most reposed and purely beautiful paintings, where as so often he has invented a composition of which no one else could have thought. It is a stunning *Femme à sa toilette* as much as anything – the theme that was initiated in Venice by the 80-year-old Giovanni Bellini three years before Tintoretto was born, and which flourished until Matisse's old age. Both artists may just have been equalled in the subject during the last 400 years but surely never surpassed.

133 GIORGIONE (GIORGIO DA CASTELFRANCO)
(1477/8-1510)
'Susanna and the Young Daniel' (Traditionally 'The Adulteress Before Christ') (Glasgow City Art Gallery)

Johannes Wilde the late and eminent historian of Venetian art, wrote that he was willing to accept the suggestion of Erica Tietze-Conrat his fellow historian that this picture did not represent the subject traditionally ascribed to it. If it does represent the Adulteress before Christ, why is it taking place virtually out of doors in the country and why is the figure identified as Christ a beardless youth who is not making any of the traditional gestures or adopting anything like the usual poses? It is a convincing argument both iconographically and in feeling. Professor Wilde also added that the hint of a halo on the Daniel figure need not surprise us in the context of the Venetian art of its time. There are also later pictures of 'Susanna and Daniel' (one by the French seventeenth-century painter Valentin de Boulogne in the Louvre) whose composition could imply that Giorgione's was once accepted as being of that subject.

Giorgione was a marvellously gifted painter of whom little of any personal nature is known and his *oeuvre* also presents problems of attribution, only a very few pictures being unanimously ascribed to him. He was a pupil of Giovanni Bellini and learned more from him than did his friend and fellow-pupil Titian – and their teacher also learned from Giorgione even though he had reached his seventies during Giorgione's brief maturity. The feeling of his art is much more diffuse than that of Bellini and Titian, although he worked closely with the latter and Titian finished some of his pictures on his early death. He is not generally as interested in the nominal subject as them, and is more concerned with offering us his reveries about the relationship of human beings with nature and the vulnerable beauty of human life. This is shown very poignantly in one of the most exquisite and enigmatic small pictures in the world, 'The Tempest', in the Accademia in Venice.

'Susanna and the Young Daniel' is by far his largest and most narrative oil painting and shows his beautiful range of colour which was always subtler and gentler than Titian's and darker and richer (with more green and red) than Bellini's. Surely the lovely young woman, who is being brought in front of a dynamic and aggressive young man, and whom Giorgione has painted and attired so beautifully, is of the two candidates (Susanna and 'The Adulteress') the one who was sinned against rather than sinning.

134 ARTEMISIA GENTILESCHI (1593-1652/3)
'Susanna and the Elders' (Schlossverwaltung, Pommersfelden, West Germany)

This is a very early work of Artemisia Gentileschi and may have been painted when she was as young as 16. Her father Orazio may or may not have painted parts of it but almost certainly must have helped her. She has made Susanna as robust a girl as self-portraits show Artemisia to have been. She could be telling us that however strong a young woman may be it is likely to be of little avail against established male power, especially in collusion. It is an image impressive beyond its precocity and is a highly original or at least very well-borrowed composition.

136 GEORGES DE LA TOUR (1593–1652)
'The Dream of Joseph' (Joseph éveillé par l'ange) (Musée des Beaux-Arts, Nantes, France)

At the beginning of this century this extraordinary picture was almost unknown and indeed its painter unidentified but his reputation and good fortune during his own lifetime were phenomenal. It is only since the mid-twentieth century that de La Tour has been recognized as one of the greatest French painters. He was the son of a baker and his mother the

daughter of one. The family business must have prospered because he was given a good education and was able to study painting. When still very young he probably visited Italy and absorbed the influence of Caravaggio. Back in his native Lorraine he married the daughter of the Duke of Lorraine's Finance Minister and lived like a prosperous country squire. When the French invaded the Duchy he soon became painter to Louis XIII and at the height of his career, in his late fifties, he died during an epidemic. The reason why he was forgotten for so long may have been that his son, a painter, gave up working after being ennobled, and perhaps had no reason or desire to foster his father's reputation. His pictures have a limited range of subject matter and are sparsely furnished with background or incidental material. He was primarily interested in figures acting out particular parts and the light that could be played on them.

'Joseph's Dream' is one of his cleverest and most beautiful pictures, and has great charm and humour. The girl angel has sent Joseph to sleep over his book as he turns the pages. The candle flame is cunningly hidden by her arm and her left hand is beautifully curved in a way that recalls that of an oriental dancer's. In de La Tour's economical world the candle-snuffer and her sash verge on being extravagant embellishments. Joseph is the ordinary man, more honoured than lucky, whom artists have liked to mock a little as bewildered and even inadequate. De La Tour does mock him here, but with tenderness.

139 FRA ANGELICO (c.1400–1455)
'The Annunciation' (Diocesan Museum, Cortona, Italy)

Whatever we may think of the psychological complexities of the cult of the Virgin Mary and its reflection of the attitude of the Church to all other women, The Annunciation remains one of the most beautiful images of all religion – the mutual deference of the angel and Mary representing a relationship of the most precious delicacy imaginable. Christian art would be considerably impoverished without it and it sometimes seems an even gentler image than that of the Madonna and Child.

Fra Angelico was one of the most purely Christian great painters who ever lived, but he was not a reclusive kind of monk as people sometimes like to think. He was a famously progressive artist in Florence and was one of the first to understand Masaccio's work (see pages 29, 185 and 228). He was also historically important in his influence on Domenico Veneziano and Piero della Francesca.

In this lovely 'Annunciation' in Cortona, painted in his thirties, Angelico shows a solicitous Gabriel who has easily reassured a pious and sensible Virgin Mary. The painter seems to have taken great pleasure in decking the angel out with charming sumptuousness, and in the top-left background Angelico shows his essential humanity by causing Adam to receive only a regretful hand on the shoulder as we are reminded what Christ was sent to redeem.

140 CARLO CRIVELLI (active 1457–1493)
'The Annunciation' (National Gallery, London)

Crivelli was a Venetian but not really a painter of the Venetian School, the source of his art being the Florentine-influenced Paduan School into which he assimilated the late-Gothic style. He used archaic gold backgrounds with thoroughly modern figures, and the general character of his work is at the same time sumptuous and astringent. It is known that he was the son of a painter but his life does not seem to have produced any interesting anecdote.

'The Annunciation' reproduced here owes its form to the town of Ascoli Piceno, and the fact that it received the news of the granting of limited self-government from Pope Sixtus IV on the day of the Feast of the Annunciation in 1482. The words 'Libertas Ecclesiastica' commemorate this, as does the figure of St Emibius (who kneels with the angel Gabriel) holding a model of Ascoli of which he is patron saint. It may seem to us a little presumptuous of the citizens to ask Crivelli to introduce a model of their city into the centre of a representation of such a sacred event, and we could even think that such an image used as a vehicle for civic pride would be tarnished thereby and unfit to be included in a trio of Annunciations of the highest quality. But if we look at it and imagine that wherever Mary was when the angel appeared to her was for a moment miraculously transformed into an ideal city, it seems a moving and not at all irreverent idea. The penetration of the miraculous beam of light, through its specially designed aperture, is as effective as it is in any other painting of the subject.

141 HUBERT VAN EYCK (attr.) (d.1426)
'The Annunciation' (Metropolitan Museum of Art, New York/Bequest of Michael Friedsam)

Some people have thought that Hubert Van Eyck did not exist at all, but it is difficult to see why he should have been invented if he didn't. Granted that he did exist, it is none the less hard to determine which are his works and which his brother Jan's. The beautiful picture here is attributed to Hubert.

There are many Northern 'Annunciations' which are shown to take place in a church, and usually the buildings are in immaculate or good condition. But there is something about the background of this one which has a greater sensitivity than any other similar setting. The wall outside the church is in bad need of repair, the church itself is modest and the makeshift step has a curious indentation – if not cypher – on it. The demeanour of both the parties is convincing, and there is something pleasing about the traditional lilies having already been put aside in a pot in the doorway. The painter (or painters) of the Ghent altarpiece liked crystal sceptres and put one in the hand of Christ the King. Gabriel has one here and it makes you feel that they should never be made of anything else. The botanical detail, which because of the unidealized setting is not nearly so luxuriant as that in the 'Adoration of the Lamb', is nevertheless worthy of either of the Van Eyck brothers, who had no peers in the depiction of plants. Whichever Van Eyck painted the picture certainly created a masterpiece of Christian art.

142 PIETER BRUEGEL THE ELDER (c.1525–1569)

'The Numbering at Bethlehem' (Musée Royal des Beaux-Arts, Brussels)
This is one of Bruegel's great village landscapes, and after the first surprise it seems a perfectly reasonable version of Bethlehem. Joseph is leading Mary on the donkey (in the central foreground) and carrying his saw on his shoulder as if he will soon be looking for work. It has been suggested that Bruegel was making a veiled reference in the picture to Spanish tyranny in Holland but it seems more likely that, if anything of the sort was intended, it was aimed at inhuman bureaucracy in general.

143 JAN MASSYS (or METSYS) (1509–1575)

'Hospitality Refused to the Virgin Mary and Joseph' (Musée Royal des Beaux-Arts, Antwerp, Belgium)

Although of course not comparable in quality with the Bruegel (opposite) this picture is interesting in that the subject is very rare in painting, perhaps owing to general reluctance to show a pregnant Mary. It has certainly always been a popular episode in Nativity plays. The landlady in this picture is not entirely unsympathetic in that she is portrayed as any hard-worked woman of her kind.

144 TINTORETTO (JACOPO ROBUSTI) (1518–1594)

'The Nativity' (Scuola di S. Rocco, Venice)

Another of the great Tintorettos from the Scuola di S. Rocco, whose ingenious and entirely original conception gives the scene a feeling uniquely humble and exalted. The shepherds have come in from the fields and gaze ardently upwards as they perhaps offer food to the women on the upper level and the whole place is warmed by a radiance that is evidently Divine. The cow is worthy of Bassano and the bedraggled peacock above is only a mystery if you forget that this bird was commonly fattened for the table in the sixteenth century.

145 GOVAERT FLINCK (1615–1660)

'The Angel Announcing the Birth of Jesus to the Shepherds' (Louvre, Paris)

Flinck has made a kind of Rembrandtian Christmas card of skill and charm. The scene has been brought in from the fields to the humble farmstead, and it enlarges the cast. The Dutch peasants contrast nicely with the pyrotechnic display of angels and recklessly tumbling cherubim.

146 PIETER BRUEGEL THE ELDER (1525/30–1569)

'The Adoration of the Magi' (National Gallery, London)

Although Bruegel has borrowed an Italian-style composition for his 'Adoration', he has made it entirely Flemish in spirit. The white Kings look more like inferior local aldermen than monarchs, but the black one leads you to think that Bruegel might have met a particular negro whom he had found charming. Mary is tired yet receiving the attention politely, but the infant Jesus seems to be cunningly appraising the gifts and reserving His judgment. The man whispering in Joseph's ear may be casting aspersions on Mary's virtue (it was once a tradition that Joseph had nagging doubts about the Virgin Birth).

147 PETER PAUL RUBENS (1577–1640)

'The Adoration of the Magi' (Musée Royal des Beaux-Arts, Antwerp, Belgium)

Rubens has here painted another of his great showpieces. He has given us 'Adorations' more serious than this – and equally beautiful – but none with such irresistible exuberance. The kneeling King is benign and charmed with the Child, and the standing one aware of the seriousness of the occasion. The black King is rolling his eyes in appreciation as if he thinks it is expected of him and the infant Jesus has been given a nascent, almost fizzling, halo. But Rubens's tender feeling for maternity manifests itself through all the Baroque high spirits and this is a more sensitive masterpiece of celebration than it at first appears.

148 JANUARIUS ZICK (1730–1797)

'The Adoration of the Magi' (Rheinisches Landesmuseum, Bonn, West Germany)

A lightweight Bavarian Rococo picture which has to be kept apart from Rubens and Bruegel for its own sake. The artist has with an engaging humour suggested humble Kings desperately anxious to please the omnipotent young Jesus. Mary seems a proud mother but a little apologetic about her inability to teach Him modesty, and poor Joseph again appears burdened as so many painters insist he must have been.

149 ADAM ELSHEIMER (1578–1610)

'The Flight into Egypt' (Alte Pinakothek, Munich)

Rembrandt was inspired by this picture to paint a moonlit 'Rest' and Rubens an active nocturnal 'Flight into Egypt', and it demonstrates once again Elsheimer's unassuming but superfine talent (see also his 'Tobias and the Angel', page 124).

151 ORAZIO GENTILESCHI (1563–1639)

'The Rest on the Flight into Egypt' (Birmingham City Art Gallery, West Midlands)

This artist shows his powerful individuality once again (see also pages 62 and 97) with what must be one of his very best pictures. His interesting language of drapery and textiles is here combined with that of clouds and the light allowed to them. The donkey is perhaps not only a faithful servant but a reflectively aware one, and Joseph's tiredness, arising as much from his sense of responsibility as from the rigours of the journey, is as powerfully and originally expressed as anywhere. Mary appears to be just an ordinary and capable Italian woman, but the infant Jesus is much older than the babe in arms he ought to be. Probably Gentileschi had made studies from a mother who did not wean her child until later than is the custom today.

152 GERARD DAVID (c.1460–1523)

'The Flight into Egypt' (National Gallery of Art, Washington)

The Flight into Egypt is one of the most popular subjects in Christian narrative art and Rests on the Flight easily outnumber pictures of the journey in progress as the characters can be shown in greater detail and with more variety of disposition.
This David is one of the most purely enjoyable of 'Rests' with subtly gentle colour and light. The details are rendered with great delicacy, the grapes being a traditional adumbration of the Passion as they would produce the sacramental wine of the Last Supper.

153 MASTER OF SCHLOSS LICHTENSTEIN
(active Austria 1525–1550)
'The Massacre of the Innocents' (Alte Pinakothek, Munich)

This is Christian art on a very coarse level but it tells us something about absences of refinement in the painting of the past that we may not suspect or are too willing to forget. Such pictures must often have been veiled or unconscious protests against the arbitrary brutalities of the artist's own time, and it is interesting to note how there is often one protagonist who, if not actually protesting against the slaughter is not joining in it, perhaps representing a token man of conscience. Many Massacres of the Innocents take place in great classical colonnades or palatial Baroque interiors and seem to have little connection with either the artist's own time or Christ's. In such pictures the essence of the subject is somehow evaded, but this example of journeyman image-making has a sense of horror which is real.

155 STUDIO OF GIOVANNI BELLINI
'The Circumcision' (National Gallery, London)

An assistant, or assistants, of Bellini (c.1430–1516) was almost certainly responsible for this picture and it is not at all a bad rendering of the master's style and spirit. There is a kind of counterpoint between the grave sanctity of the occasion and the rich refinement and beautiful colouring of the fabrics. Giovanni Bellini, as Jennifer Fletcher, an expert on this artist, has written, 'made nature minister to the Divine', and she must have meant not only nature but everything else as well. It is amazing how rich fabrics, which are so often adjuncts of human vanity or liveries of both spiritual and temporal power, can in Bellini's hands become quite the opposite. In his S. Zaccaria altarpiece in Venice, they coalesce with the natural but heavenly light, and, sumptuous as they are, become entirely holy. The conscious stoicism of the Child in this picture is touching.

156 ANDREA MANTEGNA (1430/1–1506)

'The Presentation in the Temple' (Staatliche Museen, West Berlin)

Mantegna was a paragon of skill in all aspects of painting and within the bounds of his artistic personality had no chinks in his painterly armour.

He started his career in Padua which was, before Venice superseded it, the most important centre of painting in Northern Italy. His teacher was Squarcione, the scholarly painter who had adopted him. By his early twenties, when he married the sister of Giovanni and Gentile Bellini, he was an established and brilliant artist and was engaged by Lodovico Gonzaga, the Duke of Mantua, as his court's official painter. He held the post for the rest of his life. Mantegna's art is very much based on the classical interests fostered in him by his adoptive father, and is sometimes cold and unsympathetic, with lines and contours often seeming like hard edges that could hurt, but he is without doubt in the front rank of the painters of the Italian Renaissance.

'The Presentation in the Temple' is a beautiful example of Mantegna's earlier work and is one of the occasions when his brother-in-law and he painted the same subjects around the same time, in this case using the same composition. The fabrics remind you of Bellini but have an entirely different character, the face of Mary having more in common with his style. Mantegna has painted himself on the extreme right and his wife, Bellini's sister, on the extreme left. The stonework motif on the infant Jesus' swaddling clothes is no doubt meant to prefigure the stones of the sepulchre. It is a beautiful work with one of the nicest schematic beards in art.

158 ALBRECHT DÜRER (1471–1528)
'Christ with the Doctors' (Thyssen–Bornemisza Collection, Lugano, Switzerland)

Giovanni Bellini once owned this picture and may either have bought it or received it as a present from Dürer. It was painted on the artist's second trip to Venice in 1505 and shows a pleasant exuberance, confirmed by the fact recorded on the slip of paper in the book (bottom left) which states that it took only five days to paint. The picture is a combination of Northern and Southern elements and composition and Dürer has taken a particular pleasure in the group of hands in the centre, as if in answer to a challenge – perhaps from himself.

159 WILLIAM HOLMAN HUNT (1827–1910)
'Finding the Saviour in the Temple' (Birmingham City Art Gallery, West Midlands)

Holman Hunt was the ideologically purest and most consistent of the Pre-Raphaelite Brotherhood, helping to form it with Rossetti, Millais and others after Ruskin's book *Modern Painters* (1843–60) had convinced him of a need for both more reality and loftiness of purpose in art. He went to the Holy Land three times to gain verisimilitude for his biblical pictures, among them the famous 'Scapegoat'.

He painted most of 'Finding the Saviour in the Temple' on his second visit to the Holy Land but had to leave out the figures of Mary and Jesus as he found models for the elders only by deceiving them as to his true intention and pretending that the subject of his picture was of Jews in religious disputation; the central figures were added on his return to England. The whole picture took him four years to paint and is a remarkable achievement executed in a very similar style to Ford Madox Brown's 'The Coat of Many Colours' (page 61) but rather lacking that picture's sharp, dramatic impact.

160 JOACHIM PATENIER (c.1480–1524)
'The Baptism of Christ' (Kunsthistorisches Museum, Vienna)

Patenier was a pioneer of landscape-painting for its own sake though he never entirely freed it from the narrative pretexts considered essential in his time. He was a respected master in Antwerp, Belgium, who had learned from Hieronymus Bosch. This 'Baptism' is done with his usual downward look at the landscape and straight-on look at the figures and it is known that the mountains were painted from small rocks brought into his studio. St John the Baptist can be seen preaching (in the left background) and Christ approaching him from a long way off in this two-part narrative picture. God occupies one of the comfortable 'royal boxes' he was often given at 'Baptisms' and on a few other occasions.

161 PIERO DELLA FRANCESCA (c.1416–1492)
'The Baptism of Christ' (National Gallery, London)

Like Vermeer and Georges de La Tour, Piero was neglected for a very long time, only lately becoming a revered figure of the first magnitude. He was born in Borgo Sansepolcro in Umbria and is first heard of assisting Domenico Veneziano in Florence. That was his only visit to the city but it enabled him to see Masaccio's work whose monumental gravity and use of perspective greatly influenced him. Spatial stillness, even light, and discreteness of forms mathematically ordered, mark his style of exalted but melancholy solemnity; and even – perhaps especially – the angels in his pictures seem infected with the essential sadness of earthly life and portend the slowness of redemption. Piero became an important figure at the court of the Duke of Urbino and developed his theoretical interests there, from which came his treatise *On Perspective in Painting*.

'The Baptism' is one of the most beautiful pictures in the National Gallery and although carrying the basic stamp of Piero's formal discipline it is quite a lot freer in design and looser in execution than the bulk of his work. It is thought that it belongs to his early maturity and Kenneth Clark suggested that the almost excitedly painted landscape background was derived from rapid sketches from nature. He also pointed out the crucial symbolism of the figure taking off his shirt, which is, with the dove, the most striking form in the picture. Against the partially obscured, unbelieving Jewish priests in the distance, Clark saw its meaning as being expressed first by the covered face representing the privacy of conversion to Christ, and the struggle with the shirt the spiritual effort involved, and that finally the figure's nakedness would demonstrate readiness for renewal by Baptism.

162 DUCCIO DI BUONINSEGNA (active 1278–1318)
'The Temptation of Christ' (Frick Collection, New York)

Duccio is considered the greatest painter of the Sienese school and embodies its break with Byzantine art. He was perhaps influenced by Cimabue, and there are disputes concerning the attribution of some works between the two painters. The only indisputably documented work of his is the huge two-sided 'altarpiece' (or Maestà) of the Virgin enthroned in Her Majesty, of 1308–11, for Siena Cathedral, Tuscany, most of which is now in the Cathedral Museum there (see note for page 200). He certainly saw the work of Giotto, but never emulated him in an explicit way.

This 'Temptation' is a picture which is still archaic in form but wonderfully alive in feeling, like all the artist's work. The perspective of the buildings, though still primitive, is completely confident and the device of the gold border of Christ's robe seeming a kind of protective halo works well. Sometimes the physical degeneration of a picture can be accidentally expressive, and there is no harm in feeling that Satan's failure with his scheme might be responsible for the poor condition of the paint that describes him.

163 JAKOB CORNELISZ (c.1470–1533)
'The Temptation of Christ' (Suermondt Museum, Aachen, West Germany)

Cornelisz was born near Amsterdam and worked in Antwerp, Belgium, for several years but always remained a Dutch painter in style, though with a weakness for Italianate architectural trimmings, cherubim and angels. He was also Jan van Scorel's teacher (whose 'Stoning of St Stephen' is shown on page 252). This picture is sensitive and skilful as an illustration of the Temptation. Satan is nicely understated and seems to be carrying a kind of devilish rosary, while the angels are eagerly solicitous as they minister to Christ.

165 RAPHAEL (RAFFAELLO SANZIO) (1483–1520)
'The Miraculous Draught of Fishes', Cartoon for tapestry (Victoria and Albert Museum, London)

Raphael was one of the most gifted painters who have ever lived, but he is not nearly so loved and admired today as he was in the nineteenth century, and Piero, Titian and Caravaggio of the Italians have more to say to us today than Raphael, not to speak of Michelangelo himself. His life was the same length as Mozart's and he was just as prodigious. He studied under Perugino and after emulating him perfectly he proceeded to amplify the possibilities of painting until the High Renaissance could be raised no higher. He painted many brilliant and graceful pictures when very young but the first works that we recognize as being of real weight are the Vatican decorations that Pope Julius II required of him when he was about 25. He organized a large and efficient workshop and decorated a suite of rooms known as the Stanze.

While Raphael was working on these frescos he was commissioned to make a set of large tapestries for the Sistine Chapel in the Vatican, which brought his work into direct confrontation with Michelangelo's ceiling. Although the cartoons are now much more rewarding to look at than the tapestries, the latter are said to have survived the comparison very well when they were first hung. They are in reverse to the cartoons owing to the technique the weavers employed in copying them. Whichever way round, though, 'The Miraculous Draught of Fishes' is the most beautiful picture ever made of its subject and shows all Raphael's powers of composition, grace and naturalistic skill.

166 CLAUDE (Claude Lorrain) (1600–1682)
'The Sermon on the Mount' (Frick Collection, New York)

Claude is the most famous exponent of ideal landscape and his influence on painters was enormous in Italy and Holland but even more so in England, where in the eighteenth century he was more highly regarded than any other artist. The expression of space with light was his greatest contribution to painting.

He was born in France, but soon orphaned, and then taken to Rome where he worked for a painter called Tassi. He stayed for a while in

Naples but soon returned to Rome where he spent the rest of his life painting imaginary landscapes. He made them settings for Bible stories, classical subjects and episodes from *The Aeneid*. Most of the stories are simply pretexts for landscape variations but occasionally he took the nominal subject more seriously.

Claude planned the layout of 'The Sermon on the Mount' from a map of the Holy Land and there is a drawing by him that demonstrates this. The view is conceived as being from the Valley of the Jordan looking towards Mount Tabor. On the left is the Dead Sea, but in the event not low enough in relation to Lake Tiberias on the right which should appear to be 2000 feet (610m) above it. Nazareth is shown behind the lake and, to its right, the town of Tiberias below Mount Lebanon. He has managed to animate the whole picture with feeling. The thrilled awareness of those who can just see Christ, but certainly cannot hear Him, is very convincingly conveyed – and it is a beautiful Claude as well.

169 BRITON RIVIERE (1840–1920)
'The Miracle of the Gadarene Swine' (Tate Gallery, London)

Like the artist's 'Daniel in the Lions' Den' (page 119) this picture will almost certainly never be considered a great painting of any kind, but it is a very spirited attempt to illustrate a subject which seems to have puzzled, and even a little dismayed, some Christians. Even within the story, the local people are disturbed and shocked by what took place.

Riviere, as we have seen, liked painting animals and was skilled at it. He also kept pigs, which might explain why he undertook the subject. His first Royal Academy success had been with 'Circe and the Friends of Ulysses' and it showed the enchantress with Ulysses' crew after she had turned them into a herd of swine. This picture is rather reminiscent of a good illustration to a boy's adventure story earlier in this century, if you imagine the two swineherds as young heroes having just had a narrow escape. For Riviere they were perhaps also an ingenious device, as their presence diverts attention from the fact that he did not quite have the nerve to include Christ in the picture.

170 MICHELANGELO MERISI DA CARAVAGGIO
(1573–1610)
'The Calling of St Matthew' (Confarelli Chapel, S. Luigi dei Francesi, Rome)

This picture and the other two scenes from the life of St Matthew in the same Chapel marked a turning point in the history of European painting, and were the first evidence of Caravaggio's real stature as a painter. He came from Lombardy and studied in Milan before going to Rome in his early twenties, where he led a restless life, moving around, quarrelling with people, and making a name for himself. About four years after he arrived he was given rooms by Cardinal del Monte, a connoisseur of art who both recognized his talent and liked his pictures of epicene youths.

Two years later Caravaggio was commissioned to paint two of the three St Matthew pictures in the Confarelli Chapel and the following year 'The Conversion of St Paul' (page 255) and its companion picture 'The Crucifixion of St Peter'. He was now a very successful painter but kept on becoming involved in violent brawls, sometimes being indicted for assault. In 1606 he killed a man in a quarrel during a game of tennis and had to flee to Naples, where he went on painting and had an enormous influence. He then went to Malta where he was made one of the Knights of St John of Jerusalem and after a violent episode was imprisoned but deliberately allowed to escape. He fled to Sicily and carried on painting but returned to Naples after more difficulties and although still working was handicapped by the effects of a wound. He died in 1610 while on the way back to Rome, possibly before he had heard about a pardon from the Pope.

No great artist has ever had quite so violent a temperament as Caravaggio's – Christopher Marlowe led a comparatively quiet life in comparison (it is tempting to think of Caravaggio and Rembrandt as a kind of Marlowe and Shakespeare of painting). But his art is stupendous, sometimes expressing the artist's perverse character with chilling starkness, and at others subsuming it in a most moving and true feeling for the painfulness and cruelty of human life and its need of redemption.

In this picture Caravaggio cut himself off from the world of ordinary, ambient daylight and found his own element, where shafts of light slant dimly down through dirty windows, and in doing so he created a Christian masterpiece. Bernard Berenson suggested that Christ seemed to be coming to arrest Matthew, and it is an apt analogy. Christ's commanding gesture is one of the greatest in all painting, strangely made even more effective by being partially hidden by the late addition of the figure of St Peter; and the shifty attempt at evasion in Matthew's answering movement is equally inspired. The tax collector's office is a den of the low life of which Caravaggio was so much a part, and it is being closed down forever by the real authority.

171 MASTER OF THE DARMSTADT PASSION (active *c.*1440)
'The Healing of the Widow's Son at Nain' (Bayerische Staatsgemäldesammlungen, Munich)

Miracles of healing are rarely very effective or convincing in painting perhaps because only the state of sickness or returned health can be conveyed, the healing being a metamorphosis occupying time, however short. A raising from the dead is easier, as awakening can make an image. This picture was selected partly because it makes such a complete contrast to the Caravaggio opposite and also because it has the gentle charm of a good votive offering.

172 BARTOLOME ESTEBAN MURILLO (1618–1682)
'The Feast at Cana' (Barber Institute of Fine Arts, Birmingham University, West Midlands)

The miracle of the turning of water into wine at the wedding feast in Cana is the subject of many pictures. Perhaps the most famous one is the huge Veronese in the Louvre where Christ is surrounded and almost overwhelmed by an enormous gathering of sixteenth-century Venetian courtiers in a palace which would without doubt have had very well-stocked cellars. Other, and particularly Northern visions of the subject tend to make the scene an adumbration of the Communion and there are not many who have wanted to see the incident as Christ simply helping His friends out of an embarrassing lapse of hospitality; but Murillo makes it genial enough in his slightly vapid way. (His most melting style was called his *estilo vaporoso*.) His reputation has been fostered lately after fluctuating considerably over the centuries.

Murillo was born, and worked, in Seville and must have absorbed the work of the great Zurbarán (1598–1664) although it is not evident in his production. His most popular subject is 'The Immaculate Conception' of which there are many large examples, but he did paint some good portraits and has perhaps deserved the recent attempt to rescue his reputation from the outright condemnation that his sentimentality and formlessness have often brought upon him.

173 JAN JOEST VAN KALKAR (1455/60–1519)
'Christ and the Woman of Samaria' (St Nicholas Church, Kalkar, West Germany)

The Woman of Samaria's aim in pouring water has only been very slightly deflected by the unexpected encounter with Christ, and the picture has a nice story-book charm although Christ looks in need of a rest. Joest was a German painter active in the Netherlands as well as Germany. The name Kalkar comes from his most famous work, the wings of the high altar in the church of St Nicholas at Kalkar, of which this is one.

175 PAOLO VERONESE (*c.*1528–1588)
'Christ and the Woman of Samaria' (Kunsthistorisches Museum, Vienna)

Veronese was the greatest of decorative painters and not very much more (or mostly not). His pictures are extravagant celebrations of Venetian High-Renaissance luxury and pomp, the best being very beautiful in colour and totally skilful in conception and execution. As his name implies he was born in Verona and he went to Mantua before settling in Venice at the age of 25. The rest of his life was spent making huge decorations and pictures under the influence of his older contemporaries Titian and Tintoretto. His biblical pictures rarely have any convincing feeling for the imaginative essence of the stories and are used more to express his delight in rich fabrics, beautiful women, and the privileged life which surrounded him – Moses is discovered by a beautiful Venetian courtesan with a dwarf jester, and the Marriage at Cana takes place in a sumptuous palace that could never have run out of wine. He was arraigned by the Holy Tribunal for the irreverence of a 'Last Supper' with German halberdiers, buffoons and one of the disciples picking his teeth. He put up a spirited defence and was only made to change it into 'The Feast in the House of Levi'.

This artist did, though, show another vein – a gentler poetry – particularly later in his life, of which 'Christ and the Woman of Samaria' is an example and its symmetrical design is appropriate to the subject. Veronese has made the space between the two figures almost romantically expressive of their mutual deference. Their conversation incidentally was the longest one Christ had with anyone in the Gospels.

176 SCHOOL OF FRA ANGELICO
'Salome' (Louvre, Paris)

This picture could not be mistaken for a painting by Fra Angelico (*c.*1400–55) as, apart from anything else, it is too crude in both colour and execution. But it has a convincing vitality.

177 NETHERLANDISH SCHOOL (*c*.1500)
'John the Baptist' (Musées Royaux des Beaux-Arts, Brussels)

Another rather primitive image, this time by an artist who might have painted very good shop signs. John the Baptist has not been very well served by painters except in 'Baptisms', considering that he is the second most interesting figure in the Gospels, but his curious shadow-like relationship with Christ must have made him an uneasy subject. The idea of making the whole picture into the charger – platter – on which his head was exhibited has not made the picture bloodthirsty or irreverent as are some more sophisticated ones with and without Salome.

178 MICHELANGELO MERISI DA CARAVAGGIO (1573–1610)
'Salome' (National Gallery, London)

Caravaggio made a great painting of this subject in Malta, for which he dribbled a kind of signature (his only known one) on the ground with a rivulet of John the Baptist's blood, but that picture seemed too personal and remote from normal illustrative purposes for this selection. It could be said that the concept of the one shown here is not very literal either and represents something more like a reverie on violent death than Salome's usual gratification at the success of her mother's and her own murderous spite. The model for the executioner also turns up in two 'Flagellations of Christ' by Caravaggio, rather like a malign and unforgettable gangster you have noticed several times in films without knowing the actor's name.

179 PHILIPP OTTO RUNGE (1777–1810)
'Christ Walks on the Water, Peter Sinks' (Kunsthalle, Hamburg, West Germany)

Compared to his contemporary and fellow Romantic Caspar David Friedrich, the short-lived Runge was more pantheistic than Christian, and he used images of flowers and children to express his feelings about the underlying harmony of man and nature.

In 'Christ Walking on the Water' Runge has painted a subdued, decorative Christian work which seems both timeless and ahead of its time. The various expressions of the disciples range rather mechanically from mild curiosity to something approaching terror.

180 ALESSANDRO MAGNASCO (1667–1749)
'Christ Walking on the Water' (National Gallery of Art, Washington)

Most of Magnasco's pictures still look quite extraordinary today, and must have seemed even more so in his own time. His landscapes, sometimes peopled by mad monks and mountebanks, are painted with a frenzied capriciousness which owed a lot to Salvator Rosa. The title of one of his pictures, 'Thieves Chased by Skeletons', is characteristic of his more extreme flights of fancy, and perhaps he bears some responsibility for the bizarre and rather mindless fantasy landscapes that people nowadays seem willing to pay for in department stores and from park railings. Some of his fellow artists did think his art ridiculous during his lifetime, but he had an impressive share of success and influenced both Tiepolo and Guardi. He was in fact a chief inventor of a style which we could now refer to as Rococo expressionism.

The picture reproduced here has a curious magnetism, and is a genuine dramatization of its subject. But Christ seems to have walked all the way back to the shore to test Peter, who has covered a surprising distance before his faith failed him.

182 GIOVANNI BELLINI (*c*.1430–1516)
'The Transfiguration' (Capodimonte Museum, Naples)

This picture contrasts very strikingly with two others: first the picture of the same subject Bellini had painted 25 years earlier which, though beautiful, belongs to another age, and secondly Raphael's masterpiece (opposite). It is a work of Bellini's mid-maturity and his concept of the supernatural event is entirely unsensational when compared to Raphael's, being registered only in the whiteness of Christ's robe and the attitudes of the three disciples in front of him. Overt drama has also been diminished by the flattening of the mountain, to allow the sort of pastoral landscape Bellini loved best to set the picture's mood. Roger Fry thought the season to be autumn but it has since been suggested that the greens have degenerated with time, and that it was painted as an August landscape, to coincide with the date of the Feast of the Transfiguration on the sixth of that month.

183 RAPHAEL (RAFFAELLO SANZIO) (1483–1520)
'The Transfiguration' (Vatican Museum, Rome)

If given a fully descriptive title, this extraordinary picture would be called 'The Transfiguration, with the Healing of the Boy Possessed by

the Devil'. The unusual combination of subjects was almost certainly not Raphael's idea, but that of Cardinal Giulio de'Medici who commissioned it. The Cardinal also believed that artists were spurred on to greater things by competition, so he commissioned at the same time an altarpiece from Sebastiano del Piombo of the Raising of Lazarus, which, though a very different subject, was well understood by both artists to be in competition with Raphael's picture. Sebastiano was a devotee of Michelangelo's, and he enlisted the practical aid of the master, who transformed the rivalry into a contest of considerable rancour, at any rate on their side. But that they did not win can clearly be seen in the National Gallery in London where the picture they jointly plotted now hangs.

The story of the healing of the boy by Christ after the disciples failed to do so comes directly after the Transfiguration, but is not connected to it in the narrative. By combining them, the supremacy of Christ is emphasized as two of the helpless disciples point upwards at Him in His transfigured state. Sebastiano finished his picture long before Raphael, who died before his own was completed and it had to be finished (particularly in the bottom right-hand corner) by his very capable assistant Giulio Romano. As a picture it was a fitting crown to Raphael's *œuvre*, and one of the pinnacles of the High Renaissance in that the most developed skills in the observation and manipulation of natural appearances were applied with triumphant success to the most exalted ends.

185 MASACCIO (TOMMASO 'DI GIOVANNI') (1401–1428)
'The Tribute Money' (Fresco in the Brancacci Chapel, S. Maria del Carmine, Florence)

Masaccio's seminal masterpiece which, although painted with Masolino who is considered responsible for the head of Christ, is believed to be very much his own conception. It is said that 'The Tribute Money' was commissioned in order to commend to the citizens of Florence the virtue of paying taxes. What it did do, at all events, was to commend to certain of the following generation of painters the virtue of correct perspective, and the view that solid three-dimensional form, precisely and severely realized in space, was a good idea. Apart from its immense historical importance, it is a beautiful and noble composition as it tells its story very simply in three parts. The figure on the extreme right of the central group is a self-portrait of Masaccio and makes him seem very real indeed, and eminently capable of the greater works which his early death prevented him from undertaking.

186 JACOPO (DA PONTE) BASSANO (1517/18–1592)
'The Good Samaritan' (National Gallery, London)

The artist has put his native city Bassano, near Venice, into the background of the picture. It is not an overwhelming masterpiece but is very well made, sympathetic, and subtly composed in a way that must command our respect.

187 LUCA GIORDANO (1634–1705)
'The Good Samaritan' (Musée des Beaux-Arts, Rouen, France)

You can at first mistake the Samaritan for the robber in this picture, which was for a long time understandably thought to be by José de Ribera. Giordano was a pupil of Ribera and good at emulating him. The picture has the cold-hearted passion typical of Neapolitan painting, and both figures are painted with Giordano's usual competence. It shows his ability to portray a victim visibly nearer to death than most painters of the subject.

188 DIEGO VELAZQUEZ (1599–1660)
'Christ in the House of Mary and Martha' (National Gallery, London)

One of the greatest of all European painters, as he has been considered for over a century, Velázquez was responsible for this unassuming picture. He was born of minor nobility in Seville and showed his talent when very young. He studied with a painter who was a good friend and teacher but a bad artist, and he married his daughter. His first group of works of which 'Christ in the House of Mary and Martha' was one were of domestic subjects showing the pervasive influence of Caravaggio. At the age of 22, Velázquez, through his father-in-law's machinations and a very successful equestrian portrait of the King, became court painter to Philip IV and began a long and happy relationship with him both as painter and courtier-diplomat, painting many portraits of the royal family. His steady life of painterly isolation was broken by two important visits to Italy and by a meeting with Rubens when he came to Spain on a diplomatic mission.

Velázquez produced a steady stream of great portraits and also many other masterpieces, including what is generally agreed to be his greatest picture 'Las Meninas' (The Maids of Honour). This last picture constitutes an unprecedented and mysterious essay on the life of a painter and his relationship with both his own immediate working world and with the whole idea of visual intelligence.

His religious and biblical works are fewer than might be expected of a Spanish painter of his age, but those that there are show the gravity, honesty, and much of the marvellous power of direct observation that characterizes the rest of his work. Velázquez received the highest order of nobility that King Philip could possibly grant him, dying soon afterwards of a fever following an exhausting diplomatic mission in his name. This picture, painted before Velázquez was 20, is an unsecular variant on his early theme of interiors with figures and culinary still life. He has ingeniously shown the sulky girl preparing the meal for Christ, who is talking to Mary and Martha in the background, as echoing Martha's complaint in the text.

189 JAN VERMEER (1632–1675)
'Christ with Mary and Martha' (National Gallery of Scotland, Edinburgh

Vermeer is now acknowledged as one of the supreme painters of all time and it is baffling to be told that he was obscure not only in his own time but also until the late nineteenth century. Much of his life is a closed book and few of his pictures can be dated as this one can. They are mostly beautifully observed, marvellously executed small pictures of self-absorbed women engaged in various mostly quiet activities in domestic interiors. You could say that they belong, in spirit and patience of execution, to the same area of art as that of Piero, Bellini and Chardin. Vermeer left his wife and 11 children in poverty, though as a picture dealer, which it is known he was, and even as a painter, he must have had some modestly prosperous periods.

'Christ with Mary and Martha', painted when the artist was about 22, is the only surviving Vermeer with a narrative theme, and though it does not illustrate the main point of the story, it is a beautifully unforced look at Christ having a relaxed conversation. The emphasis on the women's heads underlines their thoughtful reflection on what He has to say, and Vermeer's liking for subdued luxury in clothes and furnishings is already in evidence.

191 PETER PAUL RUBENS (1577–1640)
'The Prodigal Son' (Musée Royal des Beaux-Arts, Antwerp, Belgium)

Rubens has introduced a familiar folk/cinema myth into his illustration of the parable. It is that of the sympathetic but oppressed farmer's wife taking a kindly interest, with undertones of more tender feelings, in the misfortunes of a young hired hand, and thereby arousing the darkest suspicions of her husband who is lurking behind the wooden stanchion of the barn. Perhaps she has only been advising him to go home and face the music, but she will certainly not be allowed to forget it in a hurry. Rubens has the scene enacted in perhaps the most beautiful and lovingly detailed depiction of a farmyard in art, which he must also have seen as underlining the Prodigal Son's state of dispossession.

192 REMBRANDT VAN RIJN (1606–1669)
'The Return of the Prodigal Son' (Hermitage, Leningrad)

This very large painting (over 8 foot/2.5m high) is one of the most mysteriously conceived and moving of all Rembrandt's Christian pictures. The theme of forgiveness is one about which he felt very deeply, and it is expressed here with an almost embarrassing force which does not prevent it from being at the same time greatly consoling. Rembrandt had earlier made an etching and two drawings of the subject with the marvellously mundane feeling with which he could invest any Bible story and if you know these earlier works you are privileged to observe the leap his imagination finally made to bring the idea to its wonderful simplicity and resonance in this great painting.

Rembrandt's picture goes far beyond a literal account of the parable and we are made to feel ourselves as much in the presence of God the Father as that of the compassionate landowner. None of the watching figures seems intended to be the Prodigal Son's aggrieved brother or members of the household. They are just dispassionate chance observers who in Kenneth Clark's words watch the pathos of the scene 'as if they were on a railway platform from which the train has just departed'. It seems impossible to imagine the art of painting aspiring higher or achieving more than it does in this picture.

193 WILLIAM BLAKE (1757–1827)
'The Wise and Foolish Virgins' (Fitzwilliam Museum, Cambridge)

Blake made several versions of this glowing design, the last one being for the discriminating painter and collector Sir Thomas Lawrence. The flowing feminine forms have made the artist loosen the tension of his line to beautiful effect.

194 JEAN-LOUIS FORAIN (1852–1931)
'The Adulteress' (On loan to National Gallery of Canada, Ottawa/ Collection of Mr and Mrs Joseph M. Tanenbaum)

Forain's remarkable and vivid biblical illustration has some of the quality of a magazine-drawing based on the account of an actual witness to an event. Forain did in fact draw for magazines, and he painted and drew court scenes which are reminiscent of Daumier. He first received an academic training, then became strongly influenced by Degas and his subject matter, but produced far more graphic work than paintings. Forain had always been a practising Catholic but in 1900 was persuaded by an old friend, the Catholic writer J. K. Huysmans, to devote most of his time to Christian themes.

The unfortunate woman is here being dragged with brutal force towards the figure of Christ which has been achieved with one sharp stroke and a touch of white pigment. The contemporary note struck by the bowler hat jars all the better by not being overemphasized, and the waiting figure (far right) seems aware that the group is making for Him. It is a small *tour de force* of graphic painting.

195 PIETER BRUEGEL THE ELDER (c.1525–1569)
'Christ and the Woman Taken in Adultery' (Courtauld Institute Galleries, London/Princes Gate Collection)

This grisaille was the only picture of Bruegel's that he owned himself at the time of his death. He shows what is in a way the most interesting part of the story, when Christ appears to play for time while pondering the most effective answer to the Pharisee's deliberate provocation. Only the immediate group is made to seem aware of what is happening; the others are just going about their business, some of them possibly money-changers who will incur Christ's wrath in the near future.

196 GEORGE FREDERICK WATTS (1817–1904)
'For He Had Great Possessions' (Tate Gallery, London)

The originality of this picture's conception was much admired when it was first shown, and there is still something notable about its naïve ingenuity. Watts was once very highly rated indeed and Lord Leighton called him 'The English Michelangelo' without intending any irony. He was an enormously high-minded and rather helpless man, one of whose main ambitions was to institute a personal museum, 'The House of Life', for the spiritual enlightenment and comfort of the People. Counter to the visionary, symbolist style for which we know him best he briefly went through a phase of social realism, painting an image of the Irish famine and a picture called 'Under a Dry Arch' of a vagrant woman. But without forgetting that he painted some surprisingly straightforward and effective portraits, it is pictures like 'Hope' (sitting on a globe blindfolded, holding a lyre, of whose strings all but one are broken), that his name mostly brings to mind.

Watts always regarded Italy, and particularly Venice, as the fountainhead of all true art and at one time deliberately set out to look like Titian himself, modelling his beard and skullcap on the self-portrait in the Uffizi, Florence. He was of very different character to Gustave Moreau (see note for page 83) but they both aimed, with something less than first-class talents, at rather nebulous ends. Watts once wrote in a letter to Ruskin: 'The qualities I aim at are too abstract to be attained, or perhaps to produce any effect if attained. My instincts cause me to strive after things that are hardly within the province of art'. There are several other idealistic nineteenth-century painters who have ended up in similar historical backwaters to the one in which Watts has been consigned but none of them combined such high and sometimes grandiose aspirations with such touching humility.

197 MICHELANGELO MERISI DA CARAVAGGIO
(1573–1610) 'The Conversion of the Magdalen' (Detroit Institute of Arts, Michigan/Gift of the Kresge Foundation and Mrs Edsel Ford)

The entry of Mary Magdalen into the life of Christ and her conversion is not clearly defined in the Bible. In this vivid picture Caravaggio has identified her with Mary of Bethany, and he has shown her at the precise though entirely imaginary moment of her conversion during a conversation with her sister Martha. This is one of the earliest pictures in which Caravaggio used chiaroscuro as the main expressive vehicle of a picture's psychological or spiritual content.

Mary is deliberately illuminated to express the inner light that has dawned within her, seemingly in response to her sister's words, persuasively expressed by Martha's hands which have been used in enumerating the reasons for belief. Even so Martha's face shows an awed surprise at the effectiveness of her words. The mirror is a traditional symbol of the vanity that Mary is abandoning, and the flower represents the spiritual nature of the new life on which she is embarking. Caravaggio's picture is admirably direct, deliberately avoiding unnecessary, overall high-finish, and he chose a model who very well combines the idea of worldliness with that of intelligence and higher aspiration.

198 JAN LIEVENS (1607–1674)
'The Raising of Lazarus' (Brighton Museum, East Sussex)

This is a miracle that seems to have tested even Christ's own belief in His powers, with Lazarus so long dead and his body decomposing; and the best paintings of the subject give the impression of a painful and almost unwilling return to life. Jan Lievens has conceived a daring and original composition and the low viewpoint, with only Lazarus' hands appearing from the tomb, makes a chilling image which very well expresses the depth of the sleep from which he is being awakened.

Lievens was a prodigy, being a working artist when he was 13. He shared a studio with Rembrandt when they were both very young artists and was considered equally talented. But in the end his promise was largely unfulfilled and though he prospered his work became increasingly superficial.

199 SALVATOR ROSA (1615–1673)
'The Raising of Lazarus' (Musée Condé, Chantilly, France)

The return to life is again an ordeal for Lazarus, and Salvator Rosa has, with Christ's more than commanding gesture, made the miracle appear an achievement of sheer will-power and concentration.

200 DUCCIO DI BUONINSEGNA (active 1278–1318)
'The Entry into Jerusalem' (Cathedral Museum, Siena, Italy)
One of the first European paintings from which we can imagine the murmurs and exclamations of those inhabiting its space coming out to us as something like real sound, although no mouths are open. And it must be acknowledged as one of the very first Christian pictures that is truly animated – in a way more so than the frescos Giotto made less than a decade earlier in Padua which were more radically revolutionary in form (page 210). With its companion pictures in the Maestà 'altarpiece' in Siena Cathedral it marks a very significant step forward from the didactic narratives for the illiterate and the devotional icons which constituted Christian art until the first few years of the fourteenth century. Duccio, in what is the most beautiful picture in his great Maestà has included the diminutive figure of the tax-collector Zacchaeus who had climbed into a tree in Jericho to get a better view of Christ.

202 EL GRECO (DOMENIKOS THEOTOKOPOULOS)
(1541–1614)
'Christ Driving the Money-Changers from the Temple' (National Gallery, London)

El Greco, who was born in Crete, is stylistically the most idiosyncratic of the great Renaissance masters and the extraordinary amalgam of Byzantine, Venetian and Florentine elements which blossomed unashamed with such forthright Mannerism in Catholic Spain made him probably the most easily identifiable painter in history. He was simply too extraordinary for art lovers during the 250 years after his death and the canon of great painting did not admit him until the later nineteenth century.

This subject was nearly always excluded from Passion cycles though the incident takes place after the entry into Jerusalem. It was considered inappropriate to include a violent episode in a series which concentrates on Christ's humble submission to His destiny. El Greco's is the most memorable of all paintings of Christ's anger, probably *because* of its lack of naturalism. He made several related pictures on the subject, starting in a strongly Venetian style and moving on to the highly individual manner he displays here.

At first this picture seems to have (almost) purely objective illustrative intent, but then you begin to realize that most of the human elements are disconnected and that not everyone has even taken cognizance of Christ's presence. It seems more like a later dream of a witness to the event (or even a victim of Christ's scourge) and only the hypnotic figure of Christ appears to have been intended to register on the viewer's mind as real, or rather more than real. El Greco's obsessive defiance of gravity was seldom more effective than it is here with Christ's slowly floating – but relentlessly advancing – figure.

His elongations and distortions of figures and faces became phenomenally exaggerated but there is little possibility of them being due to the artist's optical defects as was sometimes insisted. They were more directed towards establishing a sense of spirituality through the seeming weightlessness of the figures. In late life the free interplay of his imagination and his paint resulted in some quite astonishing pictures such as 'The Opening of the Fifth Seal' (page 262) which have a more dateless (or rather twentieth-century) feeling than the work of any other master of his age.

203 GIOVANNI BENEDETTO CASTIGLIONE (*c.*1610–1665)
'Christ Driving the Money-Changers from the Temple' (Louvre, Paris)

Castiglione's painting may be a more literal illustration than the El Greco (opposite) but it does not necessarily convey more effectively the essence of the story. Although distant, the figure of Christ expresses a fury that has communicated itself to the people and animals in the foreground with money being scattered in the general alarm and there is the beginning of a virtual stampede.

Castiglione was a Genoese who absorbed many influences and became a virtuoso painter and engraver; and is credited with the invention of the monotype. He studied under Van Dyck in Genoa and was always as close to the Northern tradition as to the Southern, being the first Italian painter to appreciate Rembrandt (from whom the figure of Christ here derives).

204 LEONARDO DA VINCI (1452–1519)
'The Last Supper' (S. Maria delle Grazie, Milan)

Leonardo studied in Florence with Verocchio and very soon revealed his enormous ability and originality as draughtsman and painter. When he was 30 he went to Milan where he stayed for 18 years and worked chiefly at the court of Count Lodovico Sforza in many capacities. His most important undertaking in painting while he was there was 'The Last Supper' which took him over two years to complete. He returned to Florence a few years later and painted 'The Battle of Anghiari' on a wall of the Palazzo Vecchio in competition with Michelangelo's 'The Battle of Cascina'. Both were destroyed, Leonardo's perhaps partly because of the same technical errors which almost wrecked 'The Last Supper'.

The pursuit of knowledge of every kind and his inventiveness are hardly separable from Leonardo's artistic genius. They have in common a grandeur barely exceeded even in the later triumphs of the High-Renaissance style, of which he was the real initiator. But he had his failures, largely due to his urge to experiment. He was unsuccessful in the casting of a giant equestrian statue in Milan, earning the derision of the young Michelangelo. Most regrettably of all, he painted what was almost certainly his greatest work, 'The Last Supper', in an untried technique that proved a disastrous one. Yet you cannot imagine any other painting in a similarly wretched state rising, as it were, above its condition and looking so serene and grand. The current restoration (1983), more scientific and painstaking than any before it, may make the pilgrimage to Milan even more worthwhile.

205 WILLIAM BLAKE (1757–1827)
'The Last Supper' (National Gallery of Art, Washington)

Blake has made the Last Supper into a fairly modest Roman banquet which the disciples, except for Judas complacently counting his blood money (lower right foreground), have only just sensed to be completely transformed by the fateful pronouncement Christ is about to make. Blake's small-scale works on paper can sometimes almost achieve the resonance of a great fresco.

206 JUSTUS OF GHENT (active Urbino, 1473–1475)
'The Communion of the Apostles' (Ducal Palace, Urbino, Italy)

Justus is a shadowy figure and there is no firm agreement about attributions of work to him other than this picture which was painted for his patron the Duke of Urbino. It includes the Duke and members of his court together with Isaac, a Persian ambassador who had been converted to Christianity. This is a large painting for a Flemish artist and a rare synthesis of Italian and North-European styles. Piero della Francesca, who was a member of the Duke's court, is one of many Italian painters said to have been influenced by it.

It is rare for the Last Supper to be painted as an Institution of the Eucharist (which is what the picture is sometimes called), and Christ seems to be distributing the Communion wafers not as an adumbration of his imminent Crucifixion but more as a ritual token to a suppliant congregation hungering and thirsting after righteousness.

207 FORD MADOX BROWN (1821–1893)
'Christ Washing Peter's Feet' (Tate Gallery, London)

The characterization of Peter is what makes this such a successful picture of its kind, and it was once a very popular one. Peter's initial reaction to Christ's proposal and his reconciliation to it is one of the most touching and characteristic anecdotes about the second founder of the Church. But Brown shows him to be feeling that the whole thing is still somehow all wrong and that, moved as he is, he will be glad when it is over. The artist made Christ naked for the first showing of this picture at the Royal Academy but later decided to clothe Him. The models for the apostles included the two Rossetti brothers and their sister Christina (far right, as St John) and William Holman Hunt and his father.

208 **EL GRECO (DOMENIKOS THEOTOKOPOULOS)**
(1541–1614)
'The Agony in the Garden' (Nationalmuseum, Budapest)

The confident distortions that make El Greco such an extraordinary artist create in this 'Agony in the Garden' an expressive and beautiful composition. The fallible and somnolent disciples are in the act of settling down under their robes which El Greco has made to seem more like husks or shells not only against the cold but also the knowledge of what Christ is having to endure.

209 **GIOVANNI BELLINI** (*c*.1430–1516)
'The Agony in the Garden' (National Gallery, London)

This is another case of Bellini painting the same subject as his brother-in-law Mantegna at around the same time but their compositions are different. (They both hang in London's National Gallery.) If regarded as a competition, some people would give the prize to Mantegna, but although Bellini cannot match his brother-in-law's renowned foreshortening and some of his other accomplishments, he nevertheless painted the more beautiful picture – indeed a masterpiece – where Mantegna's in comparison seems only a conscious exercise of his superior skills at the time. Here, Bellini first gave certain intimations of his future mastery of ambient light, and to demonstrate it he made the disciples sleep well into the dawn and had no scruples about making it break from both the West and the East.

210 **GIOTTO DI BONDONE** (1266/76–1337)
'The Betrayal of Christ' (Fresco in the Arena Chapel, Padua, Italy)

Giotto established the right of the painter to depict nature and humanity freely, and allowed art the power of narrative illustration that was to be such an essential part of it for many hundreds of years.

The Arena Chapel frescos, of which this 'Betrayal of Christ' is one panel, are central to the appreciation of the revolution Giotto effected. They comprise 19 panels of The Life of the Virgin and 27 of The Life of Christ with a big Last Judgment and many attendant allegories. These fourteenth-century panels form wonderfully natural and smooth-running narratives, showing a variety of human expression and an illusion of physical reality that had never been seen before in art.

During his lifetime Giotto was very famous, drawing praise from both Dante and Bocaccio – and it is easy to see why. If you compare his work with his two great contemporaries, Duccio (pages 162 and 200) and Cimabue (probably his teacher) it is very clear how much further Giotto enlarged the possibilities of the representation of real space and solid form in painting. The next fundamental step forward in the same direction had to wait more than 100 years for the work of Masaccio (pages 29, 185 and 228).

211 **ANTHONY VAN DYCK** (1599–1641)
'The Betrayal of Christ' (Minneapolis Society of Fine Arts, Minnesota)

We do not generally think of Van Dyck as a religious artist, but it has been suggested that he would have liked to have spent much less time painting the portraits for which there was such an overwhelming demand and more on subjects like this 'Betrayal of Christ' and 'The Crowning with Thorns' (page 222). Their quality suggests that we should on balance have gained had he been free to do so.

Van Dyck was born in Antwerp over 20 years after Rubens, whose assistant he became and who was a major influence on him. At the age of 19 he was made a master of the leading painters' guild in Antwerp, at first painting a variety of subjects but soon findint that his readiest success came in portraiture. Van Dyck had stayed in London briefly in 1621 without enjoying great acclaim but in 1632 he went there again and was soon made court painter to Charles I, who knighted him. He married an Englishwoman but died not long afterwards and was buried in St Paul's Cathedral in London. In nine years he had painted 400 portraits.

'The Betrayal of Christ' was painted during Van Dyck's first Antwerp period and apart from many preparatory drawings there are three versions of it. This one is the most freely painted and is considered too big to have been intended just as a preliminary sketch. (Rubens owned the most finished version which is now in the Prado in Madrid.) It is simply a stunningly dramatic composition with the figure of Christ expressing a marvellous dignity and resignation. St Peter's downward plunge on to the High Priest's servant allows the yellow-cloaked figure of Judas to be seen with great effect. And with the seething mob seen by flickering torchlight it is a picture of its subject as vivid as has ever been painted, and in complete contrast to Giotto's archetypal fresco.

212 **ALBRECHT ALTDORFER** (1480–1538)
'Christ Before Caiphas' (from the altarpiece of St Florian, Linz, Austria)

Altdorfer was the first European artist to offer a landscape without any figures as a finished work of art and he was altogether a highly original

and idiosyncratic painter who started his career under the influences of Dürer and Cranach the Elder.

In his often perverse and quirky way, Altdorfer in his 'Christ Before Caiphas' seems to be showing contempt for the drama he depicts. There is little attempt to give Christ much more dignity, virtue or sense of the occasion than anyone else in the picture, and Caiphas is clowning grotesquely. Altdorfer's use of artificial lighting is advanced for his time and it adds to the feeling of black comedy. Although this painting must have been accepted as a valid Christian image at the time, you can't help wondering if he ever had to explain the picture's curious flavour to his patrons, and how he would do so to us now.

213 **GERRIT VAN HONTHORST** (1590–1656)
'Christ Before Caiphas' (National Gallery, London)

Honthorst was a master of candle-light effects and his work sometimes shows striking affinities with Georges de La Tour, whom he may have influenced. Honthorst was one of the Dutch painters who brought the Caravaggian message from Italy to Holland (and perhaps to Rembrandt), having spent nearly two years in Rome and Tuscany. He rather moved away from chiaroscuro in his later work, which on the whole became less interesting.

'Christ Before Caiphas' was painted during the latter part of his stay in Rome and was very famous there. It shows Christ patient and calm in a very attractive almost late-nineteenth century portrayal; the two figures besides Caiphas are considered to be the false witnesses of Matthew's account.

214 **ANONYMOUS ITALIAN, CARAVAGGESQUE**
(early seventeenth century) 'Peter's Denial' (Vatican Museum, Rome)

The status of the Rembrandt (opposite) is underlined, perhaps unnecessarily, by this piece of run-of-the-mill Caravaggism. It is essentially a study of a shrewish maidservant and Peter is not conscientiously characterized.

215 **REMBRANDT VAN RIJN** (1606–1669)
'The Denial of Peter' (Rijksmuseum, Amsterdam)

The greatness of this picture does not strike you like a blinding light, but when you are ready for it it makes itself felt more like a chord of subtle harshness and great resonance from an organ. Its quality of something akin to sonority may remind you more of Johann Sebastian Bach than of any other painter.

Peter seems to be telling his lie quite easily at first glance, but the insistent close scrutiny of the maid and the uncomfortable proximity of the soldiers with their cold steel gradually make you realize that Peter's rock-like and impulsively courageous character has crumbled within him, and that without showing it he is desperately anxious to evade detection. Christ's reproachful backward glance can surprise you here, as in Matthew's account; you could easily suppose that His certain prediction of the event would have made Him leave Peter unremarked to the agony of shame and repentance that will so surely follow.

216 **REMBRANDT VAN RIJN** (1606–1669)
'Judas Returning the Thirty Pieces of Silver' (Private Collection)

A prominent citizen of The Hague and secretary to Prince Frederick Henry of Orange, Constantijn Huygens, described his feelings about the talent of Rembrandt as expressed in this picture and that of Jan Lievens (see the latter's 'Raising of Lazarus', page 198), when as young painters they shared a studio. In some writings (not published until 1897) Huygens had declared on first seeing the picture here: 'Already the miller's son Rembrandt and the embroiderer's son Lievens are equal to the most famous painters of the day and will soon surpass them . . . Summon all Italy, summon whatever remains from remotest antiquity that is beautiful or wonderful . . . for I maintain that nobody, not Protogenes nor Apelles nor Parrhasius, ever conceived, or if they returned to life ever could conceive, the things which (I am struck dumb as I tell of them) a mere youth, a Batavian, a beardless boy has brought together one by one in a simple human being and given expression to as one universal unity . . . Bravo Rembrandt!' He goes on to describe the picture, and in particular the figure of Judas, in awestruck detail.

This picture is marvellous indeed, and one of the most inspired biblical illustrations ever made. The desperate distress of the repentant Judas is expressed with astonishing force, and although in the text the Pharisees dismiss him coldly, Rembrandt has typically and convincingly deepened the drama, making them react with superstitious horror at the sight of the almost palpably tainted money.

218 DERICK BAEGERT (1440–1515)
'Christ Before Pilate' (Germanisches Nationalmuseum, Nuremberg)

Christ is here represented in a curious Northern way as rather complacently satisfied with his superior spiritual attributes, and Pilate does not look likely to lose much sleep over the injustice demanded by the familiar crowd of grotesques. Baegert was a German and the most important Westphalian painter of his generation. He made several large altarpieces and ran a busy workshop. His son Jan Baegert worked there, as did Jan Joest van Kalkar (page 173).

221 JORG BREU (1475/6–1537)
'The Crowning with Thorns' (Melk Monastery, Lower Austria)

The cruel pressure applied to the Crown of Thorns (but unrecorded in the text) is clearly shown here with the threat of a blow from a stool and a foul grimace thrown in. Breu, as with his 'Story of Samson' (page 87), shows himself a lively and original cartoonist in paint who does not seem to identify himself *entirely* with the nastiest aspects of his subject matter – as some of his Northern brothers do – but to see them more as a pretext for balletic mimes which tell their stories with some harshness but also a relieving theatrical artifice.

222 ANTHONY VAN DYCK (1599–1641)
'The Crowning with Thorns' (Prado, Madrid)

Here is another proof of Van Dyck's underrated ability as a religious painter (see also his 'Betrayal of Christ, page 211). Christ has now started on the painful path to death, and His face has perhaps never been shown so physically *shocked* by what is being done to him. The authors of His humiliation, somehow aided by their rather formal arrangement, look subtly merciless, and the spectators through the window compound the brutality. The composition was partly borrowed from his teacher and admirer Rubens to whom the picture originally belonged, as did a version of the artist's 'Betrayal of Christ'.

223 TITIAN (TIZIANO VECELLIO) (1488/9–1576)
'The Crowning with Thorns' (Alte Pinakothek, Munich)

Most would agree that Titian, the longest lived and one of the most prolific artists of the Renaissance in Venice, was the greatest of the Venetian School however highly we are bound to think of Bellini, Giorgione, Tintoretto, Veronese and even Tiepolo. He started his apprenticeship in the workshops of Gentile and Giovanni Bellini but was influenced most by Giorgione, with whom he executed some frescos only fragments of which survive. For a time Giorgione's influence remained strong with him and Titian is known to have completed some of Giorgione's pictures after his death. He then went through a period of Classicism which gave way first to a sensuous naturalism followed by his own masterly kind of High-Renaissance Mannerism. All through this time he painted many portraits and gained great fame being ennobled by the Holy Roman Emperor Charles V. In his last phase, which started in his seventies, he painted with unprecedentedly thick oil paint using his fingers as much as his brushes to make some marvellous pictures in which the forms attain an extraordinary substance by seeming simultaneously to come into being and dissolve. The physical density of the paint, and the use of colour as a force independent of light, play a much greater part in the expression of form than any of the traditional linear and tonal means used by his predecessors. He was nearly 90 when he painted his last great picture, a *Pietà* which he left unfinished but which sets a great seal on a series of masterpieces spread over nearly 70 years.

'The Crowning with Thorns' is one of the very greatest of his late works; it is a mystery how he seems to have dispensed with nearly all the anecdotal details, and yet by a process of digestion and transfiguration turned the picture into a symbol fashioned out of paint which still contains them in essence. In retrospect Titian's complete conquest of our natural craving for physical detail is one of the great triumphs of all painting, and in this picture he has not robbed Christ of one ounce of our feeling for Him.

224 QUENTIN MASSYS (METSYS) (1464/5–1530)
'Ecce Homo' (Prado, Madrid)

Holbein was probably influenced by Massys's portraits of scholars, Erasmus among them, seated in their studies, and he painted a notable 'Lamentation Over Christ' which is in Antwerp, Belgium, where he was an important master.

In this picture what appears to be 'Aaron's withered rod' is also in evidence in the Rembrandt (opposite), and the whole picture makes an interesting contrast of closely related compositions in entirely different styles. Both Massys and Rembrandt have made Jerusalem an architecturally ugly city to reinforce an atmosphere of barbaric unpleasantness.

225 REMBRANDT VAN RIJN (1606–1669)
'Christ Presented to the People' (National Gallery, London)

Rembrandt made the painting reproduced here on paper, purely as a basis for an etching which although an exciting one somehow lost by conversion to the medium and the reversal of image involved. The turbanned Pilate's harassment by the venomous priests (in the centre foreground) is marvellously conveyed and a rare occasion when Rembrandt appears to have enjoyed the depiction of villainy. The curious long stick has been thought to be 'Aaron's withered rod' which once traditionally symbolized 'the death of divine essence'.

226 MATHIAS GRÜNEWALD (MATHIS GOTHART NEITHART) (*c.*1460–1528)
'Christ Carrying the Cross' (Staatliche Kunsthalle, Karlsruhe, West Germany)

'Meister Mathis' is how Grünewald is referred to in the documentation of his life, which was for his times a long one. His career as a painter and probably sculptor was crowned in his late middle-age by the Isenheim altarpiece in Colmar, France, with its great 'Crucifixion' (page 231). Some years later, and around the time he painted this picture, he fell out of favour with his patron Count Albrecht of Brandenburg and went to Frankfurt where he manufactured soap and worked as an engineer until he died, probably in 1528.

As a painter Grünewald was remarkably isolated, though he is said to have been well aware of Masaccio and Jan Gossaert. But he borrowed nothing and passed on nothing, having no recorded pupils or imitators. 'Christ Carrying the Cross' is as unlike any other as is his 'Crucifixion'. The frightful cruelty of the image is subsumed by an appalled sense of human brutality, its gruesome force unaccompanied by the slightest trace of vicarious gratification.

227 HIERONYMUS BOSCH (*c.*1450–1516)
'Christ Carrying the Cross' (Musée des Beaux-Arts, Ghent, Belgium)

Bosch, in his last painting of a Passion subject, appears to be offering Christ the consolation of leaving behind Him an unbearably grotesque human race. It shows a marvellous collection of caricatures, boldly set out, though St Veronica only too easily suggests a modern photo-journalist who has got her picture, as she smugly carries off her legendary handkerchief. The 'good' thief (top right-hand corner) looks entirely worthy of our sympathy but the 'bad' one (bottom right) is identifying himself with the frightful mob by snarling back at them. Christ Himself seems in another world behind his closed eyelids but Bosch has also ingeniously made Him gaze steadily at us through His image on St Veronica's handkerchief.

228 MASACCIO (TOMASSO 'DI GIOVANNI') (1401–1428)
'The Crucifixion' (Capodimonte Museum, Naples)

Masaccio's picture is at first worrying because of the strange distortion in Christ's neck and the set of His head falling on his stretched shoulders but it must be seen primarily as part of Masaccio's pursuit of unidealized naturalness, but it was also to make the figure look more insistently real from the low angle from which it had originally to be viewed when it was placed at the top of a polyptych.

A Titulus (INRI) that was later painted over the bush on the top of the cross has recently been removed. This bush must have once contained the legendary pelican, whose stabbing of her own breast to feed her young was at one time traditionally equated with the sacrifice of Christ. We can wonder if the most beautiful and original feature of the picture – Mary Magdalene making her mourning obeisance like a scarlet bird – had any conscious or unconscious connection with the pelican. The picture is another testament to the youthful genius of Masaccio and the loss his early death was to painting.

229 PETER PAUL RUBENS (1577–1640)
'The Crucifixion' (Musée Royal des Beaux-Arts, Antwerp, Belgium)

Compared with the Grünewald (page 231) this Crucifixion, known as the '*Coup de Lance*' is an image of heroic toughness and it makes you think that Rubens himself would have been a physically brave man if challenged by fate to be so. Whereas in the Grünewald Christ has been required to submit to complete physical outrage and reduction to the most degraded condition possible to mortal humanity, Rubens represents Him as a robust man who has endured His ordeal uncrushed, as He still seems to be in death. The spearing of His side, and the imminent breaking of the thief's legs are marvellously realized and the only thing that you could have reservations about in this great picture is the slightly vapid helplessness of Mary, as expressed in her hands and face.

231 MATHIAS GRÜNEWALD (*c.*1460–*c.*1528)
'The Crucifixion' centre panel of the Isenheim altarpiece (Musée d'Unterlinden, Colmar, France)

Grünewald's masterpiece is also one of the greatest of all Crucifixions and certainly unsurpassed by any other. It must be the most powerful image of physical suffering and death in all art. The character of the picture derives from *The Revelations* of the fourteenth-century visionary St Bridget of Sweden which contains the words 'Thou art the lamb that John pointed out with his finger [X-rays have shown that St John's finger was lengthened during the painting] . . . His feet were curled round the nails as round door hinges towards the other side'. The nail driven through the feet is surely the cruellest in all painting and the Cross unique in being demeaningly ramshackle. The appallingly scourged body could well derive from the physical suffering Grünewald must have witnessed in the Germany of his time.

This painting was particularly appropriate to the Isenheim monastery in whose hospital many were treated for skin diseases. Patients were brought to the high altar of the church to see the triptych before receiving treatment, thus being reassured of the possibility of a miraculous cure. Grünewald has made the physical degradation and suffering of Christ as painful as he or we could bear, but it is inspiring in just the way that the image is supposed to be, and does not give the impression of morbid fascination which can be felt in so many Northern pictures of Christ's physical ordeal.

232 REMBRANDT VAN RIJN (1606–1669)
'The Descent from the Cross' (Hermitage, Leningrad)

Little need be added to the evident meaning of this picture which Rembrandt painted for himself perhaps to resolve some discontent with his commissioned masterpiece on the same subject (opposite) but probably just to carry his ideas further. Here he has chosen a very positively warm light and his rendering of the weight of Christ's body is one of the greatest successes in the quest for physical truth to be found in all painting, as well as being a triumph of Rembrandt's most human imagination.

233 REMBRANDT VAN RIJN (1606–1669)
'The Descent from the Cross' (Alte Pinakothek, Munich)

The pictures of the Passion commissioned by Constantijn Huygens on behalf of Prince Frederick Henry of Orange are among Rembrandt's greatest religious works though some would say that the 'Descent from the Cross' from the Hermitage (opposite), which Rembrandt painted for himself after he had finished this one, is even greater.

Rembrandt found the series as difficult as anything he ever undertook and his pains were justified by what are (in spite of Rembrandt's self-portrait on the ladder in this one) the most self-effacing pictures of their kind ever painted by a young and supremely confident master painter. However great in its way, Rubens's 'Deposition' in Antwerp Cathedral (on which Rembrandt based this picture) is in comparison just a showpiece. You will surely never be able to determine exactly why the cold light on the white body and its background seem so utterly poignant.

234 MASTER OF THE ST BARTHOLOMEW ALTARPIECE (active 1475–1510) 'The Deposition' (National Gallery, London)

It seems hardly credible to us today that the name of a prolific and indeed supreme master of a school of painting should have been entirely obliterated from the record. So it is with the painter of this picture in which flamboyant accomplishment is precariously balanced with a real feeling for its subject.

'The Master' was probably trained in the Netherlands but worked most of his life in Cologne, being the most skilful artist there of the late Gothic school. The figures of Nicodemus on the ladder, Joseph of Arimathea below and the Holy Women are movingly expressive of grief in spite of the brightly gilded niche that they and the crucified Christ have been made to inhabit. Their deliberately contrived affinity with polychrome wood sculpture does not make the picture false as a painting, and only the fingers of Mary Magdalen and the figure behind her seem a little perverse.

235 MASTER OF THE VIRGO INTER VIRGINES
(active *c.*1470–1500) 'The Deposition' (Walker Art Gallery, Liverpool)

This interesting artist was as much an illustrator of books and an illuminator (in grisaille) as a painter and he lived and worked in the Low Countries in Delft. Several paintings are attributed to him in which the figures have little grace and whose faces are characterized by an almost grotesque dramatic intensity.

This 'Deposition' at first appears to be trying to convey an

unacceptable level of pathos, but a second look reveals it as a deeply felt image of people who are too appalled at what has happened to Christ to seem to mourn Him. In no other picture do His followers appear to have so entirely abandoned faith in His Resurrection, and as in the Grünewald 'Crucifixion' (page 231) it is not simply pain and death but a crushing humiliation that Christ has undergone. The picture surely ranks as one of the great images of His experience of death.

236 JACOPO (DA PONTE) BASSANO (1517/18–1592)
'The Entombment' (Kunsthistorisches Museum, Vienna)

Bassano's love of the darker aspect of light has impelled him, perhaps uniquely, to show us Christ's entombment taking place on the very brink of nightfall. The artist's robust but benign character has made an affecting image showing an entirely assured freedom of execution reminiscent of Titian as well as of Tintoretto.

237a TITIAN (TIZIANO VECELLIO) (1488/89–1576)
'The Entombment' (Prado, Madrid)

When Titian painted this picture, 30 years had elapsed since he had painted his High-Renaissance masterpiece of the same subject now in the Louvre. The latter was closely related in composition but very different in painterly essence. It was concerned to show itself a masterpiece and it seems, like many great pictures of the period, both sublime and highly competitive. In contrast, the Prado picture reproduced here stems from the confidence of an old man who no longer had to prove anything, and it is more concerned with representing its subject plainly (whatever Classical allusion may be found in it). The emphasis on Christ Himself is no longer cleverly oblique, but direct, and the inclination of the figure of Nicodemus on the right is more expressive of concern and involvement with the weight of Christ's body than any figure in the Louvre version. It is also a wonderful example of Titian's revolutionary use of colour as a direct expression of substance in painting.

237b PETER PAUL RUBENS (1577–1640)
'The Entombment' (Alte Pinakothek, Munich)

It is said that another hand worked on this sketch after Rubens had left it, and that it was probably made originally for a lost altarpiece at Courtrai in what is now Belgium. Be that as it may, it has some of the best qualities of vivid light and the masterly free handling of paint that characterize Rubens's greatest sketches in oil.

238 BENJAMIN GERRITZ CUYP (1612–1652)
'The Angel Opening the Sepulchre' (National Museum, Budapest)

This artist was the uncle of the much more famous and accomplished Aelbert Cuyp whose landscapes were once more popular in England than anywhere else. This picture is rather bucolic, with evidence of Cuyp's contact with early Rembrandt, and it is painted with great zest. To make the angel's feat more impressive, Cuyp has put at least 15 guards on the tomb and you can't help feeling that Rembrandt would have found this unnecessary.

239 PIERO DELLA FRANCESCA (*c.*1416–1492)
'The Resurrection' (Pinacoteca Communale, Borgo Sansepolcro, Italy)

This is one of the two or three most memorable and beautiful images by Piero and a rather troubling one. We ask ourselves why the great fundamental miracle of the Resurrection should seem so severely lacking in joy and the chill of death still so unrelieved.

Kenneth Clark, in his famous study of Piero, expresses his feelings about the picture eloquently: 'This country God, who rises in the grey light while human beings are still asleep, has been worshipped ever since man first knew that seed is not dead in the winter earth, but will force its way up through an iron crust. Later he will become a God of rejoicing, but his first emergence is painful and involuntary. He seems to be part of the dream that lies so heavily on the sleeping soldiers, and has himself the doomed and distant gaze of a somnambulist.' He also points out how crucially the character of the picture depends on Piero's sophisticated manipulation of perspective. When we think of the value we now put on the artist and this work it may be as well not to forget the painting owes its rather worn look to the removal of a coat of whitewash that someone saw fit to put on it in the eighteenth century.

According to Vasari, the sixteenth-century painter, historian and architect, the soldier shown full-face is a self-portrait by Piero and his features show such intelligence and judicious reserve that the idea seems entirely credible.

240 TITIAN (TIZIANO VECELLIO) (1488/89–1576)
'Noli Me Tangere' (National Gallery, London)

This refined and reposed picture was once thought to be one of the Giorgiones to have been completed by Titian on the artist's death, as was the beautiful Venus in Dresden. This view is now discounted. The sheer inventiveness of the Rembrandt (opposite) is not in evidence but it is a high-quality painting of the rising Renaissance in Venice and no one else (except perhaps Giorgione – if it had more mystery) could have painted it.

241 REMBRANDT VAN RIJN (1606–1669)
'The Risen Christ Appearing to the Magdalen' (By Gracious Permission of Her Majesty The Queen)

Charm is a word you can sometimes, but not often, want to use in connection with Rembrandt's work, and you would not expect it to be evoked as it is by this subject. Instead of the usual rather unconvincing loincloth in place of His shroud, and a hoe, Christ seems to have obtained a costume from the wardrobe of some unwritten Mozart opera. And there is great subtlety in the idea of the couple (bottom left) receding into the gloom having passed the angels without noticing them, so subdued is their luminosity compared to 'The Angel Opening the Sepulchre' of B. G. Cuyp (page 238). Faced with such a wonderful piece of work you feel that even Titian would be willing to accept second prize for his picture on the opposite page.

242 MICHELANGELO MERISI DA CARAVAGGIO
(1573–1610) 'Doubting Thomas' (Neues Palais, Potsdam, East Germany)

Many pictures of this subject show Thomas approaching Christ with respect and uncertainty, but the text implies a more explicit scepticism. The subject had to wait for Caravaggio, who dared to make it closer to, and even rather coarser than, what we read. Christ seems entirely submissive and Caravaggio presumably decided that realistic scars on His hands would have made Thomas's rude physical investigation unnecessary. The picture has combined its unprecedented if incomplete realism with a very conscious emphasis on the formal nature of the composition.

243 SCARSELLINO (IPPOLITO SCARSELLA) (c.1550–1614)
'The Pilgrims of Emmaus' (Borghese Gallery, Rome)

This minor Venetian painter born in Ferrara, and more than a generation younger than Tintoretto and Bassano, has provided us with a narrative link between Mary Magdalen's recognition of Christ and the disciples' tardy acknowledgement of the Resurrection. It is not a subject that has provoked the greatest kind of painting as the curious 'restraining' of the disciples' eyes, as described by Luke, is vexatious to us and must have restrained artists' imaginations as it does our own.

244 MICHELANGELO MERISI DA CARAVAGGIO
(1573–1610) 'The Supper at Emmaus' (National Gallery, London)

There is a marvellous small still-life painting of a basket with fruit by Caravaggio in the Ambrosiana Gallery in Milan and he is on record as believing that the depiction of objects was as important a concern of painting as that of the human face and figure. He made this 'Supper at Emmaus' a showpiece for most of his talents, and the table, with the objects on it, has been made to seem as important as what is going on around it. There are some ambiguities of physical expression in the gestures of the disciples and you could feel that an argument rather than a revelation might be taking place but it is a masterpiece of conception and execution. Christ's magisterial gesture is taken from Michelangelo's 'Last Judgment' (page 273) as is His very rare beardlessness.

245 REMBRANDT VAN RIJN (1606–1669)
'The Supper at Emmaus' (Musée Jacquemart-André, Paris)

This is one of the boldest conceptions from Rembrandt's youth, with the extraordinary silhouette of the risen Christ expressing a very vividly deliberate challenge. One disciple seen in deepest obscurity (centre foreground) has dropped to his knees in the astonishment of recognition. The other disciples' amazement is marvellously expressed, and the cook in the kitchen all unaware is another of Rembrandt's triumphant extras.

246 REMBRANDT VAN RIJN (1606–1669)
'The Ascension' (Alte Pinakothek, Munich)
The Ascension of Jesus Christ is referred to only in the Gospels of Mark and Luke and only as anything like a visible event in the latter. It has not on the whole been treated by painters with the conviction that has attended the depiction of the events preceding it and indeed there are many Resurrections which seem to be as much Ascensions as the far

lesser quantity of paintings committed by title to describing it.

The most touching visual descriptions of the Ascension may be those, mostly in manuscript illumination, which show Christ leaving deep footprints in the earth or sand as a final witness to His earthly presence, and it is possible that the discretion of the text foiled the idea of a resounding and spectacular masterpiece to equal Raphael's 'Transfiguration' (page 183) and several Resurrections where Christ is shown ascending. In any event the young Rembrandt, finishing his three pictures of Passion subjects for Prince Frederick Henry of Orange (see 'The Descent from the Cross', page 233) has left us a gentle conception of the event but with God above exerting the force which lifts Him rather than Christ Himself.

248 TITIAN (TIZIANO VECELLIO) (1488/9–1576)
'The Pentecost' (S. Maria della Salute, Venice)

Titian painted this large picture in a transitional phase before his last period. He uses the traditional centralized composition for the subject and also, as was the custom, includes the Madonna (who is not mentioned in the biblical text). It is a powerful work though the subject has never produced a masterpiece of the very first rank. The miraculous incident perhaps registers itself more on the nerves than the visual imagination in spite of the tongues of fire. The radiance from the Holy Ghost and the tongues are executed with the judicious boldness that you can always expect from Titian.

250 RAPHAEL (RAFFAELLO SANZIO) (1483–1520)
'The Healing of the Lame Man in the Temple' (Victoria and Albert Museum, London)

The customary reversal of the Raphael cartoons by the Brussels weavers in the tapestries they made from them for the Sistine Chapel in the Vatican shows that Raphael had taken their technique fully into account. In the cartoons all right-handed gestures are made with the left hand, and the initial journey of the eye from left to right of a picture is also allowed for.

'The Healing of the Lame Man' constitutes another of Raphael's credentials as one of the most fluent artists who has ever lived. Although the problems posed by the architectural and human details are formidable, the pillars (modelled on some at St Peter's, Rome, which were traditionally supposed to be replicas of those in King Solomon's temple) are very complex forms, but Raphael has evidently had no problem at all with them nor with the gestures, stance, character and clothes of the figures. It is a privilege to observe the style and skill of the Highest Renaissance, even though we may remain unconvinced that it was the summit of anything else but refinement and ambition in European art.

252 JAN VAN SCOREL (1495–1562)
'The Stoning of St Stephen' (Municipal Museum, Douai, France)

All but two of Scorel's large altarpieces were destroyed by the Calvinist iconoclasts in 1566, and the polyptych from which this picture comes was only recently discovered and restored. Scorel studied in the Low Countries in his native Alkmaar and in Harlem and Amsterdam, then travelled in Germany where he is reported by Vasari to have met Dürer. He went to Venice and then to Jerusalem where he made studies for biblical pictures. After that he spent two years in Rome, much favoured by the Dutch Pope Adrian VI, eventually returning to Utrecht where he stayed until his death. He was the originator of the Dutch group portrait.

The figures in 'The Stoning of St Stephen' are nearly life-size and clearly demonstrate his very distinctive Mannerist style with its bright light, hard shadows and acid colour. The background shows the influence of his period in Rome and the figures are much more expressive than the faces. He was greatly admired in his time and is considered historically important in bringing Italian influence to the Low Countries. He also once restored the Van Eycks's great polyptych of the Mystic Lamb (see centre panel, page 267).

253 EUGENE DELACROIX (1798–1863)
'St Stephen's Followers Taking Possession of his Body' (Barber Institute of Fine Arts, University of Birmingham, West Midlands)

Delacroix painted some of the most splendid large-scale paintings of the nineteenth century, but he also had a way of working on small-scale pictures in an entirely different spirit, though these were always very recognizably by the same artist. This little picture quite clearly belongs to the latter kind which often show a certain modesty as if the painter does not presume to be too sharp or specific. It conveys a pathos and wistful regret for the death of St Stephen, the attempt to mop up the martyr's blood being both unexpected and touching.

His career is one of the most important in nineteenth-century French painting and his contribution to the dialectic which resulted in twentieth-century art is of crucial importance. He took over the leading position of

Géricault, and engaging the spirits of Titian and Rubens, brought nineteenth-century French Romanticism to its most luxuriant flowering. His most famous large works are probably 'The Massacre at Chios', 'The Death of Sardanapalus' and 'Liberty Guiding the People' (all in the Louvre), which demonstrate the mixture of the exotic and radical in his nature – both forward- and backward-looking.

He was early in recognizing Constable's genius and was very friendly with Bonington, with whom for a time he shared a studio in Paris. He once met Turner in Paris but was repelled by him, and in his famous *Journal* only wrote of the art of his great fellow-Romantic to remark on his fatal and common English fault of 'exaggerating' natural effects.

254 PETER PAUL RUBENS (1613–1669)
'Sketch for a Conversion of St Paul' (Courtauld Institute Galleries, London/Princes Gate Collection)

This extraordinarily lively oil-sketch is believed to be only the central part of a larger composition Rubens had in mind which may have been lost. Be that as it may, for our eyes it is a marvellous expressionist picture of blinding light, bolting horses and figures seen from above in a landscape. There is little doubt that Rubens would have preferred his finished picture if he ever completed it, but we are permitted to imagine that this version could not be improved on.

255 MICHELANGELO MERISI DA CARAVAGGIO
(1573–1610) 'The Conversion of St Paul' (S. Maria del Popolo, Rome)

A very strange kind of genius is needed to take the story of the conversion of 'Saul' by a blinding light on a journey through a landscape and successfully set it in a stable with an unconcerned horse and groom. Caravaggio had conceived the whole drama as taking place only in Saul's mind. He was convinced that the true theatre for the dramas of painting was the confined space of the painter's studio, and the most compelling miracle to be his own power of creation.

Only one of the greatest of all painters could have curbed a given text of this nature as Caravaggio did, and presents us with such a ruthless and even perverse reduction of it that nevertheless seems not primarily disturbing but rather the final and truest image of its subject. It would be very interesting indeed to see what the artist's first (rejected) version of the picture looked like.

256 HENDRICK TER BRUGGHEN (1588–1629)
'The Angel with St Peter in Prison' (Mauritshuis, The Hague)

With Honthorst (see his 'Caiaphas', page 213) Ter Brugghen was probably the best of the Northern Caravaggists. He painted many biblical pictures but his favourite subject was that of male and female musicians playing and singing together. He may have influenced Georges de La Tour and is considered certainly to have affected Vermeer, which can be clearly seen in the latter's picture of 'Christ with Mary and Martha' (page 189).

This picture of Ter Brugghen's is touching and humorous. Although interrupted in prayer for deliverance, St Peter seems confounded by the sudden appearance of his heaven-sent liberator, who is taking harmless pleasure in his confusion. But the most lovable and human of all the apostles will no doubt soon gather his wits together and express his gratitude and relief.

257 RAPHAEL (RAFFAELLO SANZIO) (1483–1520)
'The Freeing of St Peter' (Fresco in the Stanza of Heliodorus in the Vatican, Rome)

Pope Julius II felt no shame when Raphael, in this masterpiece, gave St Peter the Pontiff's own features; and if it wasn't his own idea he must have actively encouraged it. As a Cardinal he had been in charge of an early Christian church in Rome, S. Pietro in Vincoli, and had a strong attachment to the Saint. Raphael's picture was supposed to make an analogy with the deliverance of the Pontifical State from the domination of the French and he felt no qualms about being identified with the apostle.

This decoration is one of the greatest of all representations of a miracle and a marvellous counterpoint of three kinds of light – moonlight, torchlight and the heavenly light brought by the angel; and with its highly ingenious composition represents an imaginative and technical leap in the history of art.

258 HANS MEMLING (1430/40–1494)
'The Vision of St John' (Memling Museum, Bruges)

This is the right wing of an altarpiece 'The Mystic Marriage of St Catharine' – the other wing rather jarringly illustrates the decapitation of St John the Baptist. Both Saints are present in the main panel. Memling has probably made the author of Revelation a self-portrait and he is

observing or rather inwardly-seeing the awesome apocalyptic events with unruffled calm and has painted them as if they could be an everyday occurrence. This sanguine view is enviable and probably arises from pure faith but cannot entirely satisfy us as illustration of what is after all an account of the end of the entire universe as we know it. He shows himself again to be a master painter but without any of the depths of two or three others of his School, particularly his master Rogier van der Weyden.

259 DIEGO VELAZQUEZ (1599–1660)
'St John on Patmos' (National Gallery, London)

Traditionally this is thought to be a self-portrait and if so it is one of the most unpretentious of painters' biblical impostures. It is painted neither very carefully nor at all carelessly and there is something perfectly acceptable about St John the Divine looking like an ordinary Spanish youth (which Velázquez, of course, was far from being).

260 J. M. W. TURNER (1775–1851)
'Death on a Pale Horse' (Tate Gallery, London)

Once given one of the strangest titles of any painting, 'A Skeleton Falling off a Horse in Mid-Air', this picture was first recognized by Lawrence Gowing as illustrating the opening of the Fourth Seal. Turner has made one of his most troubling and most beautiful pictures – Gowing has suggested it may have been connected with Turner's grief at the death in 1828 of his father, who was his studio assistant and life-long companion. The subject was a popular one in the late eighteenth century but Turner has made of it a picture unlike any of the others or indeed any other picture.

262 EL GRECO (DOMENIKOS THEOTOKOPOULOS)
(1541–1614) 'The Opening of the Fifth Seal' (Metropolitan Museum of Art, New York)

At the end of his life El Greco painted three pictures for the Tavera Hospital in Toledo of which the other two were a Baptism and an Annunciation. The extraordinary painterly freedom that he managed to claim for himself throughout most of his life is shown in this picture to have reached a totality which must still astound us today.

Like so many great biblical pictures, this one does not pretend slavishly to illustrate the text and the analogy of the 'mighty wind' which attends the opening of the Sixth Seal seems to have been adopted by the artist, who also might have been thinking of the sky 'receding like a scroll' and mountains and islands 'moved from their places'. El Greco put St John himself into the picture in the form of the amazing giant figure on the left and he also seems to be adumbrating the division of the blessed and the damned, the former on the left-hand side seeming to be gaining the protection of a golden covering, with those on the right remaining vulnerable.

The only painter with whom El Greco shows any real affinity here is William Blake, who would probably have deplored the lack of specific illustrative exposition and also the enduring influence of the Venetians whom he so abhorred. But it would surely have stirred his pulse and his sympathies all the same.

264 FRANCIS DANBY (1793–1861)
'The Opening of the Sixth Seal' (National Gallery of Ireland, Dublin)

In an almost ludicrously perverse way, those Royal Academicians whom John Martin had outraged with his apocalyptic extravagances adopted a rival in his own genre to discredit him. They did not have to seek him out: he conveniently appeared with a huge 'Delivery of Israel out of Egypt' and was made an A.R.A. (Associate, Royal Academy) within months – as a reward for being so successfully influenced by the painter they abhorred, and whom they always steadfastly refused to honour. Danby had, it seems, produced a much better class of cataclysm. He later painted a 'Deluge' (which now hangs in the Tate Gallery, London, near the three Martin 'Judgment' pictures, see note for page 38) and that colourless and glum inundation was praised by the novelist Thackeray as superior by far to Poussin's, Turner's and Martin's efforts on the subject. It was to be Danby's last Romantic epic of disaster, and he stuck mainly to rustic idylls after that.

'The Opening of the Sixth Seal' is one of his most impressive essays in Martin's manner, though the latter's 'The Great Day of His Wrath' has a more catastrophic impact. Danby simply did not have a comparable commitment, or what could be called the imaginative passion that can be felt in Martin. Their rivalry, which was largely nourished by Martin's detractors, is one of the most bizarre stories in the annals of nineteenth-century British painting, reflecting though, in an oblique way, the more *outré* aspects of the genre they shared for 15 years.

267　JAN (c.1395–1441) and HUBERT VAN EYCK (d.1426)
'The Adoration of the Holy Lamb' (centre panel from the altarpiece 'The Mystic Lamb', St Bavon Church, Ghent, Belgium)

The marvellous altarpiece from which this picture comes is one of the wonders of the world of painting, and one of the very greatest Christian paintings to have come out of Northern Europe. It is a complete embodiment of all the skills of hand and eye attainable by a painter, as well as being one of the most devoutly felt images of Christendom. The lower half consists of five panels of which this is the centre one and it is equal in area to the other four put together. The five panels represent a continuous landscape in which all the figures are paying tribute to the Holy Lamb.

The altarpiece's iconography is complex and it is much more than an illustration of the text of Revelation. There are popes, bishops, martyrs, saints, virgins, angels and figures from antiquity, including the poet Virgil. The figures are set in one of the most painstakingly executed landscapes ever created. It is a paradise, painted with accurately rendered earthly plants and grasses of an enormous variety but with no sense of laboriousness. And in the background are the sacred shrines of Bruges, Mayence (Mainz), Cologne and Utrecht (which may have been added by Scorel when he restored it). The only painful detail is the tongue of St Livinus, patron saint of Ghent, which he is carrying with the tongs that had ripped it out (see far right figure wearing a mitre). It is said on an inscription on the altarpiece that Hubert began the work and Jan finished it, though we shall never be quite sure of this.

269　J. M. W. TURNER (1775–1851)
'The Angel Standing in the Sun' (Tate Gallery, London)

The biblical text from Revelation was printed in the Royal Academy catalogue when this picture was first exhibited there in 1846. Turner has however added things not seen by St John. Adam and Eve are mourning over the body of Abel (left foreground) and Judith can be seen holding on high the head of Holofernes. The Serpent, who is Satan and chained up by an angel (Revelation 20:1–3) is also represented (centre foreground). On Turner's part the picture seems also to express the pessimism of his old age. Whether or not he made the possibly apocryphal exclamation 'The Sun is God', for him it had become the power which consumes as much as it illuminates. His contemporaries were, as so often, baffled by it but not entirely unimpressed.

The Spectator after some nervous praise declared, 'of the figures we can only say that Turner has taken leave of form altogether'. And although there was outright condemnation from other quarters and later suggestions from Turner's complex champion Ruskin that it was pathological, The Times (we may think rightly) protested, 'It is all very well to treat Turner's pictures as jests, but things like these are too magnificent for jokes.'

270　HANS MEMLING (1430/40–1494)
'The Last Judgment (Pomorskie Museum, Gdansk, Poland)

In paintings and frescos there is seldom any attempt to illustrate the text of Revelation literally and it is rationalized into an even symmetry, the Damned going down to Hell rather than into the Lake of Fire and the Blessed upwards to Heaven. The Book of Life is often represented but the other books mentioned are generally not in evidence.

This very accomplished example is also one of the blandest ones, as we could expect from the artist. It was painted for a Jacopo Tani who represented the Medici in Bruges, and he put it on a ship bound for Italy which was captured by a certain Peter Benecke of Danzig (now Gdansk in Poland) who took it home with him. It has remained there ever since except for a short spell in Paris as booty of the Napoleonic wars. In many Northern 'Last Judgments' the Blessed are seen to be being received almost over-affectionately by the angels which presents an often charming prospect. The Damned are generally much more horribly punished than they are in 'Last Judgments' from the South.

273　MICHELANGELO BUONARROTI (1475–1564)
'The Last Judgment' (fresco in the Sistine Chapel in the Vatican, Rome)

Michelangelo's great image and container of images was started 24 years after the painting of the ceiling of the Sistine Chapel. It conveys a feeling which is quite different and much grimmer than the stupendous decoration that stretches away above it. It was accepted as a work of God-like creativeness by contemporary artists and by Pope Paul III but severely condemned by counter-Reformation zealots and others, and seriously physically damaged by more than one over-painting of the naked bodies. It was without doubt one of the most influential pictures ever painted for all European artists of the next few centuries whose main concern was the language of the human body.

For us today this fresco seems much more pitiless than voluptuous and the figure of Christ is perhaps the most severe image of Him ever painted, with even His Mother seeming to turn away from involvement rather than being ready to intercede for us. All the most memorable images within the picture are of the Damned, and Michelangelo has not only damned himself but portrays the flayed skin from his own body held by St Bartholomew (below Christ, centre right). It is, like all his greatest large-scale work, a monument to the creative power of the human race as well as being an acknowledgment (in this case perhaps not an entirely willing one) of the irresistible power of God.

274　JOHN MARTIN (1789–1854)
'The Plains of Heaven' (Tate Gallery, London)

In the famous Victorian novel East Lynne (1861) by Mrs Henry Wood this picture is described thus: 'Oh, you should have seen it! There was a river you know, and boats, beautiful gondolas they looked, taking the redeemed to the shores of Heaven. They were shadowy figures in white robes, myriads and myriads of them, for they reached all up in the air to the holy city; it seemed to be in the clouds, coming down from God. The flowers grew on the banks of the river, pink and blue and violet; all colours, but so bright and beautiful; brighter than our flowers are here.'

'The Plains of Heaven' was extravagantly praised on its great tours with its two companion 'Judgment' pictures in the mid-nineteenth century but, as already noted, in 1935 it was sold together with them for only £7.00 at auction. It is in its way the resting place and final justification for all the biblical anxiety, menace and disaster with which John Martin preceded it. It terminates this collection, not as a great climax of art but because few painters have ever had the urge or the nerve to attempt to illustrate this part of St John's text and none could have done so with a more painfully whole-hearted expression of faith and yearning.

SELECT BIBLIOGRAPHY

Bindman, David Blake as an Artist (Oxford, 1977)
Brown, Stephanie Religious Painting (Oxford and New York, 1979)
Clark, Kenneth Introduction to Rembrandt (London and New York, 1978)
Clark, Kenneth Piero della Francesca (Oxford, 1951, 2nd edn 1969;
　Ithaca, N.Y., 1981)
Feaver, William Art of John Martin (Oxford and New York, 1975)
Fletcher, Jennifer Rubens (Oxford, 1968, 4th edn 1974)
Gash, John Caravaggio (London and New York, 1981)
Larousse Dictionary of Painters (Feltham, Middlesex and New York, 1981)
Pope-Hennessy, John Raphael (New York, 1979)
Schiller, Gertrud Ikonographie der Christlichen Kunst (Iconography of
　Christian Art) Vol. 1 & 2 (London, 1971, 1972);
　Vol. 3, Vol. 4 Parts I & II (Gütersloh, W. Germany, 1971, 1977, 1980)

ALPHABETICAL LIST OF PAINTERS

Annotations (pages 275–299) to illustrations are listed under the page numbers on which the illustrations appear. References within another artist's note are indicated in *italics*.